TAKING SIDES

Clashing Views on Controversial

Issues in World History, Volume I

D0207868

Clashing Views on Controversial

Issues in World History, Volume I

Selected, Edited, and with Introductions by

Joseph R. Mitchell
Howard Community College

and

Helen Buss Mitchell
Howard Community College

McGraw-Hill/Dushkin
A Division of The McGraw-Hill Companies

For Jason, our first successful collaboration

Photo Acknowledgment
Cover image: © 2002 by PhotoDisc, Inc.

Cover Art Acknowledgment
Charles Vitelli

Portions of this material were published in *Taking Sides: Clashing Views on Controversial Issues in World Civilizations,* 2d ed. and *Taking Sides: Clashing Views on Controversial Issues in Western Civilization,* 1st ed.

Library of Congress Cataloging-in-Publication Data
Main entry under title:
Taking sides: clashing views on controversial issues in world history, volume i/selected, edited, and with introductions by Joseph R. Mitchell and Helen Buss Mitchell.—1st ed.
Includes bibliographical references and index.
1. World history. 2. History, ancient. I. Mitchell, Joseph R., ed. II. Mitchell, Helen Buss, ed. III. Series.

909

0-07-254866-5
ISSN 1538-716X

Printed on Recycled Paper

Preface

In *Taking Sides: Clashing Views on Controversial Issues in World History, Volume I,* we identify the issues that are typically covered in the teaching of world history, using scholarly and readable sources that argue these issues. We have taken care to choose issues that will make this volume multicultural, gender based, and reflective of current historical scholarship. We frame these issues with preview and follow-up sections that are user-friendly for both teachers and students. Students who use this volume should come away with a greater understanding and appreciation of the value of studying history as well as enhanced skills in critical thinking.

Plan of the book This book is made up of 18 issues that argue pertinent topics in the study of world history. Each issue has an issue *introduction,* which sets the stage for the debate as it is argued in the yes and no selections that follow. Each issue concludes with a *postscript* that makes some final observations and points the way to other questions related to the issue. In reading the issue and forming your own opinions, you should not feel confined to adopt one or the other of the positions presented. There are positions in between the given views or totally outside them, and the *suggestions for further reading* that appear in each issue postscript should help you to find resources to continue your study of the subject. We have also provided Internet site addresses (URLs) in the *On the Internet* page that accompanies each part opener. At the back of the book is a listing of all the *contributors to this volume,* which will give you information on the historians and commentators whose views are debated here.

Using the book Care has been taken to provide issues that are in various ways related. They could be used to (a) compare/contrast those with like content, (b) show relationships between and among some topics across time, geographic, and cultural boundaries, and (c) make connections between past historical events and their contemporary relevance. For example, Issues 1 and 3 cover the changing interpretations of Africa's role in human history, stretching back to the origins of humankind. Issues 2 and 8 analyze the reasons for the demise of two civilizations, one Asian, the other Native American. Issues 4, 6, and 11 explore the roles played by women in ancient Sumeria, early Christianity, and Renaissance Europe. Issues 5 and 15 evaluate the role of two leading historical figures—Alexander the Great, a man of arms, and Martin Luther, a man of God —and how they influenced the course of history. Issues 7 and 16 point out historical antecedents of contemporary issues involving gay rights and violence against women. Issues 9 and 10 explore the historical relationship between the Islamic and Christian worlds; one resulting in a peaceful exchange of ideas, the other in the most brutal of wars. Issues 13, 14, and 18 deal with overseas exploration and expansion, from both Asian and European perspectives. Fi-

nally, Issues 12 and 17 show the power of ideas in shaping the history of two civilizations, Japanese and Western.

A word to the instructor An *Instructor's Manual With Test Questions* (multiple-choice and essay) is available through the publisher for the instructor using *Taking Sides* in the classroom. A general guidebook, *Using Taking Sides in the Classroom*, which discusses methods and techniques for integrating the pro-con approach into any classroom setting, is also available. An online version of *Using Taking Sides in the Classroom* and a correspondence service for *Taking Sides* adopters can be found at http://www.dushkin.com/usingts/.

Taking Sides: Clashing Views on Controversial Issues in World History is only one title in the Taking Sides series. If you are interested in seeing the table of contents for any of the other titles, please visit the Taking Sides Web site at http://www.dushkin.com/takingsides/.

Acknowledgments We would like to thank Larry Madaras of Howard Community College—fellow teacher, good friend, coeditor of *Taking Sides: Clashing Views on Controversial Issues in American History,* and editor of *Taking Sides: Clashing Views on Controversial Issues in American History Since 1945*—for his past and present assistance in making our work possible. Special acknowledgment also goes to David Stebenne of Ohio State University—friend, scholar, teacher, and author of *Arthur J. Goldberg: New Deal Liberal* (Oxford University Press, 1996)—for his suggestions and advice. Thanks also go out to the library staffs of Howard County, Maryland; University of Maryland, College Park; University of Maryland, Baltimore County (UMBC); and Howard Community College— particularly Ela Ciborowski, who secured interlibrary loans.

At McGraw-Hill/Dushkin, a debt of gratitude is owed to list manager Ted Knight and developmental editor Juliana Gribbins, who guided us through the publishing side of the book and gave encouraging words and positive feedback.

A final word We would appreciate any questions or comments that you may have on our work, especially which issues work best in your classroom and which issues you never use. Please contact us at joemitch@bigjar.com. We promise a quick response.

<div align="right">

Joseph R. Mitchell
Howard Community College

Helen Buss Mitchell
Howard Community College

</div>

Contents In Brief

Contents

Professor John Boswell (1947–1994) states that same-sex unions, which dated back to pagan times, existed in medieval Europe until they were gradually done away with by the Christian Church. Reviewer Philip Lyndon Reynolds, while admitting that "brotherhood" ceremonies took place in the prescribed period, asserts that these ceremonies did not have the same authority as sacred unions and therefore cannot be equated with marriage rites.

Professor of anthropology Richard E. W. Adams argues that although military factors played a role in the Maya demise, a combination of internal and environmental factors was more responsible for that result. Professor of anthropology George L. Cowgill states that although there is no monocausal explanation for the Maya collapse, military expansion played a more important role than scholars originally thought.

German historian Hans Eberhard Mayer states that although there were other factors important to the development of the Crusades, the strongest motivation was a religious one. British historian Ronald C. Finucane counters that although the religious influence on the Crusades was significant, political, social, economic, and military factors in medieval Europe also played a role in their origin, development, and outcome.

Professor of history and philosophy of education Mehdi Nakosteen traces the roots of the modern university to the golden age of Islamic culture (750–1150 C.E.). He maintains that Muslim scholars assimilated the best of classical scholarship and developed the experimental method and the university system, which they passed on to the West before declining. The late historian Charles Homer Haskins (1870–1937) traces the university of the twentieth century to its predecessors in Paris and Bologna, where, he argues, during the twelfth and thirteenth centuries the first universities in the world sprang up.

Historian Margaret L. King surveys Renaissance women in domestic, religious, and learned settings and finds reflected in their lives a new consciousness of themselves as women, as intelligent seekers of a new way of being in the world. Historian Joan Kelly-Gadol discovered in her work as a Renaissance scholar that well-born women seemed to have enjoyed greater advantages during the Middle Ages and experienced a relative loss of position and power during the Renaissance.

Religious scholar Winston L. King credits the monk Eisai with introducing Zen to the Hōjō samurai lords of Japan who recognized its affinity with the warrior's profession and character. Japanologist Catharina Blomberg emphasizes the diversity of influences on the samurai psyche—Confucianism, Shinto, and Zen—stressing the conflict between a warrior's duty and Buddhist ethical principles.

Historian Felipe Fernández-Armesto states that although Columbus was far from perfect, the overall results of his work merit consideration as having helped to shape the modern world. Writer Kirkpatrick Sale sees Columbus as a product of a sick, dispirited Europe and concludes that the selfish nature of his work and what resulted from it prevented Europe from using the New World discoveries as an opportunity for the continent's salvation.

Journalist Nicholas D. Kristof states that China's worldview, shaped by centuries of philosophical and cultural conditioning, was responsible for its decision to cease its maritime ventures during the Ming dynasty. Naval historian Bruce Swanson acknowledges that China's worldview played a role in its decision to cease its maritime programs, but maintains that there were other, more practical considerations that were responsible for that decision.

Religion and history professor Robert Kolb contends that Martin Luther was seen as a prophetic teacher and hero whose life brought hope, divine blessing, and needed correctives to the Christian church. Theologian and professor emeritus of theology Hans Küng views Martin Luther as the inaugurator of a paradigm shift and as the unwitting creator of both bloody religious wars and an unhealthy subservience by ordinary Christians to local rulers in worldly matters.

History professor Anne Llewellyn Barstow asserts that the European witch-hunt movement made women its primary victims and was used as an attempt to control their lives and behavior. History professor Robin Briggs

states that although women were the European witch-hunts' main victims, gender was not the only determining factor in this socio-cultural movement

Historian of ideas Herbert Butterfield argues that the late sixteenth and early seventeenth centuries witnessed a radical break with the past and the emergence of dramatically new ways of understanding both knowledge and the world—in short, a Scientific Revolution. Professor of sociology and historian of science Steven Shapin questions the idea of a Scientific Revolution, suggesting that there was no radical break with the past and rejecting the existence of a single event that might be called a Scientific Revolution.

Professor of history William H. McNeill states that in 1500, western Europe began to extend its influence to other parts of the world, resulting in a revolution in world relationships in which the West was the principal benefactor. History professor Steven Feierman argues that because historians have viewed modern history in a unidirectional (European) manner, the contributions of non-European civilizations to world history have gone either undiscovered or unreported.

Introduction

The Study of World History

Joseph R. Mitchell

Helen Buss Mitchell

What Is History?

History is a dialogue between the past and the present. As we respond to events in our own world, we bring the concerns of the present to our study of the past. What seems important to us, where we turn our attention, how we approach a study of the past—all these are rooted in the present. It has been said that where you stand determines what you see. This is especially the case with history. If we stand within the Western tradition exclusively, we may be tempted to see its story as the only story or the only one worth telling. And whose perspective we take is also critical. From the point of view of the rich and powerful, the events of history take one shape; through the lens of the poor and powerless, the same events can appear quite different. If we take women or non-Western cultures or the ordinary person as our starting point, the story of the past may present us with a series of surprises.

Tools of the Historian

Much of the raw material of history consists of written sources. Original sources —from a period contemporary with the events or ideas described—are called *primary sources*. These may consist of documents of all kinds, including official records as well as personal letters and diaries. The writings of historians reflecting on the past are called *secondary sources*. It is important to keep in mind that primary sources may not automatically be assumed to be free from bias. Each contains historical and personal perspectives. Their principal limitation, however, is that they record what people considered noteworthy about their own age and not necessarily what would most interest us today. As the concerns of the present evolve, the questions we bring to our study of the past will also change. Much of what you read in this book will reflect differences in focus between one historian and another. As Edward Hallett Carr points out, the historian constructs a working model that enables him or her to understand the past. It would be a great mistake to confuse this working model with a photocopy.

Traditional History

Only recently has history considered itself a social science and striven for a kind of scientific accuracy in speaking about the past. For much of human history, until perhaps the late nineteenth century, history was considered a branch of literature rather than a kind of science. It was concerned first of all with narrative, with the telling of a compelling story, and its focus was on the fascinating characters whose lives shaped and defined the past.

Biography, the recounting of the life and times of a powerful man, was regarded as one of the most reliable windows on the past. The so-called "great man" was credited with shaping and defining his own time. As a result, studying Alexander the Great or Christopher Columbus was assumed to offer one of the most reliable keys to unlocking a specific historical time period.

And, traditional history looked relatively uncritically at the great men from the past. Military heroes, for example, were lauded for their conquests with little or no focus on the carnage that made those conquests possible. Another unspoken assumption was the dominance and superiority of the West as the creator and bearer of human civilization. Divine power was sometimes seen as directing, or at least approving, the actions of powerful nations and men.

The traditional areas of focus for the historian have been political, diplomatic, and constitutional. Political history considers how power has been organized and enforced by the state within human societies. Diplomatic history looks at what influenced the power struggles between states as they continually struggled for dominance. Constitutional history examines the evolution of national states with special attention to who ruled and who or what conferred the right to rule.

A related domain of the traditional historian has been that of intellectual history, or the history of ideas—in the fields of politics, economics, sociology, theology, and science. Probing the power of Christianity or Zen Buddhism, tracing the roots of the modern university, examining the influence of a worldview on a nation's commercial enterprises—all these are the province of intellectual history. Taking this approach to its widest scope, one might explore the intellectual climate of an entire age, such as the Renaissance, the Reformation, or the Scientific Revolution. Which ideas shaped and defined each of these distinct historical periods? And, what marked the change from one to another?

Revisionism

However, history is not a once-and-for-all enterprise. Each generation formulates its own questions and brings new tools to the study of the past, resulting in a process called *revisionism*. Much of what you will read in this book is a product of revisionism as historians reinterpret the past in the light of the present. One generation values revolutions, the next focuses on their terrible costs. One generation assumes that great men shape the events of history, the next looks to the lives of ordinary people to illuminate the past. There is no final answer, but where we stand will determine which interpretation seems more compelling to us. Issues 5, 13, and 15 introduce the tension between traditional

and revisionist interpretations of Alexander the Great, Christopher Columbus, and Martin Luther.

As new tools of analysis become available, our ability to understand the past improves. Bringing events into clearer focus can change the meaning that we assign to them. Many of the selections in this book reflect new attitudes and new insights made possible by the tools that historians have borrowed from other social sciences. For instance, finding and deciphering long-hidden manuscripts can shed new light on belief systems such as Christianity, studied in Issue 6. And physical artifacts can help us to decode elements of language and culture; for example, Issue 8 looks at conflicting theories in determining why the civilization of the Mayas collapsed.

Presentism

While we stand in the present, we must be wary of what historians call *presentism,* that is, reading the values of the present back into the past. If we live in a culture that values individualism and prizes competition, we may be tempted to see these values as good even in a culture that preferred communalism and co-operation. And we may miss a key component of an ancient civilization because it does not match what we currently consider worthwhile. Issue 18 questions whether we can any longer deny the role of non-Europeans in shaping the modern world. We cannot and should not avoid our own questions and struggles. They will inform our study of the past; and yet, they must not warp our vision. Ideally, historians engage in a continual dialogue in which the concerns, but not the values, of the present are explored through a study of the past.

At the same time, though, we might bring the moral standards of the present to bear on the past. Cultural relativism, pioneered in the field of anthropology, made us sensitive to the many and varied ways in which civilizations define what is "normal" and what is "moral." So, we remain appropriately reluctant to judge individuals from other times and places by our standards since they were or are, in fact, behaving perfectly normally and morally by the standards of their own time and place. However, from the perspective of the present, we do not hesitate to condemn slaveholding, genocide, or even the zealotry that leads to what the modern world calls "ethnic cleansing," explored in Issue 9 on the Crusades.

Changing Historiographical Focuses

All cultures are vulnerable to the narrow-mindedness created by *ethnocentrism* —the belief that one's own culture is superior to all others. From inside a particular culture, certain practices may seem normative—that is, we may assume that all humans or all rational humans must behave the way we do or hold the attitudes we hold. When we meet a culture that sees the world differently from ourselves, we may be tempted to write it off as inferior or primitive. As an alternative to ethnocentrism, we might want to enter the worldview of another and see what we can learn from expanding our perspective. These issues will offer you many opportunities to try this thought experiment.

Stepping outside the Western tradition has allowed historians to take a more globocentric view of world events. Accusing their predecessors of Eurocentrism, some historians have adopted an Afrocentric view of world history that emphasizes Africa's seminal role in cultural evolution, which we explore in Issue 3. Within the Western tradition, women have challenged the male-dominated perspective that studied war but ignored family. Including additional perspectives complicates our interpretation of past events but permits a fuller picture to emerge. We must be wary of *universalism*—assuming, for example, that patriarchy has always existed or that being a woman was the same for every woman no matter what her historical circumstances. If patriarchy or the nuclear family has a historical beginning, then there was a time when some other pattern existed; Issue 4 on Sumerian civilization explores this possibility. If cultures other than the West have been dominant or influential during the past, what did the world look like under those circumstances?

Social History

Some historians have moved beyond political, diplomatic, and constitutional history to explore economics and demographics as well as to study social processes. Moving from a focus on nations and rulers to a close examination of forces that can be studied analytically has opened up the realms of business and the family to the historian. Proponents of the so-called new social history rejected what they called history from the "top down." Instead of the great man whose influence shaped his age, they looked to the lives of ordinary people and called what they were doing history from the "bottom up." The previous generation of historians, they asserted, had sometimes acted as if only the influential had a role in shaping history. Social history assumes that all people are capable of acting as historical agents rather than being passive victims to whom history happens. With this shift in attitude, the lives of slaves, workers, women of all kinds, and children, too, become worthy subjects of historical investigation.

Because the poor and powerless seldom leave written records, other methods must be used to understand their lives. Applying the methods of social scientists to their own discipline, historians have broadened and deepened their field of study. Archaeological evidence, DNA analysis, the tools of paleoanthropology, computer analysis of demographic data—all these have allowed the voiceless to speak across centuries. Fossil evidence, for instance, and the analysis of mitochondrial DNA—the structures within cells we inherit only from our mothers—may each be employed, sometimes with strikingly different results, to trace the migrations of preliterate peoples. The debate between these two conflicting interpretations shapes Issue 1, which considers an African origin for *Homo sapiens*.

What historians call *material culture* reveals the everyday lives of people by analyzing what they discarded as well as the monuments and other material objects they intended to leave as markers of their civilizations. At certain points in human history, owning a plow made the difference between merely surviving and having some surplus food to barter or sell. What people leave to their heirs can tell us how much or how little they had to brighten their lives while

they lived. As we continue to dig, we may find our assumptions confirmed or denied by the fossils of once-living organisms. Evidence of sea life on the top of a mountain lets us know that vast geologic changes have taken place. And, in another example, our genetic material has information that we are just now learning to decode and interpret that may settle important questions of origin and migration as we learn to read the data locked inside our DNA.

The high-speed comparative functions of computers have allowed the historian to analyze vast quantities of data and look at demographic trends. How old are people when they marry for the first time, have a child, or die? Only with the expanded life expectancy made possible by the modern world has it been possible for people to see their children's children—to become grandparents. Looking at the time between marriage and the birth of a first child can help us calculate the percentage of pregnant brides and gain some insight into how acceptable or unacceptable premarital sex may have been in the context of an expected future marriage. If we study weather patterns and learn that certain years were periods of drought or that the glacier receded during a particular time period, we will know a little more about whether the lives of people who lived during these times were relatively easier or more difficult than those of their historical neighbors in earlier or later periods.

Race, Class, and Gender

The experience of being a historical subject is never monolithic. That is, each of us has a gender, a race, a social class, an ethnic identity, a religion (even if it is atheism or agnosticism), an age, and a variety of other markers that color our experiences. At times the most important factor may be one's gender, and what happens may be more or less the same for all members of a particular gender. Under other circumstances, however, race may be predominant. Being a member of a racial minority or of a powerful racial majority may lead to very different experiences of the same event. At other times social class may determine how an event is experienced; the rich may have one story to tell, the poor another. And other factors, such as religion or ethnic identity—even age—can become the most significant piece of a person's identity, especially if prejudice or favoritism is involved. Historians try always to take into account how race, class, and gender (as well as a host of other factors) intersect in the life of a historical subject. Issue 16 asks this question: Were those accused as witches of a different social class and gender than their accusers? And, were these differences significant?

Issues Involved in Historical Interpretation

Often historians will agree on what happened but disagree about why or how something happened. Sometimes the question is: Were internal or external causes more responsible? Both may have contributed to an event, but one or the other may have played the more significant role. Looking at differing evidence may lead historians to varying interpretations. Issue 2 explores the demise of

the Indus Valley civilization in the context of both internal (environmental and social conditions) and external (an Aryan invasion) factors.

A related question is: Was it the circumstances that changed or only the attitudes of those who experienced them? If we find less protest, for instance, can we conclude that things have gotten better or only that people have found a way to accommodate themselves to a situation beyond their control? In this context, consider the questions raised by Issue 7: Did those who contracted same-sex unions consider themselves linked in a sacred union or only bound in a kind of "brotherhood" ceremony? Did the rituals disappear because they were suppressed by the religious establishment or because they no longer met a need? Is our context so different that we have no hope of understanding what these rituals meant to the people who engaged in them?

Periodization

Even more basically, the student of the past must wonder whether the turning points that shape the chapters in our history books are the same for all historical subjects. The process of marking turning points is known as *periodization*. It is the more or less artificial creation of periods that chunk history into manageable segments by identifying forks in the road that took people and events in a new direction. Using an expanded perspective, we may learn that the traditional turning points hold for men but not for women or reflect the experiences of one ethnic group but not another. And, if periodization schemes conflict, which one should we use? Issues 10, 11, and 17 examine questions of periodization. If Europe was experiencing a "dark age" while the Islamic world enjoyed a "golden age," which one more accurately describes the time period? Issue 10 looks at the rise of the university from within the context of this question. And, was there a distinct break at the periods we designate the Renaissance (Issue 11) and the Scientific Revolution (Issue 17)? If so, did women and men experience these breaks identically?

It is also important to keep in mind that people living at a particular moment in history are not aware of labels that later historians will attach to their experience. People who lived during the Middle Ages were surely not aware of living in the middle of something. Only much after the fact were we able to call a later age the Renaissance. To those who lived during what we call the Middle Ages or the Renaissance, marriage, childbirth, work, weather, sickness, and death were the real concerns, just as they are for us. Our own age will certainly be characterized by future historians in ways that might surprise and shock us. As we study the past, it is helpful to keep in mind that some of our assumptions are rooted in a traditional periodization that is now being challenged.

Continuity or Discontinuity?

A related question concerns the connection or lack of connection between one event or set of events and another. When we look at the historical past, we must ask ourselves whether we are seeing continuity or discontinuity. In other words, is the event we are studying part of a normal process of evolution or does it represent a break from a traditional pattern? Questions of continuity

versus discontinuity are the fundamental ones on which the larger issue of periodization rests. Did the Industrial Revolution take the lives of workers in wholly new directions? Were the periods we refer to as the Renaissance and the Scientific Revolution really more discontinuous with the past than continuous with it? And if some elements shift while others constitute a seamless web, which is the more significant element for the historian?

Sometimes events may appear continuous from the point of view of one group and discontinuous from the point of view of another. Suppose that factory owners found their world and worldview shifting dramatically, whereas the lives and perspectives of factory workers went on more or less as they had before. When this is the case, whose experience should we privilege? Is one group's experience more historically significant than another's—and how should we decide? Modern historians are struggling with these questions as the voices of Native Americans compete with those praising Columbus's voyages of discovery.

The Power of Ideas

Can ideas change the course of history? People have sometimes been willing to die for what they believe in, and revolutions have certainly been fought, at least in part, over ideas. Some historians believe that studying the clash of ideas or the predominance of one idea or set of ideas offers the best key to understanding the past. Issue 12 looks at the roles of Zen, Confucianism, and Shinto in defining the bushido code of the Samurai warrior. And Issue 14 examines whether it was China's view of itself or more practical considerations that brought a halt to its commercial and maritime efforts during the Ming dynasty.

What do you think? Do ideas shape world events? Would devotion to a political or religious cause lead you to challenge the status quo? Or, would economic conditions be more likely to send you to the streets? Historians differ in ranking the importance of various factors in influencing the past. Do people challenge the power structure because they feel politically powerless, or because they are hungry, or because of the power of ideas?

The Timeliness of Historical Issues

When we read the newspaper or listen to the evening news, we find numerous and confusing political, economic, religious, and military clashes that can be understood only by looking at their historical contexts. The role of the United States in world events, the perennial conflicts in the Middle East, China's emerging role as an economic superpower, the threat posed by religious fundamentalism, Africa's political future, the question of whether revolutions are ever worth their costs—these concerns of the global village have roots in the past. Is it helpful, for instance, to look at Islamic revivalism in the context of a similar Christian revivalism called the Crusades? Understanding the origins of conflicts gives us the possibility of envisioning their solutions. The issues in this book will help you think through the problems facing our world and give

you the tools to make an informed decision about what you think is the best course of action.

In a democracy, an informed citizenry is the bedrock on which a government stands. If we do not understand the past, the present will be a puzzle to us and the future may seem out of our control. Seeing how and why historians disagree can help us to determine what the critical issues are and where informed interpreters part company. This, at least, is the basis for forming our own judgments and acting upon them. Looking critically at clashing views also hones our analytic skills and makes us thoughtful readers of all our textbooks as well as magazines and newspapers.

Why Study World History?

You may be wondering why this book deals with world history rather than exclusively with Western civilization. At times the West has felt that its power and dominance in the world made only its own story worth studying. History, we are sometimes told, is written by the winners. For the Chinese, the Greeks, the Ottoman Turks, and many other victors of the past, the stories of other civilizations seemed irrelevant, unimportant, and not nearly as valuable as their own triumphal saga. The Chinese considered their Middle Kingdom the center of the world, the Greeks labeled all others barbarians, and the Ottoman Turks expected never to lose their position of dominance. From our perspective in the present these stories form a tapestry. No one thread or pattern tells the tale, and all seem to be equally necessary for a complete picture of the past to emerge.

Any single story—even that of a military and economic superpower—is insufficient to explain the scope of human history at a given moment in time. Our story is especially interesting to us and you will find issues specific to Western civilization in this book. However, as we are learning, our story achieves its fullest meaning only when it is told in concert with those of other civilizations that share an increasingly interconnected planet with us. As communications systems shrink the Earth into a global village, we may be ignoring the rest of the world at our own peril. At the very least the study of civilizations other than our own can alert us to events that may have worldwide implications. And, as we are beginning to learn, no story happens in isolation. The history of the West can perhaps be accurately told only within a global context that takes into account the actions and reactions of other civilizations as they share the world stage with the West. As you read the issues that concern non-Western civilizations, stay alert for what you can learn about your own.

Your textbook may take a global focus, or it may be restricted to the study of Western civilization. In either case, the readings in this book will enrich your understanding of how the peoples of the world have understood themselves and their relationships with others. As we become a more clearly multicultural society, we have an additional reason for studying about other civilizations that have blended with our own through immigration. Perhaps the biggest challenge for an increasingly diverse United States of America is to understand its own role in world affairs and its relationship with other countries, which may have different histories, value systems, and goals.

On the Internet ...

In Search of Human Origins

This Web site, based on a three-part PBS/NOVA television program entitled *In Search of Human Origins*, contains transcripts of each part, including commentary from some of the world's leading archaeologists.

> http://www.pbs.org/wgbh/nova/transcripts/

Aryan Invasion and the Fall of the Indus Empire

The Aryan Invasion and the Fall of the Indus Empire Web site is dedicated to proving the existence of the Aryan invasion and examining the demise of the Indus Empire. This site uses a variety of evidences as proof.

> http://www.geocities.com/Athens/Ithaca/1335/
> Hist/fall_ind.html

Black Athena

Black Athena is Professor Martin Bernal's personal Web site, and it provides relevant information regarding the connections between African and Egyptian civilizations.

> http://www.blackathena.com/outline.html

Materials for the Study of Women and Gender in the Ancient World

The Materials for the Study of Women and Gender in the Ancient World Web site provides lists of Web site materials in sections entitled bibliography, essays, and images.

> http://www.stoa.org/diotima

Alexander the Great

This Alexander the Great Web site provides a cradle-to-grave treatment of Alexander's life and accomplishments in small segments, and it also includes some interesting visuals.

> http://1stmuse.com/frames/index.html

From Jesus to Christ: The First Christians

From Jesus to Christ: The First Christians Web site is based on a four-part PBS/FRONTLINE television series. This page, which is devoted to the roles for women, raises important questions on the subject.

> http://www.pbs.org/wgbh/pages/frontline/

The Ancient World

*B*eginning with the question of the origins of humankind, this section covers the development of the world's earliest civilizations and crosses over to the classical era. It analyzes and evaluates the origins and development of the world's oldest civilizations, the challenges they faced, how they responded to them, and what resulted from that process. It is during this period that written history originated, and with it began the never-ending process of historical revisionism.

- Did *Homo Sapiens* Originate in Africa?

- Were the Aryans Responsible for the Demise of the Indus Valley Civilization?

- Was Egyptian Civilization African?

- Was Sumerian Civilization Exclusively Male Dominated?

- Does Alexander the Great Merit His Exalted Historical Reputation?

- Did Christianity Liberate Women?

ISSUE 1

Did *Homo Sapiens* Originate in Africa?

YES: Christopher Stringer and Robin McKie, from *African Exodus: The Origins of Modern Humanity* (Henry Holt & Company, 1996)

NO: Milford Wolpoff and Rachel Caspari, from *Race and Human Evolution* (Simon & Schuster, 1997)

ISSUE SUMMARY

YES: Science researcher Christopher Stringer and science writer Robin McKie state that modern humans first developed in Africa and then spread to other parts of the world.

NO: Paleoanthropologists Milford Wolpoff and Rachel Caspari counter that modern humans developed simultaneously in different parts of the world.

Where did we come from? This question strikes at the heart of human existence. For each individual, its answer provides an identity that no one else can share. When it is applied universally to all humankind, it can provide answers that go back to the origin of the species: How did we get here? From whom are we descended? To what extent are we all related?

In the twentieth century the origin of our ancestors was determined by the most recent fossilized discovery. With each time period, the location shifted from one part of the world to another, until the last generation's pioneering work placed humankind's origins firmly in East Africa. But this answers only the origins part of the human puzzle. When did these "ancestors" evolve into *Homo sapiens*, and where did this occur?

Answers to these questions have come within the domain of scientists known as *paleoanthropologists*. Relying on fossil discoveries and the latest tools and methodologies used to analyze and evaluate them, these scientists have done much to provide information regarding the origins of humankind. But, recently, they have been joined in the quest by another group of scientists—molecular biologists (or molecular geneticists)—who have used advances in the study of DNA in their search for answers to the same questions.

In 1987 the latter group published their findings, thus firing the opening shots in what would become an interdisciplinary conflict within the scientific

community. By examining the mitochondrial DNA, taken from the placentas of women representing every identifiable racial and ethnic group possible, they concluded that approximately 200,000 years ago, our earliest traceable ancestor existed in Africa. This species migrated throughout the world, thus making Africa the birthplace of *Homo sapiens*. This is known as the "out of Africa" theory.

The popular media has picked up this debate: articles in *Time, Newsweek,* the *New York Times,* and many other publications have publicized the new findings, naming our common ancestor "Eve" and proclaiming her to be "the mother of us all."

For a time, the DNA proponents seemed to dominate the world's attention with "Eve." But it did not take long for some paleoanthropologists to fire back. Claiming the reasoning of the DNA disciples to be flawed, they offered evidence to support a multiregional approach to the evolution of humankind, in which prehistoric creatures originated in Africa, migrated to other parts of the world, and then separately evolved into *Homo sapiens*. This has been referred to as the "multiregional" theory in regard to the origins of humankind.

Although the media has made this seem more like a battle between the old school paleoanthropologists and the new school molecular biologists than it really is, there are fundamental differences in the arguments developed by both sides that require further research and evaluation. In the April 1992 issue of *Scientific American,* the two sides squared off for a page-by-page debate on the subject. This was followed by the publication of several books on the subject, as each side attempted to gain the upper hand in this academic dispute.

The debate has also been clouded by the emergence of race and political correctness as factors included in the equation. Those who argue for a rightful place for Africa in world history resist any attempt to deny the continent its position as the home of the progenitor of humankind and see racism behind any scheme to do so. See Milford Wolpoff and Rachel Caspari, *Race and Human Evolution* (Simon & Schuster, 1997), pp. 43–47, for an analysis of the current controversy. It is hoped that this diversion will not in any way obfuscate the search for answers to the questions inherent in this debate—questions that are important to an understanding of the origins of human existence.

In the following selections, Christopher Stringer and Robin McKie argue for the "out of Africa" theory by presenting DNA evidence to support their assertions. Wolpoff and Caspari contend that the "multiregional" theory is more accurate by presenting what they perceive are flaws in the "out of Africa" theory.

3

**Christopher Stringer
and Robin McKie**

 YES

The Mother of All Humans?

It is not the gorilla, nor the chimpanzee, nor the orangutan, that is unusual.... Each enjoys a normal spectrum of biological variability. It is the human race that is odd. We display remarkable geographical diversity, and yet astonishing genetic unity. This dichotomy is perhaps one of the greatest ironies of our evolution. Our nearest primate relations may be much more differentiated with regard to their genes but today are consigned to living in a band of land across Central Africa, and to the islands of Borneo and Sumatra. We, who are stunningly similar, have conquered the world.

This revelation has provided the unraveling of our African origins with one of its most controversial chapters. And it is not hard to see why. The realization that humans are biologically highly homogeneous has one straightforward implication: that mankind has only recently evolved from one tight little group of ancestors. We simply have not had time to evolve significantly different patterns of genes. Human beings may look dissimilar, but beneath the separate hues of our skins, our various types of hair, and our disparate physiques, our basic biological constitutions are fairly unvarying. We are all members of a very young species, and our genes betray this secret.

It is not this relative genetic conformity per se that has caused the fuss but the results of subsequent calculations which have shown that the common ancestor who gave rise to our tight mitochondrial DNA lineage must have lived about 200,000 years ago. This date, of course, perfectly accords with the idea of a separate recent evolution of *Homo sapiens* shortly before it began its African exodus about 100,000 years ago. In other words, one small group of *Homo sapiens* living 200 millennia ago must have been the source of all our present, only slightly mutated mitochondrial DNA samples—and must therefore be the fount of all humanity. Equally, the studies refute the notion that modern humans have spent the last one million years quietly evolving in different parts of the globe until reaching their present status. Our DNA is too uniform for that to be a realistic concept....

Not surprisingly, such intercessions into the hardened world of the fossil hunter, by scientists trained in the "delicate" arts of molecular biology and genetic manipulation, have not gone down well in certain paleontological circles. The old order has reacted with considerable anger to the interference of

these "scientific interlopers." The idea that the living can teach us anything about the past is a reversal of their cherished view that we can best learn about ourselves from studying our prehistory. Many had spent years using fossils to establish their interpretations of human origins, and took an intense dislike to being "elbowed aside by newcomers armed with blood samples and computers," as *The Times* (London) put it. "The fossil record is the real evidence for human evolution," announced Alan Thorne and Milford Wolpoff in one riposte (in *Scientific American*) to the use of mitochondrial DNA to study our origins. "Unlike the genetic data, fossils can be matched to the predictions of theories about the past without relying on a long list of assumptions." Such a clash of forces has, predictably, generated a good many sensational headlines, and triggered some of the most misleading statements that have ever been made about our origins. Scientists have denied that these genetic analyses reveal the fledgling status of the human race. Others have even rejected the possibility of ever re-creating our past by studying our present in this way. Both views are incorrect, as we shall see. Even worse, the multiregionalists have attempted to distort the public's understanding of the Out of Africa theory by deliberately confusing its propositions with the most extreme and controversial of the geneticists' arguments. By tarnishing the latter they hope to diminish the former. This [selection] will counter such propaganda and highlight the wide-ranging support for our African Exodus provided, not just by the molecular biologists, but by others, including those who study the words we speak and who can detect signs of our recent African ancestry there. We shall show not only that the majority of leading evolutionists and biologists believe in such an idea but that their views raise such serious questions about the multiregional hypothesis that its future viability must now be very much in doubt.

Unraveling the history of human migration from our current genetic condition is not an easy business, of course. It is a bit like trying to compile a family tree with only an untitled photograph album to help you. "Our genetic portrait of humankind is necessarily based on recent samplings, [and] it is unavoidably static," says Christopher Wills of the University of San Diego. "Historical records of human migrations cover only a tiny fraction of the history of our species, and we know surprisingly little about how long most aboriginal people have occupied their present homes. We are pretty close to the position of a viewer who tries to infer the entire plot of *Queen Christina* from the final few frames showing Garbo's rapt face."

It is an intriguing image. Nevertheless, biologists are beginning to make a telling impact in unraveling this biological plot and in understanding *Homo sapiens'* African exodus. And they have done this thanks to the development of some extraordinarily powerful techniques for splitting up genes, which are made of strands of DNA (deoxyribonucleic acid) and which control the process of biological inheritance. . . .

[T]his is exactly what Allan Wilson, Rebecca Cann, and Mark Stoneking, working at the University of California, Berkeley, did in 1987. They took specimens from placentas of 147 women from various ethnic groups and analyzed each's mitochondrial DNA. By comparing these in order of affinity, they assembled a giant tree, a vast family network, a sort of chronological chart for

mankind, which linked up all the various samples, and therefore the world's races, in a grand, global genealogy.

The study produced three conclusions. First, it revealed that very few mutational differences exist between the mitochondrial DNA of human beings, be they Vietnamese, New Guineans, Scandinavians, or Tongans. Second, when the researchers put their data in a computer and asked it to produce the most likely set of linkages between the different people, graded according to the similarity of their mitochondrial DNA, it created a tree with two main branches. One consisted solely of Africans. The other contained the remaining people of African origin, and everyone else in the world. The limb that connected these two main branches must therefore have been rooted in Africa, the researchers concluded. Lastly, the study showed that African people had slightly more mitochondrial DNA mutations compared to non-Africans, implying their roots are a little older. In total, these results seemed to provide overwhelming support for the idea that mankind arose in Africa, and, according to the researchers' data, very recently. Their arithmetic placed the common ancestor as living between 142,500 and 285,000 years ago, probably about 200,000 years ago. These figures show that the appearance of "modern forms of *Homo sapiens* occurred first in Africa" around this time and "that all present day humans are descendants of that African population," stated Wilson and his team.

The Berkeley paper outlining these findings was published in the journal *Nature* in January 1987, and made headlines round the world, which is not surprising given that Wilson pushed the study's implications right to the limit. He argued that his mitochondrial tree could be traced back, not just to a small group of *Homo sapiens,* but to one woman, a single mother who gave birth to the entire human race. The notion of an alluring fertile female strolling across the grasslands of Africa nourishing our forebears was too much for newspapers and television. She was dubbed "African Eve"—though this one was found, not in scripture, but in DNA. (The honor of so naming this genetic mother figure is generally accorded to Charles Petit, the distinguished science writer of the *San Francisco Chronicle.* Wilson claimed he disliked the title, preferring instead, "Mother of us all" or "One lucky mother.")

The image of this mitochondrial matriarch may seem eccentric but it at least raises the question of how small a number of *Homo sapiens* might have existed 200,000 years ago. In fact, there must have been thousands of women alive at that time. The planet's six billion inhabitants today are descendants of many of these individuals (and their male partners), not just one single super-mother. As we have said, we humans get our main physical and mental characteristics from our nuclear genes, which are a mosaic of contributions from myriad ancestors. We appear to get our mitochondrial genes from only one woman, but that does not mean she is the only mother of all humans.

"Think of it as the female equivalent of passing on family surnames," states Sir Walter Bodmer, the British geneticist. "When women marry they usually lose their surname, and assume their husband's. Now if a man has two children, there is a 25 percent chance both will be daughters. When they marry, they too will change their name, and his surname will disappear. After twenty generations, 90 percent of surnames will vanish this way, and within 10,000

generations—which would take us from the time of 'African Eve' to the present day—there would only be one left." An observer might assume that this vast, single named clan bore a disproportionately high level of its originator's genes. In fact, it would contain a fairly complete blend of all human genes. And the same effect is true for mitochondrial DNA (except of course it is the man who is "cut out"). The people of the world therefore seem to have basically only one mitochondrial "name." Nevertheless, they carry a mix of all the human genes that must have emanated from that original founding group of *Homo sapiens.* It is a point that Wilson tried, belatedly, to make himself. "She wasn't the literal mother of us all, just the female from whom all our mitochondrial DNA derives." ...

And there we have it. The blood that courses through our veins, the genes that lie within our cells, the DNA strands that nestle inside our mitochondrial organelles, even the words we speak—all bear testimony to the fact that 100,000 years ago a portion of our species emerged from its African homeland and began its trek to world dominion. (The other part, which stayed behind, was equally successful in diversifying across the huge African continent, of course.) It may seem an exotic, possibly unsettling, tale. Yet there is nothing strange about it. This process of rapid radiation is how species spread. The real difference is just how far we took this process—to the ends of the earth. A species normally evolves in a local ecology that, in some cases, provides a fortuitously fertile ground for honing a capacity for survival. Armed with these newly acquired anatomies, or behavior patterns, it can then take over the niches of other creatures. This is the normal course of evolution. What is abnormal is the supposed evolution of mankind as described by the multiregionalists. They place their faith in a vast global genetic link-up and compare our evolution to individuals paddling in separate corners of a pool.... According to this scheme, each person maintains their individuality over time. Nevertheless, they influence one another with the spreading ripples they raise—which are the equivalent of genes flowing between populations.

Let us recall the words of Alan Thorne and Milford Wolpoff....
They state that:

> The dramatic genetic similarities across the entire human race do not reflect a recent common ancestry for all living people. They show the consequences of linkages between people that extend to when our ancestors first populated the Old World, more than a million years ago. They are the results of an ancient history of population connections and mate exchanges that has characterised the human race since its inception. Human evolution happened everywhere because every area was always part of the whole.

Gene flow is therefore crucial to the idea that modern humans evolved separately, for lengthy periods, in different corners of the earth, converging somehow into a now highly homogeneous form. Indeed, the theory cannot survive without this concept—for a simple reason. Evolution is random in action and that means that similar environmental pressures—be they associated with climate change, or disease, or other factors—often generate different genetic responses in separate regions. Consider malaria, a relatively new disease

that spread as human populations became more and more dense after the birth of agriculture. Our bodies have generated a profusion of genetic ripostes for protection in the form of a multitude of partially effective inherited blood conditions. And each is unique to the locale in which it arose. In other words, separate areas produced separate DNA reactions. There has been no global human response to malaria.

Nevertheless, multiregionalism maintains that gene flow produces just such a global response. Given enough time gene exchange from neighboring peoples will make an impact, its proponents insist. This phenomenon, they say, has ensured that the world's population has headed towards the same general evolutionary goal, *Homo sapiens;* though it is also claimed that local selective pressure would have produced some distinctive regional physical differences (such as the European's big nose). And if the new dating of early *Homo erectus* in Java is to be believed (as many scientists are prepared to), then we must accept that this web of ancient lineages has been interacting—like some ancient, creaking international telephone exchange—for almost two million years.

Now this is an interesting notion which makes several other key assumptions: that there were enough humans alive at any time in the Old World over that period to sustain interbreeding and to maintain the give and take of genes; that there were no consistent geographical barriers to this mating urge; that the different human groups or even species that existed then would have wished to have shared their genes with one another; and that this rosy vision of different hominids evolving globally towards the same happy goal has some biological precedent.

So let us examine each supposition briefly, starting with the critical question of population density. According to the multiregionalists, genes had to be passed back and forward between the loins of ancient hominids, from South Africa to Indonesia. And this was done, not by rapacious, visiting males spreading their genotype deep into the heart of other species or peoples (a sort of backdoor man school of evolution), but by local interchange. In neighboring groups, most people would have stayed where they were, while some individuals moved back and forward, or on to the next group as they intermarried. In other words, populations essentially sat still while genes passed through them. But this exchange requires sufficient numbers of neighboring men and women to be breeding in the first place. By any standard, hominids—until very recent times—were very thin on the ground. One calculation by Alan Rogers, a geneticist at the University of Utah, in Salt Lake City, and colleagues uses mitochondrial DNA mutations to assess how many females the species possessed as it evolved. The results he produced are striking. "The multiregional model implies that modern humans evolved in a population that spanned several continents, yet the present results imply that this population contained fewer than 7,000 females," he states in *Current Anthropology.* It is therefore implausible, he adds, that a species so thinly spread could have spanned three continents and still have been connected by gene flow.

Then there is the question of geography. To connect humanity throughout the Old World, genes would have had to flow ("fly" might be a better word) back and forth up the entire African continent, across Arabia, over India, and

down through Malaysia; contact would therefore have had to have been made through areas of low population density such as mountains and deserts, coupled with some of the worst climatic disruptions recorded in our planet's recent geological past. Over the past 500,000 years, the world was gripped by frequent Ice Ages: giant glaciers would have straddled the Himalayas, Alps, Caucasus Mountains; meltwater would have poured off these ice caps in torrents, swelling inland lakes and seas (such as the Caspian) far beyond their present sizes; while deserts, battered by dust storms, would have spread over larger and larger areas. Vast regions would have been virtually blocked to the passage of humans. At times our planet was extremely inhospitable while these straggling hordes of humans were supposed to be keeping up the very busy business of cozy genetic interaction. "Even under ecologically identical conditions, which is rarely the case in nature, geographically isolated populations will diverge away from each other and eventually become reproductively isolated. . . . It is highly improbable that evolution would take identical paths in this multi-dimensional landscape," writes the Iranian researcher Shahin Rouhani.

[Luca] Cavalli-Sforza agrees: "What is very difficult to conceive is a parallel evolution over such a vast expanse of land, with the limited genetic exchange that there could have been in earlier times." He acknowledges that it is theoretically possible that the genes of west European humans would have been compatible with those of east Asia despite their ancient separation. Barriers to fertility are usually slow to develop: perhaps a million years or more in mammals. However, he adds, "barriers to fertility of a cultural and social nature may be more important than biological ones." Two very different looking sets of people may have been able to interbreed physically but would have considered such action as breaking a gross taboo.

In other words, we are expected to believe that a wafer-thin population of hominids, trudging across continents gripped by Ice Ages, were supposed to be ready to mate with people they would have found extraordinarily odd-looking and who behaved in peculiar ways. Cavalli-Sforza, for one, does not buy this. "Proponents of the multiregional model simply do not understand population genetics," he states. "They use a model that requires continuous exchange of genes, but it requires enormous amounts of time to reach equilibrium. There has been insufficient time in human history to reach that equilibrium." The spread of modern humans over a large fraction of the earth's surface is more in tune with a specific expansion from a nuclear area of origin, he adds.

Now this last point is an important one, for it is frequently presented in the popular press that the Out of Africa theory represents a divergence from the natural flow of biological affairs, that its protagonists are somehow on the fringes of orthodoxy, proposing strange and radical notions. The reverse is true —the large number of scientists quoted [here] indicates the wide intellectual support now accorded the theory. It is a very new idea, admittedly. It is only a little more than a decade since it was first proposed, on the basis of fossils, by scientists like [Gunter] Bräuer and [Chris] Stringer. Yet its precepts now affect many areas of science, and its implications are accepted by their most distinguished practitioners. We are witnessing a rare moment in science, the replacement of a redundant orthodoxy by a formerly heretical vision. Hence

the words of Yoel Rak as he staggered from a multiregionalists' symposium in 1991. "I feel like I have just had to sit through a meeting of the Flat Earth Society," he moaned. Of course, Rak became an African Exodus proselytizer many years ago. A more damning convert, if you are multiregionalist, is that of *Science,* a journal noted for its dispassion and conservatism. "The theory that all modern humans originated in Africa is looking more and more convincing," it announced in March 1995, "and the date of the first human exodus keeps creeping closer to the present... the evidence coming out of our genes seems to be sweeping the field."

In fact, the idea that the opposition—the multiregionalists—represent the norm in biological thinking is to present the story of human origins "ass backwards," as Stephen Jay Gould succinctly puts it.

> Multi-regionalism... is awfully hard to fathom. Why should populations throughout the world, presumably living in different environments under varying regimes of natural selection, all be moving on the same evolutionary pathway? Besides, most large, successful, and widespread species are stable for most of their history, and do not change in any substantial directional sense at all. For non-human species, we never interpret global distribution as entailing preference for a multiregional view of origins. We have no multiregional theory for the origin of rats or pigeons, two species that match our success and geographical spread. No one envisions proto-rats on all continents evolving together toward improved ratitude. Rather we assume that *Rattus rattus* and *Columbia livia* initially arose in a single place, as an entity or isolated population, and then spread out, eventually to cover the globe. Why uniquely for humans, do we develop a multiregional theory and then even declare it orthodox, in opposition to all standard views about how evolution occurs?

The answer to that critical question has much to do with an outlook that has pervaded and bedeviled science throughout history. We have, at various times, been forced to abandon species-centric scientific notions that we live at the center of the cosmos, and that we were specially created by a supreme being. A last vestige of this urge to self-importance can be seen in multiregionalism, which holds that our brain development is an event of all-consuming global consequence towards which humanity strived in unison for nearly two million years. It argues that *Homo sapiens'* emergence was dictated by a worldwide tendency to evolve large braincases, and share genes and "progress." Humanity is the product of a predictable proclivity for smartness, in other words, so we cannot possibly be the outcome of some local biological struggle. Surely that would demean us. To believe that humanity could be the product of a small, rapidly evolving African population who struck it lucky in the evolution stakes is therefore viewed as being worse than apostasy by these people. Unfortunately for them, there is little proof to support their specialist, global promotion of mankind—as we have seen. Once again we must adopt the simplest scientific explanation (i.e., the one for which the facts best fit) as the superior one. As this [selection] has made clear, there is no good genetic evidence to sustain an argument that places humanity on a plinth of global superiority. To do so is to indulge in mysticism. *Homo sapiens* is not the child of an entire planet, but a

creature, like any other, that has its roots in one place and period—in this case with a small group of Africans for whom "time and chance" has only just arrived. Nor is our species diminished in any way by such interpretations. Indeed, we are enriched through explanations that demonstrate our humble origins, for they place us in an appropriate context that, for the first time, permits proper self-evaluation and provides an understanding of the gulf we are crossing from a clever ape to a hominid that can shape a planet to its requirements—if only it could work out what these are.

Multiregional Evolution and Eve: Science and Politics

What Is Multiregional Evolution?

The fundamental question that has been asked historically is how people all over the world could evolve in the same way, all becoming modern humans, and yet maintain some regional differentiation for long periods of time. This is an observation, and the fundamental problem is how to resolve the contradiction that seems to lie at its heart. The genic exchanges between populations that would seem critical for one would seem equally destructive of the other. Confronted with compelling similarities between Australasian specimens separated by three quarters of a million years, and somewhat different similarities across perhaps an even longer time span in China, patterns of details not shared by fossils from other regions, Milford [Wolpoff], Alan [Thorne], and Wu [Xinzhi] developed a model to explain these sets of seemingly contradictory observations that have puzzled paleoanthropologists for close to a century—evidence of long-standing regional differences between human groups in the face of evidence of important global similarities in the direction of evolution....

Multiregional evolution provides resolution of the contradictions between genetic exchanges and population differentiations in a broad-based theory that links gene flow and population movements, and natural selection, and their effects on populations both at the center and at the peripheries of the geographic range of the human species. In a nutshell, the theory is that *the recent pattern of human evolution has been strongly influenced by the internal dynamics of a single, far-flung human species, internally divided into races. Human populations developed a network of interconnections, so behavioral and genetic information was interchanged by mate exchanges and population movements. Gradients along these interconnections encouraged local adaptations. These and other sources of population variation that depended on population histories developed, and stable adaptive complexes of interrelated features evolved in different regions. But, at the same time, evolutionary changes across the species occurred as advantageous features appeared and dispersed because of the success they imparted. These changes took on different forms in different places because of the differing histories*

of populations reflected in their gene pools, and the consequences of population placements in terms of habitat and their relations to other populations. Some evolutionary changes happened everywhere, because of these processes and because of common aspects of selection created by the extra information exchanges allowed by the evolving cultural and communications systems. Consequently, throughout the past 2 million years humans have been a single widespread polytypic species, with multiple, constantly evolving, interlinked populations, continually dividing and merging. Because of these internal divisions and the processes that maintain them, this species has been able to encompass and maintain adaptive variations across its range without requiring the isolation of gene pools. This pattern emerged once the Old World was colonized, and there is no evidence of speciations along the human line since then that would suggest there were different evolutionary processes, such as complete replacement, at work.

Over the past decade Multiregional evolution has itself evolved into a broad and malleable frame. It is a *general* explanation for the pattern and process of human evolution within which virtually any hypothesis about dynamics between specific populations can be entertained, from the mixture, even replacement, of some populations to the virtual isolation of others. To be valid, the model must be able to incorporate a wide range of population dynamics, from expansion to extinction, leaving paleoanthropologists room to derive more detailed understandings of specific evolutionary patterns for particular times and places. Various groups of people behave in different ways that affect their demographic structure (that is, the specific attributes of their population, such as its size, mortality rates, sex ratios, age profiles). If you are trying to predict patterns of evolutionary change, this demographic information is absolutely essential, since the major evolutionary forces of natural selection and genetic drift operate differently on populations with diverse demographic structures. As with all social animals, every human population has a different evolutionary story, with its own historical, biological, and social constraints that affect its evolution. The human evolutionary pattern is even more dynamic than that of other species, because cultural and linguistic factors are added to the list of constraints, even as they expand the different ways in which populations can exchange and share information. Culturally prescribed marriage systems, trading networks, religious practices, likes and dislikes, all affect reproduction, death, and breeding group size and therefore the evolution of these populations. Consequently, *detailed* understanding of the course and processes of human evolution is unusual, and can be obtained only for small temporal and geographic windows, where many ecological, demographic, and cultural variables are known. Multiregional evolution can be thought of as the structure in which these windows sit. It is compatible with all the windows we've looked through so far, a structure that allows them all to exist together. In other words, it is a model that fits the skeletal and genetic data we have today, and we also think it works in the past, where the information is much less precise, and there is much less of it.

Using the Multiregional model for interpreting the past assumes that the modern pattern of human evolution is the best model for interpreting the human condition ever since the first colonizations of the world outside of Africa

began. If this assumption is valid, the present can be used as a model for explaining the past; this is the principle of "uniformitarianism" that the geologist Charles Lyell so successfully applied during the last century to interpreting the geological and paleontological record, work that was critical to Darwin's emerging theory of evolution. We consider this the most logical approach to understanding the recent pattern of human evolution, and treat it as the null hypothesis (the hypothesis of no difference, or no change, is the hypothesis to disprove, or try to disprove, with ongoing research and discoveries) for interpreting the past. It is the simplest hypothesis, one that models the evolutionary patterns of our behaviorally complex, geographically widespread predecessors after the living species most like them: our own.

We are quite aware that people have not always been the same. The evolutionary dynamics of modern humans are far from fully understood, and there are many factors in modern human populations that cannot be applied to the past. People have changed dramatically in recent times—their cultures have become incredibly complex, their demographics have altered remarkably, populations have expanded dramatically—and there is no way that evolutionary processes at work today can be expected to be identical with those of the past, just as the evolutionary processes at work today vary from population to population. But stepping away from the details, there is a frame of conditions these processes work within, and it is here that we draw the basis for applying the uniformitarian principle. It seems to us that the bases for approaching the past this way are twofold: we recognize no biological species formation in humanity once *Homo sapiens* appeared some 2 million years ago, and the fundamental shift from a solely African scavenging/gathering species to a colonizing species taking place at *Homo sapiens* origins or early in their evolution set up the conditions of polytypism across a broad geographic range that allowed Multiregionalism to work.

Thus Multiregional evolution is a gradualist model, with the primary tenet that humans *are* a single polytypic species and *have been* for a very long time into the past. It interprets the fossil record to show that human beings —that is, our species *Homo sapiens* and its main attribute *humanity*—happened only once, and once on the scene they evolved without a series of speciations and replacements. No speciation events seem to separate us from our immediate ancestors, and cladogensis, the splitting of one species into two, last characterized our lineage at the origin of *Homo sapiens* some 2 million years ago, when members of what we once called *"Homo erectus"* first appeared in East Africa. For 2 million years, from the end of the Pliocene until now, ancient and modern *Homo sapiens* populations are members of the same species. This doesn't mean they didn't change—*au contraire*—but we think these changes neither led to nor required a speciation. The broad-based evolutionary processes proposed in Multiregional evolution are formulated to explain patterns of variation *within* a polytypic species: the same evolutionary processes shown to be important in other polytypic species have shaped our patterns of diversity in the past and do so in the present.

The ability to account for all the data it is supposed to explain is only one hurdle for a hypothesis. It also must, at least in principle, be refutable. Mul-

tiregional evolution would be wrong, a disproved and invalid hypothesis, if the evolutionary changes it accounts for and the contradiction between genic exchanges and local continuity of features it resolves were explained instead by a series of successive speciations and replacements. Multiregional evolution would also be wrong if the pattern of human evolution it describes never existed—that is, if the interpretation of long-standing polytypism in the human fossil record is incorrect, since the explanations would then be elucidating a pattern that did not exist. Evidence of multiple speciations, indicating a different *pattern* of human evolution and, in particular, a recent speciation for modern humans, could provide this refutation, and the Eve theory claimed to rest on just such evidence.

So Eve came as a wake-up call for Multiregionalism. Although not particularly aimed that way at first, it was soon correctly perceived by all as the first serious attempt at its disproof, and for "Popperian" scientists, refutation is the key way that science proceeds. Milford is a deductionist, strongly influenced by the philosopher of science Karl Popper and most concerned with refuting hypotheses. The role of deduction comes after a hypothesis is framed; what matters most is whether it is explanatory, is testable, and requires the least number of assumptions. Multiregional evolution is our null hypothesis, the simplest and most explanatory hypothesis that covers the pattern of Pleistocene human evolution. But it was just recently developed, at least in its modern form, and until the Eve theory there were no significant attempts to disprove it.

After the publication of the 1984 paper, Alan, Wu, and Milford didn't think too much about Multiregional evolution in a theoretical way. Prior to the marketing of Eve, they had each proceeded to treat Multiregional evolution as a working hypothesis. Many others accepted the hypothesis as well, and research was initiated within a Multiregional paradigm, which in itself was not the focus of the investigations. As Multiregionalists studied human evolution, they were consciously aware of geographic variation and its confounding effects in understanding human evolution as a whole; Multiregional scholars were, and are, careful to view temporal trends as potentially regional phenomena and cautious not to generalize too quickly between one region and another, often avoiding a kind of ethnocentrism applied to the fossil record.

Before Eve, the few attempts to show species change in the recent human fossil record were focused on the seemingly unending Neandertal issue and were unconvincing to most scientists. Nothing effectively challenged the explanatory value of Multiregionalism as an explanation for worldwide change. As Alan made movies all over the world, the patterns of variation in the people he visited fit the Multiregional model. He collected and bred snakes, and the patterns of their variation fit the Multiregional model. Wu struggled with the long-awaited completion of his monograph on the Dali skull. Milford returned to focused, problem-oriented research. Always interested in patterns and causes of variation, he wrote papers on allometry, on sexual dimorphism, and on biomechanics, seeking explanations for trends that extended across broad periods of human evolution. But they all returned to issues of Multiregional evolution after the 1987 publication announcing what was soon widely called the Eve theory, and several publications following in the next year cited evi-

dence that could refute the Multiregional model and our entire understanding of the human fossil record.

The Eve theory played *the* lead role in what quickly became a confrontation between paleontological and molecular genetic interpretations of the past. The development of Multiregionalism owes a great deal to her. When the Eve publications emerged, the Multiregional camp quickly responded to them, pointing out several problems that prevented them from refuting the Multiregional hypothesis. The Eve debates made us very introspective about our proposals and their implications. We were forced to think about Multiregionalism's development and testability and the things we think make it a good hypothesis. . . .

The Politicization of Eve

Eve was new. Eve was modern. Eve was glamorous and sexy. Eve was a simple theory that made science reporting easy and fun. Eve gave answers and represented 20th-century technology providing answers—telling us about our origins. Eve implied the brotherhood of all humankind and was politically correct. Eve was perfect in every way, actually too good to be true. How is it that a theory so flawed could be embraced by so many? Why was she so uncritically accepted? The answer incorporates politics, and Eve gained political favor two ways: first by the appeal of new science, new technology, and new ideas replacing old-fashioned ones. It was a demonstration that public tax dollars were not really being misspent, that the results tell us something new about ourselves and something we can all understand. Second, it underscored the genetic unity of the human species, something we all need to be reminded of in the face of so many factious elements in our world. Both factors contributed to Eve's appeal to the public, and both entered the scientific discourse because science, in the end, is a human activity.

Unlike many scientific debates, where different sides may write quiet (or not so quiet) articles back and forth in professional journals for decades, the Eve debate quickly became politicized for a variety of reasons. . . . As the science of human origins has always been, this debate is public. It is sometimes pitched as a battle between the paleontologists (using archaic science) and the geneticists (modern scientists, exploiting the advantages of new techniques and modern technology), although this is far from true. Much hay is made over personal differences between the investigators in the different disciplines and even more over the differences in technology used. In a sense the fuss over Eve is an appealing topic because it illustrates the advantages of the modern age. Images are fostered of bright young geneticists using modern techniques the doddering old fossil hunters, ill prepared to understand, let alone participate in real science, cannot hope to. This is actually actively promoted by a few of the Eve researchers in statements such as those of [Allan] Wilson and [Rebecca] Cann in *Scientific American,* no less, where they contrast paleoanthropologists with "biologists trained in modern evolutionary theory" who "reject the notion that fossils provide the most direct evidence of how human evolution actually proceeded." Cann then held paleoanthropology in especially low

regard, once saying "it is too much to hope the trickle of bones from fossil beds would provide a clear picture of human evolution any time soon." The paleo-anthropologists themselves are portrayed as poor scientists engaged in circular reasoning. For instance Wilson and Cann quipped in *Scientific American,* "fossils cannot, in principle, be interpreted objectively... [paleoanthropologists'] reasoning tends to circularity."

In fact, there is nothing particularly difficult to understand about mitochondrial genetics, or the Eve position. We find the fuss over technology something less than relevant, since quality of science is not measured by the level of technology employed, but by the design of questions asked and testing methodology (not technology). Many people seem to believe something seen with the naked eye is less valid or scientific than something seen with a microscope, and the more powerful the microscope the more valuable the observation. But microscopes "showed" scientist after scientist that humans had 48 chromosomes, when they actually have only 46.

Scientists working today do have great advantages over their historical counterparts, and some of the advantage comes from technology and its applications in research. Advances in instrumentation are extremely beneficial, but by themselves do not make "good" science. In fact, there has been a real tendency for the technologies themselves to drive the direction of scientific research, as they become techniques in search of questions to answer. Real advantages we enjoy come from our recognition of the understandings arrived at by our predecessors and their incorporation into our consciousness, our world view. As Newton said of himself, "If I see so far, it is because I stand on the shoulders of giants." Multiregional evolution was only derived now, in spite of age-old grappling with many of the same problems, not because of the advance of technology, but because our world view has changed. The triumph of Darwinian thinking and an appreciation of population dynamics are actually very recent. Whatever insights we may have into the evolution of humans as a polytypic species are due to the influence on our thinking, both conscious and unconscious, of the prior work of others.

Misconceptions about the power of technology are generated by the press, not the geneticists (with one or two notable exceptions). For the most part, there are very good feelings between geneticists and paleontologists, two groups of scientists who study different data bases, but who sometimes ask the same questions of them. Both kinds of data can give us information about evolutionary history and relationships. One kind of data, whether from genes or bones, is not "better" than the other, and if data from different, independent sources seem to bring totally conflicting evidence to bear on a single question, it is not time to choose between them, but rather to see what is wrong with our hypotheses and methods of analysis.

There are other, far more serious ways than the technology issue in which the public aspects of the debate have influenced it, the positions taken by its participants, and its perceived outcome. These evolved over the question of political correctness. It is possible, as the late Glynn Isaac reportedly said, that Multiregional evolution holds the high ground on the political correctness issue because by positing an ancient divergence between races it implies that the

small racial differences humans show must have evolved slowly and therefore are insignificant. But the high ground is widely perceived to be held by the Eve theory, not Multiregional evolution, and in any event Multiregional evolution does not mean that the modern *races* are particularly ancient: groups of features, not groups of populations, are ancient according to this model.

Even as the debate was first joined, Eve theorists claimed the high moral ground for themselves. In 1987 S. J. Gould wrote: "We are close enough to our African origins to hope for the preservation of unity in both action and artifacts." In 1988 he proclaimed: "Human unity is no idle political slogan... all modern humans form an entity united by physical bonds of descent from a recent African root." Of course, if the Eve theory means the *unity* of humankind, what could Multiregional evolution mean? And why should either side be more politically correct? A paper read by Fatimah Jackson at the 1994 meetings of the American Anthropological Association tars all of the modern human origins theories with typology and racism in one form or another. As she sees the debate, it begins with the presumption that there are typologically distinct races. She believes that this assumption is a reflection of Eurocentrism: the races must be distinct for Europeans to be distinct from the others. Writing with L. Lieberman, she goes on to conclude of all the theories, "Each... relies to varying degrees on static, typological definitions of human biological variation at some point in its analysis, and this reliance limits the explanatory power and utility of each model for understanding the origins and maintenance of human diversity."

Although there is much truth in what she says, Dr. Jackson misses a fundamental point. Far from having the same view on race and human variation, different views on these topics underscore the various theories of modern human origins. The different origins theories hold very different positions on how to model human variation, or race, and therefore on evolutionary pattern. Or perhaps it is the other way around: proponents of different origins theories have different ideas about evolutionary pattern, and this influences their views on race and modern human variation. Whatever the case, the two issues (race and modern human origins) are inextricably related. Multiregional evolution is clearly tied to race: it was developed to explain regional continuity which, given our own views of race, *should not exist*. But by accepting the existence of regional continuity, we recognize morphology that has been interpreted to both elevate and rank the importance of human differences, we believe incorrectly, with horrendous consequences. In order to understand the nature of the mutual influences of race and human evolution we need to examine how these mutual influences developed.... There, we can also find clues to the origins of modern predispositions toward one theory or another.

POSTSCRIPT

Did *Homo Sapiens* Originate in Africa?

Agood starting place for an academic search for human origins would begin with general sources of information to provide background necessary for research. A book that provides this is Richard Leakey, *The Origins of Humankind* (Basic Books, 1994). Also, three articles, complete with interesting visuals, are John Tierney et al., "The Search for Adam and Eve," *Newsweek* (January 11, 1988); Michael D. Lemonick, "How Man Began," *Time* (March 14, 1994); and Rick Gore, "Expanding Worlds: The Dawn of Humans," *National Geographic* (May 1997). Two video series, each in three parts, would also be helpful: *In Search of Human Origins* (PBS/NOVA, 1997) and *Dawn of Man: The Story of Human Evolution* (British Broadcasting Corporation, 2000).

The role Neanderthals played in human evolution has become a timely topic, and many questions have been raised about them. What were their chief characteristics? How did they compare with *Homo sapiens*? Did the two species cohabitate? Were they genetically related? And, most importantly, what happened to them and why? Answers to these questions are important to the study of human evolution, and some books useful to examining these questions are James Shreeve, *The Neanderthal Enigma: Solving the Mystery of Human Origins* (Avon Books, 1995); Christopher Stringer and Clive Gambee, *In Search of the Neanderthals: Solving the Puzzle of Human Origins* (Thames & Hudson, 1995); Paul Mellars, *The Neanderthal Legacy* (Princeton University Press, 1995); Ian Tattersall, *The Last Neanderthal: The Rise, Success, and Mysterious Extinction of Our Closest Human Relatives* (Westview Press, 1999); and Paul Jordan, *Neanderthal Man and the Story of Human Origins* (Sutton Publishing, 2000). There are also many articles on the subject available from various Internet providers.

Of course, the central question raised by this issue is where *Homo sapiens* originated. The answers to this question are shaped by the differing opinions espoused by molecular scientists with their "out of Africa" theory and paleoanthropologists with their "multiregional" theory. There are many sources to recommend, beginning with the books by Stringer/McKie and Wolpoff/Caspari that have been excerpted for this issue. A book that presents both sides of the debate and also explores other issues relevant to the human origins debate is Geoffrey A. Clark and C. M. Willermet, eds., *Conceptual Issues in Modern Human Research* (Wayne State University Press, 1997). Their use of articles by many scholars well known in the field makes this a most useful tool.

When pursuing this subject, be aware that every piece of new evidence may alter the framework of the debate.

ISSUE 2

Were the Aryans Responsible for the Demise of the Indus Valley Civilization?

YES: Stanley Wolpert, from *A New History of India*, 6th ed. (Oxford University Press, 2000)

NO: Jonathan Mark Kenoyer, from *Ancient Cities of the Indus Valley Civilization* (Oxford University Press, 1998)

ISSUE SUMMARY

YES: Historian Stanley Wolpert states that the Aryan invasion of the Indus Valley did occur and that it played a role in the demise of the Indus Valley civilization.

NO: Archaeologist Jonathan Mark Kenoyer counters that there is little proof that the Aryan invasion occurred and that the decline of the Indus Valley civilization was due to internal environmental and social conditions.

Which of the world's ancient civilizations was the oldest? The most advanced? Prior to the 1920s three civilizations could stake a claim to those titles —Mesopotamian, Egyptian, and Chinese. However, circumstances would soon bring another claimant into the mix.

In the 1920s archaeologists digging in the Indus River Valley (located in present-day Pakistan) discovered the remains of two major cities, which they named Harappa and Mohenjo-Daro. These sites had the earmarks of urban environments, with a well-planned street system, numerous public facilities, and what may have been the world's first indoor plumbing/drainage system. Other archaeological digs in the area produced evidence of other lesser cities and seemed to point the way to the existence of a fourth major ancient civilization. Work today continues as scholars and scientists attempt to draw a picture of this civilization and its place in human history.

Information today remains incomplete. It is certain that this Indus civilization began to develop in the third millennium B.C.E. and reached its apex in the period from 2500–1500 B.C.E. It began to decline and soon disappeared, until rediscovered in the twentieth century. What happened to it is the subject of this issue.

Who were the creators of the Indus civilization? Archaeologists can trace the roots of this civilization to the Neolithic era, when people in the area began to domesticate animals, grow crops, and live in communities. As their settlements grew into a civilization, they began to trade with their Mesopotamian neighbors to the north, which brought further sophistication to their cities. Eventually the Dravidians, a dark-skinned people from what is today south/central India, began to move into the Indus valley. Although there is little evidence available regarding this migration, there is nothing to indicate that it took the form of an invasion, but rather occurred as a peaceful synthesis of two people's cultures. This situation existed until circa 1500 B.C.E. when the Aryans, a nomadic, warlike people, entered the Indus Valley and perhaps changed the course of Indian history. This Aryan migration was part of a larger movement of Indo-European peoples who eventually settled throughout the European and Asian continents, influencing the development of civilizations wherever they settled.

How the Aryan and Indus/Dravidian cultures mixed is a subject of scholarly dispute. For most of this century, based primarily on linguistic and religious sources, it was assumed that the Aryans entered India as conquerors, applied the final blow to a dying civilization, and adopted much of its more advanced civilization. Hinduism, the caste system, and India's sacro/mythological worldview were all products of what Stanley Wolpert has called "India's first cultural synthesis" ("Multiculturalism in History: India, the Multicultural Paradigm," *Orbis* [Fall 1999]).

Within the last generation this theory has come under scholarly attack. Based on recent archaeological evidence and written sources, this new generation of scholars argues that there is little solid evidence to support the Aryan invasion theory and that those who espoused it in the past were misinterpreting the linguistic and religious sources they used as proof. They counter that the Aryan migration into the area may have been a peaceful one, and that the demise of the Indus civilization was caused by a combination of environmental, political, and social circumstances and conditions.

The importance of the question of Aryan influence on Indus civilization extends beyond the boundaries of history. If the Aryan invasion theory is true, the major roots of India's civilization, including its language, religion, and social system, developed from an non-Indian source. There are some, Hinduism nationalists especially, who see this not only as a falsification of the historical record, but as depriving India of its true cultural roots.

In the selections that follow, Stanley Wolpert, a long-time student and scholar of Indian history and culture, argues that the Aryan invasion did take place and that it resulted in a blending of Aryan and Indo-Dravidian societies from which Indian civilization sprang. Jonathan Mark Kenoyer, who has spent 23 years working in Pakistan and India, states that there is little evidence to support the Aryan invasion theory and that the demise of Indus civilization can be found in environmental and internal societal factors.

Stanley Wolpert

A New History of India

The Aryan Age (ca. 1500–1000 B.C.)

Around 2000 B.C. the original Indo-European-speaking, seminomadic barbarians, who most probably lived in the region between the Caspian and the Black seas, were driven from their homeland by some natural disaster, possibly drought, prolonged frost, or plague. Whatever the cause of their dispersion —it may even have been a series of Mongol invasions from Central Asia—the ancestors of the Italic-, Greek-, Germanic-, English-, Celtic-, Iranian-, Sanskritic-, and modern Hindi-speaking peoples were forced to flee from southern Russia to survive. These tribes moved in every direction, splitting up into smaller, more cohesive units, driving their herds of cattle, sheep, goats, and domesticated horses with them, and opening a new chapter in the history of Europe, as well as of India. The Hittites were the first Indo-Europeans to settle in a new homeland, for we find traces of them just south of Caucasia in Cappadocia that date from approximately 2000 B.C. Other tribes pushed on, however; some to the west, across Anatolia, and some to the east, across Persia (now named Iran, a cognate of Aryan, for the Indo-Iranian language brought by Indo-Europeans to that region between 1800 and 1500 B.C.) The Indo-Iranians seem to have lived for some time in harmony following their long migration. By about 1500 B.C., however, they appear to have split once more, and pastoral tribes known to history as the Indo-Aryans, or simply Aryans, advanced still further east, across the perilous Hindu Kush Mountains, into India.

Our knowledge of the earliest history of our linguistic ancestors is derived from over a century of patient reconstruction of their "Urheim" by philologists such as Friedrich Max Müller (1823–1900), who developed the science of linguistic paleontology. By analyzing all the languages within this great linguistic family and extracting the geographic, climatic, botannical, and zoological terms that all have in common, it has been possible to chart an ecological map of the "original homeland," which most closely resembles Caucasia. The ingenious insight that sparked this magnificent labor of comparative linguistics and philology was publicized most effectively by Sir William Jones (1746–94), a judge of the British East India Company's High Court. Sir William studied Sanskrit after his arrival in Calcutta in 1783, and three years later he wrote an

illuminating and learned paper that noted the vocabulary and other linguistic bonds that make the Greek, Latin, Germanic, and Sanskrit tongues all relatives within one single Indo-European family of languages.

We have no archeological evidence for the first centuries of India's Aryan age (from about 1500 to 1000 B.C.), but we have been able to piece together some picture of the era from the Aryans' religious "Books of Knowledge," or Vedas, which were so sedulously preserved by the bards of each tribe through rigorous oral tradition. The oldest and most important of these sacred works, the Rig Veda (literally "Verses of Knowledge"), consists of 1,017 Sanskrit poems, most of which are addressed to various Aryan gods and solicit their bounty. It is the world's earliest surviving Indo-European literature.

Unlike the pre-Aryan peoples of Harappa, the Aryans lived in tribal villages with their migrant herds. Their houses, fashioned of bamboo or light wood, have not survived the ravages of time; they baked no bricks, built no elaborate baths or sewer systems, created no magnificent statues or even modest figurines; they had no seals or writing, no faience art, no splendid homes. Were these relatively primitive tribal peoples, in fact, capable of storming and conquering fortified Indus cities? Perhaps. They had harnessed their horses to chariots, and they seem to have wielded hafted bronze axes (a few of which were found in the highest strata of Indus cities), as well as long bows and arrows. They had been toughened by their trek, had endured blistering sun and crossed high passes deluged with sleet and snow. The Rig Veda itself, however, is unconscious of that journey and of the Aryan "invasion" of India, yet it does mention Aryan victories against "fortified places" (*pur*), within which dark-skinned people (*dasas*) had sought in vain to defend themselves against the fairer-skinned ("wheat-colored") Aryans. (The Sanskrit word *dasa* later came to mean "slave.")

Since the Rig Veda was not written down before about 600 B.C. and the earliest surviving text dates back only as far as about 1200 A.D., we may ask, first of all, how we know that the Vedic hymns were actually composed as early as 1500 B.C., when it is generally assumed the Aryans first invaded India? Before 1909 the only way the age of the Vedas could be approximated was by Max Müller's "dead-reckoning-backwards" technique. Müller analyzed the entire corpus of Vedic literature, linguistically as well as ideologically, noting the various changes in Sanskrit case endings and word forms, as well as syntax, vocabulary, and meaning. He determined how long it had taken to effect comparable changes in ancient Greek and Latin and framed a similar timetable for the evolution of Sanskrit. There are three major stages in the evolution of those sacred Vedic texts that are still considered "revealed" literature, or *shruti* (literally "heard"), by Hindus. The initial stage includes the Rig Veda and three other ancient "collections" (*Samhitas*) of hymns and magical incantations or spells, the Sama, Yajur, and Atharva Vedas, all of which are archaic poetic texts. Next emerged a series of prose commentaries on each of the Vedas, elaborating upon those often cryptic hymns and describing in minute detail the procedures required for preparing the Vedic sacrifices and properly propitiating the gods. Because they exalt the significance and role of the Aryan priestly class, the *brāhmans* (from the word "sacred utterance," or "those who chant sacred utterances"), the commentaries are called the Brahmanas. Finally, a third group

of mystical philosophic works appeared, whose predominant form, the poetic dialogue, and whose radical new religious messages sharply differentiate them from the Brahmanas and Samhitas alike; these are the Vedanta Upanishads, many of whose ideas are similar to those in early Buddhism. Müller reasoned that they must have been composed at about the time the Buddha lived, or somewhere during the sixth century B.C. Then, by dead reckoning backwards, he estimated that within the 108 surviving Upanishadic texts there had been significant ideological, if not linguistic, evolution, which probably took several centuries. That would move the date of their composition back to about the eighth century B.C., from whence it would have taken at least two centuries for the Brahmanas to have been written. If the last of the Vedic Samhitas was then completed and ready for commentary by 1000 B.C., it seemed safe to infer that the oldest sections of the Rig Veda must have been at least four centuries older, and hence the estimated date of around 1400 B.C. for the compilation of the Rig.

In 1909 excavations at the Hittite site of Boghaz-köi in Capadocia yielded tablets containing a treaty concluded between the Hittite King Subiluliuma and his Mitanni neighbor to the east, King Mattiwaza, who reigned in about 1400 B.C. Invoked as divine witnesses to this treaty were four gods, Indara, Uruvna, Mitira, and the Nasatiya, whose Sanskrit names in the Rig Veda were spelled virtually the same (*Indra, Varuna, Mitra,* and *Naksatras*), proving that by this date the Vedic pantheon had acquired its identity. This confirmation of Müller's estimates leads us to assume that, since the Rig Veda itself does not mention the Aryan invasions of India, the process must have begun at least a century earlier, or probably around 1500 B.C. The final wave of tribal invasions may have come centuries after the first Aryans started over the northwest passes. This was the most important invasion in all of India's history, since the Aryans brought with their Caucasian genes a new language—Sanskrit—and a new pantheon of gods, as well as the patriarchial, patrilineal family and the three-class social structure (priests, warriors, and commoners) into which their tribes were organized.

Limited as we are by Vedic sources, we naturally know more about ancient Aryan religion than other aspects of the culture. Before considering Rig Vedic religious beliefs and practices, however, let us see what can be gleaned from that work about Aryan social organization and other mundane matters. The term *aryan,* while primarily a linguistic family designation, had also the secondary meaning of "highborn" or "noble." The Aryan "commoners" or *vish* (the word later used to designate the largest class in Aryan society, *vaishyas*), were most broadly divided into "tribes," or *jana.* Though united by language and religion, as well as in warfare against their common non-Aryan, "dark" enemies, the *dasas,* these tribes appear generally to have been at war with one another. The foremost Aryan tribe was called Bharata, probably the name of its first *rājā* or "king"; it is honored to this day by the Republic of India, which adopted Bharat as its official Sanskrit name with the inauguration of its constitution in 1950. The later Aryan Epic, *Mahābhārata* ("Great Bharata") is the tale of many raja cousins and their interminable battles. Each Aryan tribe had its bards, who were priests, and they alone memorized the Vedic hymns and officiated over the sacrifices. The raja, his brahmans, and *vish* settled in vil-

lages (*grāma*), keeping their herds of valuable cattle, horses, sheep, and goats in nearby pastures. Cows were so highly valued by Aryans that they came to be treated as currency and were paid to brahmans for performing religious services. The Vedic Aryans were, however, beef eaters and wine drinkers as well as warriors. It is not clear exactly when the Indians began to consider the cow divine; it must have been a later development, or perhaps a pre-Aryan concept resurrected in transmuted form, since we can assume that the pre-Aryans worshipped the bull. Indians may thus have been the earliest people, though they would not remain the only ones, to worship their money.

Just as each Aryan tribe was ruled by an autocratic male raja, each family was controlled by its father, whose dominant role over his wife and children was to become the standard pattern for subsequent Indian familial relationships, in which male supremacy and hierarchy dictated by age were to remain the rule. The joint or extended family, where the wives of all sons come to live and raise their children within the patriarchal household, seems to have developed early in the Aryan age. One of the most common prayers in the Vedas is for "manly, heroic" (*vira*) sons, who were not only needed to help care for the herds, but who would also bring honor to their fathers and tribes in battle and be able to perform the sacrifice to aid the souls of their fathers attain peace after death. The word *vira* in the Rig Veda was, in fact, hardly distinguishable from "son," since all young men were expected to be heroic fighters. Daughters, however, were little valued. Dowries would be required for them, and, although the status of women in Aryan society was probably higher than it was to remain throughout most of Indian history, they were forbidden to participate in any sacrifice to the gods since their presence was considered a source of pollution. Sons alone could inherit property, which was usually divided equally among them after the father's death. Primogeniture was reserved for royal families, unless the first-born was blind or otherwise seriously handicapped. We find no evidence of polygamy or child marriage in the Vedas, though both were subsequently practiced in most parts of India, which may again reflect the reemergence of pre-Aryan customs.

The country inhabited by the Aryans during the period in which the Rig Veda was composed was known as the "Land of the Seven Rivers" (*Sapta Sindhava*). It consisted primarily of the Punjab, whose five great rivers (the Jhelum, Chenab, Ravi, Beas, and Sutlej) flow into the Indus, which may then have captured the seventh river, called Sarasvati, now only a minor stream in the Rajasthan desert. The river Ganga was barely known to the Aryans by the end of the Rig Vedic era (it is mentioned only once in a late book), indicating that the conquering tribes expanded quite slowly toward the east, taking about five centuries to move from the Khyber to beyond the region of Delhi. Throughout that interlude, the process of Aryan and pre-Aryan conflict, cooperation, and assimilation must have effected major changes in the character of Aryan society and thought, as well as in the nature of the indigenous civilization.

The simple tribal structure grew more complex during this period as warfare and conquest brought new peoples and problems under the ruling rajas, who required the assistance of noble "warriors" (*kshatriyas*) and the advice of "councils" (*sabha* and *samiti*) of household elders to govern their burgeoning

tribes. We know little more about these earliest political institutions of India than their Sanskrit names, but from what is known of tribal rule elsewhere, especially among other Indo-Europeans, it seems fair to assume that each king picked the heartiest soldiers to serve in his entourage and sought the advice of those patriarchs in his tribe who were most shrewd or powerful. Surely the *rishis* ("sages"), who are named in the Rig Veda, were among those first approached by rajas for assistance in practical as well as spiritual matters. The distinct separation between martial, royal, and priestly classes found among the Aryans appears to have diminished over time; if, indeed, priest-kings had ruled pre-Aryan Harappa, it may be that Aryan rajas learned from their slaves to rely more heavily upon the counsel of their own brahmans. At any rate, the hymn of the "Sacrifice of the Cosmic Man" (*Purusha-sukta*), which appears in the tenth and final "book" of the Rig Veda, explains that the four great "classes" (*varna*) of Aryan society emerged from different parts of the original cosmic man's anatomy: the *brahmans* issuing forth first, from the mouth; the *kshatriyas* second, from the arms; the *vaishyas* third, from the thighs; and the *shudras* last, from the feet. This "revelation," according to which all rajas, who were *kshatriyas* by birth, fell below all *brahmans*, who alone were associated with the cosmic "head," may well have roused ancient royal wrath, though not enough to delete the sacred hymn or alter a word of it.

Gold, the metal most frequently mentioned in the Rig Veda, must have been panned from the rivers of the northwest and used in ritual sacrifices as well as for jewelry. The next most common metal was *ayas,* which appears initially to have meant bronze, rather than iron, since later, in the Atharva Veda, we find the distinction made between "red" *ayas* and "dark" *ayas,* the former most likely referring to bronze and the latter to iron. Some of the passages in the Atharva Veda are known to have been added a few centuries after the Rig Veda had been finished, and it is most probable that iron was not discovered in India until the Aryans had moved as far east as the modern state of Bihar (where rich deposits of ore continue to be mined to this day), which could not have been before 1000 B.C. By that time, the use of iron had spread to Iran from its center of discovery by the Hittites in the west: it may have entered India with fresh waves of invading Iranians, since its use was initially associated with pins and other parts of horse harnesses, as well as weapons. B. B. Lal's excavations in the Doab east of Delhi, starting in 1950, unearthed traces of the ancient city of Hastinapura, the epic capital of a great Aryan tribe. Shards of painted greyware date its lowest level to about 1000 B.C., while from later levels iron weapons and tools have been unearthed, the oldest found as yet in India.

By the time the Rig Veda was written, the Aryans had apparently made the transition from a nomadic pastoral economy to a combined agricultural and pastoral one, for they reaped some variety of "grain" (*yava*), which must have been barley or wheat. There is no reference to rice, however, until the Atharva Veda. The lion was known in Rig Vedic times, as was the elephant, whose Sanskrit name means "beast with a hand," but neither the rhinoceros nor the tiger, both so prominent on Indus Valley seals, is mentioned. The horse was second only to the cow in importance, and chariot racing was one of the Aryans' leading sports.

The Vedic Aryans appear to have loved music, wine, and gambling, as well as war and chariot racing. All their hymns were chanted, but the Sama Veda was especially designed for song, and there were lutes, flutes, and drums, which the gods and goddesses were said to have played. From this era, at least, Indians continued to use song and dance as an integral part of their religious worship, and no sacred Hindu ceremony today, including the funeral procession, would be complete without its musicians, no temple without its dancers. Indian devotion to song and dance, however, predated the Aryan invasions, for the "dancing girl" of Mohenjo-daro survives to speak mutely to us of an art that is surely as old as Indian civilization itself. Another statue, found at Harappa though possibly of later vintage than that civilization, is a grey stone miniature torso of a dancer, whose distinctive three-way twist of shoulders and hips reminds us of Shiva in his most magnificent pose as "King of the Dance" (*Nātārāja*). As for drink, *soma* was daily imbibed by the Vedic warrior god Indra to help him overcome the terrible demon with whom he did battle, and we must assume that Aryan tribesmen also indulged in such libation. It is not quite clear whether this heavenly drink was alcoholic, psychodelic, or narcotic, though we assume that it was made from a plant that grows wild in the foothills of the Himalayas, which may have been hashish or peyote. The effects of this drink were so remarkably powerful that *soma* was deified, and the *soma* sacrifice became the foremost religious event of the Aryan year.

Since the game of dice, like chess, was invented in India, and many dice carved of nuts were found at Mohenjo-daro, it is hardly surprising to note that the Aryans were avid gamblers. "Cast on the board like magic bits of charcoal, though cold themselves, they burn the heart to ashes," lamented the Rig Veda's gambler in one of the rare secular hymns of that sacred collection. "The abandoned wife of the gambler mourns.... In debt, fear, and need of money, he wanders by night to the homes of others." Gambling continued to preoccupy Aryan Indians throughout the epic era as well, and in the *Mahabharata* we find the five virtuous and noble Pandava brothers losing their very kingdom and their single beloved wife (the most famous case of polyandry in Sanskrit literature) to the treacherously seductive roll of the dice.

Other secular humans give us insight into the daily occupations and aspirations of Rig Vedic Indians. There were carpenters and wheelwrights, blacksmiths and tanners, weavers and spinners, as well as farmers and herders, among the tribesmen who settled down to the routine of village interdependence as they expanded toward Delhi and the Gangetic plain. The *shudras*, who did the menial labor, may originally have been pre-Aryan *dasas*, reduced to serfdom or slavery by captivity and easily kept in lowly status because of darker skin color. The Sanskrit word that came to mean "class" (*varna*) and that is still used with the modifiers *brahman, kshatriya, vaishya,* and *shudra* to identify the four broadest categories of Hindu caste society, originally meant "covering," associated with skin covering and its varying colors. Each *varna* had its distinguishing color; white for *brahmans,* red for *kshatriyas,* brown for *vaishyas,* and black for *shudras.* Acute color consciousness thus developed early during India's Aryan age and has since remained a significant factor in reinforcing the hierarchical social attitudes that are so deeply embedded in Indian civilization. There is no

reference to "untouchables" in the Rig Veda, but fears of pollution became so pervasive in Indian society that it is difficult to believe they were not, in fact, pre-Aryan in origin. In all probability the subclass of untouchables emerged late in the Aryan age, recruited first perhaps from those *shudras* or *dasas* who performed tasks that were considered "unclean," such as the work of tanners, associated with animal carcasses, and that of sweepers, especially among the ashes of cremation grounds. While all *shudras* were, therefore, held to be fully a life below the three higher "twice-born" classes, whose sacred thread ceremony of "rebirth" marked their attainment of manhood and access to Vedic lore, some were considered so much less worthy than others that they were cast beyond the pale of recognized society.

The religion of the early Aryans centered around the worship of a pantheon of nature gods, to whom sacrificial offerings were periodically made for the good things of life and for repose thereafter. No one deity ruled over the pantheon, which included some thirty-three divinities named in the Rig Veda, but the most powerful gods, to whom many humans were addressed, were Indra, Varuna, Agni, and Soma. Indra was the war god, youthful, heroic, ever victorious. Like Thor, he wields thunderbolts and hovers in atmospheric realms, assisted by an obscure storm god named Rudra, who comes to be identified only much later as the Rig Vedic form of Shiva. The association of Indra with the power to release waters as well as win wars helps explain his special significance, for he is hailed as "surpassing floods and rivers in his greatness." Perhaps he was the first great leader of the Aryan conquest, a historic figure whose youthful force overcame all obstacles, standing so tall and strong he seemed to hold Father Sky upon his shoulders, separating it from Mother Earth, as one simplistic myth of Vedic creation insisted. He required much nourishment and drank his *soma* greedily in three gulps every morning before going forth to defeat the demon Vritra, whose limbless body enclosed all creation, including the sun, waters, and cows, holding life in a state of inert suspension and darkness. With his "mighty and fatal weapon," the thunderbolt, Indra pierced the dark demon's covering and released the dawn (which is why Hindu prayers to Indra are chanted so early every morning, to help him defeat the night), leaving the demon "prostrate" while the waters, "like bellowing cows," rushed lowing toward the ocean. Indra then became "the lord of what moves and what remains rested." Vritra was the symbol of pre-Aryan power, "warder" of the "*dāsa* lord"; hence the hymn that tells of the battle between Indra and Vritra may be viewed as a historic as well as cosmogonic significance, conveying the essence of the Aryan victory. It has, indeed, been suggested that Vritra was no demon at all, but a dam constructed across the Indus by pre-Aryans to control the river for irrigation agriculture, and that by destroying that "barrier" or "cover" the Aryans flooded the region and its great cities, facilitating their conquest.

Once Indra's victory was achieved, however, Varuna, the King of Universal Order (initially *rita* and later *dharma*) stepped forward to take the central position of Aryan religious authority. Presiding over the sun-filled sky, Varuna was the divine lord of justice "who has spread out the earth, as the butcher does the hide, by way of a carpet for the sun ... extended the air above the trees ... put strength in horses, milk in cows, willpower in hearts, fire in waters, the

sun in the heaven, and soma upon the mountain." Varuna was the divine judge of Aryan India, and appeals for mercy would be chanted to him by those who strayed from the path of virtue. Older and wiser than Indra, Varuna was most honored by the Aryans, the elder statesman on high, closely connected with the sun god Surya and with one of his lesser manifestations in the Rig Veda, Vishnu, who later shared with Shiva virtual monotheistic dominance over Hinduism.

Agni was god of fire, and as such had many forms, traversing the three realms of earth, atmosphere, and heaven. He was needed for every sacrifice; he mirrored the sun; and he had the power to heal, save, defend, or destroy. Hailed as "offspring of the (primeval) waters," he was also called "illuminator of darkness," and as the many-tongued deity of the sacred altar he presided over "ritual function." Soma was the god of immortality, the nectar whose "glorious drops" impart "freedom" and protect one's body from disease. "May we enjoy with an enlivened spirit the juice thou givest like ancestral riches," chanted the Aryans to divine Soma. "O Soma, King, prolong thou our existence ... favour us and make us prosper. . . . For thou has settled in each joint, O Soma."

Among the lesser personified powers of nature worshipped by the Vedic Aryans, the loveliest was Ushas, the dawn, "rosy-fingered" daughter of the sky. For her most beautiful poems were changed. She brought of all "lights the fairest."

The seeming simplicity of the Aryan nature-worshipping religion was soon obscured by the Vedic quest for an understanding of cosmic origins and control over cosmic forces. The immediate purpose of a sacrifice was to secure some divine favor, whether fortune, longevity, or progeny, but it also had cosmic meaning in that its proper performance helped maintain the balance of order in the universe. The Aryan householder gave his gods soma, *ghi* (clarified butter), and other delicacies not simply in return for their favors, but because it was his duty to propitiate them so, just as they in turn were obliged to act in the appropriate fashion toward him. For gods as well as men had their individual duties, which were part of the cosmic scheme of things, and only when all behaved properly would the universe function as it was designed to do—in accord with the *rita,* the true order. Demons of falsehood were always trying to destroy that perfect balance, starting floods, bringing drought or famine, appearing in the guise of tigers or mad elephants; they were ever present as mosquitos and other evil creatures that buzzed, crawled, or walked upon the earth. The balance was tenuous at all times, which was why so many sacrifices were required, and why brahmans had to be employed day and night to chant the hymns they memorized. Truth (*rita*) could always be subverted by falsehood (*an-rita*), just as the "real" (*sat*) or existent world might always be disguised by imagined or "unreal" (*asat*) illusions, fantasies, and nonexistent fears and terrors. The word *sat,* which originally meant "existent," came thus to be equated with cosmic reality and its underlying ethical principle, truth. To Vedic man the universe was divided between earth's fair surface and the heavenly dome above it, the realm in which *sat* prevailed, and the demon-darkness beneath this world, where unreality and falsehood dominated all. Indra's daily battle renewed the wonder of creation, but speculation about this mighty hero soon

led to profound questions: "Who ever saw him? Who is he that we should praise him?" ...

By about 1000 B.C., then, India's Aryans were asking questions and positing hypothetical solutions to problems that still remain unfathomable. In crediting self-incubating "heat" (*tapas*) with the origin of creation, the Rig Veda sounds so surprisingly scientific that we may find it difficult to reconcile such latter-day sophistication with much of the Rig Veda's earlier naiveté. The word *tapas,* however, was subsequently used in relation to yogic contemplation, and its use in the Rig Veda may reflect the reemergence of India's oldest form of religion as well as "science," the self-imposed rigor of isolated meditation that gave birth to so many illuminating insights throughout Indian history. "Desire" (*kāma*), which later came to mean "love," was the source of That One's stirring to life, the force behind creation, moving even a neuter spirit to sow the first "seed of mind," as it was so often to move India's noblest sages and gods from the austere depths of their contemplation to peaks of passionate bliss. Had pre-Aryan yogis ... learned by now the language of their conquerors, teaching their own secrets in turn to brahman bards? Was India's "heat" and ancient wisdom starting already to take its toll of youthful Aryan energy and optimistic self-assurance?

North Indian Conquest and Unification

The Aryan "conquest" of North India was thus a process of gradual institutional assimilation and sociocultural integration between invading barbaric hordes and their more civilized pre-Aryan "slaves." It would take more than a thousand years for that process of historic change to reach its peak of political unification under Mauryan rule in 326 B.C., by which time the center of North Indian power and civilized achievement had shifted more than a thousand miles east of the Indus to the region of modern Patna (then called Pataliputra) in the Gangetic plain. Our sources for reconstructing that slow and complex process of historic evolution are both literary and archeological; yet for many centuries, in most parts of India the record remains as blank as most Indian cave walls, and even when excitingly beautiful historic frescoes are found, they emerge only as fragments.

The *Mahabharata,* whose epic core probably reflects Indian life at about 1000 B.C., starts with King Santanu's intoxicated love for the beautiful goddess Ganga, whom he "marries," symbolizing the Aryan advance east of the Doab into the Gangetic plain. It was no simple romance or conquest, however, requiring heavy ploughs and other sturdy tools to clear the primitive forests of that lush region that even sophisticated Harappan technology had not been able to master. Recent discoveries of painted greyware at Hastinapura, Alamgirpur, and Kausambi in Uttar Pradesh indicate that, by about 1000 B.C., the Aryans had mastered the metallurgy of iron, which they may have learned from their Indo-European cousins who ruled the neighboring Iranian plateau during Sialk VI. Iron ploughs yoked to oxen and hafted iron axes were able to clear ground that had been impervious to tools of stone, copper, and bronze.

Although they were armed with force enough to overcome the natural barriers to their eastward advance and equipped with weaponry to subdue resistance from their *dasa* prercursors, the Aryans could never seem to resolve their own intertribal conflicts. The *Mahabharata,* much like the *Iliad,* is drenched in the blood of endless warfare, echoing the cries of royal cousins who are locked in mortal combat over their legacy to King Santanu's domain. A residue of quite primitive, or perhaps non-Aryan, barbarism survives in the blood lust of the noble warrior Bhima, who howls like a wolf and dances wildly about the battlefield of Kurukshetra after drinking the heart's blood of his slaughtered cousin, Dushasana. Aryan chivalry had by now reached the level of Arthurian legend. Religious virtue was all too humanly united, however, with hopeless addiction to gambling in the hero Yudhishthira, *Dharmarājā* ("King of Religious Law") himself, who loses at dice not only his fortune and kingdom, but all that was owned by his noble Pandava brothers as well, and their lovely polylandrous wife, Draupadi. The epic struggle marks a transition at about this time from pastoral nomadism to the consolidation and confederation of Aryan tribes into royal territorial kingdoms with capitals like Hastinapura (near Delhi), dominating the surrounding agricultural and forest domain, which came to be called Arya-varta, "Land of the Aryans."

Decline and Legacy of the Indus Cities

Sprouting amidst tangled roots that mark the furthest growth of the parent tree, a new pipal sapling struggles to spread its own roots into fertile soil. Over time the sapling grows to dominate the jungle with rich foliage and fruit, and imperceptibly what was once the edge of the old tree becomes the center of the new. In much the same way, the first urban civilization of the subcontinent gradually faded into the background as new cultures emerged at the eastern and northern edges of the Indus Valley region. It took over one-thousand years for the political and cultural center of the northern subcontinent to shift from the Indus Valley to the middle Ganga region. Because the process of change was gradual, it is unlikely that anyone living during the period between the decline of the Indus cities (1900 to 1300 B.C.) and the rise of the Early Historic cities (800 to 300 B.C.) would have been aware of the shift.

Factors that played a role in the decline of the Indus cities are as diverse as those which stimulated their growth. In the core regions of the Indus and Ghaggar-Hakra valley, the wide extension of trade networks and political alliances was highly vulnerable to relatively minor changes in the environment and agricultural base. Due to sedimentation and tectonic movement, some water that would normally have flowed into the ancient Saraswati river system was captured by two adjacent rivers, the Sutlej river of the Indus system to the west and the Yamuna river of the Gangetic system to the east. With the increase in water flow, the Indus itself began to swing east, flooding many settlements and burying them with silt. The mounds of Mohenjo-daro survived because they were on slightly higher land and were protected by massive mud-brick walls and platforms, but many smaller sites were destroyed. Extensive and repeated flooding, combined with shifting rivers, had a devastating effect on the agricultural foundation and economic structure of the Indus cities. Although sites such as Harappa continued to be inhabited, the economic infrastructure for long-distance trade to the south was irreparably damaged as many less fortunate settlements along the dry bed of the ancient Saraswati river were abandoned. The refugees were forced to develop new subsistence strategies or move to more stable agricultural regions.

The cultivation of summer crops, such as rice, millet and sorghum, made it possible to expand into the monsoon-dominated regions of the Ganga-Yamuna Doab and Gujarat that were previously underdeveloped. During this period of change, animals that had been in use in the western highlands were adapted for transport and communications on the plains. Horse and donkey as well as the Bactrian camel were gradually integrated into the economic sphere and in the symbolic and decorative arts. Terracotta animal figurines and painted pottery styles reflecting these new developments were incorporated into the previously existent technologies, many of which continued to be practiced.

Excavations at sites such as Mehrgah, Nausharo and Pirak provide a complete sequence of the gradual transformation that was going on in the Kachi Plain, and excavations in Swat Valley to the north provide a complementary perspective. Additional information on the nature of cultural developments outside the Indus Valley come from recent work in Central Asia at sites belonging to the Bactria-Margiana Archaeological Complex. To the east, in the Ganga-Yamuna Doab and Gujarat numerous surveys and excavations have radically altered models for the decline of the Indus cities and the emergence of new cities of the Indo-Gangetic Tradition.

Prior to these relatively recent discoveries, most scholars thought the introduction of new pottery styles, plants and animals, as well as "foreign" artifacts represented the intrusion of new peoples. The discovery of unburied skeletons among the latest levels of the Harappan occupation at Mohenjo-daro combined with uncritical and inaccurate readings of the Vedic texts led some scholars to claim that the decline of the Indus civilization was the result of "invasions" or "migrations" of Indo-Aryan-speaking Vedic/Aryan tribes. The invasion and/or migration models assumed that the Indo-Aryan-speaking Vedic communities destroyed the Indus cities and replaced the complex urban civilization with their new rituals, language and culture. Many scholars have tried to correct this absurd theory, by pointing out misinterpreted basic facts, inappropriate models and an uncritical reading of Vedic texts. However, until recently, these scientific and well-reasoned arguments were unsuccessful in rooting out the misinterpretations entrenched in the popular literature.

Current theories on the role of Indo-Aryan-speaking peoples are beyond the scope of this [selection], but there is no archaeological or biological evidence for invasions or mass migrations into the Indus Valley between the end of the Harappan Phase, about 1900 B.C. and the beginning of the Early Historic period around 600 B.C. In Central Asia and Afghanistan the Bactria-Margiana Archaeological Complex (BMAC), dating from around 1900 to 1700 B.C., represents a complex mixture of nomadic and settled communities; some of these may have spoken Indo-Aryan dialects and practiced Indo-Aryan religion. These communities and their ritual objects were distributed from the desert oases in Turkmenistan to southern Baluchistan and from the edges of the Indus Valley to Iran. As nomadic herders and traders moved from the highlands to the lowlands in their annual migration, they would have traded goods and arranged marriages as well as other less formal associations resulting in the exchange of genes between the highland and lowland communities.

Recent biological studies of human skeletal remains from the northern subcontinent and Central Asia have uncovered no evidence for new populations in the northern subcontinent during this time. Yet, these two regions were not isolated from one another. A limited degree of interaction is clearly demonstrated by overlapping genetic traits that would normally occur between adjacent populations. This pattern is not surprising because the highlands of Afghanistan and Central Asia had intermittent contact with the Indus Valley for thousands of years prior to and during the Harappan Phase. There is no major change in this relationship during the decline of the Indus cities.

In the absence of direct external forces, we can attribute the decline of the Indus cities to internal factors that over time undermined the economic and political power of the ruling elites. Overextended networks of trade and political control were easily disrupted by changes in river patterns, flooding and crop failure. Refugees and overcrowded cities would have caused a legitimacy crisis for the ritual leaders and political rulers that ended with the emergence of new elites and localized polities around 1900 B.C. The previously integrated regions of the Indus Valley and Gujarat broke up into three major localized cultures that can be defined by new painted motifs and ceramic styles, seals with geometric designs and new burial customs. For 600 years, until around 1300 B.C. the Localization Era (commonly referred to as the Late Harappan period) was an interlude during which a new social order was being established as new technologies and agricultural practices spread up and down the Indus Valley, east into the Ganga-Yamuna Valley and into the peninsular subcontinent.

The three cultural phases of the Localization Era were named after the important sites where specific pottery styles were first discovered or the geographical region in which their cities and towns are found. The Punjab Phase refers to the northern regional culture that includes the large site of Harappa and sites further to the east in northern India. In the southern Indus Valley the Jhukar Phase is named after a site near Mohenjo-daro and incorporates all sites in Sindh, as well as parts of Baluchistan. The Rangpur Phase refers to the entire region of Kutch, Saurashtra and mainland Gujarat.

At the site of Harappa the Punjab Phase is represented by elaborately painted ceramics that are referred to as the Cemetery H culture, because they were first discovered in a large cemetery filled with painted burial urns and some extended inhumations. In contrast to the use of plain pottery in burials during the final Harappan Phase, the reemergence of heavily decorated burial pottery reflects a major change in ritual practices and ideology. New painted motifs include ritual symbols that combine animal, plant and human themes in a manner unknown on the earlier Harappan phase painted ceramics. In addition to fairly normal illustrations of humped bull, gazelle, blackbuck, flying peacocks, unique combination figures include double serpents with a horned headdress that has two pipal leafs sprouting from the center; humped bulls with three pipal leaves sprouting from the middle of the forehead and flying peacocks with antelope horns or a five-pronged tail made of pipal leaves. One spectacular form combines a bull's body, antelope horns and a human head and torso, with hands resting on the hips and arms covered with bangles. Although the style of these motifs is unique, the use of the trefoil and pipal leaf

headdresses along with horned figures strongly argues for the incorporation of some Indus beliefs with new rituals.

Recent research at Harappa has shown that the transition from the Harappan to the Punjab Phase (Cemetery H culture) was gradual, thus confirming what was found in the excavations of cemetery H in the 1930s. The earlier burials in this cemetery were laid out much like Harappan coffin burials, with pottery arranged at the head and feet. Painted jars with high flaring rims are a new style that can be associated with highland cultures to the west, but the large jars with ledge rims and the heavy dish-on-stands have strong links with earlier Harappan styles. Decorative plates or lids and votive offerings in small pottery vessels were placed in the burials. A new variation of the dish-on-stand has ridges on the base and a hole in center that may have been used in preparing some form of distilled drink. In the later burials, adults were cremated, but children were placed inside large urns, then covered with a second pot. These large burial urns are heavily decorated with painted motifs described above.

Cemetery H pottery and related ceramics of the Punjab Phase have been found throughout northern Pakistan, even as far north as Swat, where they mix with distinctive local traditions. In the east, numerous sites in the Ganga-Yamuna Doab provide evidence for the gradual expansion of settlements into this heavily forested region. Although the Punjab Phase encompassed a relatively large area, the trade connections with the western highlands began to break down as did the trade with the coast. Lapis lazuli and turquoise beads are rarely found in the Punjab Phase settlements, and marine shell for ornaments and ritual objects gradually disappeared. On the other hand the technology of faience manufacture becomes more refined, possibly in order to compensate for the lack of raw materials such as shell, faience and possibly even carnelian....

Changing Social Order

Although the Localization Era covers the decline of the Indus cities, it is also a time of regional development leading up to the rise of new cities in the larger geographical area encompassed by the Indo-Gangetic tradition. In each major region of the Indus Valley, even as the Indus cities decline, small city-states or chiefdoms began to reorganize the social life and consolidate regional power. These regional polities destroyed the integration achieved by the Harappan Phase cities and established new peripheral polities in Afghanistan and Central Asia and to the east in the Ganga-Yamuna Doab. In both regions the rise of new polities is clearly an indigenous process and not the result of outside invaders.

In the Gangetic region from 1200 to 800 B.C., the gradual spread of communities using a distinctive form of pottery known as Painted Gray Ware can be related to the Indo-Aryan communities of the later Vedic texts and the Mahabharata Epic. The Northern Black-polished Ware culture (500–300 B.C.) is the term given to the next major cultural development, but both the Painted Gray Ware and the early Northern Black-polished Ware culture can be grouped together as the formative phases that precede the development of urban states in the Indo-Gangetic region.

This was a time of social and religious change, as Indo-Aryan languages, religion and culture gained dominance first in the Punjab and Gangetic regions and then down the Indus Valley and across the Malwa plateau into Gujarat. For the first time in South Asia, archaeological evidence for these transformations is supplemented by oral traditions that later came to be codified in ritual texts such as the Rig Veda, the Ramayana and the Mahabharata. During this period religious traditions such as Brahmanical Hinduism, Buddhism and Jainism emerged.

The change of focus from the Indus to the Gangetic plains is a pattern that can be best explained through core-periphery models of political development. A new social hierarchy based on different belief systems, ritual practices and language could not have developed within the Indus Valley, where towns and cities of the Localization Era still existed. The peripheral regions of the Ganga-Yamuna and eventually the Middle to Lower Ganga provided the necessary setting for the establishment of a new religious elite and a new urban process. The Early Historic city-states reflect the development of a sociopolitical system that reached a completely different level of integration during the Indo-Gangetic tradition than was possible in the preceding Indus Valley tradition. By 300 B.C. the smaller city-states established throughout the Indo-Gangetic region were integrated through the newly created military power of the Mauryan Empire, supported by cavalry, horse-drawn chariots, iron weapons and a highly developed political infrastructure.

The Legacy of the Indus Valley Civilization

Since the discovery of the Indus cities, scholars have made comparisons and contrasts between the Indus cities and later urban cultures of the subcontinent. Current studies of the transition between the two early urban civilizations claim that there was no significant break or hiatus. All of the major subsistence items and grains that became important during the Early Historic period had already been cultivated in some region of the Indus Valley during the Harappan Phase or the subsequent Localization Era. Nevertheless, a more complex process of seasonal agriculture and multicropping using the recently exploited summer crops of sorghum, millet, rice allowed the production of considerable surplus that was needed to support the new cities and their armies.

Newly established trade networks linked the rapidly developing urban areas to distant resource areas and rural producers. These networks add to, and build from, the earlier interaction networks of the Indus Valley tradition. As such, they undoubtedly incorporated many of the remnant polities, economic and technological features of the Indus Localization Era.

Copper metallurgy of the Early Historic period built on the earlier technical expertise of Indus artisans and their descendants who may have formed specialized occupational communities that continued to smelt and process copper ores. Copper workers may have invented iron production which appeared in the northern subcontinent around 1200 B.C. Earlier scholars proposed that iron technology was brought to the subcontinent by invading Aryan tribes, but a careful reading of the early Vedic texts indicates that there was no invasion

and in fact, the earliest Indo-Aryan speaking communities of the northwestern subcontinent did not know of or use iron.

The earliest ironworks (1200 B.C.) were located in the northern Aravalli hills, close to the important sites of Mathura, Noh, Bairat and Indrapat (Delhi), which lie in the core area of the Indo-Gangetic tradition. Later, during the early Northern Black-polished Ware period, a second iron source area was exploited far to the east, in the Chota Nagpur plateau, adjacent to the most important sites of the middle and lower Ganga plain, i.e. Rajgrha, Pataliputra, and Champa. The control of iron production and trade may have been a critical factor in determining the location and eventual dominance of the major cities and capitals of the Early Historic states....

As was the case with the Indus cities, the ability to reinforce the social and economic order is ensured by having massive walls and gateways. The major differences between the Harappan Phase and the Early Historic walled cities are the overall scale, the construction of defensible gateways and the use of multiple walls. Another important difference is concrete evidence for intensive conflict and aggression as reflected in the large numbers of iron weapons and accounts of battles in the epic and shastric literature. For example, the Mahabharata battle documents late Vedic internecine warfare that seriously traumatized the entire population.

The use of settlement-planning to define social and ritual status is another important contribution from the earlier Indus cities. In the Early Historic cities, elaborate drains, wells and water tanks provided pure water to communities living in the cities, a pattern that had been established in the Indus cities. Water management for agriculture and drinking is also confirmed with the discovery of a massive water tank at Sringaverpura that was built for capturing water at the high flood levels, much like the Harappan Phase tank at Lothal. Although the literary texts refer to palaces and royal storerooms, few sites have been excavated horizontally, so we do not know if they can be sufficiently differentiated from other domestic structures. Further evidence from literary texts indicates that the settlements were divided into sectors according to *varna* and occupational specialization, a pattern similar to that already established in the Indus cities.

Many continuities between the Indus and the Early Historic cities may result from living in similar environments and the availability of similar raw materials, but other continuities clearly reflect strong social and ideological linkages. Changes demonstrate the dynamic processes of cultural evolution leading to new forms of socioeconomic organization and political complexity. Through the critical analysis of continuity and change between the Indus cities, the Early Historic cities, and modern towns in Pakistan and India, we can identify major cultural patterns that continue to affect communities throughout the northern subcontinent. The Indus Valley tradition may represent the first urban, state-level society in southern Asia, but it is only the beginning of a longer trajectory of sociopolitical development that affected the entire subcontinent.

POSTSCRIPT

Were the Aryans Responsible for the Demise of the Indus Valley Civilization?

Historians have expressed steady interest in the reasons for the decline and fall of civilizations and spend much time analyzing and evaluating the reasons for those occurrences. Historically, they are interested for professional reasons—to set the historical record straight. Contemporarily, they hope that lessons from the past can be learned in order to warn of the potential demise of present civilizations. There are no guarantees that our own civilization can assume indefinite survival. Perhaps it behooves us to learn some lessons from the past.

There are many civilizations whose demise can be fitted into a decline/fall paradigm. In this book, material is available for a comparison of the reasons for the downfall of the Indus Valley and Maya civilizations (see Issue 8). Also see *Taking Sides: Clashing Views on Controversial Issues in Western Civilization* (McGraw-Hill/Dushkin, 2000) for an issue devoted to the decline and fall of the Roman Empire (Issue 4), as well as the book's final issue, "Is Western Civilization in a State of Decline?" Any of this material could provide useful information for comparative purposes, as would material on the decline of the Greek, Islamic, Aztec, or Ottoman civilizations. A useful source to consult would be Norman Yoffee and George L. Cowgill, eds., *The Collapse of Ancient States and Civilizations* (University of Arizona Press, 1988).

There are many sources that are useful to a study of Indus civilization. Gregory Possehl, ed., *Harappan Civilization: A Contemporary Perspective* (American Institute of Indian Studies, 1982) offers a series of essays on the subject, including one that compares the Indus demise with the Maya collapse. Possehl has also edited *Ancient Cities of the Indus* (Carolina Academic Press, 1979), another useful compilation.

In a more recent vein, Wolpert's book used for this issue is in its 6th edition, attesting to its interest and value. His *India* (University of California Press, 1991) covers the same material, with obviously similar results. Kenoyer's book that has been excerpted for this issue is mainly an archaeology book, with many interesting photographs of artifacts and other useful materials. For a recent summary of his work, see his article entitled "Birth of a Civilization," *Archaeology* (January/February 1998). Finally, Padma Manian "Harappans and Aryans: Old and New Perspectives of Ancient Indian History," *The History Teacher* (November 1998) presents information as to how the questions raised in this issue are covered in the various history textbooks used in American colleges.

ISSUE 3

Was Egyptian Civilization African?

YES: Clinton Crawford, from *Recasting Ancient Egypt in the African Context: Toward a Model Curriculum Using Art and Language* (Africa World Press, 1996)

NO: Kathryn A. Bard, from "Ancient Egyptians and the Issue of Race," in Mary R. Lefkowitz and Guy MacLean Rogers, eds., *Black Athena Revisited* (University of North Carolina Press, 1996)

ISSUE SUMMARY

YES: Clinton Crawford, an assistant professor who specializes in African arts and languages as communications systems, asserts that evidence from the fields of anthropology, history, linguistics, and archaeology proves that the ancient Egyptians and the culture they produced were of black African origin.

NO: Assistant professor of archaeology Kathryn A. Bard argues that although black African sources contributed to the history and culture of ancient Egypt, its civilization was basically multicultural in origin.

For a place that is considered by many to be the birthplace of humankind, Africa has not been treated kindly by its global neighbors. Exploitation of every kind imaginable—culminating with the heinous Atlantic slave trade and resultant imperialism—has marked Africa's experience with the outside world. Westerners, in particular, developed theories to prove African inferiority in order to justify their barbaric actions. No field of academic endeavor escaped this prejudicial treatment, and by the nineteenth century Africa had been totally denied its history, and its culture had been denigrated as savage and primitive.

It is not surprising, therefore, that when most African countries gained independence after World War II, their intellectuals sought to reaffirm their continent's rich and glorious past in order to eradicate the onus placed upon their homeland by Western historians and scientists. With assistance from African American scholars such as W. E. B. Du Bois, African historians—led by the Senegalese scientist and historian Cheikh Anta Diop—sought to write history from

an African perspective in order to provide the continent with a positive account of its past. The Afrocentric view of history came of age during this time.

With archaeological discoveries suggesting that humankind originated in East Africa, it was natural for Africa's historians to explore the connections between black African and ancient Egyptian civilizations. Their findings seemed to confirm the interrelatedness of the two. Hence, these historians concluded that one of the oldest and most respected ancient civilizations was African in origin.

But is this conclusion totally accurate? Many scholars today maintain that ancient Egypt possessed a cosmopolitan, multicultural society, one that was influenced by all of its neighbors. While acknowledging the African influences on Egyptian civilization, these scholars hold that the assertions of the Afrocentrists are too broad and sometimes historically inaccurate. In their opinion, to deny Egypt its multicultural past does a great disservice to all concerned parties.

Some Western scholars have brought recognition to the work of their African brethren, the most important being Martin Bernal and his two-volume work, *Black Athena: The Afroasiatic Roots of Classical Civilization* (Rutgers University Press, 1987, 1991). By referring to the Greek goddess of wisdom as "Black," in the book's title, he was intimating a connectiveness between Greek and African civilizations, which he asserts came mainly from Egypt. He also states that Asiatic forces, mainly Phoenician, also influenced the development of Greek civilization.

Although the Egypt-as-African theory is not a major feature of *Black Athena*, Bernal's work does lend credibility to it in the following ways: (1) it exposes the scholarly classical community of the last two hundred years as blatantly racist and antisemitic, thus incapable of seeing that Greek civilization may have been influenced by African and Asiatic sources, and (2) it supports the idea that Egypt had strong African roots, which contributed to its civilization, and ultimately to Greece's.

Regarding the questions raised by Bernal and others, his opponents have stated that while every group has the right to seek the glories of its past, exaggerations and false claims benefit no one. Africans and African Americans, who have seen their past distorted beyond recognition, maintain that they are merely writing their history to give credibility to what has been denied for centuries.

In the following selections, Clinton Crawford, using evidence from a variety of academic disciplines—history, linguistics, archaeology, anthropology, and art—argues that ancient Egypt was indeed African in origin. Those who believe so, he states, "share a common ideological concern, namely that the social and political histories of the Egyptians must be told truthfully." Kathryn A. Bard analyzes the same information and comes to a different conclusion—that ancient Egyptians were "North African peoples, distinct from Sub-Saharan blacks" and that anyone who asserts that Egypt was a black or white society is promoting "a misconception with racial overtones that appeals to those who would rather increase than decrease the racial tensions that exist in modern society."

Clinton Crawford

 YES

Origin and Development of the Ancient Egyptians

This [selection] discusses the origin, development, and interrelationship of the people and the culture of ancient Egypt. When people and their culture are viewed as reciprocal, we can understand more fully the evolution of a culture.

Slowly but surely, American academia is beginning to admit the centrality of Egyptian civilization and its sub-Saharan antecedents to the history of the arts and sciences. It is impossible to reprise this debate in any detail here, but let us at least develop the outlines of the discourse. It is also imperative that ancient Egypt be understood as a Black civilization if it is to be a source of self-esteem for African-Americans.

Consider the following oft-cited remarks from Count C. F. Volney's *Ruins of Empire:*

> There [at Thebes, ancient metropolis of Upper Egypt], a people, now forgotten, discovered, while others were yet barbarians, the elements of the arts and science. A race of men now rejected for their *sable skin and frizzled hair,* founded on the study of the laws of nature, those civil and religious systems which still govern the universe. (Volney 1991: 16–17)

This eighteenth-century scholar was puzzled by characterizations of the "Negro" slaves of the western hemisphere because they looked very similar to the indigenous Africans he met in Egypt. Volney attempted to prove that the indigenous Africans in Egypt were similar to the American "Negro" slaves on the basis of his description of the Sphinx of Gizeh. He described the monument's facial characteristics—a common determinant of racial origin—as identical with all people of the Black races.

Similarly, a contemporary of Volney, Baron Denon (1798), also sought the identity of the ancient Egyptians through an examination of the Sphinx. He described the portraits he examined as having the indigenous African characteristics—broad noses, thick lips, and wooly hair. Denon argues that his drawings document an accurate appearance of the Sphinx's head before Napoleon's troops destroyed some of the evidence of its "Negroid looks" (ben-Jochannan, 1989, p. 14).

The list of historians and artists who affirm Volney's and Dennon's work is long. Among them are the German scholar and explorer Frobenius (1910), and Egyptian art historian Cyril Aldred (1956, 1961; 1962). On numerous occasions both scholars have made reference to the racial characteristics of the ancient Egyptians. Hopefully, Reba Ashton-Crawford's faithful rendering of the head of King Aha, or Narmer-Memes, together with the photograph of the Boston Museum of Fine Arts bust of Khafre, may help convert those who have been misled by the modern falsification that the makers of ancient Egypt were not Negroid and African.

Among other scholars on the long list, Cheikh Anta Diop, who is well known in the disciplines of history, egyptology, and anthropology, has advanced well-researched arguments in support of the position that the ancient Egyptians were Africoid and undoubtedly "black" in racial origin. Supporting Diop is Yosef ben-Jochannan, a renowned scholar of ancient and contemporary history and egyptology. Other supporters are Basil Davidson, Ivan Van Sertima, John Henrik Clarke, Chancellor Williams, Leonard Jefferies, Frank Snowden, and James Brunson.

Foremost, ben-Jochannan (1989) places the controversy in its historical context. Ben-Jochannan and Chancellor Williams (1976) argue that the ancient Egyptians were always referred to by the Greeks and Romans as people whose descendants came from the interior of Africa. He cites many examples from ancient texts which validate the point.

For example, Manetho (early and third century B.C.), a high priest of mixed Egyptian and Greek parentage, who wrote the first chronology of the Egyptian dynasties, testifies to the undisputed Negroid origin of the ancient Egyptians. Ben-Jochannan, as if unsatisfied with Manetho's accounts, recalls the many works of Herodotus which referred to the Egyptian as black. Herodotus observed that the probability of encountering men with black skin, woolly hair, without any other ethnic feature common of Negroes, is scientifically nil. To term such individuals as "whites" with black skin because of their fine features is no less absurd than the appellation "blacks" with white skin. If the absurdity of the latter is applied to three-fourths of the Europeans who lack Nordic features, then what can one conclude? Looking at these two appellations and their contradictions, one can conclude that a pseudo-scientific approach has given way to inaccurate generalization (History of Herodotus, p. 115). This decree by Herodotus is but one of many such testimonies by the Greek "father of history," who made many pilgrimages to Egypt in the fifth century B.C.

Over the span of several centuries, from the fall of ancient Egypt to sometime in the 1800s, classical authors of antiquity [cited by Anta Diop (1974) and ben-Jochannan (1989)] had no difficulty classifying the physical characteristics of the ancient Egyptians. Diop commends Aristotle (389–332 B.C.), Lucan the Greek (125–190 A.D.), Aeschylus (525–456 B.C.), Strabo (58–25 A.D.), and Diodorus of Sicily (63–14 B.C.), among many others, for bearing out this evidence about the ancient Egyptians. Each of the ancient historians usually

included a graphic description of the ancient Egyptians. For example, Diodorus of Sicily described the Egyptians as follows:

> The Ethiopians say that Egyptians are one of their colonies which was brought into Egypt by Osiris.... It is from them that the Egyptians have learned to honor kings and gods and bury them with such pomp; sculpture and writing were invented by the Ethiopians. (Anta Diop, 1974, pp. 1–2)

Diodorus' account supports Herodotus' statement. Diop employs Diodorus' account to illuminate at least two plausible implications: (1) that Ethiopia is an older civilization than Egypt; (2) that the Egyptians were a different race than the Ethiopians. Diodorus seriously discussed the possibility of considering the ancient Egyptians to be either close neighbors (separated by a physical barrier—a cataract) or actual descendants of Black Africans (Ethiopians). Herodotus, in Histories II (457–450 B.C.) had stated that the Colchians, Ethiopians, and Egyptians bore all of the Negroid racial characteristics of thick lips, broad nose, woolly hair, and dark complexion—a statement that parallels Diodorus' observations, documented many years later.

Despite the testimonies of the ancients, ben-Jochannan and Diop also sought new data to support their position. Ben-Jochannan uses many strategies to advance his claims. Conspicuously, some of the strategies included examining the names and terminologies which the African Egyptians used to describe themselves and their country. He also reviews the works of some of the modern-day scholars who have advanced the claim of an Indo-European/Caucasian genesis for the ancient Egyptians. Furthermore, to counter what he regards as a deliberate attempt to discredit the contributions of a great Black civilization, ben-Jochannan cites the findings from Ellio Smith's examination of mummies from the tombs of Egyptian Royalty (1912).

Ben-Jochannan argues that before the Greeks imposed the name *Egyptos* on the people of *Alke-bu-lan* (modern day Africa), the linguistic and papyrological evidence show that the Egyptians called their land *Kimit, Kham, Ham, Mizrain,* and *Ta-Merry*. It cannot be coincidental, according to ben-Jochannan, that the same words chosen to describe the empire of the ancient "Egyptians" also refer to the land and its people as "children of the sun." The fact remains, these people were of dark pigmentation. And it is no mistake that even the Greek word *Egyptos* means "land of the dark people."

In addition to his linguistic and papyrologic evidence, ben-Jochannan cites that the Nile Valley and (African) Great Lakes High Cultures, peopled by Blacks of Egypt and its close neighbor Nubia, had an organized system of education called the Mysteries System.... At the height of ancient Egyptian culture, the Grand Lodge of Alexandria was known as the world center of learning. Those foreign to ancient Egypt who did not attend the main educational center received training at the "established subordinate Lodges of the Osirica—which was centered in the Grand Lodge at Luxor, Nubia" (ben-Jochannan, 1989, p. xxv). This puts into a new perspective the well-known fact that the Greek philosophers Socrates, Aristotle, and Pythagoras all testified to the education they received from the Egyptians.

Having established the ancient Egyptian preference for how they wanted to be called and the consistent testimonies of other ancients, ben-Jochannan focuses primarily on several examples of the racist hypotheses which are still used in academic circles as authentic scholarship on Africa, especially as it relates to Egypt.

To expose some of the racist hypotheses, ben-Jochannan examines several attempts to undermine the Negroid origin of the ancient Egyptians. The most striking appeared in the January 9th, 1972 issue of the *New York Times* in a report by Donald Janson of his interview with archaeologist Ray Winfield Smith, of the Museum of the University of Pennsylvania. The article concerned a computer reconstruction of a bas-relief sculpture in which Queen Nefertiti is shown with the same pear-shaped, elongated torso used to characterize her husband, pharaoh Akhenaten, and all other persons during their reign. Their stylized portrayal represented the aesthetic choice of King Akhenaten and Queen Nefertiti's reign—a shift away from the conventional royal portrayal to a more naturalistic style. In apparent ignorance of the aesthetic shift of the eighteenth dynasty, Smith interpreted Akhenaten's "long, narrow face, hatchet chin, thick lips, thick thighs and spindly legs" as the manifestation of apparent glandular trouble associated with the syndrome of "a physical monstrosity" (p. 12), namely, "an extreme case of destructive periodontal disease—badly abscessed teeth which results in long narrow face, thick lips, and hatchet chin." Moreover, he insisted that the outstanding and intelligent achievements of Akhenaten's reign, particularly monotheism, cannot be attributed to him. Instead, Smith credited Nefertiti (who is generally perceived to be of European extraction) with the idea of monotheism, and with the change of aesthetic canons in art. Janson goes on to quote Smith's speculation that the abnormalities of Akhenaten are usually accompanied by sterility, so that Nefertiti's four daughters could not have been his. In his conclusion on Akhenaten, Smith compounded the pharaoh's plight by suggesting that Queen Nefertiti generally stood in her husband's shadow, an indication she had no need to embarrass him about his ineptness.

Winfield Smith's analysis of the Akhenaten bas-relief may not necessarily be racist, but rather one isolated incident plagued with errors. Ben-Jochannan, however, uses this article to illustrate the vicious, deliberate errors and the racism still leveled at people from Africa. He invites his readers to compare the facial characteristics of Akhenaten with those of all people indigenous to Africa and their descendants living in North America, the Caribbean, Brazil, and other parts of South America, and with the descriptions of the Egyptians by ancient Greek and Roman historians. Are we to understand that all those people who seem to fit Smith's description of Akhenaten were/are actually physically deformed?

In his quest to present further convincing evidence about the origin of the ancient Egyptians, ben-Jochannan uses some of the mummies presently on display at the Egyptian Museum in Cairo. These mummies represent many of the various facial types present in Egypt before and after the Dynastic periods. Referring to Smith's illustration, ben-Jochannan observes that most "reconstructions" of the ancient Egyptians we generally see are of the "C" type, which

bears the facial characteristics of Europeans. Most people, however, if shown the majority of mummies and surviving sculpture in the round, would not have great difficulty deciding the racial origin of the ancient Egyptian. If ben-Jochannan has presented forceful and cogent evidence of the negroid origin of the ancient Egyptians, the findings presented in Anta Diop's great work, *African Origin of Civilization: Myth or Reality* (1974), are utterly convincing.

Like his contemporary ben-Jochannan, Diop presents evidence from the accounts of ancient Greeks and Romans. Beyond the ancients' testimonies, Diop employs several other approaches—linguistic, totemic, physical anthropology, microscopic analysis, osteological measurements, blood-group typing, cultural data, and the papyrus documents which illustrate how the Egyptians saw themselves. From the wealth of data Diop presents, I will focus on his scientific evidence, which has received the greatest attention from people in archaeology, anthropology, egyptology, history, and linguistics.

Diop (cited, Van Sertima, 1989) prefaces his argument by citing the theory of paleontologist Louis Leakey (cited, Diop, 1974), which has received general acceptance. Central to Leakey's theory is mankind's monogenetic and African origin. His evidence shows that man of 150,000 years ago was "morphologically identical with the man of today" and was "living in the regions of the Great Lakes of Africa, at the sources of the Nile and no where else" (p. 9). Justifying the morphological identity claim, Leakey advances two important points. First, it was out of pure necessity that the earliest men were "ethnically homogeneous and negroid" (p. 9). In defense of this assumption, Leakey uses Gloger's law, which posits that living organisms most likely adapt to their environment by developing characteristics peculiar to the given circumstances. In the case of human beings, Leakey insists, "warm blooded animals evolving in a warm humid climate will secrete black pigment (eumelanin)" (p. 9). Leaky implies that if mankind originated in the areas of the tropics, around the latitude of the Great Lakes of Africa, then logic would lead us to conclude that early man of this region had a dark pigmentation. Consequently, those who moved to other climatic regions must have adapted appropriately. Accordingly then, he argues that the "original stock" was split into different races, and this is one possible conclusion. To ensure that his hypothesis is taken seriously, Leakey points to the geographical constraints of early man, identifying the only two routes available to early man for migration to other continents—the Sahara and the Nile Valley.

To support his position about the African origin of the ancient Egyptians, Diop (1974) uses the historical background of the Nile Valley route and the peopling of that Valley by Negroid races. In substance, although the evidence provided by the physical anthropologists can be used to build "reliable and definitive truths, and sound scientific conclusions," the criteria used to supposedly finalize a solution of this problem are arbitrary, thus giving way to "scientific hair-splitting" (p. 129). He cites many studies which exemplify the hair splitting of the varying percentage of negroid presence in the Valley from the distant prehistoric ages to predynastic times. Diop examines one of the conclusions in Emile Massoulard's *Histoire et protohistoire d' Egypt* (1949). Massoulard states that the Negadah skulls are said to belong to a homogeneous

group and therefore can provide sufficient data for a general conclusion about the racial origin. He cites that the dimensions of the skulls' total height, length, breadth of face, nasal capacity and so forth, approximate that of the present-day negro. However, he insists that "the nasal breadth, height of orbit, length of palate and nasal index," seem similar to Germanic peoples. Generally, those who argue for the caucasian origin of the early Egyptians bypass the evidence which suggests negroid characteristics of predynastic Negadian people. Instead they focus almost exclusively on the few racial characteristics akin to the white races.

The other studies Diop cites include Thomson and Randall MacIver's 1949 study of skulls from El Amrah and Abydos, and Keith Falkenburger's recent study of 1,800 male skulls from the Egyptian populations ranging from predynastic to present day. Falkenburger's conclusions report 36 percent Negroid, 33 percent Mediterranean, 11 percent Cro-Magnoid, and 20 percent are estimated to be either Cro-Magnoid or Negroid. Falkenburger's percentage of Negroid skulls during the predynastic period of Egypt is higher than Thomson and Randall MacIver's findings of 25 percent men and 28 percent women.

Consequentially, Diop's analysis considers the discrepancies among the percentages of Negroid, Mediterranean, Cro-magnoids, and cross-bred individuals. He draws our attention to what is, perhaps, the most salient of all the arguments put forth. Common to all these arguments is that all bodies of evidence converge at a point which shows that the Egyptian population in the predynastic epoch was Negroid. In view of the common and convincing evidence about the Negro origin of predynastic Egypt, those who insist on arguments that the Negro presence came later remain suspect (Diop, 1974, pp. 129–131).

To further reverse the present-day hypothesis of "White African/Egyptians," Diop employs the science of microscopic analysis of skin to accurately define ethnic affiliation. Since melanin (eumelanin), which determines color of pigmentation, is known to be virtually indestructible, and the scientific community widely agrees that the melanin in animal skin and fossils has survived for millions of years, Diop reasons that the skin of the Egyptian mummies (unparalleled specimens of embalming technique) are prime subjects for melanocyte analysis. Although melanin is mainly found in epidermis, it also penetrates the epidermis and lodges in the dermis. For example, the sample of mummies examined from the Marietta excavation in Egypt shows a higher level of melanin than in any "white skinned races" (p. 125). He assures us that if a similar analysis is done on the best preserved mummies in the Cairo Museum, the result will parallel his findings, proving that the ancient Egyptian belongs to the black races.

Osteological measurements were also a part of Diop's scientific analysis. In physical anthropology, the measurement of bones is a more accepted criterion than craniometry for accurately determining the distinctions of race. In other words, by means of osteological measurement one can differentiate the racial characteristics of a white and a black. Citing the study of the distinguished nineteenth-century German scientist Lepsius, Diop reconfirms that the ancient Egyptians belong to the black races, for, even though physical an-

thropology has progressed in its methodology, Lepsius' findings have not been invalidated by the new approaches. For example, his notation of some specific characteristics unique to the Egyptian skeleton still stands unchallenged. Lepsius contends that the bodily proportions, especially the short arms, are consistent with the negroid or negrito physical type.

Further, in his quest to provide more substantive evidence for the identity of the ancient Egyptians, Diop examines the etymology of the pharaonic language to see what they called themselves. Connected to the idea of self-description, Diop finds only one term that was designated for this purpose. That word was *kmt*, which literally translated means "the negroes." It is, according to Diop, the strongest term existing in pharaonic language to indicate blackness. Likewise, the character used to symbolize the word *kmt* in hieroglyph is "a length of wood charred at both ends" and not "crocodile scale" (as is commonly misinterpreted). Actually, the word *kmt* is etymologically related to the well-known word *Kamit,* which is common in modern anthropological literature. Diop cautions, however, against the manipulation of modern anthropological literature, which seeks to distort the meaning of the word *kmt* to have it imply "white." To guard against misinformation, he redirects our attention to the authenticity of the pharaonic mother tongue where the word *kmt* meant "coal black." (For an extensive discussion of the grammar of the pharaonic language see his *The African Origin of Civilization* [1974])....

In divine epithets, according to Diop, "black" or "negro" was invariably used to identify the chief beneficent gods of Egypt. Thus, for example, *kmwr* means the "great Negro" (for Osiris). More importantly, *km* always precedes the names of the revered gods of Egypt: for example, Apis, Min Thot, Isis, Hathor, and Horus.

Many other scholars besides ben-Jochannan and Anta Diop who have succeeded in re-establishing the true origin of the ancient Egyptians also point out the African influence on the development of Greco-Roman civilization. Whereas it is not possible within the scope of this work to review many of those who have argued for the Negroid origin of the ancient Egyptians, I must not neglect to mention the challenging and thought-provoking work of Martin Bernal in *Black Athena* Volumes I and II (1987 and 1991, respectively). *Black Athena Volume I* is particularly important for establishing the racial origin of the ancient Egyptians and their contributions to a great civilization. Convinced by the archaeological findings for at least 7,000 years, he asserts that the Egyptian population comprised African, South-West Asian, and Mediterranean types. Furthermore, historically speaking, the farther south one moves along the Nile Valley, where the upper Egyptian Kingdoms had influence, "the darker and more negroid the population becomes" (p. 242). In fact, the darker and more negroid population is still dominant in these regions today.

Bernal's overall view of the ancient Egyptians is summarized in his introduction. He asserts that the Egyptian population was fundamentally African/Black and that the African dominance was remarkable in the Old and Middle Kingdoms before the approximately 150 years of Hyksos reign, which notably was restricted to Lower Egypt. Supporting the claim of African dominance, Bernal joins Basil Davidson and James Brunson (cited, Van Sertima, 1989) in

affirming that the most important and powerful dynasties were I–IV, VI, XI–XIII, XVII–XVIII, and XXV, and that the pharaohs of these dynasties were black (Bernal, 1987, p. 242).

Notwithstanding that Bernal devotes little time to the racial origin of the ancient Egyptians, he echoes the views of Diop, ben-Jochannan, and others with respect to what the ancients thought of the Egyptians. He professes that the ancient Greeks unanimously agreed upon the cultural supremacy of the Pharoanic civilization. Judging from how eloquently and respectfully the ancients wrote about the Egyptians, Bernal believes, if it were possible for the Greeks to review some of the modern arguments that deny the Black African origin of ancient Egypt, they would rebuke the absurdity of early nineteenth-century scholarship. Bernal enforces his position by recalling the fact that the Greeks of the Classical Age went to Egypt to learn philosophy, mathematics, history, and many more arts and sciences. In short, Egypt was the center of learning.

Closely associated with the modern distortion of the ancient Egyptian racial origin, Bernal argues, modern racism and slavery figured prominently in the modern debasement of the negroid presence in early Egyptian civilization. Bernal suggests that those people who imposed the most brutal form of human degradation upon African people through the slave trade employed a strategy which included "proving" that Blacks were biologically incapable of creating a civilization as magnificent as Egypt. By thus establishing the so-called "biological truth," the perpetrators of racism and "continental chauvinism" were able to discount the genius of Black Egyptians and replace it with an Indo-Asiatic, white model of civilization. The mission, then, of many nineteenth- and twentieth-century historians was to maintain this status quo as "truth" despite many contradictions (Bernal, 1987, pp. 240–247).

The arguments presented here are a mere sampling of the voluminous body of findings that addresses the question of the racial origin of the ancient Egyptians. Ben-Jochannan, Anta Diop, Van Sertima, Bernal, and Williams are only a few of the modern scholars who have given credence to the testimonies of the ancients about the racial composition of the ancient Egyptians. The Greeks, in particular, maintained a reverence for the genius of the African civilization, Egypt, which was responsible for so many of their own cultural advancements.

By presenting convincing scientific evidence about the racial characteristics of the ancient Egyptians, Diop in particular helps write an important chapter in human history for the benefit of all people, especially downtrodden African peoples. The findings are overwhelmingly in favor of classifying the ancient Egyptians as belonging to the negro race.

Finally, in my arguments, I have used the work of contemporary observers —Volney, Denon, Aldred, ben-Jochannan, Chandler, Anta Diop, and museums with Egyptian art collections—who have presented written and photographic documentation about the physical characteristics of the ancient Egyptians. In every case that I have cited favoring the African/Negroid origin of the Egyptians, none of the sources sought to discount or discredit the importance of European civilization. In fact, the proponents of the African origin of Egyp-

tian civilization share a common ideological concern, namely that the social and political histories of the Egyptians must be told truthfully. Those who are interested in having this truth told understand the need to recast Egypt into its rightful historical position. Diop and ben-Jochannan warn that the reestablishing of African history should not be used as a tool of divisiveness, but rather as a unifying force on behalf of all mankind.

This [selection] has addressed the reconsideration and accurate representation of the origin of the ancient Egyptians. In the discussion I have cited the findings of Yosef ben-Jochannan, Chiekh Anta Diop, and Martin Bernal. Generally speaking, the evidence of ancient Greek and Roman accounts affirms the African influence on ancient Egypt. In addition, scientific data from osteological measurement, eumelanin analysis, and cranium measurements independently support the argument that the ancient Egyptians were Black. As further evidence, the etymology of pharaonic language was examined to find out how the ancient Egyptians referred to themselves. Finally, photographic evidence of ancient Egyptian sculpture supplies mute yet eloquent testimony about the origin of the ancient Egyptians.

Ancient Egyptians and the Issue of Race

Egypt straddles two major geographical regions: the continent of Africa and the Middle East. Because it was located on the African continent, ancient Egypt was an African civilization, though perhaps its African identity has been subtly minimized within the discipline of Near Eastern studies, which has its roots in European Orientalism of the nineteenth century. Many earlier European scholars working in Egypt, particularly during the days of the British empire, assumed that ancient history began with Egypt and Mesopotamia—in other words, that the earliest civilizations were Near Eastern ones, and ancient Egypt could be understood as such (and not as an African civilization). Some scholars, such as Sir Flinders Petrie (1899, 10) and Walter Emery (Emery 1967, 39), assumed that civilization was introduced into Egypt by an invading dynastic race from southwestern Asia, who replaced the prehistoric hunters and gatherers and early farmers living along the Nile—peoples much too primitive to "invent" civilization.

It is now known that as the land bridge between Asia and Africa, Egypt was the recipient of earlier technological developments in southwestern Asia, especially agriculture. The major cereal cultigens, emmer wheat and barley, as well as the domestic sheep/goat, are species not known in their wild form in Africa; they were domesticated much earlier, in southwestern Asia, and only later introduced into Egypt (Wetterstrom 1993, 200). There is no archaeological evidence, however, to suggest that a large-scale migration of peoples from southwestern Asia brought farming into Egypt, and the mechanisms by which domesticated cereals and perhaps the technology of farming were introduced into Egypt remain unclear. But recent research on the Predynastic period in Egypt (ca. 4000–3000 B.C.E.), including my excavations near Nag Hammadi in Upper Egypt, has shown that the cultural roots of Egyptian civilization are indeed indigenous (Hoffman, 1988, 47).

Less clear, however, has been the issue of race in ancient Egypt. The modern concept of race was unknown to the ancient Egyptians. Non-Egyptians were identified by their ethnic/tribal affiliations or by the region/country from which they came. Most physical anthropologists in the second half of this century do not believe that pure races ever existed, and they view the concept of "race" as a misleading one for their studies (Trigger 1978, 27). But a number of

Afrocentrists have claimed that black civilization began with ancient Egypt. The very title of Martin Bernal's *Black Athena* alludes to the putative roots of Greek —and therefore Western civilization—as a black African civilization in Egypt.

Ancient Egyptians were Mediterranean peoples, neither Sub-Saharan blacks nor Caucasian whites but peoples whose skin was adapted for life in a subtropical desert environment. Ancient Egypt was a melting pot; peoples of different ethnic identities migrated into the Nile Valley at different times in its prehistory and history. The question of whether ancient Egyptians were black or white obscures their own identity as agricultural peoples of *Kmt*, as opposed to *dšrt*, the barren "Red Land" of the desert. *Kmt* means "Black Land," the fertile floodplain of the lower Nile Valley, where cereal crops grew in such abundance. It does not mean "Land of Blacks."

Egyptians were Egyptians, the people of *Kmt*. The name points to the importance of the Nile in their lives. Unlike that of other early riverine civilizations, the Egyptian floodplain required no fallow time, nor was salinization of soils a problem with irrigation agriculture (Butzer 1976, 90). The economic base of pharaonic civilization was provided by the incredibly rich potential of cereal agriculture in the Egyptian Nile Valley. Egyptians were the indigenous farmers of the lower Nile Valley, neither black nor white as races are conceived of today.

Just who the ancient Egyptians were can be addressed by several types of evidence: language, historical records, the material culture, and physical remains (usually skeletons from burials). Evidence may be used to study cultural and biological relationships between different groups as well as within groups. For the most part, analyses of the different types of evidence have to be pursued independently, using different data because of the very different variables of such data; only after that can relationships between the different data be studied—within a specific cultural context.

Looking first at the linguistic evidence, there is nothing that links Egypt to other areas in Africa except very generally. Egyptian, the language spoken by the ancient Egyptians and written on monuments in hieroglyphs, evolved over more than four thousand years, to be finally replaced by Arabic following the Arab invasion in the seventh century C.E. Egyptian is classified by linguists as one of the five main groups of what is called the Afro-Asiatic language family. The other languages in this family include the Semitic languages spoken in southwestern Asia (including modern Arabic and Hebrew); Berber, spoken by Berbers in North Africa to the west of the Nile; the Chadic languages, spoken in northern Central Africa in the vicinity of Lake Chad; and the Cushitic languages spoken in the Horn of Africa, such as Galla in eastern Ethiopia (and probably covering Omotic; cf. Greenberg 1955, 43). Egyptian is so distinctly different from these languages in its structure and vocabulary as to be classified by itself. But it is more closely related to other languages in the Afro-Asiatic family than to any Indo-European languages or to the Bantu languages spoken today in Sub-Saharan Africa. In the New Kingdom (ca. 1558–1085 B.C.E.), when Egypt had an empire in southwest Asia, more Semitic words appeared in what is called Late Egyptian, but this can be explained by increased interaction with Semitic-speaking peoples, and not with other Africans (although that too cer-

tainly occurred). The linguistic evidence, then, points to the relative isolation of speakers of Egyptian in relation to other languages spoken in Africa.

Another important type of evidence for the study of ancient populations is from the physical remains that have been preserved in Egyptian burials. D. E. Derry, who studied the physical remains of Old Kingdom elites buried at Giza (excavated in the first decade of this century by George Reisner of Harvard University), took skull measurements and concluded, like Petrie and Emery, that the pyramid builders were a dynastic race of invaders, probably from the East, "who were far removed from any negroid element" (1956, 81).

As practiced by Derry, however, craniometry is no longer considered a valid statistical means for evaluating genetic relationships of ancient populations. A more recent analysis of nonmetrical variations in skulls (Berry and Berry 1973) suggests that the Egyptian samples show genetic continuity from Predynastic times through the Old and Middle Kingdoms—over two thousand years—with a shift in the New Kingdom, when there were considerable infiltrations of new peoples into the Nile Valley. In this same study the Egyptian skulls were then analyzed with samples from the northern Sudan (the Neolithic site of Jebel Moya), West Africa (Ashanti), Palestine (the site of Lachish), and Turkey (Byzantine period). Not surprisingly, the Egyptian skulls were not very distinct from the Jebel Moya skulls but were much more distinct from all others, including those from West Africa. Such a study suggests closer genetic affinity between peoples in Egypt and the northern Sudan, which were close geographically and are known to have had considerable cultural contact throughout prehistory and pharaonic history. But the Egyptian and the Jebel Moya samples also seemed no more related to the samples from southwestern Asia in Palestine and Turkey than to modern (black) populations of West Africa (Berry and Berry 1973, 206).

Clearly more analyses of the physical remains of ancient Egyptians need to be done using current techniques, such as those Nancy Lovell at the University of Alberta is using in her work (see A. L. Johnson and N. Lovell 1994). Two problems, however, hinder such studies. First, graves in Egypt have been robbed since prehistoric times. Intact tombs, such as Tutankhamen's, are the great exception, and even his tomb had been penetrated twice in antiquity by robbers. Second, many skeletons excavated by earlier archaeologists working in Egypt were either not kept, or have been stored so poorly that today they are in very bad condition. The prehistoric burials that I excavated in 1978 at Naqada in Upper Egypt were sent off to storage in the basement of the Cairo Museum, never to be seen again. Even for the same age/sex group within a burial sample representing one small village community (in which there probably was some or even considerable intermarriage), there can be significant skeletal variability, and large samples need to be analyzed so that statistical findings will be valid. But nonskeletal features, which are the ones most frequently used to distinguish race today, have long since disappeared in the physical remains of burial —even when they have been mummified as in pharaonic Egypt (Trigger 1968, 11).

It is disturbing to me as an archaeologist that archaeological evidence— the artifacts, art and architecture of ancient Egypt—has been identified with

race and racial issues. Racial issues, which in all fairness have arisen because of racial inequalities in the United States and elsewhere, have been imposed on the material remains of a culture even though these remains do not in themselves denote race. I am reminded of the excavation report of the Wellcome expedition at the site of Jebel Moya (Addison 1949). The English archaeologists who worked there in 1911–12 were certain that the advanced stone tools they excavated had to have been made by a prehistoric people who were white. This seems like a ridiculous conclusion today: stone tools thousands of years old cannot tell us the race of their makers any more than they can tell us what language their makers spoke.

The conventions of Egyptian art, as established by the beginning of the First Dynasty (ca. 3050 B.C.E.) do not represent humans as seen in perspective by the eye, but represent them in an analytic manner that transforms reality. The head, arms, and legs are drawn in profile; the torso is depicted frontally. Art may sometimes be grossly mannered and exaggerated, as it was during the reign of Akhenaten (ca. 1363–1347 B.C.E.) because of religious and cultural reforms conceptualized by that pharaoh. The conventions of Egyptian art were those of the crown and elites associated with the crown, and what is characteristic of Egyptian style in art for the most part represents a very small segment of the population.

Who and what were depicted on the walls of temples and tombs depended on Egyptian beliefs and ideology. Art was functional, and much of what is seen today in museums was created for the mortuary cult. Ancient Egypt was a class-stratified society, and age and sex in art were differentiated by scale of figures, style of dress, and symbols of status or office, as well as by skin tone. Statues and reliefs of women were painted in lighter tones of yellow ochre-based paint; men were painted in darker tones of red ochre-based paint. This is not to suggest that all Egyptian men were darker than all Egyptian women, but rather that established artistic conventions served to convey such ideas as sex differentiation. Such conventions, however, were not hard and fast rules, and there are many known exceptions. For example, in the tomb of Queen Nefertari, Rameses II's chief wife, the queen's skin is painted a brown (red ochre) color in a scene where she is playing a board game, as a contrast to the solid background of yellow ochre paint.

Non-Egyptian Africans, as well as Asiatics, were usually depicted in representational art as distinctly different from Egyptians, especially in their clothing and hairstyles. In the well-known scenes from the Eighteenth Dynasty tomb of Rekmire, Asiatics, Cretans, and Nubians are painted in registers bringing tribute to the court of Tuthmoses III. The Nubians, from the Nile Valley south of the First Cataract at Aswan, are painted in darker skin tones than the Asiatics, and are depicted with more prognathous jaws than the Egyptians. Bringing exotic goods and pets that originated in regions south of Nubia, the Nubians also carry gold ingots shaped into large rings. Nubia had little agricultural potential compared to Egypt, but rich gold mines were located there in *wadis* to the east of the Nile. That in part explains why Egypt occupied Nubia and built forts and temple towns there in the Middle and New Kingdoms.

Nubians bearing gold ingots and exotic tribute in paintings from the tomb of Huy (Thebes, no. 40), dating to the time of Tutankhamen, wear long, pleated Egyptian robes, but their hairstyles and large earrings are distinctly non-Egyptian. They have neck markings that may represent scarification, a practice unknown in ancient Egypt, and their facial features may possibly be interpreted as prognathous. In one scene an elite Nubian woman is depicted standing in a cart drawn by oxen, something in which Egyptian women would never have ridden. The Nubian tribute-bearers are painted in two skin tones, black and dark brown. These tones do not necessarily represent actual skin tones in real life but may serve to distinguish each tribute-bearer from the next in a row in which the figures overlap. Alternatively, the brown-skinned people may be of Nubian origin, and the black-skinned ones may be from farther south (Trigger 1978, 33). The shading of skin tones in Egyptian tomb paintings, which varies considerably, may not be a certain criterion for distinguishing race. Specific symbols of ethnic identity can also vary.

Nor are black Africans depicted by standardized conventions. The scenes of Queen Hatshepsut's expedition to the land of Punt, from her Eighteenth Dynasty mortuary temple at Deir el-Bahri, show a land very different from Egypt. Punt is thought to have been located along and to the west of the Sudanese/Eritrean coast (Kitchen 1993). The houses of the Punt peoples were hemispherical and built on elevated posts, unlike the rectangular mudbrick houses of Egyptians. Punt was the source of incense, ivory, and ebony, and tribute-bearers are seen carrying these goods to the seafaring Egyptians. A grossly obese "queen" of Punt is very unlike the lithe Egyptian upper-class women shown in tombs of this period. The "king" of Punt, whom she follows, is depicted in an Egyptian loincloth, but with a long and very un-Egyptian beard.

Though some Egyptian details appear, the ethnographic details in the Punt expedition scenes portray a culture that is distinctly non-Egyptian. But what race the Punt peoples were cannot really be determined from these scenes. Egyptian artists or scribes who accompanied this expedition recorded very distinctive ethnographic details, but the Puntites' facial features look more Egyptian than "black." Identifying race in Egyptian representational art, again, is difficult to do—probably because race (as opposed to ethnic affiliation, that is, Egyptians versus all non-Egyptians) was not a criterion for differentiation used by the ancient Egyptians.

As enemies of Egypt—peoples who threatened the boundaries of Egypt's kingdom—Nubians and Asiatics were depicted generically on the walls of Egyptian temples in the New Kingdom. The enemies of Egypt were shown as bound captives, being vanquished by pharaoh. On Egyptian temples in Nubia, reliefs showing such scenes must have had as one of their purposes the intimidation of local people. It was the duty of the king to destroy Egypt's enemies, and this is what is symbolized on the handle of a cane and on a footstool from Tutankhamen's tomb, both carved with generic Asiatic and Nubian captives. The Nubians carved on these two artifacts have very different facial features from those of the bearded Asiatics, but the facial features of both types of foreigners differ from the sculpture of Tutankhamen in the tomb.

Given that conventions for differentiating ethnic identity varied, as did artistic conventions for skin tones, anomalies in Egyptian art cannot be used with any certainty for drawing inferences about the race of ancient Egyptians. A limestone female head found in Giza tomb 4440, dating to the Fourth Dynasty (ca. 2613–2494 B.C.E.), is described in the catalogue of the Museum of Fine Arts in Boston as "of negroid type with thick lips, wide nostrils, and full cheeks" (W. S. Smith 1960, 35). A limestone head representing the woman's husband, also from tomb 4440, is distinctly different in its facial features: "the aquiline type of face so characteristic of some of the members of the Cheops family" (Smith, 35). Neither of these heads is painted, so their skin tones are unknown. The genre (called "reserve heads"), known only from the Fourth Dynasty, suggests more individualistic portraits than are usual in Egyptian art, and this female head "of negroid type" is different from other known reserve heads. As the identity of the person represented is unknown, her place in Egyptian society cannot be ascertained—though she certainly was a woman of high position.

A sandstone statue of Mentuhotep II, the king who unified Egypt and founded the Middle Kingdom in the twenty-first century B.C.E., was found in a pit to the east of the king's mortuary complex at Deir el-Bahri. The king is shown wearing a white robe and the red crown of Lower Egypt—and his skin is painted black. But as with analogous cases noted above, paint applied to a statue offers no real indication of his actual skin color. Black-painted skin could be symbolic of something of which we are unaware four thousand years later.

Perhaps better known than the painted statue of Mentuhotep II are the two New Kingdom figures of Tutankhamen that Howard Carter found guarding the entrance to that king's burial chamber. The black, resin-covered skin on these two wooden figures is contrasted by their gold skirts, sandals, headdresses, and jewelry (Reeves 1990, 128). These two black renditions of the king contrast the lighter-toned paintings of him on the walls of the burial chamber, and with the colored inlay on the back of the famous golden throne. Other art in this tomb likewise depicts a young man with brown skin, in keeping with Egyptian artistic conventions. Far from suggesting that the king had black skin, the two guardian figures of Tutankhamen may appear black simply because resin was applied to the skin areas. It is possible, too, that the resin was originally lighter and became dark over time. Resin, a costly and exotic import in ancient Egypt, was a material befitting a king who was to go to the afterlife displaying all forms of worldly wealth.

The people who lived south of Egypt are also known from archaeological evidence excavated in Nubia. From the fourth millennium B.C.E., when complex society evolved in Egypt, there is evidence in Lower Nubia of what archaeologists call the A-Group culture: people who traded with the Egyptians for Egyptian craft goods found in their burials. But with the founding of the First Dynasty in Egypt, ca. 3050 B.C.E., the newly unified Egyptian state penetrated into Lower Nubia, probably by military campaigns, and the A-Group disappeared there. Who the A-Group were in terms of race cannot be ascertained from the artifacts in their graves, but their locally made grave goods demonstrate a different material culture from that of the Predynastic Egyptians (Trigger 1976, 33).

From the Old Kingdom (ca. 2686–2181 B.C.E.) there is some archaeological evidence of small-scale Egyptian settlements in Lower Nubia, but by the late Old Kingdom a group of indigenous peoples, known to archaeologists as the C-Group, moved into Nubia as Egyptian occupation ended. After Egypt was reunified during the Middle Kingdom (ca. 2040–1786 B.C.E.), large mudbrick forts were built along the Nile in the region of the Second Cataract (near the modern-day border of Egypt and the Sudan). But evidence of the C-Group in Lower Nubia is also known to date to the Middle Kingdom, and the C-Group culture actually survived the Egyptian withdrawal from Nubia at the collapse of the Middle Kingdom.

During the Middle Kingdom a powerful African polity arose whose capital was at Kerma near the Third Cataract in the Nile, in the northern Sudan. In Egyptian texts this culture is called "Kush." The eastern cemetery at Kerma was excavated by George Reisner, and artifacts from eight very large round tumuli are now in the Museum of Fine Arts in Boston (Reisner 1923a). These tumuli are of a different architecture than Egyptian tombs. Some of them, moreover, contained human sacrifices, not found in Egyptian burials (with the possible exception of the First Dynasty royal tombs at Abydos). A Swiss archaeologist currently excavating the town and cemetery at Kerma estimates that there are 30,000 to 40,000 burials (Bonnet 1992, 613). The sway of Kerma extended into Lower Nubia until the reunification of Egypt at the beginning of the New Kingdom.

With Egyptian control in the New Kingdom extending as far south as Gebel Barkal near the Fourth Cataract, where a temple to the god Amen was built, the Kerma kingdom came to an end. Egyptians restored the Middle Kingdom forts in Lower Nubia and built temple towns farther south. But after the collapse of the New Kingdom, ca. 1085 B.C.E., a new Kushite power eventually arose at Gebel Barkal, where the cult of Amen continued to be practiced. The earliest burials in the royal cemetery at el-Kurru near Gebel Barkal (see Dunham 1950), also excavated by George Reisner, date to around 850 B.C.E. A hundred years later the first Kushite garrisons were established in southern Egypt during the reign of the Kushite king Piye, who later established his rule over all of Egypt (Trigger 1976, 140, 145). The Twenty-fifth Dynasty (ca. 760–656 B.C.E.), whose kings were all Kushites, ruled in Egypt for about sixty years. The later kings of this dynasty were frequently at battle with the Assyrian army, which finally succeeded in ending Kushite control in Egypt. Piye built the first pyramid tomb at el-Kurru, whereas in Egypt pyramids as royal burial monuments had not been built for a thousand years. Later Kushite kings were mummified, according to Egyptian custom, and spread the cult of Amen throughout Nubia.

The archaeological evidence of African kingdoms south of Egypt, at Kerma and Gebel Barkal, suggests distinctly different cultures that came into contact with Egypt. During the Twenty-fifth Dynasty the polity centered at Gebel Barkal actually controlled Egypt for a period. Cultural connections, if any, between the earlier Kerma kingdom and the later kingdom centered farther up the Nile at Gebel Barkal are uncertain, but the well-preserved burials recently excavated at Kerma by Bonnet (1992) provide a new source of information about Nubian populations.

Presumably the Kushites buried at Kerma and later at el-Kurru were related to the Nubians depicted in New Kingdom tomb paintings, as opposed to blacks living farther south in Africa, but once again the evidence seems ambiguous. Skin color, which is considered a criterion for race, cannot be determined from skeletal remains, and the evidence of representational art is problematic. The archaeological evidence at Kerma and el-Kurru points to African cultures that were different from Egyptian culture but that were responsible nonetheless for major cultural achievements. The Kushite peoples were considered non-Egyptians by Egyptians—in other words, ethnically different—but how physically different they were has yet to be determined by physical anthropologists. In any event, they are certainly better candidates for "black" African kingdoms than is ancient Egypt.

Culturally and linguistically the ancient Egyptians were different from other peoples living outside the Nile Valley, as well as those farther south and east. From textual and representational evidence it may be shown that ancient Egyptians had a sense of ethnic identity—of being Egyptian, as opposed to non-Egyptian. Today in Africa there are many different ethnic groups speaking many different languages. With the exception of South Africa, identity in Africa today is not by race or, for the most part, by nation, but by ethnic or tribal affiliation, which often has a close association with a spoken language or dialect. Ancient Egypt was definitely the earliest African civilization and as such certainly had an influence not only on the other cultures that arose in the Near East, but also on the states that arose farther south in Africa—at Kerma, Gebel Barkal, and later at Meroë. The evidence cited here strongly suggests that the ancient Egyptians were North African peoples, distinct from Sub-Saharan blacks. But to state categorically that ancient Egypt was either a black—or a white—civilization is to promote a misconception with racist undertones that appeals to those who would like to increase rather than decrease the racial tensions that exist in modern society.

POSTSCRIPT

Was Egyptian Civilization African?

One of the difficulties one faces in judging the validity of the evidence presented in this issue is the number of academic disciplines with which they must be familiar. Some experience in linguistics, the study of languages, is very important as much of the proof offered stems from an analysis of them. Scientific knowledge is also necessary when analyzing information regarding skeletal matter, head shape, and melanin—an element which gives skin its color. Finally, since the subject is of ancient, and even prehistoric times, familiarity with archaeology, anthropology, and related sciences would also be useful. Lack of such knowledge, common to most who come upon the Egypt-as-African question, makes an assessment of the evidence a difficult process.

Another problem is that so much of the debate regarding the origin of Egyptian civilization is influenced by today's volatile racial climate. Afrocentrists consider the view that Egyptian civilization had multicultural origins to be another attempt by Eurocentric scholars to "whitewash" African history. Those who oppose the Afrocentric view of the origins of Egyptian civilization maintain that they are merely stating the facts as they have been uncovered, and that no one benefits from a distortion of the historical record.

Works useful to the Afrocentrist side begin with two books by Cheikh Anta Diop, *The African Origins of Civilization: Myth or Reality?* (Lawrence Hill Books, 1974) and *Civilization or Barbarism: An Authentic Anthropology* (Lawrence Hill Books, 1981). For an Afrocentric viewpoint on the subject covered in this issue, see Ivan Van Sertima, ed., *Egypt: Child of Africa* (Transaction Press, 1994), which contains a series of essays on various phases of the subject.

For works that dispute the Afrocentric view, see Mary Lefkowitz, *Not Out of Africa: How Afrocentrism Became an Excuse to Teach Myth as History* (Basic Books, 1996) and Stephen Howe, *Afrocentrism: Mythical Pasts and Imagined Homes* (Verso Books, 1998).

Much of the recent debate on Egyptian origins has been fueled by Martin Bernal's two-volume *Black Athena*, documented in this issue's Introduction. An anthology of critical responses to Bernal's work is contained in Mary R. Lefkowitz and Guy MacLean Rogers, *Black Athena Revisited* (University of North Carolina Press, 1996). A response to this book is *Black Athena Writes Back: Martin Bernal Responds to His Critics* (Duke University Press, 2001). An attempt to evaluate both sides of this debate can be found in Jacques Berlinerblau, *Heresy in the University: The Black Athena Controversy and the Responsibilities of American Intellectuals* (Rutgers University Press, 1999). A third volume of *Black Athena* is currently being written, and when published, will certainly raise the level of the debate.

ISSUE 4

Was Sumerian Civilization Exclusively Male Dominated?

YES: Chester G. Starr, from *A History of the Ancient World* (Oxford University Press, 1965)

NO: Samuel Noah Kramer, from "Poet and Psalmists: Goddesses and Theologians: Literary, Religious, and Anthropological Aspects of the Legacy of Sumer," in Denise Schmandt-Besserat, ed., *The Legacy of Sumer: Invited Lectures on the Middle East at the University of Texas at Austin* (Undena Publications, 1976)

ISSUE SUMMARY

YES: Historian Chester G. Starr finds Sumerian society to be male dominated, from the gods to human priests and kings, and he barely acknowledges the status of women in either the heavenly or the earthly realm.

NO: Museum curator Samuel Noah Kramer relies on much of the same data as Starr, but finds powerful goddesses and earthly women to have played prominent roles in both cosmic and everyday Sumerian life.

This issue rests on a difference in interpretation rather than on a clearly stated topic debate. Each writer makes assumptions about what ancient Sumerian society was like and each finds evidence to support those assumptions. As you read the following two selections, notice that both cite remarkably similar findings. The difference is that for Chester G. Starr they are asides, whereas, for Samuel Noah Kramer they are the focus. For centuries the story of life in the Fertile Crescent has been told as if only men were actors in the drama. If royal queens received splendid burials, does it make sense to refer to rulers exclusively as kings? If women in a particular culture exhibited what historians like to call *agency*, acting on their own behalf to shape their own lives, is it accurate to term that culture male dominated? Much will depend on interpretation, on whose perspective seems to you more accurate. Was Inanna a "fertility goddess" as Starr assumes or "Queen of Heaven" and goddess of everything as Kramer

implies? Although Kramer's perspective is gaining acceptance, your textbook may continue to make Starr's assumptions.

Since the sophisticated civilization at Sumer is one of the earliest in human history, it has become a model for our understanding of human behavior. If men have always dominated women, then arguments that this arrangement is "natural" have greater strength. If, on the other hand, women played more active roles, then perhaps our understanding of what is by nature and what is by custom needs to be rethought. Virtually all of Kramer's evidence is present in Starr's essay. Is Starr correct to downplay or ignore most of it in favor of male-centered givens? As you read the first essay, pay particular attention to every mention of women as a group and to particular royal and divine women. When you find these female characters more fully developed in the second essay, ask yourself which viewpoint you question.

One of the dangers that historians must constantly be aware of is called *presentism*. We all have a tendency to judge whatever we read about the past in terms of our present values. If we assume that our ways of doing and being are best, we may judge the past in terms of what makes sense for us. Those who find it proper and even natural for men to dominate social, cultural, and religious life may assume that the past generated this pattern and fit existing evidence into these assumptions. Those who question patriarchal dominance may be inclined to look for and find evidence of strong, contributing, and empowering women. The historian's task is to take the evidence on its own terms and let it tell its own story, whether or not that story meshes with the present one.

In 1970 virtually all world history books would have told the story of Sumer as Starr has done. Thirty years later new understandings have led a growing number of scholars to take a fresh look at all of the past and question its archaeological and literary records, making as few assumptions as possible. Kramer represents this new breed of scholars. He does not assert that women dominated Sumerian society, but he finds areas in which women seem to have held as exalted positions as men and he discovers female deities who refuse to be demoted. Their authority and enduring inspiration suggest that women were not seen as outsiders to power. Indeed, the idea of "sacred marriage" suggests that the vital acts of creation and sustenance flowed from a blending of male and female energies.

Try to set aside your own assumptions about how women and men should behave and your own early-twenty-first-century way of looking at the world. Try to see only the evidence as it has come to us in cylinder seals, burial chambers, and texts. Based purely on what both selection authors agree is there, what conclusions can we draw about Sumerian society? Being able to critically evaluate what we learn permits us to make our own judgments and frees us from dependence on the theories of others.

 YES

The First Civilization of Mesopotamia

The Mesopotamian Outlook

Sumerian civilization. The Sumerians, who were in the forefront of early Mesopotamian progress, are linguistically a puzzle, for their agglutinative, largely monosyllabic speech cannot be connected with any of the major groups of languages. By about 3500 B.C. they had begun to draw conventionalized pictograms (representations of physical objects) on clay tablets, found at Kish and Uruk, and perhaps on other, less enduring materials. Three hundred years later, about 3200, tablets show that the scribes of Sumer took a tremendous step, which we do not know ever to have occurred independently elsewhere; that is, they advanced to a mixture of ideograms (marks representing concepts such as "day") and phonograms (symbols expressing syllabic phonetic values, as we might draw a bee for the sound be). Since some symbols expressed more than 1 phonetic value and, on the other hand, 1 single sound could be expressed by up to 14 different marks, sometimes "determinatives" were prefixes to indicate the class to which the word in question belonged, as deity, bird, and so on. These elements came to be wedge-shaped marks impressed in the clay by a stylus; from the Latin word *cuneus* for wedge the Mesopotamian script is called "cuneiform."

From this stage onward cuneiform script could be employed to set down languages of any type; both Semitic dialects like Akkadian and Indo-European tongues like Hittite and Old Persian were so written. Due to the mixture of ideograms, syllabic phonograms, determinatives, and other complications the number of individual signs was much larger than in an alphabetic form of writing. The earliest Sumerian script had perhaps 2000 symbols, but eventually about 500–600 sufficed. Each of these, though considerably simplified over the years, remained so complicated that only professional scribes commonly wrote in the ancient Near East. Writing was an arcane mystery down to Greek times.

The earliest Sumerian tablets are very difficult to comprehend. Largely, though not entirely, they are temple accounts: "so many sheep, so many goats"; or "to so-and-so, beer and bread for one day." If we place them against the much larger bulk of written documents which had appeared by the end of the third

millennium, it is nonetheless possible to gain precious light upon early Sumerian thought. The main characteristics of this outlook appeared very swiftly and were essentially fixed as the main lines of Mesopotamian civilization over the next 2500 years. Yet we can also observe that the structure of this outlook became ever more complicated and advanced. The "black-headed people," as the Sumerians called themselves, affected greatly their Semitic neighbors and followers, reaching on up through the Fertile Crescent, and were in turn influenced from the outside.

To a modern observer the pattern of thought which developed in third-millennium Mesopotamia is marked by its formal, outwardly static, and religious qualities. In the Sumerian view their arts and crafts had been "revealed" to them by the gods above and were unchanging. Everything must have its name to assure its place in the universe, and one who knew the true name of something had a power over it. Among the earliest Sumerian documents are lists of stones, animals, plants, and the like, classified on their outward characteristics. Yet these lists, which students probably learned by heart, reflect the fact that men were deliberately analyzing and imposing abstract order upon the materials of nature. We must not make the mistake of underestimating the tremendous achievements of these first civilized thinkers merely because their approach was so different from our own, indeed, they created many of the basic tools of thought and concepts we take for granted.

It was now, for instance, necessary to count and to write down numbers; Mesopotamian arithmetic was based sometimes on units of 10, sometimes on units of 60. The latter style, which through its fractions gives us our division of the hour and of the circle, was eventually used especially in astronomy, where men charted the major constellations still marked on modern sky-charts. By the first millennium Mesopotamian scholars began a tradition of ever more refined, precise, and abstract thinking and evolved a concept of place-value notation which was the root of our number system. Civilization also required the measurement and weighing of quantities of grain and metals; the chief weight, a talent of 60 minas, remained the standard quantity on down through the Greek era. Geometry began in the measurement of fields and the requirements of building. The year was solar but was defined in 12 lunar months, with an intercalary month inserted about every 3 years, to fix the great religious festivals and so to regulate agricultural activity.

The arts also progressed. The use of mudbrick and baked brick produced heavy, massive architecture, in which true arches were developed. To cover the ugly brick walls the Sumerians decorated their temples with bands of colored clay cones rammed into the walls and semi-columns; painted frescoes appeared later.

The gods were now visualized in human shape and were represented in statues which are, as it were, the gods themselves; for any transcendental quality was lacking. In some temples there were placed before the gods statues of the rulers, commemorating their devout piety in an equally straightforward, factual, yet reverent manner. The technical problem that stone was hard to come by forced sculptors often to create seated figures and almost always to exaggerate the size of the head. Although some pieces are sharply conceived,

they do not exhibit in general an intense interest in nature or a sense of human individuality. Equally significant are the many cylinder seals of men of property, carved with a representation of gods, imaginary animals, or myths. The demonic or bestial motifs that developed in this field were a rich repertoire of great influence on other Near Eastern and Greek art forms, but a modern rationalist will often feel disturbed by their suggestion that man did not yet recognize the distinctiveness of his own nature.

Early Mesopotamian religion. Man's failure fully to recognize himself is reflected in the religious aspect of the early Mesopotamian outlook. Sumerian civilization had a very strong religious imprint. Only in the confidence born of their common belief in divine support could these men have endured the hardships and unremitting toils necessary to assure a firm foothold in the valley. Their greatest building, the temples, are a mighty testimonial to a human ideal; the priests who clustered about these temples were so important that one may almost call an early Sumerian city-state a theocracy.

The character of this religious system becomes more apparent once there are written copies of Mesopotamian myths and artistic representations of the gods and heroes. To the inhabitants of Mesopotamia the gods were many, for they represented the forces which drove mankind; and in primitive thought these forces were many, distinct in origin. Yet the gods were grouped in a regular pantheon.

Highest was An, the divine force, which could be visualized in the overarching bowl of Heaven; his name meant "sky" or "shining." Then came Enlil, the active force of nature, who at times manifested himself in the raging storms of the plains, and at other times aided men. The goddess of earth was worshiped as Nin-khursag and under other names. Last of the four creator gods came Enki, the god of waters who fertilized the ground, and by extension became the patron of the skills of wisdom. To these were added 50 "great gods" who met in the assembly of the gods, the Annunaki; a host of other deities, demons, and the like also floated in the Mesopotamian spiritual world.

To the Sumerians their physical environment had come into being from a primordial chaos of water, whence the forces Tiamat and Abzu arose and, by processes of procreation, created the gods. Thereafter came the sky, the earth, and finally mankind. In the spring of each year occurred the greatest religious festival of the land, known as the Akitu in later Babylonia. This was the New Year's feast, an 11-day ceremony of gloom and purification and then of joy, which ended as the gods set the lots for mortal men during the coming year. On the fourth day of the festival the priests recited a myth of the creation called from its opening words *enuma elish:*

> When on high the heaven had not been named,
> Firm ground below had not been called by name . . .
> No reed hut had been matted, no marsh land had appeared.

Beside this ritual myth many other tales evolved to explain the nature of life. The underlying scheme of thought expressed therein postulated that the

world was the product of conscious divine action for divine purposes; obvious, too, is the feeling that the world was all animate. Throughout ancient times, down to and past the rise of Christianity, mankind could not quite divest itself of the idea that trees, springs, and the like were endowed with human characteristics or were directed by manlike immortals. In Mesopotamia, as elsewhere, religion not only bound together society but also assured to man the fertility of his fields, his flocks, and himself. One of the greatest figures in Mesopotamian myth was the goddess of human fertility, Inanna (later Ishtar), who may in root have gone back to the Neolithic female figurines found in Halafian levels. Her descent to the underworld and then her return symbolized the renewal of agricultural life; her husband Dumuzi (later Tammuz), went permanently to the nether regions as a substitute for her. Each year he was mourned, and his marriage with Inanna was celebrated at the New Year's feast.

To modern men, who approach these early myths from a scientific point of view, the tales of the gods are neither sensible nor logical, and the view of life which they express in their repetitious verse is basically a primitive one of gross action and elemental passions. In explaining the nature of the universe men translated into divine terms their own earthly concepts of personal clash and procreation. Yet in early civilized societies these tales were so satisfying that people all over the Near East accepted them. Mesopotamian stories thus passed into the early chapters of the Book of Genesis, where they continued to answer men's curiosity about the Creation down to the past century.

Place of man. The gods, though human in appearance, paid little attention to mortal men as they drank and made merry, and also wrangled and abused each other in the divine assemblies. Men feared and honored the gods; each city-state was but the earthly domain of certain divine forces on high, for whose ease men toiled throughout their lives. Once dead, men and women could expect only to go to a shadowy, gray land of departed spirits. Such views befitted a land that had recently raised itself to the level of civilization by hard labor, where the climate was severe, where the dangers of flood and sudden disease were ever present, inexplicable, and incurable by human means.

Yet two further reflections may be made. In the first place, the spiritual world of early Mesopotamia was an orderly structure, within which men could operate in a rational fashion; the gods could be propitiated by their human servants through the creation of divine ceremonies. Again, mankind could not quite forget that *it* was the agent that built and tilled, even though human society was far from perfect. In part this hidden realization led to a nagging fear that men might be upsetting an order laid down by the gods. One myth thus depicted the gods, angered by the clamor of men, sending down the Flood; other myths seem akin to the Hebrew story of the Fall of Man from a primitive grace and leisure through his own unwillingness to be passive. In part, however, men were proud of their achievements. A prime reflection of this point of view is the myth of Gilgamesh.

The Gilgamesh epic. The tale of the hero Gilgamesh, two-thirds god in origin, had Sumerian roots but was more fully formulated into a continuous epic

about 2000 B.C. Then it spread all over the Near East and long exercised men's imagination; one artistic symbol drawn from it, that of Gilgamesh strangling a lion, was handed down age after age until it appeared on medieval cathedrals in Western Europe.

Unlike the other myths, which were largely theological creations associated with certain rituals, this epic was centered on human figures. Essentially it was a mighty reflection on the nature of man, who strives and creates but in the end must die. Gilgamesh himself was a legendary king of Uruk, who built its great wall but treated his subjects so harshly that the gods created a wild man, Enkidu, to subdue him. Gilgamesh, wily as well as harsh, did not meet Enkidu head-on, but sent out a harlot, who by her arts tamed Enkidu—this taming we may perhaps take as an exemplification of the passage of mankind to civilization. "Become like a man," Enkidu put on clothing and went forth to protect the cattle against lions and wolves. The bulk of the epic then recounts the heroic adventures of Gilgamesh and Enkidu against various inhuman monsters:

> Who, my friends, [says Gilgamesh] is superior to death?
> Only the gods live forever under the sun.
> As for mankind, numbered are their days;
> Whatever they achieve is but the wind!

So, while they lived, let them at least make a name for themselves.

During the course of these exploits Enkidu offended the gods (especially Ishtar), and died after a long death-bed scene of recrimination against divine decrees. Gilgamesh first lamented, then set out to seek the plant of eternal life so that he might bring his friend back to life. Eventually Gilgamesh made his way to Ut-napishtim, the original Noah, who told him the story of the Flood and advised him how to get the miraculous plant under the sea. Although Gilgamesh succeeded in his quest, on his return journey he lost the plant to a snake. The dead, in sum, cannot be brought back to life.

When later we come to Greek civilization we shall meet another half-divine hero, Achilles, who fought in the war against Troy and there lost his friend Patroclus; and at that point we shall be able to compare the essential qualities of two different civilizations, the Greek and the Mesopotamian, as reflected in their great epics, the tale of Gilgamesh and the *Iliad*. Here it may be observed that in the earlier tale the story is balder and has less artistic unity; it is more naive, far earthier (especially in the harlot scenes). Monsters are prominent in the plot of Gilgamesh's adventures, and the appeal is rather to emotion and passion than to reason, as is that of the *Iliad*.

In both epics the divine plane determines earthly events, though men have freedom to oppose the gods; but the heroes of the *Iliad* are more strongly characterized and far more optimistic. Mesopotamian pride in human achievements went hand in hand with fear for human audacity. Men must cling closely to their fellow men on earth and must appease the jealous gods carefully. The individualism of Homer's heroes, their ability to accept human fate while yet enjoying life, their passionate curiosity and delight in the physical world—these

were qualities which did not exist in early, god-fearing Mesopotamia. Yet in saying so much, in an effort to relate the alien world of Gilgamesh to a world that most of us know far better, we must not depreciate the earlier epic too much. Poetically it was a magnificent creation, and psychologically it reflects a truly civilized meditation upon the qualities of mankind.

The Results of Civilization

Rise of classes (3000-2000 B.C.*).* That the early Mesopotamian outlook had at times a gloomy cast the modern historian can well understand. Not only did the fabrication of civilization itself impose terrific social burdens upon its human creators, but also the subsequent developments during the third millennium resulted in disturbing changes.

This evolution must be considered, if only briefly, in any sketch of early Mesopotamian civilization, for the structure of society had been greatly elaborated by the time of Hammurabi (1700); therewith, inevitably, the outlook of the Mesopotamian world was modified in important particulars. Although the documents available at the present time are not yet adequate to trace the political history of the third millennium in detail, it is amazing—and instructive —to see even dimly the rise of many critical problems which have been enduring issues in all subsequent civilized societies. Social classes, for example, became differentiated. Economic exploitation and social unrest inevitably followed hard upon this differentiation; law developed both to regulate social and economic relationships and to prevent undue oppression. Interstate warfare appeared and led to imperialism, which in turn produced military classes and bureaucratic systems to run the larger states born of conquest.

The first cities seem to have been masses of relatively undifferentiated fellow workers who were tightly grouped in an economic and spiritual unity. Separate classes, however, evolved rather quickly. Toward the top were the priests, who also worked in the early days but tended to become managers on behalf of the gods; the temples grew into powerful economic centers, which owned much of the land and absorbed a large part of the product in rents and temple dues. The records of Baba, divine consort of the main god of Lagash, show that her priests directed about one-sixth of the farm land of the city-state in the Early Dynastic period. Half of this domain was rented out to peasants, who paid their dues at the rate of one-third to one-sixth of the yield and also owed sums in silver, which they obtained by selling other parts of their produce in the city. The second half of her domain was cultivated by the labor of the peasants, organized in guilds under foremen. The goddess also controlled large flocks, shipping craft, fishermen, brewers, bakers, and spinners of wool; the growth in industrial production in Early Dynastic times, which was remarkable, was largely for purposes of cult as well as for military use and for the kings and their henchmen. The raw materials needed from outside Mesopotamia were obtained by merchants, who trafficked by sea, by river, and by land for stone, metals, wood incenses, and jewels.

Beside and above the priests rose the king or *lugal*. In later views kingship "was lowered from heaven by the gods" as a guarantee of earthly order. Palaces began to appear; the tomb of one queen of Ur, about 2500 B.C., astounded the modern world with its wealth of delicate jewelry, its harps, and the masses of sacrificed servants. To conclude that the kings and priests were simply parasites would be unjust, for these upper elements held together the state, harbored its reserves, and expanded its strength. Yet they did draw profit from their superior position, and the rest of society now fell into a dependent status.

One mark of this situation is the appearance of slavery. Some men were forced to sell themselves or their children into bondage through the workings of debt; others were captives, especially from the hilly country to the east. While the reduction of human beings to the legal level of chattels always has a distorting influence upon social relationships, morals, and general views of human nature, its effects must be assessed soberly. In the present case, the institution of slavery was but the extreme edge of the fact that the leisure of the upper classes and the great monuments of early times rested upon the forced labor of the multitude and otherwise would have been impossible. In other words, civilization was not lightly bought and did not directly benefit all men alike. Most of the labor force, however, in Mesopotamia as in other slave-holding societies of the ancient world consisted of technically free men. Slaves were rarely used in agriculture, the main occupation of mankind throughout the ancient world; rather, slaves lived in cities, where they were domestic servants, concubines, and artisans. As valuable pieces of capital, slaves were usually accorded a minimum standard of human needs, and at times were able to rise again into freedom through hard work....

Conclusion. If we look back, rather than forward, the story of man's advance in Mesopotamia from the first Neolithic villages of the valley down to the age of Hammurabi must strike us as one of the most amazing achievements of mankind. Despite the difficulties of climate and terrain the settlers had harnessed their energies toward a remarkable physical progress, and the compact masses of population which now dotted lower Mesopotamia were far larger than had ever before been possible.

NO ↩

Samuel Noah Kramer

Poets and Psalmists:
Goddesses and Theologians

Introductory

Let us now turn... to an anthropological inquiry relating to the Sumerian counterpart of one of modern man's more disturbing social ills: the victimization of woman in a male-dominated society. At the *XVIII Rencontre assyriologique internationale* held in Munich in 1970, I read a paper entitled "Modern Social Problems in Ancient Sumer," that presented evidence in support of the thesis that Sumerian society, not unlike our own rather tormented society, had its deplorable failings and distressing shortcomings: it vaunted utopian ideals honored more in the breach than in observance; it yearned for peace but was constantly at war; it preferred such noble virtues as justice, equity and compassion, but abounded in injustice, inequality, and oppression; materialistic and shortsighted, it unbalanced the ecology essential to its economy; it was afflicted by a generation gap between parents and children and between teachers and students; it had its "drop-outs," "cop-outs," hippies and perverts.

This highly competitive, and in some ways hypocritical, unjust, oppressive, genocidal Sumerian society, resembled our own sick society in one other significant aspect—it was male dominated: men ran the government, managed the economy, administered the courts and schools, manipulated theology and ritual. It is not surprising to find therefore, that by and large, women were treated as second-class citizens without power, prestige, and status, although there are some indications that this was predominantly true only of later Sumerian society, from about 2000 B.C. on; in earlier days the Sumerian woman may have been man's equal socially and economically, at least among the ruling class. Moreover, in the religious sphere, the female deity was venerated and worshipped from earliest times to the very end of Sumer's existence; in spite of some manipulative favoritism on the part of the male theologians, God in Sumer never became all-male.

From Samuel Noah Kramer, "Poet and Psalmists: Goddesses and Theologians: Literary, Religious, and Anthropological Aspects of the Legacy of Sumer," in Denise Schmandt-Besserat, ed., *The Legacy of Sumer: Invited Lectures on the Middle East at the University of Texas at Austin* (Undena Publications, 1976). Copyright © 1976 by Undena Publications. Reprinted by permission of The Estate of Samuel Noah Kramer.

Woman in Early Sumer

We begin our inquiry with the little that is known about women's rights and status in early Sumer. Some time about 2350 B.C., a king by the name of Uruk-agina reigned for a brief period in Lagash, one of Sumer's important city-states. Many of his inscriptions were excavated by the French almost a century ago and have since been deciphered and translated. Among them is a "reform" document in which Urukagina purports to depict the evil "of former days," that is, of the times preceding his reign, as well as the measures he introduced to alleviate them. One of these reforms reads as follows: "The women of former days used to take two husbands, but the women of today (when they attempted to do this) were stoned with stones inscribed with their evil intent." To judge from this rather strident boast, women in pre-Urukagina days practiced polyandry, which hardly smacks of a male-dominated society.

Or, take the case of Baranamtarra, the wife of Urukagina's predecessor, Lugalanda. Quite a number of administrative documents concerned with this lady have been uncovered, and these indicate that she managed her own estates, and even sent diplomatic missions to her counterpart in neighboring city-states, without consulting her husband.

Even Urukagina who, because of his uptight reaction to polyandry, might perhaps be stigmatized as the first "sexist" known to history, was not all anti-feminine. His wife Shagshag, for example, like her predecessor Baranamtarra, was the mistress of vast estates, and ran her affairs every bit her husband's equal. In fact Urukagina might well be acclaimed as the first known individual to favor "equal pay for equal work" regardless of sex. One of the remedial measures he proudly records in the above-mentioned reform document, concerns the bureaucratic gouging of the bereaved by officials in charge of a funeral. In pre-Urukagina days, reads the document, when a citizen was brought to rest "among the reeds of Enki," a cemetery that was deemed more desirable than an ordinary burial ground, there were on hand three male officials who received a considerable amount of beer, bread, and barley, as well as a bed and a chair, as compensation for their services. But Urukagina decreed that the food rations of the three male attendants be reduced considerably and that the furniture "bonus" be eliminated altogether. At the same time he ordered that a woman designated as *nin-dingir*, "Lady Divine," who formerly had received no remuneration, be given a headband and a *sila*-jar (about one-fifth of a gallon) of scented ointment as compensation for her services—a payment that compared not unfavorably with that received by her male colleagues.

Enheduanna: The First Woman Poet on Record

Nor was the *nin-dingir* the only priestess who played a significant role in the cult. A more prominent and important lady was the *en*, a Sumerian word that may be rendered "high priestess" as well as "high priest." According to Sumerian religious practice, the main temple in each large city had its *en* who was male if the deity worshipped in that temple was female, and was female if the deity worshipped there was male. Quite a number of these high-priestesses are known to us by name, beginning with about 2300 B.C., a generation or two after the

days of Urukagina. The first of these is Enheduanna, the daughter of Sargon the Great, one of the first empire-builders of the ancient world, whom her father appointed to be high priestess of great moon god temple in the city of Ur. But not only was she the spiritual head of one of Sumer's largest temples, she was also a poet and author of renown. Quite recently it has been demonstrated that at least three poetic compositions—a collection of temple hymns and two hymnal prayers to the Goddess Inanna, are at least in part, the imaginative literary creation of this Enheduanna. Here, in Sumer, therefore, some 4300 years ago, it was possible for a woman, at least if she was a princess, to hold top rank among the literati of the land, and to be a spiritual leader of paramount importance.

Woman in Later Sumer

From the three centuries following the days of Enheduanna, little is known about Sumerian society and the status of woman. But from about 2000 B.C. there have been recovered legal documents and court decisions of diverse content, and from these we learn that the role of woman had deteriorated considerably, and that on the whole it was the male who ruled the roost. Marriage, for example, was theoretically monogamous, but the husband was permitted one or more concubines, while the wife had to stay faithful to her one and only spouse. To be sure, a married woman could own property and other possessions, could sometimes buy and sell without consulting her husband, and on rare occasions, could even set special conditions in her marriage contract. In case of divorce, however, the husband had very much the upper hand—he could divorce his wife virtually at will, although if he did so without good cause, he had to pay her as much as *mina* (about a pound) of silver, no mean sum in those days.

Female Deities: Victimization and Resentment

But it was not only on the human plane that women had lost some of their rights and prerogatives in the course of the centuries—it also happened on the divine plane. Some of the female deities that held top rank in the Sumerian pantheon, or close to it, were gradually forced down the hierarchical ladder by the male theologians who manipulated the order of the divinities in accordance with what may well have been their chauvinistic predilections. The goddesses, however, were no "pushovers"; more determined and aggressive than their human counterparts, they struggled to hold or regain at least part of their deprived supremacy to the very end of Sumer's existence. What is more, at least one of the goddesses, Inanna, "Queen of Heaven," continued to be predominant and preeminent to the very last, although the theologians ranked her only seventh in the divine hierarchy. The available texts are not explicit on the subject, but with a bit of between-the-lines reading and burrowing, it is possible to follow the struggling career of at least two important female deities, and to trace some of their ups and downs in myth and cult.

Nammu, Goddess of the Primeval Sea

The female deity that seems to have suffered the sharpest decline was Nammu, the goddess of the primeval sea who, according to several texts, was the creator of the universe and the mother of all the gods. By all genealogical rights, therefore, had the theologians played it fair, she should have had top billing in the pantheon. But in the god-lists where the deities are arranged in hierarchical order, she is rarely mentioned, and never at the head of the list. Moreover, her vast powers as goddess of the sea were turned over to the male deity Enki, who was designated by the theologians as the son of Nammu, in an apparent attempt to mitigate and justify this bit of priestly piracy. Even so, the king who founded the Third Dynasty of Ur, and ushered in a political and cultural Sumerian renaissance about 2050 B.C., chose as his royal name *Ur-Nammu,* "Servant of Nammu," which indicates that the goddess was still worshipped and adored by the mighty of the land.

Ki, Mother Earth

But it is Nammu's daughter Ki, "(Mother) Earth," whose gradual decline can be followed almost step by step with the help of the ancient texts. As noted above, the sea-goddess Nammu was conceived as the creator of the universe. Now the Sumerian word for universe is the compound *an-ki,* where *an* means both "heaven," and "(Father) Heaven," and *ki* means both "earth," and "(Mother) earth." It was the sexual union of Father Heaven with Mother Earth, that according to the Sumerian theologians, ushered in the birth of the gods unto their generations. The first to be born of this Heaven-Earth union, was the air-god Enlil, "Lord Air," and it was he who, by making use of his atmospheric power, succeeded in separating Heaven from Earth, thus preparing the way for the creation of vegetation and all living things including man. In view of these theological premises and postulates, the leading deities of the pantheon, once Nammu had been deprived of her supremacy, should have been ranked by the theologians in the order An (Heaven), Ki (Earth), and Enlil (Lord Air), and this may have been so in very early times. But by 2400 B.C., when the relevant inscriptional evidence first becomes available, we find the leading deities of the pantheon usually arranged in the order An (Heaven), Enlil (Lord Air), Ninhursag (Queen of the Mountain), and Enki (Lord of the Earth). What had evidently happened was, that the theologians, uncomfortable and unhappy with a female deity as the ruler of so important a cosmic entity as earth, had taken this power away from her and transferred it to the male deity Enlil who, as one poet puts it, "carried off the earth," after he had separated it from heaven. Moreover, after taking away from the goddess the rulership over the earth, the theologians also deprived her of the name *Ki,* (Mother) Earth," since it no longer accorded with her reduced status. Instead they called her by one of her several epithets, Ninhursag, that means "Queen of the Mountain," and demoted her to third place in the pantheon.

But the worst was yet to come—even third place was deemed too high by male "chauvinistic" theologians, and she was finally reduced to fourth place,

third going to Enki, "Lord of the Earth." This god's name was actually a mis-
nomer, since he had charge only of the seas and rivers, and even this power,
as noted earlier, he usurped from the Goddess Nammu. But the theologians of
Eridu, a city not far from Ur, which was the God's main seat of worship, were
consumed with ambition. As the name "Lord of the Earth" indicates, the devo-
tees of this God were really out to topple the God Enlil who had become the
ruler of the earth after he had separated it from heaven. To achieve their goal,
they went so far as to have their God Enki confound the speech of man and
turn it into a "babel" of tongues, in order to break up Enlil's universal sway
over mankind that worshipped him "in one tongue." In spite of this, however,
they failed to dethrone Enlil from second place, since his bailiwick was Nippur,
Sumer's holy city, whose priests were too powerful to overcome. Disappointed
and frustrated the Eridu theologians turned upon the female deity Ninhursag
(originally named Ki) whose devotees were evidently too weak to prevent her
victimization. And so, by 2000 B.C., when the pertinent texts become available
once again, the order of the four leading deities of the pantheon is no longer
An, Enlil, Ninhursag, Enki, but An, Enlil, Enki, and Ninhursag.

Still, as already noted, the Sumerian goddesses did not take male-domina-
tion "lying down," and not infrequently, according to the mythographers, they
registered their resentment in no uncertain terms, and showed the male "vic-
tors" who was really "boss." As of today, for example, we have two myths
in which Ninhursag and Enki are the main protagonists, and in both it is
Ninhursag who dominates the action, with Enki "playing second fiddle."

The scene of one of these myths is Dilmun, the Sumerian "Paradise" land,
where both Ninhursag and Enki are at home. Here, after considerable maneuver-
ing, Ninhursag contrived to make eight different plants sprout. But when Enki
sees them, they tempt his appetite, and he sends his vizier to pluck them and
bring them to him. After which, he proceeds to eat them one at a time. This so
enrages Ninhursag that she pronounces against him the "curse of death." And
mighty male though he was, eight of his organs become sick, one for each of
the plants he had eaten without permission from the goddess. The failing Enki
would surely have died in due course, had not the goddess finally taken pity on
him, and created eight special deities, each of whom healed one of Enki's ailing
organs.

In the other available myth, we find Ninhursag and Enki acting as partners
in the creation of man from the "clay that is over the Deep." In the course of
a banquet of the gods, however, the two deities become tipsy, and the partner-
ship turns into a competition. First Ninhursag fashions six malformed creatures
whom Enki dutifully blesses and for whom he even finds useful "jobs" in spite
of their handicaps. Then it was Enki's turn. But the creature he fashions dis-
pleased Ninhursag who proceeds to rebuke Enki bitterly for his clumsy effort,
a reproach that the god accepts as his due, in language that is obsequious and
flattering.

Prestigious Female Deities

Nor was Ninhursag the only female deity who, in spite of occasional victimization by the theologians, continued to be revered and adored in the land. There was Nidaba, the patroness of writing, learning, and accounting, whom the theologians provided with a husband by the name of Haia, who seemed to be no more than a shadowy reflection of the goddess. There was the goddess of medicine and healing who was worshipped in Lagash under the name of Bau, and in Isin under the name of Ninisinna. In Lagash, it is true, the theologians did succeed in making her husband Ningirsu paramount in cult and adoration. Even so, there are indications that originally Bau was of higher rank than her spouse. Moreover, when it came to the naming of their children, the people of Lagash preferred by far to include Bau rather than Ningirsu in the chosen theophoric name—clear evidence of the popularity of the goddess, no matter what the theological dogma. As for Ninisinna, it was she who was venerated as the heroic tutelary deity of Isin, while her husband Pabilsag is a far less impressive figure. Most interesting is the case of the Lagashite goddess Nanshe who was acclaimed and adored as Sumer's social conscience, and who was depicted as judging mankind every New Year. Her spouse Nindara, a far less significant figure, did not participate in this solemn and fateful procedure; it was her bailiff, the male deity Hendursagga, who carried out obediently and faithfully the verdict of his deeply revered mistress.

Inanna, "Queen of Heaven"

But the goddess that should be soothing balm to the resentful wounds of liberated women the world over, is the bright, shining Inanna, the brave, crafty, ambitious, aggressive, desirable, loving, hating "Queen of Heaven," whose powers and deeds were glorified and extolled throughout Sumer's existence in myth, epic, and hymn. No one, neither man nor god, dared oppose her, stand in her way, or say her nay. Early in her career, perhaps about 3000 B.C., she virtually took over the divine rulership of the important city, Erech, from the theoretically and theologically all powerful heaven-god An. In an effort to make her city Erech the center of civilized life, she braved a dangerous journey to the *Abzu*, "the Deep," where the cosmic and cultural divine laws were guarded by its King Enki. When this same Enki organized the universe and somehow failed to assign her the insignia and prerogatives she felt were her due, he had to defend himself apologetically and contritely against her angry complaint. When the rebellious highland, Ebih, failed to show her due honor, she virtually destroyed it with her fiery weapons, and brought it to its knees. Raped by the gardener Shukalletuda while sleeping wearily after a long cosmic journey under one of his shade-trees, she pursued him relentlessly and finally caught up with him and put him to death, but was gracious enough to console him with the promise to make his name endure in story and song.

The role that no doubt delighted Inanna most, one that guaranteed her the affection and veneration of every Sumerian heart, was that which she played in the New Year "Sacred Marriage" rite, that celebrated her sexual union with the King of Sumer in order to ensure the fertility of the soil and the fecundity

of the womb. The first king whom the goddess selected as her mortal spouse was Dumuzi (Biblical Tammuz), who reigned early in the third millennium B.C. From then on, many, if not most of the rulers of Sumer, celebrated their marriage to the goddess as avatars, or incarnations of Dumuzi. Throughout the "Sacred Marriage" ceremony, it was the goddess who was the active, dominant protagonist; the king was but the passive, ecstatic recipient of the blessings of her womb and breasts, and of just a touch of her immortality. And when—so tell the mythographers—Dumuzi, with typical male arrogance, became weary of being subordinate to the goddess, and, in her absence, began to play high and mighty, she fastened upon him her "eye of death," and had him carried off to the Nether World. There he would have remained forever, had not his loving sister offered herself as his substitute, thus allowing him to return to earth for half the year.

Monotheism: Death-Knell of the Female Deity

So much for the Goddess Inanna, the feared and beloved "Holy Terror" of the ancients. The female deity, as is clear from what was said above, had her ups and downs in Sumerian religion, but she was never really licked or totally eclipsed by her male rivals. Even in much later days, when Sumer had become generally known as Babylonia, and the Sumerian language was superseded by the Semitic Akkadian, the poets continued to compose hymns and psalms to the female deities, and especially to the Goddess Inanna under her Semitic name Ishtar. The death-knell of the female deity in Near Eastern religious worship came with the birth of monotheism, and especially the Jahwistic monotheism propagated by the Hebrew prophets. For them, Jahweh was the one and only, omniscient, omnipotent and all-male—there was no room for any goddess no matter how minimal her power, or how irreproachable her conduct. Still, even in Jahwistic Judaism there are faint echoes of the female divinities of earlier days, and it is not altogether surprising to find that the Hebrew mystics, the Kabbalists, spoke of a feminine element in Jahweh designated as the "Shekinah," opposed to a masculine element designated as the "Holy One, Blessed Be He." And at least one passage in the renowned Kabbalistic book, the Zohar, states that Moses, the son of God, actually had intercourse with the "Shekinah,"—a distant but not so faint reminder of the "Sacred Marriage" between Dumuzi and Inanna, that provides us with one more example of the far, gossamer, reach of the "legacy of Sumer."

POSTSCRIPT

Was Sumerian Civilization Exclusively Male Dominated?

Because humans make assumptions about race and gender and then find evidence to support these assumptions, it is not surprising that Starr and Kramer reach different conclusions. Among Kramer's many books is *Sumerian Mythology: A Study of Spiritual and Literary Achievement in the Third Millennium B.C.* (Peter Smith Publisher, 1980). Sir C. Leonard Woolly discovered and excavated the Royal Cemetery of Ur; his *The Sumerians* (Oxford at the Clarendon Press, 1928, 1929) is a classic in the field. William W. Hallo, who participated with Kramer in the Invited Lectures, which produced the book from which the No-side selection is taken, is a prolific and compelling chronicler of this period. His recent *Origins: The Ancient Near Eastern Background of Some Modern Western Institutions* (E. J. Brill, 1996) contains three chapters concerning women—in law, in public life, and as authors.

Has patriarchy—the rule of society by men—always existed? Or, as historian Gerda Lerner argues in *The Creation of Patriarchy* (Oxford University Press, 1986), was this pattern created as a historical event? Erich Newman's *The Great Mother: An Analysis of the Archetype* (Princeton University Press, 1963) broke new ground in explaining the goddess archetype as did Elizabeth Gould Davis's *The First Sex* (Putnam, 1971); Merlin Stone's *When God Was a Woman* (Dorset Press, 1976); and Marija Gimbutus's *Goddesses and Gods of Old Europe* (University of California Press, 1982). All of these books explore goddess cultures and the earthly women who lived within them. *Engendering Archaeology: Women and Prehistory,* Joan M. Gero and Margaret W. Conkey, eds. (Basil Blackwell, 1991) examines the archaeological record for gender-based approaches and assumptions. In that work, see Susan Pollack's "Women in a Man's World: Images of Sumerian Women." Also see Pollack's book entitled *Ancient Mesopotamia: The Eden That Never Was* (Cambridge University Press, 1999).

For a look at assumptions challenged, students may enjoy Elaine Morgan's anthropological study *The Descent of Woman* (Bantam, 1972). Playing on the title of Charles Darwin's *The Descent of Man,* Morgan assumes that the mother/child dyad rather than the male/female pair-bond is the basis of evolution. What brought about the worldwide transition to patriarchy? Leonard Shlain's *The Alphabet Versus the Goddess* (Viking/Penguin, 1998) states that the widespread acquisition of alphabet literacy changes the way we perceive the world and rewires the brain. In each world civilization, Shlain finds this transition from image to word leading to the demise of goddess worship, a plunge in women's status, and the advent of harsh patriarchy and misogyny.

ISSUE 5

Does Alexander the Great Merit His Exalted Historical Reputation?

YES: N. G. L. Hammond, from *The Genius of Alexander the Great* (University of North Carolina Press, 1997)

NO: Ian Worthington, from "How 'Great' Was Alexander?" *The Ancient History Bulletin* (April–June 1999)

ISSUE SUMMARY

YES: Professor emeritus of Greek N. G. L. Hammond states that research has proven that Alexander the Great is deserving of his esteemed historical reputation.

NO: Professor Ian Worthington counters that Alexander's actions were self-serving and eventually weakened his Macedonian homeland; therefore, he does not merit the historical reputation he has been given.

From 431–404 B.C.E. Greek city-states (polei) were destroying themselves in a needless but predictable series of wars that have become known as the Peloponnesian Wars. Chronicled by Thucydides (460–400 B.C.), an eyewitness and participant, these wars showed the Greek polei at their worst—selfish, contentious, avaricious, and power-hungry. The result was a series of conflicts in which one side, Sparta and its allies, was able to defeat its traditional enemy, Athens and its Delian League allies. Both sides suffered heavy losses and learned no lessons from the prolongued conflict. In their weakened, unenlightened state, they were easy prey to a strong, united Greek kingdom from the north —the Macedonians and their powerful king Philip.

The Macedonians were considered by the Greek city-states of the south to be barbaric. However, they had unification and military prowess on their side, and soon all of Greece was under their control. Philip was deprived of his chance for a more exalted place in history when he was assassinated by a bodyguard while attending a wedding festival in 336 B.C.E. He was succeeded by his son Alexander, then a young man of 19 years.

Alexander seemed to be destined for greatness. At an early age he displayed strong leadership and military skills, and to complement these, Philip

hired the noted Greek philosopher Aristotle as a tutor to help develop Alexander's intellectual side. Although it is difficult to pinpoint specific contributions that Aristotle made to the development of his pupil, some general ones were a passion for Greek culture, a strong affinity for intellectual pursuits, and a keen interest in Greek literature and art.

Given the volatile nature of Macedonian politics and Alexander's lack of experience, accession to his father's crown was not guaranteed. But he did succeed, and within 14 years he conquered most of the then-known world. This earned him a place in history with the sobriquet—Alexander the Great.

Alexander's place in history was created immediately after his death. There were some who spoke of him as a divinity, even while he was alive, and Alexander did nothing to discourage it. This glorification process continued through the next few centuries. The Romans, who featured likenesses of him in many of their art works, saw themselves in him as they began to follow in his footsteps, conquering much of the known world. The apex of his Roman reputation occurred when Plutarch (42–102 C.E.) wrote glowingly of him in his *Lives,* claiming that Alexander was descended from Hercules. A few of the historical figures who engaged in Alexandrine worship included Julius Caesar, Napoleon Bonaparte, and U.S. World War II general George Patton. Alexander's persona has also been featured in literary works from ancient to modern times.

What is the basis of Alexander's glowing historical reputation? Obviously, his conquests form its essence—but it is based on more than territorial accumulation. It is the story of the "philosopher-king," the cultured leader who attempted to create a cultural synthesis by fusing the best of the East and the West. It is the saga of an attempt by a man to create a "one world" ideal, a man trying to achieve the "impossible dream" and coming close to it.

For most of recorded history, humankind's story has been told through the words and deeds of its great men, and occasionally, great women. This is the "heroic" approach to the study of history. In the first part of the twentieth century, this version of history dominated. Historical figures such as Alexander still received favorable press. But the repetitive violence of the twentieth century influenced people to interpret history in a less militaristic vein, and the positive assessment of Alexander the Great began to change. How much it will change remains to be seen.

N. G. L. Hammond, who has written three books about Alexander, still finds much to admire in him, especially his love of Greek culture and his strong intellectual qualities. To Hammond, Alexander is worthy of his historical appellation. On the other hand, Ian Worthington states that Alexander's historical reputation may be undeserved due to the death and suffering caused by his military campaigns, and how they weakened the Macedonian state at home.

The Plans and Personality of Alexander

Arrangements Affecting the Macedonians and Macedonia

After the reconciliation in late summer 324 Alexander [the Great] offered his terms for any Macedonians who might volunteer to go home. They would be paid the normal wage up to their arrival in Macedonia, and each man would receive a gratuity of one talent. They were ordered to leave their Asian wives and children in Asia, where Alexander undertook to bring up the boys "in the Macedonian manner in other respects and in military training"; and he said he would send them thereafter to their fathers in Macedonia. He made provision also for orphans of Macedonian soldiers in Asia. Some 10,000 Macedonians accepted these terms. "He embraced them all, with tears in his eyes and tears in theirs, and they parted company." They were being released from the campaign in Asia, not from military service. In summer 323 they reached Cilicia, where Alexander intended that they should winter. In spring 322 they were to be transported to Macedonia by his newly built fleet. By then Alexander expected to have completed his Arabian campaign and to be in Egypt or Cilicia. He was to be joined there by 10,000 Macedonians "in their prime," who would be replaced in Macedonia by the returning veterans....

Arrangements Affecting the City-States

Alexander respected the sovereignty of the Greek Community in the settlement of affairs after the defeat of Agis and his allies, and he continued to do so, for instance by sending captured works of art to the states in the Greek Community. His conduct in these years indicates that the allegations of exceeding his powers as *Hegemon,* which were made in a speech "On the Treaty with Alexander" in 331, were groundless. Within the Greek Community only one breach of the charter was reported in our sources, the expulsion of the people of Oeniadae from their city by the Aetolians. It happened perhaps in 325; for Alexander said that he himself would punish the Aetolians, presumably on his return to the West. In the years of peace a large number of Greek allies went east to serve in Alexander's army, and no doubt others emigrated to trade or settle in Asia. At

Athens Phocion was re-elected general repeatedly as the advocate of compliance with the Charter, and Lycurgus used the prosperity which Athens enjoyed under the peace to complete the construction in stone of the auditorium of the theatre of Dionysus and to improve the naval shipyards.

In June 324, when Alexander was at Susa, one of his financial officers, Harpalus, fled to Greece in order to escape punishment for misconduct. He came to Cape Sunium with 5,000 talents, 6,000 mercenaries and 30 ships, and as an Athenian citizen (for he had been honoured earlier by a grant of citizenship) he proceeded to Athens and asked for asylum and in effect alliance against Alexander. The Assembly rejected his request. He and his forces went on to Taenarum in the Peloponnese, but he returned as a suppliant with a single ship and a large amount of money. The Assembly then granted him asylum as an Athenian citizen. Although he gave bribes freely in Athens, he did not win over the leading politicians. Meanwhile Antipater [general "with full powers"] and Olympias [handler of religious and financial affairs] made the demand that Athens as Macedonia's ally should extradite Harpalus; and envoys from Alexander came from Asia with a similar demand. On the proposal of Demosthenes the Assembly voted to arrest Harpalus, confiscate his money, and hold him and his money "for Alexander." . . .

When his forces were assembled at Susa, Alexander announced to them that all exiles, except those under a curse and those exiled from Thebes, were to be recalled and reinstated. . . . The wording was as follows: "Alexander to the exiles from the Greek cities . . . we shall be responsible for your return . . . we have written to Antipater about this, in order that he may compel any states which are unwilling to restore you." . . . The purpose of Alexander was twofold: to resettle the floating population of exiles (we may call them refugees today), which caused instability and often led to mercenary service; and to reconcile the parties which had fought one another and caused the vicious circle of revolutionary faction.

Such an act of statesmanship was and is unparalleled. It affected almost all Greek city-states to varying degrees, and it hit Athens and Aetolia hardest. For Athens had expelled the population of Samos in 365 and occupied the island herself; and now, forty years later, she would have to restore the island to its proper owners. And Aetolia had to hand back Oeniadae to the Acarnanians she had expelled. At the time Alexander could not be accused of restoring his own partisans; for the bulk of the exiles had been opponents of the pro-Macedonian regimes in power. According to Hieronymus, an objective historian born around 364, "people in general accepted the restoration of the exiles as being made for a good purpose." In many states the restoration had taken place at the time of Alexander's death, but Athens and Aetolia were still making objections. . . .

Alexander's Beliefs and Personal Qualities

Alexander grew up in a kingdom which was continually at war, and he saw it as his duty to lead the Macedonians in war not from a distance but in the forefront of the fighting. He saw the destiny of Macedonia as victory in war,

and he and his men made military glory the object of their ambitions. Thus he spoke of the victorious career of Philip [king of Macedonia (359–336 B.C.) and father of Alexander] as conferring "glory" both on him and on "the community of Macedonians." His own pursuit of glory was boundless. As he declared to his Commanders at the Hyphasis, "I myself consider that there is no limit for a man of spirit to his labours, except that those labours should lead to fine achievements." He made the same demand on his Commanders and his men. They had committed themselves to following him when they had sworn the oath of allegiance (*sacramentum pietatis*), to be loyal and have the same friend and enemy as their king. If a man should be killed in his service, Alexander assured them that his death would bring him glory for ever and his place of burial would be famous.

Life was competitive for boys in the School of Pages and for boys being trained for the militia in the cities, and thereafter in civilian affairs and in the services. No Macedonian festival was complete without contests in such arts as dramatic performance, recitation of poetry, proclamation as a herald, and musicianship, and in athletic events which on occasion included armed combat. Alexander was intensely competitive throughout his life. He would be the first to tame Bucephalus [a wild horse], to attack the Theban Sacred Band [an army of the boldest Theban warriors, organized to fight the Spartans in 371 B.C.], to mount a city wall or climb an impregnable rock. He was the inspirer and often the judge of competition in others. He alone promoted soldiers and officers, awarded gifts for acts of courage, bestowed gold crowns on successful Commanders, and decided the order in the hierarchy of military rank up to the position of Senior Friend and Leading Bodyguard. Competitions between military units and between naval crews were a part of training and of battle. Alexander himself believed that he must compete with Philip, Cyrus the Great, Heracles and Dionysus and surpass them all, and as Arrian remarked, "if he had added Europe to Asia, he would have competed with himself in default of any rival."

His belief in the superiority of Greek civilisation was absolute. His most treasured possession was the *Iliad* of Homer, and he had the plays of the three great tragedians sent to him in Asia, together with dithyrambic poems and the history of Philistus. They were his favourite reading. He admired Aristotle as the leading exponent of Greek intellectual enquiry, and he had a natural yearning (*pothos*) for philosophical discussion and understanding. His mind was to some extent cast in the Aristotelian mould; for he too combined a wide-ranging curiosity with close observation and acute reasoning. His belief in the validity of the Greek outlook of his time was not modified by his acquaintance with Egyptian, Babylonian and Indian ideas. One mark of Greek civilisation was the vitality of the city, both in Europe and in Asia, and Alexander believed that the best way to spread Greek culture and civilisation was by founding cities throughout Asia. At the outset the leaders in these cities were the Macedonians and the Greek mercenary soldiers, who conducted the democratic form of self-government to which they were accustomed. At the same time the future leaders were being educated "in Greek letters and in Macedonian weaponry" in the schools which Alexander established. The process was already well under way

before Alexander died, as we see from a passage in Plutarch's *Moralia:* "When Alexander was civilising Asia, the reading was Homer and the boys (*paides*) of the Persians, Susianians and Gedrosians used to chant the tragedies of Euripides and Sophocles . . . and thanks to him Bactria and Caucasus revered the Greek gods." Egypt has yielded a teaching manual of the late third century, which was designed to teach Greek as a foreign language and included selections from Homer and the tragedians. The excavations at Ai Khanoum in Afghanistan have revealed Greek temples, theatre and odeum (for music) alongside a very large Asian temple in the late fourth century. Alexander was the standard-bearer of Greek civilisation. His influence in education and so in civilisation has been profound, extending even into our own age.

Faith in the orthodox religion of Macedonia was deeply implanted in Alexander's mind. He sacrificed daily, even in his last illness, on behalf of himself and the Macedonians and on innumerable other occasions. He organised traditional festivals in honour of the gods in the most lavish fashion. He believed as literally as Pindar had done in the presence in our world of the Olympian gods, in the labours of heroes such as Heracles and the exploits of Achilles, both being his ancestors. The deities made their wishes or their warnings manifest to men through natural phenomena and through omens and oracles, which were interpreted and delivered by inspired men and women. It was an advantage of polytheism that the number of gods was not limited, and Alexander could see Zeus in the Libyan Ammon and in the Babylonian Belus, and Heracles in the Tyrian Melkart or the Indian Krishna. His special regard for Ammon was probably due to the prophetic oracles which he received at Siwah and which were evidently fulfilled *in toto* when Alexander reached the outer Ocean. He gave thanks time and again to "the usual gods" (the twelve Olympians) for the salvation of himself and his army, and he must have thought that he owed his charmed life to them. Even in his last illness he believed that his prayers in the course of sacrifices would be heard and that he would live. For he died without arranging for the transition of power.

Of the personal qualities of Alexander the brilliance, the range and the quickness of his intellect are remarkable, especially in his conduct of warfare. At Gaugamela and at the Hydaspes he foresaw precisely the sequence of moves by his own units and the compulsion they would place on his enemies. As Ptolemy, himself a most able commander, observed of the first campaign, "the result was as Alexander inferred that it would be," and after the last campaign "not a one of the operations of war which Alexander undertook was beyond his capability" *(aporon)*. In generalship no one has surpassed him. Arrian wrote that Alexander had "the most wonderful power of grasping the right course when the situation was still in obscurity." Thus he knew on his landing in Asia that he must set up his own Kingdom of Asia and obtain the willing cooperation of his subjects. Already at Sardis he began the training of boys who would become soldiers of that kingdom. The orginality of his intellect was apparent in his development of the Indus, the Tigris and the Euphrates as waterways of commerce and his reorganisation of the irrigation of Mesopotamia. The boldness of his calculations was rewarded with success in many engagements and especially in the opening of navigation between the Indus Delta and the Persian Gulf.

His emotions were very strong. His love for his mother was such that one tear of hers would outweigh all the complaints of Antipater. He sent letters and gifts to her constantly, and he said that he would take her alone into his confidence on his return to Macedonia. His loyalty to the friends of his own generation was carried sometimes to a fault, and his passionate grief for Hephaestion [his closest friend from childhood days] was almost beyond reason. He loved his soldiers and they loved him; he and his veterans wept when they parted company; and he and they acknowledged that love in his last moments. When he killed Cleitus [an old-fashioned noble in a drunken brawl], his remorse was desperate. His compassion for the Theban Timoclea and for the family of [Persian ruler] Darius and his love for [wife] Roxane were deeply felt and led to actions which were probably unique in contemporary warfare.

As King of the Macedonians and as King of Asia he had different roles to fill. His way of life was on the same level as that of the Macedonians on campaigns and in leisure. As he said at Opis, his rations were the same as theirs and he shared all their dangers and hardships; and he enjoyed the same festivals and drinking parties as they did. He led them not by fiat but by persuasion, and a crucial element in that persuasion was that he should always tell them the truth, and they should know that he was telling them the truth. Thus he respected the constitutional rights of the Macedonians, and his reward was that he was generally able to convince them in their Assemblies that they should accept his policies. His role as King of Asia was almost the opposite. His court, like that of the Persian King of Kings, was the acme of luxury and extravagance. He gave audience in a huge pavilion which rested on fifty golden columns, and he himself sat on a golden chair, surrounded by so many richly-dressed guardsmen that "no one dared approach him, such was the majesty associated with his person." He accepted obeisance, and he ruled by fiat. The wealth at his command was beyond belief; for he had taken over the accumulated treasure of the Persian monarchy, and he received the fixed tribute which was paid by his subjects over a huge area. His expenditure was extraordinary by Greek standards, for instance on memorials commemorating Hephaestion, but it was in proportion to his wealth as King of Asia. The strength of his personality was such that he was able to keep the two roles separate in his mind and in his behaviour, and Ptolemy and Aristobulus were correct in seeing the real Alexander as Alexander the Macedonian.

Alexander combined his extraordinary practicality with a visionary, spiritual dimension which stemmed from his religious beliefs. As a member of the Temenid house he had a special affinity with his ancestors Heracles and Zeus, and he inherited the obligation to rule in a manner worthy of them and to benefit mankind. His vision went beyond Macedonia and the Greek Community. When he landed on Asian soil, his declaration, "I accept Asia from the gods," and his prayer, that the Asians would accept him willingly as their king, were expressions of a mystical belief that the gods had set him a special task and would enable him to fulfil it. This spiritual dimension in his personality created in him the supreme confidence and the strength of will which overrode the resistance of the Macedonians to his concept of the Kingdom of Asia, and which convinced the Asians of the sincerity of his claim to treat them as

equals and partners in the establishment of peace and prosperity. The power of his personality was all-pervading. It engaged the loyalty of Persian commanders and Indian rulers after defeat in battle and the loyalty of Asian troops at all levels in his service. It inspired *The Alexander Romance* in which Asian peoples adopted Alexander as their own king and incorporated his exploits into their own folk-lore. We owe to Plutarch [Greek writer and historian (45 A.D.–125 A.D.)], drawing probably on the words of Aristobulus, an insight into this spiritual dimension in Alexander.

> Believing that he had come from the gods to be a governor and reconciler of the universe, and using force of arms against those whom he did not bring together by the light of reason, he harnessed all resources to one and the same end, mixing as it were in a loving-cup the lives, manners, marriages and customs of men. He ordered them all to regard the inhabited earth (*oikoumene*) as their fatherland and his armed forces as their stronghold and defence.

Ian Worthington

NO

How "Great" Was Alexander?

Why was Alexander III of Macedon called 'Great'? The answer seems relatively straightforward: from an early age he was an achiever, he conquered territories on a superhuman scale, he established an empire until his times unrivalled, and he died young, at the height of his power. Thus, at the youthful age of 20, in 336, he inherited the powerful empire of Macedon, which by then controlled Greece and had already started to make inroads into Asia. In 334 he invaded Persia, and within a decade he had defeated the Persians, subdued Egypt, and pushed on to Iran, Afghanistan and even India. As well as his vast conquests Alexander is credited with the spread of Greek culture and education in his empire, not to mention being responsible for the physical and cultural formation of the hellenistic kingdoms—some would argue that the hellenistic world was Alexander's legacy. He has also been viewed as a philosophical idealist, striving to create a unity of mankind by his so-called fusion of the races policy, in which he attempted to integrate Persians and Orientals into his administration and army. Thus, within a dozen years Alexander's empire stretched from Greece in the west to India in the far east, and he was even worshipped as a god by many of his subjects while still alive. On the basis of his military conquests contemporary historians, and especially those writing in Roman times, who measured success by the number of body-bags used, deemed him great.

However, does a man deserve to be called 'The Great' who was responsible for the deaths of tens of thousands of his own men and for the unnecessary wholesale slaughter of native peoples? How 'great' is a king who prefers constant warfare over consolidating conquered territories and long-term administration? Or who, through his own recklessness, often endangered his own life and the lives of his men? Or whose violent temper on occasion led him to murder his friends and who towards the end of his life was an alcoholic, paranoid, megalomaniac, who believed in his own divinity? These are questions posed by our standards of today of course, but nevertheless they are legitimate questions given the influence which Alexander has exerted throughout history—an influence which will no doubt continue.

The aims of this [selection] are to trace some reasons for questioning the greatness of Alexander as is reflected in his epithet, and to add potential evidence dealing with the attitude of the Macedonians, Alexander's own people,

in their king's absence. It is important to stress that when evaluating Alexander it is essential to view the 'package' of king as a whole; i.e., as king, commander and statesman. All too often this is not the case. There is no question that Alexander was spectacularly successful in the military field, and had Alexander only been a general his epithet may well have been deserved. But he was not just a general; he was a king too, and hence military exploits form only a percentage of what Alexander did, or did not do—in other words, we must look at the 'package' of him as king as a whole. By its nature this [selection] is impressionistic, and it can only deal rapidly with selected examples from Alexander's reign and discuss points briefly. However, given the unequalled influence Alexander has played in cultures and history from the time of his death to today, it is important to stress that there is a chasm of a difference between the mythical Alexander, which for the most part we have today, and the historical.

Alexander died in 323, and over the course of time the mythical king and his exploits sprang into being. Alexander himself was not above embellishing his own life and achievements. He very likely told the court historian Callisthenes of Olynthus what to say about his victory over Darius III at the battle of Issus in 333, for example. Contemporary Attic oratory also exaggerated his achievements, and so within a generation of his death erroneous stories were already being told.

As time continued we move into the genre of pulp fiction. In the third or second century BC Alexander's exploits formed the plot of the story known as the *Alexander Romance,* which added significantly to the Alexander legend and had such a massive influence on many cultures into the Middle Ages. Given its life-span, deeds were attributed to Alexander which are unhistorical, such as his encounters with the tribe of headless men, his flying exploits in a basket borne by eagles, and the search for the Water of Life, which ended with his transformation into a mermaid. These stories became illustrative fodder for the various manuscripts of the *Alexander Romance*—one of the most popular episodes is Alexander's ascent to heaven, inspired by the myth of Bellerephon to fly to Mount Olympus on Pegasus, which is found in many Byzantine and later art-works, sculptures and paintings. As a result of the *Romance* Alexander astonishingly appears in the literature of other cultures: in Hebrew literature, for example, he was seen as a preacher and prophet, who even becomes converted to Christianity. In Persian literature he is the hero Sikandar, sent to punish the impure peoples. In the West he appears as a Frank, a Goth, a Russian and a Saxon.

Then there is Plutarch, writing in the late first and second century AD, who has probably done the most damage to our knowing the historical Alexander. In his treatise *On The Fortune or The Virtue of Alexander,* Plutarch was swayed (understandably) by the social background against which he was writing and especially by his own philosophical beliefs, and he portrayed Alexander as both an action man and a philosopher-king, whose mission was to impose Greek civilisation on the 'barbarian' Persians. Plutarch's work is essentially a rhetorical exercise, but as time continued the rhetorical aspects were disregarded in favour of a warrior-king who was more than the stuff legends were made of; this was a warrior who was seen to combine military success with wisdom and

unification. And so Alexander emerges as the promoter of the brotherhood of man in Tarn's 1948 biography, which was greatly influenced by what Plutarch wrote.

The Alexander legend was a ready feeding ground for artists throughout the centuries as well. When Alexander invaded Persia in 334 he detoured to Troy to sacrifice at the tomb of his hero Achilles. This was a stirring story, which became a model for heroic piety in the Renaissance and later periods; thus, for example, we have Fontebasso's painting of Alexander's sacrifice at Achilles' tomb in the eighteenth century. In modern Greece Alexander became both an art-work and a symbol, as seen in the painting by Engonopoulos in 1977 of the face-less Alexander standing with his arm around the face-less Pavlos Melas, a modern hero of the struggle for Macedonian independence.

Thus, we can see how the historical Alexander has faded into the invincible general, the great leader, explorer and king, as time continued, especially in the Middle Ages with its world of chivalry, warriors and great battles: a superb context into which to fit Alexander, even if this meant distortion of the truth, and history subsumed to legend. Indeed, during the Middle Ages he was regarded as one of the four great kings of the ancient world. Let us now consider some specific aspects of Alexander's reign in support of this.

<center>⋅⊙⋅</center>

In 334 Alexander III left home for Asia, entrusting to Antipater as guardian . . . a stable—for a while—Greece and Macedon. The king also unilaterally made Antipater deputy hegemon in the League of Corinth. Alexander's 'mandate' or prime directive, as inherited from his father Philip II and endorsed by the League of Corinth, was to pursue his father's plan of punishing the Persians for their sacrilegious acts of 150 years ago and to 'liberate' (whatever that meant) the Greek cities of Asia Minor. In other words, a panhellenic mandate. After he had fulfilled it, people quite rightly would have expected him to return home. People were wrong: the king would soon disregard the prime directive for personal reasons, causing discontent amongst the army with him and also, even more ominously, with his countrymen back home.

We have a fair amount of information for events in mainland Greece, especially Athens, during the reign of Alexander, however events in Macedon in this period are undocumented and largely unknown. We certainly cannot say that there was a hiatus in Macedonian history, for Antipater kept Macedon powerful and united while Alexander was absent, so much so that there was economic growth, and education and military training, for example, remained at a high standard. However, appearance is not likely to reflect reality. Macedon in this period may well have been fraught with discontent, and it provides insights into the Macedonians' attitude to their king and he to them. At the same time a consideration of the Macedonian background also lends further weight to questioning the aptness of Alexander's title 'Great'.

Alexander's military successes throughout his reign were spectacular to a very large degree—and certainly manufactured by the king to be great—and we should expect his people back home to feel proud of their king at the head

of his panhellenic mission of punishment and liberation, and to proclaim his victories to all and sundry. His deeds and the geographical extent of his conquests were certainly known for we have references to them in contemporary Attic oratory. However, the impression which strikes us about the Macedonians themselves is that Alexander was far from their idea of an ideal king. Why might they feel this way? In addressing this, we can begin with the vexed question of Macedonian manpower. Did Alexander's demands for reinforcements from the mainland seriously deplete the fighting strength of the army under Antipater? Did he make these demands regardless of the pressure under which he was putting Antipater and without regard for the lives of his people and the security of his kingdom from external threat? And if so, how did the people feel and how did they react? . . .

Alexander's generalship and actual military victories may be questioned in several key areas. For example, after the battle of Issus in 333 Darius fled towards Media, but Alexander pressed on to Egypt. He did not pursue Darius, as he surely ought to have done and thus consolidate his gains, especially when so far from home and with the mood of the locals so prone to fluctuation, but left him alone. He was more interested in what lay to the south: the riches of Babylon and then Susa, or as Arrian describes them the 'prizes of the war'. However, a war can hardly be seen as won if the opposing king and commander remains at large and has the potential to regroup. Alexander's action was lucky for Darius, then, as he was able to regroup his forces and bring Alexander to battle again almost two years later, at Gaugamela (331). It was not lucky for Alexander, though, and especially so for those men on both sides who fell needlessly that day in yet another battle.

We have also the various sieges which Alexander undertook and which were often lengthy, costly, and questionable. A case in point is that of Tyre in 332 as Alexander made his way to Egypt after his victory at Issus. In Phoenicia Byblos and Sidon surrendered to Alexander, as did the island town (as it was then) of Tyre until the king expressed his personal desire to sacrifice in the main temple there. Quite rightly considering his demand sacrilegious, the Tyrians resisted him and Alexander, his ego affronted and refusing to back down, laid siege to the town. The siege itself lasted several months, cost the king a fortune in money and manpower, and resulted in the slaughter of the male Tyrians and the selling of the Tyrian women and children into slavery. There is no question that control of Tyre was essential since Alexander could not afford a revolt of the Phoenician cities, given their traditional rivalries, as he pushed on to Egypt. Nor indeed, if we believe his speech at Arrian, could he allow Tyre independence with the Persian navy a threat and the Phoenician fleet the strongest contingent in it. However, there was no guarantee that the destruction of Tyre would result in the Phoencian fleet surrendering to him as he only seems to have *expected* it would. Moreover, laying siege to Tyre was not necessary: he could simply have left a garrison, for example, on the mainland opposite the town to keep it in check. Another option, given that the Tyrians had originally surrendered to him, would have been the diplomatic one: to recognise the impiety of his demand in their eyes and thus relinquish it, thereby continuing on his way speedily and with their goodwill. Ultimately no real gain came from his siege

except to Alexander on a purely personal level again: his damaged ego had been repaired; the cost in time, manpower and reputation mattered little.

Alexander's great military victories over his Persian and Indian foes which have so long occupied a place in popular folklore and been much admired throughout the centuries are very likely to have been embellished and nothing like the popular conceptions of them. A case in point is the battle of Issus in 333. Darius threw victory away at that battle and he was, to put it bluntly, a mediocre commander—the battle might have been very different if Alexander had faced a more competent commander such as Memnon, for example. Alexander was lucky, but this does not come in the 'official' account we have of the battle, probably since he told Callisthenes, the court historian, what to write about it.

...[W]ord would filter through to the Macedonians back home. Alexander's growing orientalism, as seen in his apparent integration of foreigners into his administration and army, was a cause of great discontent as the traditional Macedonian warrior-king transformed himself into something akin to a sultan. He began to change his appearance, preferring a mixture of Persian and Macedonian clothing, despite the obvious displeasure of his troops, and he had also assumed the upright tiara, the symbol of Persian kingship. Some saw the writing on the wall and duly pandered to the king. Thus, Peucestas, the Macedonian satrap of Persis, was well rewarded by the king for adopting Persian dress and learning the Persian language. However, he was the only Macedonian to do so according to Arrian.

Significant also was Alexander's attempt to adopt the Persian custom of *proskynesis*—genuflection—at his court in Bactra in 327, and his expectation that his men would follow suit. *Proskynesis* was a social act which had long been practised by the Persians and involved prostrating oneself before the person of the king in an act of subservience, and thereby accepting his lordship. The custom however was regarded as tantamount to worship and thus sacrilegious to the Greeks—worship of a god or a dead hero was one thing, but worship of a person while still alive quite another. Callisthenes thwarted Alexander's attempt, something which the king never forgot and which would soon cost Callisthenes his life in sadistic circumstances.

Why Alexander tried to introduce *proskynesis* is unknown. Perhaps he was simply attempting to create a form of social protocol common to Macedonians, Greeks and Persians. However, he would have been well aware of the religious connotations associated with the act and hence its implications for his own being. It was plain stupidity on his part if he thought his men would embrace the custom with relish, and his action clearly shows that he had lost touch with his army and the religious beliefs on which he had been raised. Evidence for this may be seen in the motives for the Pages' Conspiracy, a serious attempt on Alexander's life, which occurred not long after Alexander tried to enforce *proskynesis* on all. A more likely explanation for the attempt to introduce *proskynesis* is that Alexander now thought of himself as divine, and thus *proskynesis* was a logical means of recognising his divine status in public by all men.

Indeed, Alexander's belief that he was divine impacts adversely on any evaluation of him. History is riddled with megalomaniacs who along the way

suffered from divine pretensions, and the epithet 'Great' is not attached to them. Regardless of whether his father Philip II was worshipped as a god on his death, Alexander seems not to have been content with merely following in his footsteps but to believe in his own divine status while alive....

Was Alexander using his own people for his own personal ends now? Philip II risked the lives of his men as well, but for his state's hegemonic position in international affairs, not for his own selfish reasons or a *pothos* which might well jeopardise that position of Macedon. Others saw the danger, even from early in his reign. Thus in 335, after the successful termination of the Greek revolt, which broke out on the death of Philip II, Diodorus says that Parmenion and Antipater urged Alexander not to become actively involved in Asia until he had produced a son and heir. Alexander opposed them for personal reasons: he could not procrastinate at home waiting for children to be born when the invasion of Asia had been endorsed by the League of Corinth! In the end, says Diodorus, he won them over. Then in 331 Darius III offered *inter alia* to abandon to Alexander all territories west of the Euphrates and to become the friend and ally of the king. Parmenion thought the Persian king's offer to be in the Macedonians' best interests, but Alexander refused to accept it (in a famous exchange in which Parmenion is alleged to have said that if he were Alexander he would accept the terms, and a displeased Alexander is alleged to have replied that if he were Parmenion he would, but instead he was Alexander)....

Alexander's autocratic nature and its adverse impact on his army have been illustrated many times, but it extended beyond the men with him to the Greeks back on the mainland. One example is his Exiles Decree of 324, which ordered all exiles to return to their native cities (excluding those under a religious curse and the Thebans). If any city was unwilling, then Antipater was empowered to use force against it. The context was no doubt to send home the large bands of mercenaries now wandering the empire and which posed no small military or political danger if any ambitious satrap [subordinate official] or general got his hands on them. The decree was technically illegal since it clearly flouted the autonomy of the Greek states, not to mention the principles of the League of Corinth, but Alexander cared little about *polis* autonomy or the feelings of the Greeks. Although the Athenians refused to receive back their exiles, resistance, to coin a phrase, was futile: Alexander was king, the Macedonians controlled Greece, and the final clause of the decree on coercing Greek cities would not be lost on them. The flurry of diplomatic activity to the king over the decree proves this, even though outright rebellion was not planned at that stage. His death altered the situation dramatically, and only one state, Tegea, actually implemented the decree.

There is no need to deal in great detail with the notion which originates in Plutarch's treatise on Alexander, and has found its way into some modern works (such as Tarn's biography), that Alexander pursued an actual policy to promote a unity of mankind. In other words, that Alexander is deserving of the title 'Great' for these ideological reasons. The belief is 'founded' on such factors as his integration of foreigners into his army and administration, the mass mixed marriage at Susa (324), and Alexander's prayer for concord amongst the races after the Opis mutiny (also 324). The belief is quite erroneous, and

Alexander, as with everything else, was acting for purely political/military, not ideological, purposes. For one thing, it is important to note that in the army foreigners were not peppered consistently amongst existing units, and when this did happen the instances are very few and far between. Thus, a few Persians are found incorporated in the *agema* [the Royal squadron] of the Companion cavalry, and Persians and Macedonians served together in a phalanx at Babylon, but Alexander's motive in both cases was military.

While Alexander did use Persians and Orientals in his administration it was always Macedonians and Greeks who controlled the army and the treasury. For example, at Babylon Alexander appointed as satrap the Persian Mazaeus, who had been satrap of Syria under Darius and commander of the Persian right at the battle of Gaugamela. However, Apollodorus of Amphipolis and Agathon of Pydna controlled the garrison there and collected the taxes. In a nutshell, the natives had the local knowledge and the linguistic expertise. The conscious policy on the part of Alexander was to have the different races working together in order to make the local administration function as efficiently as possible, and had nothing to do with promoting racial equality.

Then there is the mass wedding at Susa, also in 324, at which Alexander and 91 members of his court married various Persian noble women in an elaborate wedding ceremony (conducted in Persian fashion too), which lasted for five days. The symbolism as far as a fusion of the races is concerned is obvious, but again too much has been made of this marriage: it is important to note that no Persian men were given honours at Alexander's court or in his military and administrative machinery. Moreover, no Macedonian or Greek women were brought out from the mainland to marry Persian noble men, which we would expect as part of a fusion 'policy'. A closer explanation to the truth is probably that Alexander could not afford these noble women to marry their own races and thus provide the potential for revolt, something mixed marriages with his own court might offset. That the marriages were forced onto his men is proved by the fact that all apart from Seleucus seem to have divorced their wives upon the king's death. Once again, however, Alexander seems to have ignored the displeasure of his men, ultimately at great cost to himself and his empire.

Finally, the great reconciliation banquet at Opis in 324 (after the second mutiny), in which Macedonian, Greek, Persian and Iranian sipped from the same cup, and Alexander significantly 'prayed for various blessings and especially that the Macedonians and Persians should enjoy harmony as partners in the government'. Yet, *inter alia* it is important to remember that Alexander had played on the hatred between the Macedonians and the Persians in ending the mutiny, and that the Macedonians were seated closest to him at the banquet, thereby emphasising their racial superiority and power. Moreover, we would expect a prayer to future concord after such a reconciliation since dissension in the ranks was the last thing Alexander needed given his plans for future conquest, which involved the invasion of Arabia in the near future! Thus, we may reject the notion of a 'brotherhood of mankind', and divorce it from any objective evaluation of Alexander.

In conclusion, the 'greatness' of Alexander III must be questioned, and the historical Alexander divorced from the mythical, despite the cost to the legend.

There is no question that Alexander was the most powerful individual of his time, and we must recognise that. For sheer distance covered, places subdued, battle strategy, and breadth of vision he deserves praise. In just a decade he conquered the vast Persian empire that had been around for two centuries, and he amassed a fortune so vast that it is virtually impossible to comprehend. Alexander also improved the economy of his state (to an extent) and encouraged trade and commerce, especially by breaking down previously existing frontiers (of major importance in the hellenistic period), and an offshoot of his conquests was the gathering of information on the topography and geography of the regions to which he went, as well as new and exotic flora and fauna. However, at what cost? Was the wastage in human lives, the incalculable damage to foreign peoples, institutions, livelihoods, and lands, not to mention the continuation of the dynasty at home, the security of Macedon, the future of the empire, and the loyalty of the army worth it?

That Alexander did not endear himself to his own people and that they grew discontented with him, has significant implications for his ultimate objectives and how he saw himself. The move to establish a kingdom of Asia with a capital probably at Babylon is significant. Given his disregard of the feelings of his own people (as evidenced by his lack of interest in producing a legal and above-age heir to continue the dynasty and hegemonic position of Macedon), we can only surmise that his belief in his own divinity and his attempts to be recognised as a god while alive—including the attempt at *proskynesis*—are the keys to his actions and motives. As Fredricksmeyer has so persuasively argued, Alexander was out to distance himself as far as possible from the exploits and reputation of Philip II since his attitude to his father had turned from one of admiration and rivalry, from one warrior to another, to resentment. He strove to excel him at all costs and he could not handle praise of Philip. . . . Military conquest was one thing, but simple conquest was not enough: Alexander had to outdo Philip in other areas. Deification while alive was the most obvious way. Everything else became subordinated to Alexander's drive towards self-deification and then his eventual and genuine total belief in it.

Therefore, it is easy to see, on the one hand, why Alexander has been viewed as great, but also, on the other hand, why that greatness—and thus his epithet—must be questioned in the interests of historical accuracy.

POSTSCRIPT

Does Alexander the Great Merit His Exalted Historical Reputation?

Someone once stated, "Pity the nation that has no heroes!" Someone else wryly replied, "Pity the nation that needs them!" To what extent have national desires created the aura of Alexander the Great? How many historical figures were so inspired by his story that they sought to emulate it? And what were the results of such actions? Military historian John Keegan, in *The Mask of Command* (Jonathan Cape, 1987), contends that Alexander's "dreadful legacy was to ennoble savagery in the name of glory and to leave a model of command that far too many men of ambition sought to act out in the centuries to come." But should Alexander be held responsible for the actions of those who have attempted to emulate him?

Also contributing to future analyses of Alexander might be a reaction against the experiences of many in what was the most violent century in the history of the world. The twentieth century saw two world wars and countless smaller ones. Words such as *Holocaust* and *genocide* were created to describe some of the century's barbarities. It saw the names of Hitler, Stalin, and Mao Zedong become infamous for the millions of deaths they have caused, many in their own countries. Noted Holocaust historian Yehuda Bauer sums up the world's propensity for violence and war—and its consequences—in *Rethinking the Holocaust* (Yale University Press, 2001), pp. 40, "Napoleon. . . won the Battle of Austerlitz—but was he there alone? Was he not helped a little bit by a few tens of thousands of soldiers whom he (and others) led into battle? How many soldiers were killed on both sides? . . . And what about the civilians near the roads that the armies traveled on? What about the dead, the wounded, the raped, and the dispossessed? We teach our children about the greatness of the various Napoleons, Palmerstons, and Bismarcks as political or military leaders and thus sanitize history." Should Alexander's name be added to this list?

As one can imagine, the number of books about Alexander are numerous. The late Ulrich Wilcken's classic biography, *Alexander the Great,* first published in 1931, has been reissued in 1997 (W. W. Norton). It contains an insightful chapter entitled, "Introduction to Alexander Studies" by Eugene N. Borza of Pennsylvania State University. Other Alexander biographies that are worth reading are A. B. Bosworth, *Conquest and Empire: The Reign of Alexander the Great* (Cambridge University Press, 1993) and Peter Green, *Alexander of Macedon: A Historical Biography* (University of California Press, 1991). Michael Wood's *In the Footsteps of Alexander the Great* (University of California Press, 1997) is a recent book/television series that is worth recommending.

ISSUE 6

Did Christianity Liberate Women?

YES: Karen L. King, from "Women in Ancient Christianity: The New Discoveries," a Report From *FRONTLINE* (April 6, 1998)

NO: Karen Armstrong, from *The Gospel According to Woman: Christianity's Creation of the Sex War in the West* (Anchor Press, 1987)

ISSUE SUMMARY

YES: Professor of New Testament studies and the history of ancient Christianity Karen L. King presents evidence from biblical and other recently discovered ancient texts to illuminate women's active participation in early Christianity—as disciples, apostles, prophets, preachers, and teachers.

NO: Professor of religious studies Karen Armstrong finds in the early Christian Church examples of hostility toward women and fear of their sexual power, which she contends led to the eventual exclusion of women from full participation in a male-dominated church.

Have women been excluded from leadership roles in the Christian Church from the beginning? The ordination of women as ministers and priests during the twentieth century gives the impression that new ground is being broken by women who seek to lead congregations. Some believe that these women are carrying the movement for women's liberation in civil society inappropriately into churches and defying a two-thousand-year tradition that has properly excluded them. Radical, however, means "from the roots," and a return to ancient sources may link modern assertions with ancient practices.

It is deeply challenging to our modern notions of progress to think that, even by present standards, women may have been more "liberated" two thousand years ago than they are today. Our greatest challenge might come from trying to imagine how early Christian women regarded their own status in what was frequently called the Jesus movement. Did they feel liberated from the more patriarchal world of first-century Palestinian Judaism and Hellenistic paganism? And, regardless of how they felt, does our assessment of their status merit stating that Christianity liberated them?

Before the Christian Church became institutionalized and before a theology was clearly defined, early converts acted out of intense personal conviction and met informally to share their faith. Most churches were based in people's homes and some state that it was this private dimension that made women's leadership possible. Gender conventions of the time declared the public sphere male and confined the woman's sphere of influence to the home. An outcast sect because its followers refused to worship the emperor, Christianity remained an underground religion until the early fourth century when Constantine, the Roman emperor, forbade government persecution and, eventually, made Christianity the state religion.

Missionaries converted many Greeks to Christianity, resulting in more Gentile, or non-Jewish, Christians than Jewish Christians by the third century. The Greek-speaking world, where many of the women in these selections lived, was the first to accept Christianity in large numbers. If Christian women in both Jewish and Gentile environments during the early centuries enjoyed equality with men, what happened to create the climate of misogyny, or hatred of women, during later centuries?

In the sixth century a Christian Church Council actually debated whether or not women had souls. The question seemed to be whether women were made in the image and likeness of God, as men were, or merely in the image and not in the likeness. Women are still barred from the Roman Catholic priesthood, primarily using a theological argument introduced by Saint Thomas Aquinas in the thirteenth century. He stated that women are inferior by nature and incapable of assuming leadership positions. If only males can "image" God to their congregations, women must be barred from the priesthood.

Karen L. King is widely regarded as a leading authority on women in ancient Christianity. Using both the scrolls included in the Bible and newly-discovered texts from the same period, she reconstructs the enthusiastic and welcome participation of women in every aspect of the early Christian Church. Once Christianity moved from house churches to public meeting places and became the state religion of the Roman Empire, however, women's roles were restricted in a bid for legitimacy and in conformity with prevailing gender conventions.

Karen Armstrong focuses on negative cultural attitudes toward women. She begins the chapter from which the following selection is taken by quoting modern feminist Germaine Greer, "Women have very little idea of how much men hate them." She finds our modern culture uncomfortable with sex and traces the roots of hostility between men and women to the early days of Western Christianity. The Eastern (primarily Russian and Greek Orthodox) Christian Church, which split with the Western Church in an act of mutual excommunication in 1054, is judged by Armstrong as less misogynistic.

Karen L. King

 YES

Women in Ancient Christianity: The New Discoveries

In the last twenty years, the history of women in ancient Christianity has been almost completely revised. As women historians entered the field in record numbers, they brought with them new questions, developed new methods, and sought for evidence of women's presence in neglected texts and exciting new findings. For example, only a few names of women were widely known: Mary, the mother of Jesus; Mary Magdalene, his disciple and the first witness to the resurrection; Mary and Martha, the sisters who offered him hospitality in Bethany. Now we are learning more of the many women who contributed to the formation of Christianity in its earliest years.

Perhaps most surprising, however, is that the stories of women we thought we knew well are changing in dramatic ways. Chief among these is Mary Magdalene, a woman infamous in Western Christianity as an adulteress and repentant whore. Discoveries of new texts from the dry sands of Egypt, along with sharpened critical insight, have now proven that this portrait of Mary is entirely inaccurate. She was indeed an influential figure, but as a prominent disciple and leader of one wing of the early Christian movement that promoted women's leadership.

⚜

Certainly, the New Testament Gospels, written toward the last quarter of the first century CE [Christian Era], acknowledge that women were among Jesus' earliest followers. From the beginning, Jewish women disciples, including Mary Magdalene, Joanna, and Susanna, had accompanied Jesus during his ministry and supported him out of their private means (Luke 8:1–3). He spoke to women both in public and private, and indeed he learned from them. According to one story, an unnamed Gentile woman taught Jesus that the ministry of God is not limited to particular groups and persons, but belongs to all who have faith (Mark 7:24–30; Matthew 15:21–28). A Jewish woman honored him with the extraordinary hospitality of washing his feet with perfume. Jesus was a frequent visitor at the home of Mary and Martha, and was in the habit of teaching and eating meals with women as well as men. When Jesus was arrested, women

From Karen L. King, "Women in Ancient Christianity: The New Discoveries," a Report From *FRONT-LINE* (April 6, 1998), From Jesus to Christ: The First Christians. Copyright © 1998 by PBS and WGBH/FRONTLINE. Reprinted by permission of WGBH. http://www.pbs.org/wgbh/pages/frontline/shows/religion.

remained firm, even when his male disciples are said to have fled, and they accompanied him to the foot of the cross. It was women who were reported as the first witnesses to the resurrection, chief among them again Mary Magdalene. Although the details of these gospel stories may be questioned, in general they reflect the prominent historical roles women played in Jesus' ministry as disciples.

Women in the First Century of Christianity

After the death of Jesus, women continued to play prominent roles in the early movement. Some scholars have even suggested that the majority of Christians in the first century may have been women.

The letters of Paul—dated to the middle of the first century CE—and his casual greetings to acquaintances offer fascinating and solid information about many Jewish and Gentile women who were prominent in the movement. His letters provide vivid clues about the kind of activities in which women engaged more generally. He greets Prisca, Junia, Julia, and Nereus' sister, who worked and traveled as missionaries in pairs with their husbands or brothers (Romans 16:3, 7, 15). He tells us that Prisca and her husband risked their lives to save his. He praises Junia as a prominent apostle, who had been imprisoned for her labor. Mary and Persis are commended for their hard work (Romans 16:6, 12). Euodia and Syntyche are called his fellow-workers in the gospel (Philippians 4:2–3). Here is clear evidence of women apostles active in the earliest work of spreading the Christian message.

Paul's letters also offer some important glimpses into the inner workings of ancient Christian churches. These groups did not own church buildings but met in homes, no doubt due in part to the fact that Christianity was not legal in the Roman world of its day and in part because of the enormous expense to such fledgling societies. Such homes were a domain in which women played key roles. It is not surprising then to see women taking leadership roles in house churches. Paul tells of women who were the leaders of such house churches (Apphia in Philemon 2; Prisca in I Corinthians 16:19). This practice is confirmed by other texts that also mention women who headed churches in their homes, such as Lydia of Thyatira (Acts 16:15) and Nympha of Laodicea (Colossians 4:15). Women held offices and played significant roles in group worship. Paul, for example, greets a deacon named Phoebe (Romans 16:1) and assumes that women are praying and prophesying during worship (I Corinthians 11). As prophets, women's roles would have included not only ecstatic public speech, but preaching, teaching, leading prayer, and perhaps even performing the eucharist meal. (A later first century work, called the Didache, assumes that this duty fell regularly to Christian prophets.)

Mary Magdalene: A Truer Portrait

Later texts support these early portraits of women, both in exemplifying their prominence and confirming their leadership roles (Acts 17:4, 12). Certainly the most prominent among these in the ancient church was Mary Magdalene. A

series of spectacular 19th and 20th century discoveries of Christian texts in Egypt dating to the second and third century have yielded a treasury of new information. It was already known from the New Testament gospels that Mary was a Jewish woman who followed Jesus of Nazareth. Apparently of independent means, she accompanied Jesus during his ministry and supported him out of her own resources (Mark 15:40–41; Matthew 27:55–56; Luke 8:1–3; John 19:25).

Although other information about her is more fantastic, she is repeatedly portrayed as a visionary and leader of the early movement.(Mark 16:1–9; Matthew 28:1–10; Luke 24:1–10; John 20:1, 11–18; Gospel of Peter). In the Gospel of John, the risen Jesus gives her special teaching and commissions her as an apostle to the apostles to bring them the good news. She obeys and is thus the first to announce the resurrection and to play the role of an apostle, although the term is not specifically used of her. Later tradition, however, will herald her as "the apostle to the apostles." The strength of this literary tradition makes it possible to suggest that historically Mary was a prophetic visionary and leader within one sector of the early Christian movement after the death of Jesus.

The newly discovered Egyptian writings elaborate this portrait of Mary as a favored disciple. Her role as "apostle to the apostles" is frequently explored, especially in considering her faith in contrast to that of the male disciples who refuse to believe her testimony. She is most often portrayed in texts that claim to record dialogues of Jesus with his disciples, both before and after the resurrection. In the Dialogue of the Savior, for example, Mary is named along with Judas (Thomas) and Matthew in the course of an extended dialogue with Jesus. During the discussion, Mary addresses several questions to the Savior as a representative of the disciples as a group. She thus appears as a prominent member of the disciple group and is the only woman named. Moreover, in response to a particularly insightful question, the Lord says of her, "You make clear the abundance of the revealer!" (140.17–19). At another point, after Mary has spoken, the narrator states, "She uttered this as a woman who had understood completely"(139.11–13). These affirmations make it clear that Mary is to be counted among the disciples who fully comprehended the Lord's teaching (142.11–13).

In another text, the Sophia of Jesus Christ, Mary also plays a clear role among those whom Jesus teaches. She is one of the seven women and twelve men gathered to hear the Savior after the resurrection, but before his ascension. Of these only five are named and speak, including Mary. At the end of his discourse, he tells them, "I have given you authority over all things as children of light," and they go forth in joy to preach the gospel. Here again Mary is included among those special disciples to whom Jesus entrusted his most elevated teaching, and she takes a role in the preaching of the gospel.

In the Gospel of Philip, Mary Magdalene is mentioned as one of three Marys "who always walked with the Lord" and as his companion (59.6–11). The work also says that Lord loved her more than all the disciples, and used to kiss her often (63.34–36). The importance of this portrayal is that yet again the work affirms the special relationship of Mary Magdalene to Jesus based on her spiritual perfection.

In the Pistis Sophia, Mary again is preeminent among the disciples, especially in the first three of the four books. She asks more questions than all the rest of the disciples together, and the Savior acknowledges that: "Your heart is directed to the Kingdom of Heaven more than all your brothers" (26:17–20). Indeed, Mary steps in when the other disciples are despairing in order to intercede for them to the Savior (218:10–219:2). Her complete spiritual comprehension is repeatedly stressed.

She is, however, most prominent in the early second century Gospel of Mary, which is ascribed pseudonymously to her. More than any other early Christian text, the Gospel of Mary presents an unflinchingly favorable portrait of Mary Magdalene as a woman leader among the disciples. The Lord himself says she is blessed for not wavering when he appears to her in a vision. When all the other disciples are weeping and frightened, she alone remains steadfast in her faith because she has grasped and appropriated the salvation offered in Jesus' teachings. Mary models the ideal disciple: she steps into the role of the Savior at his departure, comforts, and instructs the other disciples. Peter asks her to tell any words of the Savior which she might know but that the other disciples have not heard. His request acknowledges that Mary was preeminent among women in Jesus' esteem, and the question itself suggests that Jesus gave her private instruction. Mary agrees and gives an account of "secret" teaching she received from the Lord in a vision. The vision is given in the form of a dialogue between the Lord and Mary; it is an extensive account that takes up seven out of the eighteen pages of the work. At the conclusion of the work, Levi confirms that indeed the Saviour loved her more than the rest of the disciples (18.14–15). While her teachings do not go unchallenged, in the end the Gospel of Mary affirms both the truth of her teachings and her authority to teach the male disciples. She is portrayed as a prophetic visionary and as a leader among the disciples.

Other Christian Women

Other women appear in later literature as well. One of the most famous woman apostles was Thecla, a virgin-martyr converted by Paul. She cut her hair, donned men's clothing, and took up the duties of a missionary apostle. Threatened with rape, prostitution, and twice put in the ring as a martyr, she persevered in her faith and her chastity. Her lively and somewhat fabulous story is recorded in the second century Acts of Thecla. From very early, an order of women who were widows served formal roles of ministry in some churches (I Timothy 5:9–10). The most numerous clear cases of women's leadership, however, are offered by prophets: Mary Magdalene, the Corinthian women, Philip's daughters, Ammia of Philadelphia, Philumene, the visionary martyr Perpetua, Maximilla, Priscilla (Prisca), and Quintilla. There were many others whose names are lost to us. The African church father Tertullian, for example, describes an unnamed woman prophet in his congregation who not only had ecstatic visions during church services, but who also served as a counselor and healer (On the Soul 9.4). A remarkable collection of oracles from another unnamed woman prophet was discovered in Egypt in 1945. She speaks in the first person as the feminine

voice of God: Thunder, Perfect Mind. The prophets Prisca and Quintilla inspired a Christian movement in second century Asia Minor (called the New Prophecy or Montanism) that spread around the Mediterranean and lasted for at least four centuries. Their oracles were collected and published, including the account of a vision in which Christ appeared to the prophet in the form of a woman and "put wisdom" in her (Epiphanius, Panarion 49.1). Montanist Christians ordained women as presbyters and bishops, and women held the title of prophet. The third century African bishop Cyprian also tells of an ecstatic woman prophet from Asia Minor who celebrated the eucharist and performed baptisms (Epistle 74.10). In the early second century, the Roman governor Pliny tells of two slave women he tortured who were deacons (Letter to Trajan 10.96). Other women were ordained as priests in fifth century Italy and Sicily (Gelasius, Epistle 14.26).

Women were also prominent as martyrs and suffered violently from torture and painful execution by wild animals and paid gladiators. In fact, the earliest writing definitely by a woman is the prison diary of Perpetua, a relatively wealthy matron and nursing mother who was put to death in Carthage at the beginning of the third century on the charge of being a Christian. In it, she records her testimony before the local Roman ruler and her defiance of her father's pleas that she recant. She tells of the support and fellowship among the confessors in prison, including other women. But above all, she records her prophetic visions. Through them, she was not merely reconciled passively to her fate, but claimed the power to define the meaning of her own death. In a situation where Romans sought to use their violence against her body as a witness to their power and justice, and where the Christian editor of her story sought to turn her death into a witness to the truth of Christianity, her own writing lets us see the human being caught up in these political struggles. She actively relinquishes her female roles as mother, daughter, and sister in favor of defining her identity solely in spiritual terms. However horrifying or heroic her behavior may seem, her brief diary offers an intimate look at one early Christian woman's spiritual journey.

Early Christian Women's Theology

Study of works by and about women is making it possible to begin to reconstruct some of the theological views of early Christian women. Although they are a diverse group, certain reoccurring elements appear to be common to women's theology-making. By placing the teaching of the Gospel of Mary side-by-side with the theology of the Corinthian women prophets, the Montanist women's oracles, Thunder Perfect Mind, and Perpetua's prison diary, it is possible to discern shared views about teaching and practice that may exemplify some of the contents of women's theology:

- Jesus was understood primarily as a teacher and mediator of wisdom rather than as ruler and judge.

- Theological reflection centered on the experience of the person of the risen Christ more than the crucified savior. Interestingly enough, this is true even in the case of the martyr Perpetua. One might expect her to identify with the suffering Christ, but it is the risen Christ she encounters in her vision.
- Direct access to God is possible for all through receiving the Spirit.
- In Christian community, the unity, power, and perfection of the Spirit are present now, not just in some future time.
- Those who are more spiritually advanced give what they have freely to all without claim to a fixed, hierarchical ordering of power.
- An ethics of freedom and spiritual development is emphasized over an ethics of order and control.
- A woman's identity and spirituality could be developed apart from her roles as wife and mother (or slave), whether she actually withdrew from those roles or not. Gender is itself contested as a "natural" category in the face of the power of God's Spirit at work in the community and the world. This meant that potentially women (and men) could exercise leadership on the basis of spiritual achievement apart from gender status and without conformity to established social gender roles.
- Overcoming social injustice and human suffering are seen to be integral to spiritual life.

Women were also actively engaged in reinterpreting the texts of their tradition. For example, another new text, the Hypostasis of the Archons, contains a retelling of the Genesis story ascribed to Eve's daughter Norea, in which her mother Eve appears as the instructor of Adam and his healer.

The new texts also contain an unexpected wealth of Christian imagination of the divine as feminine. The long version of the Apocryphon of John, for example, concludes with a hymn about the descent of divine Wisdom, a feminine figure here called the Pronoia of God. She enters into the lower world and the body in order to awaken the innermost spiritual being of the soul to the truth of its power and freedom, to awaken the spiritual power it needs to escape the counterfeit powers that enslave the soul in ignorance, poverty, and the drunken sleep of spiritual deadness, and to overcome illegitimate political and sexual domination. The oracle collection Thunder Perfect Mind also adds crucial evidence to women's prophetic theology-making. This prophet speaks powerfully to women, emphasizing the presence of women in her audience and insisting upon their identity with the feminine voice of the Divine. Her speech lets the hearers transverse the distance between political exploitation and empowerment, between the experience of degradation and the knowledge of infinite self-worth, between despair and peace. It overcomes the fragmentation of the self by naming it, cherishing it, insisting upon the multiplicity of self-hood and experience.

These elements may not be unique to women's religious thought or always result in women's leadership, but as a constellation they point toward one type of theologizing that was meaningful to some early Christian women, that had a

place for women's legitimate exercise of leadership, and to whose construction women contributed. If we look to these elements, we are able to discern important contributions of women to early Christian theology and praxis. These elements also provide an important location for discussing some aspects of early Christian women's spiritual lives: their exercise of leadership, their ideals, their attraction to Christianity, and what gave meaning to their self-identity as Christians.

Undermining Women's Prominence

Women's prominence did not, however, go unchallenged. Every variety of ancient Christianity that advocated the legitimacy of women's leadership was eventually declared heretical, and evidence of women's early leadership roles was erased or suppressed.

This erasure has taken many forms. Collections of prophetic oracles were destroyed. Texts were changed. For example, at least one woman's place in history was obscured by turning her into a man! In Romans 16:7, the apostle Paul sends greetings to a woman named Junia. He says of her and her male partner Andronicus that they are "my kin and my fellow prisoners, prominent among the apostles and they were in Christ before me." Concluding that women could not be apostles, textual editors and translators transformed Junia into Junias, a man.

Or women's stories could be rewritten and alternative traditions could be invented. In the case of Mary Magdalene, starting in the fourth century, Christian theologians in the Latin West associated Mary Magdalene with the unnamed sinner who anointed Jesus' feet in Luke 7:36–50. The confusion began by conflating the account in John 12:1–8, in which Mary (of Bethany) anoints Jesus, with the anointing by the unnamed woman sinner in the accounts of Luke. Once this initial, erroneous identification was secured, Mary Magdalene could be associated with every unnamed sinful woman in the gospels, including the adulteress in John 8:1–11 and the Syro-phoenician woman with her five and more "husbands" in John 4:7–30. Mary the apostle, prophet, and teacher had become Mary the repentant whore. This fiction was invented at least in part to undermine her influence and with it the appeal to her apostolic authority to support women in roles of leadership.

Until recently the texts that survived have shown only the side that won. The new texts are therefore crucial in constructing a fuller and more accurate portrait. The Gospel of Mary, for example, argued that leadership should be based on spiritual maturity, regardless of whether one is male or female. This Gospel lets us hear an alternative voice to the one dominant in canonized works like I Timothy, which tried to silence women and insist that their salvation lies in bearing children. We can now hear the other side of the controversy over women's leadership and see what arguments were given in favor of it.

It needs to be emphasized that the formal elimination of women from official roles of institutional leadership did not eliminate women's actual pres-

ence and importance to the Christian tradition, although it certainly seriously damaged their capacity to contribute fully. What is remarkable is how much evidence has survived systematic attempts to erase women from history, and with them the warrants and models for women's leadership. The evidence presented here is but the tip of an iceberg.

The Result: Eve

From almost the earliest days of Western Christianity, men started to see women as sexually dangerous and threatening, and in the grip of this fear they started a process which would eventually push women away from the male world into a separate world of their own. This might at first seem an odd development: neither Jesus nor Paul had pushed women away, but had worked closely with them and granted them full equality with men. However, later books of the New Testament, particularly the First Epistle to Timothy, which was probably written at the beginning of the 2nd century some sixty years after Paul's death, have a very different message. By this time Christianity is coping with the Gentile world of the late Empire and its terrors of sexual excess. A fear of sexuality had changed official Church policy toward women:

> I direct that women are to wear suitable clothes and to be dressed quietly and modestly without braided hair or gold and jewellery or expensive clothes; their adornment is to do the sort of good works that are proper for women who profess to be religious. During instruction, a woman should be quiet and respectful. I am not giving permission for a woman to teach or to tell a man what to do. A woman ought not to speak, because Adam was formed first and Eve afterwards, and it was not Adam who was led astray but the woman who was led astray and fell into sin. Nevertheless, she will be saved by childbearing, provided she lives a modest life and is constant in faith and love and holiness.
>
> — (1 Timothy 2:9–15)

When Paul had told the women in Corinth to keep quiet in Church, there was no hint of sexual disgust, nor was there any idea that women were potentially wicked (they just have to remember their place!). In 1 Timothy we have something different and sinister. Woman is not just inferior, she is wicked also, because of Eve. Eve fell into sin first and led Adam into sin. This is a theme which will recur again and again in the writings of the Early Fathers, and is also a deeply sexual idea.

The author of 1 Timothy begins his remarks about women with directions about the sort of clothes they should wear. Glancing through the works of the Fathers, it is extraordinary how much time they devoted to writing about

women's dress—a concern that should have been beneath them. Diatribes about the way women load themselves with jewelry, cake their faces with makeup and douse themselves with perfume crop up with extreme frequency. One of the first was written by Tertullian in the 3rd century. In a treatise written to his "best beloved sisters" in the faith, Tertullian glides from affection and respect to an astonishing attack:

> If there dwelt upon earth a faith as great as we expect to enjoy in heaven, there wouldn't be a single one of you, best beloved sisters, who, from the time when she had first "known the Lord" and learned the truth about her own condition, would have desired too festive (not to say ostentatious) a style of dress. Rather she would have preferred to go about in humble garb, and go out of her way to affect a meanness of appearance, walking about as Eve, mourning and repentant, so that by her penitential clothes she might fully expiate what she has inherited from Eve: the shame, I mean, of the first sin, and the odium of human perdition. *In pains and anxieties dost thou bear children, woman; and toward thine husband is thy inclination and he lords it over thee.* And do you not know that you are each an Eve? The sentence of God on this sex of yours lives in this age: the guilt must of necessity live too. *You* are the devil's gateway: *you* are the unsealer of that forbidden tree: *you* are the first deserter of the divine law: *you* are she who persuaded him whom the devil was not valiant enough to attack. *You* destroyed so easily God's image, man. On account of *your* desert—that is death—even the Son of God had to die. And do you think about adorning yourself over and above your tunics of skins.

> — (*On Female Dress*, I:i)

It is exactly the same complex of ideas that we find, less clearly articulated, in 1 Timothy: female appearance, Eve, childbirth. It seems at first sight strange that this enormous attack—each woman is completely responsible for destroying men and crucifying Christ—should start and finish with something as apparently unimportant as women's clothes. What prompts Tertullian's virulent attack is pure irrational fear. As the treatise goes on, we see that it is wholly about sex. Woman is as much of a temptation to man as Eve was to Adam, not because she is offering him an apple but because she is offering the forbidden fruit of sex. She can cause a man to lust after her just by walking around looking beautiful. "You must know," Tertullian insists, "that in the eye of perfect Christian modesty, having people lusting after you with carnal desire is not a desirable state of affairs but is something execrable" (II, ii). He is thinking of Jesus' words when he said that a man who looks at a woman lustfully has already committed adultery in his heart. Jesus was not making a particular issue of lust here, but was illustrating his admirable religious insight that mere external conformity to a set of rules is not enough for the truly religious man. It is the attitude in his heart that counts, not a meticulous performance of burdensome commandments. Tertullian twists this potentially liberating idea into a truly frightening view of the moral world. "For as soon as a man has lusted after your beauty, he has in his mind already committed the sin which his lust was imagining and he perished because of this, and you [women] have been made the sword that destroys him" (II, ii). A man's lustful glance may be entirely

involuntary, but he still perishes. The woman is guilty of destroying him just as Eve was guilty of destroying Adam. She may have had absolutely no intention of tempting him—she may not even realize that she has caused any lustful thoughts at all, but she is still guilty. Both the man and the woman have sinned even though what happened was quite beyond their control.

Tertullian is quite clear that women are to blame: "even though you may be free of the actual crime, you are not free of the odium attaching to it" (II, ii). This means that, far from dressing up and making herself look pretty and desirable, a woman has a duty to look as unattractive as she possibly can:

> ... it is time for you to know that you must not merely reject the pageantry of fictitious and elaborate beauty, but even the grace and beauty you enjoy naturally must be obliterated by concealment and negligence, because this is just as dangerous to the people who glance at you. For even though comeliness is not to be censured exactly, because it is certainly a physical felicity and a kind of goodly garment of the soul, but it is to be feared, because of the injury and violence it inflicts on the men who admire you.

> — (II, ii)

This is an oft-repeated theme for Tertullian. In his treatise *On the Veiling of Virgins,* it surfaces in a particularly disturbed form. St. Paul had said that women had to wear veils in Church "because of the angels." Here he was referring to the legend of the "Sons of God," the "angels" who lusted after earthly women and came down from heaven to mate with them.

> For if it is "because of the angels"—those beings of whom we read as having fallen from God and from heaven because of lusting after women—who can presume that it was bodies already defiled and relics of human lust which the angels yearned after, but that rather that they were inflamed for virgins, whose bloom pleads an excuse for human lust?... So perilous a face, then, ought to be kept shaded, when it has cast stumbling stones even so far as heaven. This face, when it stands in the presence of God, at whose bar it already stands accused of driving the angels from their heavenly home, may blush before the other angels who didn't fall as well.

> — (*On the Veiling of Virgins,* VII)

There is something extremely unpleasant here. It is not simply the view that sex always defiles a woman, so that afterward she is merely a "relic of human lust," a memory of a shameful act. There is also a horrible leering prurience about unsullied virgins being especially lustworthy, and there is a real terror in the idea that a woman's beauty is so dangerous and powerful that it can even cause angels to abandon heaven and fall irretrievably into sin. If even angels are not safe from a woman's beauty, then what hope is there for mere men? A woman must keep her "perilous" face hidden. She must disguise her beauty, or she will destroy men just as surely as Eve destroyed Adam. Already, years before Augustine would finally formulate for the West the doctrine of Original Sin, the emotional trinity which exists at the heart of that doctrine has been formed in the Christian neurosis of Tertullian: woman, sex and sin are fused together in his mind indissolubly. The only hope for man is that women hide themselves

away—veil their faces from man's lustful eyes, hide their beauty by disfiguring themselves and make themselves ugly and sexless in the penitential garb that befits each woman as an Eve.

Christian men were told to inhabit a separate world from women. When Jerome wants to defend his friendship with the noble Roman lady St. Paula, who became one of his staunchest disciples, he stresses the fact that he was scrupulous about keeping away from women:

> Before I became acquainted with the household of the saintly Paula all Rome was enthusiastic about me. Almost everyone concurred in judging me worthy of the highest office in the Church. My words were always on the lips of Damasus of blessed memory. Men called me saintly: men called me humble and eloquent. Did I ever enter a house of any woman who was included to wantonness? Was I ever attracted by silk dresses, flashing jewels, painted faces, display of gold? No other matron in Rome could dominate my mind but one who mourned and fasted, who was squalid with dirt, almost blind with weeping. All night long she would beg the Lord for mercy, and often the sun found her still praying. The psalms were her music, the Gospels her conversation: continence was her luxury, her life a fast. No other could give me pleasure, but one whom I never saw munching food.
>
> — (Letter xiv: To Asella)

For Jerome the only good woman is a sexually repulsive one. Paula has made herself "repellent." When Jerome went to visit her, he felt disgusted by her and his virtue was quite safe. He was in no sexual danger. Paula herself would have been delighted by this appalling description; she was only one of the new breed of Roman ladies who were taking up the ascetic life and mutilating themselves physically and spiritually in this way. This pattern of mutilation is one that recurs in all sorts of psychological and physical ways among the women of Western Christianity. By telling a woman that she should not be physically attractive if she wanted to consort with men and still be virtuous, Jerome and his like were deeply damaging the women who obeyed them.

If a woman is not repulsive then she must be isolated and ostracized. In his letter to Nepotian, a young priest, Jerome tells him that he must be careful to keep himself away from women, even the most innocent and virtuous women, unless they are sexually repellent:

> A woman's foot should seldom or never cross the threshold of your humble lodging. To all maidens and to all Christ's virgins show the same disregard or the same affection. Do not remain under the same roof with them; do not trust your chastity. You cannot be a man more saintly than David, or more wise than Solomon. Remember always that a woman drove the tiller of Paradise from the garden that had been given him. If you are ill let one of the brethren attend you, or else your sister or your mother or some woman of universally approved faith. If there are no persons marked out by ties of kinship or reputation for chastity, the Church maintains many elderly women who by their services can both help you and benefit themselves, so that even your sickness may bear fruit in almsgiving.... There is a danger for you in the ministrations of one whose face you are continually watching. If in the course of your clerical duties you have to visit a widow or a virgin,

> never enter the house alone.... Never sit alone without witnesses with a
> woman in a quiet place. If there is anything intimate she wants to say, she
> has a nurse or some elderly virgin at home, some widow or married woman.
> She cannot be so cut off from human society as to have no one but yourself
> to whom she can trust her secret.

— (Letter lii)

Merely sitting with a woman or letting her nurse you is to put yourself in grave
danger. Women, therefore, have to be shunned, even if they are in trouble and
need help. A woman is to be avoided and left alone in a world which is quite
apart from men.

It becomes part of the advice that is given to your aspirants of both sexes
who want to lead virtuous Christian lives. Men are to shun women, and women
are urged to withdraw from the world and take themselves off into a separate
and totally female existence. Inevitably that will be maiming, even without the
fasting and the deliberate physical mutilation that the woman is urged to under-
take in the name of physical penance. Simply by being deprived of the realities
of the male world, by being deprived of education and normal activity, women
were only being able to function in half the world. However, the most destruc-
tive thing of all was the sexual disgust which drove women into their separate
worlds. There is a continual process of repulsion which we have already seen in
Tertullian, a process which is neurotic and probably not even conscious. You be-
gin speaking lovingly to your "best beloved sisters" and you end up castigating
"Eve." Jerome has exactly the same reaction. Here he is writing to a young girl
who has written asking for his advice about the Christian life. Jerome urges her
to lock herself away from the world. Simply by walking around she will inspire
male lust, however virtuous she is. In fact, virtue itself can turn a man on:

> What will you do, a healthy young girl, dainty, plump, rosy, all afire amid
> the fleshpots, amid the wines and baths, side by side with married women
> and with young men. Even if you refuse to give what they ask for, you may
> think that the asking is evidence of your beauty. A libertine is all the more
> ardent when he is pursuing virtue and thinks that the unlawful is especially
> delightful. Your very robe, coarse and sombre though it be, betrays your
> unexpressed desires if it be without crease, if it be trailed upon the ground
> to make you seem taller, if your vest be slit on purpose to let something
> be seen within, hiding that which is unsightly and disclosing that which
> is fair. As you walk along your shiny black shoes by their creaking give an
> invitation to young men. Your breasts are confined in strips of linen, and
> your chest in imprisoned by a tight girdle. Your hair comes down over your
> forehead or over your ears. Your shawl sometimes drops, so as to leave your
> white shoulders bare, and then, as though unwilling to be seen, it hastily
> hides what it unintentionally revealed. And when in public it hides the face
> in a pretence of modesty, with a harlot's skill it shows only those features
> which give men when shown more pleasure.

— (Letter cxvii)

It is not surprising that Jerome doesn't let himself near women, because this
letter shows him to be sexually obsessed and one of the great voyeurs of all

time. He has obviously studied women minutely, and is pruriently eager to pick up each and every movement, every mannerism. He is even excited by the creaking of a woman's shoe. Watching a woman walk down the street, he immediately imagines her underwear; his eyes are skinned to catch a glimpse of her white shoulders. It is taken for granted that she is teeming with lust. Every movement, intentional or unintentional, is a sign of her "unexpressed" sexual desire. What Jerome is doing is over-sexualizing women because of his own sexual repression. *He* is rampantly frustrated so he tells women that *they* are sexually insatiable. He has forgotten here that he is writing to a good little girl, who has asked him for advice. He is so lost in his fantasy that by the end of the paragraph he is comparing her to a harlot. In just the same way Tertullian begins by calling his readers "best beloved" and ends by calling them "Eve." Christian love for women easily modulates into sexual hatred.

Woman then is man's deepest enemy. She is the harlot who will lure a man to his doom because she is Eve, the eternal temptress. Just as Original Sin comes to be linked with sex, so woman is Eve because she is sexual. Jerome's pathological disgust with sex is shown in his letter to Furia, who had written to seek his advice about getting married again:

> The trials of marriage you have learned in the married state: you have been surfeited to nausea as though with the flesh of quails. Your mouth has tasted the bitterest of gall, you have voided the sour unwholesome food, you have relieved a heaving stomach. Why would you put into it again something which has already proved harmful to you. *The dog is turned to his own vomit again and the sow that was washed to her wallowing in the mire.*
>
> — (2 Peter 2:22)

What must Furia have felt like when she received this letter? Again she seems to have been a virtuous woman, a genuine and enthusiastic Christian, but because of her sexuality she would have been made to feel foul and sinful. Jerome is clear that she is sexually obsessed and voracious. As a widow she must be inflamed by the "pleasures of the past." The widow "knows the delights that she has lost and she must quench the fire of the devil's shafts with the cold streams of fast and vigil." Jerome sees a woman as having such strong sexual cravings that if she dresses attractively she is crying out for sex, her "whole body reveals incontinence." Again he sees her as luring poor unsuspecting men into sex and sin. Woman is Antichrist:

> What have rouge and white lead to do on a Christian woman's face? The one simulates the natural red of cheeks and lips, the other the whiteness of the face and neck. They are fires to inflame young men, stimulants of lustful desire, plain evidence of an unchaste mind. How can a woman weep for her sins when tears lay her skin bare and make furrows on her face? Such adorning is not of the Lord, it is the mask of Antichrist.
>
> — (Letter liv)

Reading this one might assume that Jerome is writing about prostitutes whose garish makeup advertises their availability. In fact here, as elsewhere, he was

writing about ordinary Roman matrons who used frequently to wear cosmetics at this time.

This hostility and fear of women's sexual powers we see again and again. Augustine sees danger even in the virtuous women of the Old Testament, sometimes with ludicrous results. Trying to come to terms with the sex lives of the Patriarchs, he presents Abraham and Isaac copulating with their wives dutifully but with enormous distaste, in order to obey God's command to found the Chosen Race. They would far rather have abstained. Abraham, Augustine says, had to go on copulating with his wife Sarah for years before he managed with God's help to conceive his son Isaac. Abraham, who seems to have been a highly sexed man, would have read all this with considerable bewilderment. Isaac, Augustine continues, was more fortunate. The Bible only mentions his having sex once, and he was lucky enough to produce the twins, Esau and Jacob, straight off so he never had to do it again. When he came to Jacob, however, who had twelve sons, Augustine is in a bit of a quandary. This looks like zeal in excess of duty. However, he decides that Jacob would gladly have followed the example of Isaac and only had sex once in his life, but his two wives, Leah and Rachel, kept pestering him because of their excessive lust and sexual greed, forcing the holy Patriarch to abandon his high ideals. Yet Rachel and Leah are good women. For Augustine, as for his predecessors Jerome and Tertullian, all women, however virtuous, are men's enemies. "What is the difference," he wrote to a friend, "whether it is in a wife or a mother, it is still Eve the temptress that we must beware of in any woman" (Letter 243, 10).

There is no room for this enemy in the male world. Indeed, there is no room for her at all in God's plan. Augustine seems puzzled about why God made women at all. It is not possible that she was a friend and helpmate to man. After all, "if it was good company and conversation that Adam needed, it would have been much better arranged to have two men together, as friends, not a man and a woman" (*De Genesis ad Litteram* IX, v, 9). The only reason he made women was for the purposes of childbearing. Luther shared this view. The only vocation he could see for a woman was to have as many children as possible, so that all the more people could be led to the Gospel. It didn't matter what effect this might have on women: "If they become tired or even die, that does not matter. Let them die in childbirth—that is why they are there." There was no other way that a woman could help man. Her place was "in the home" (the famous phrase was actually coined by Luther). There was no place for her in the male world of affairs. Similarly Calvin, who is virtually the first Christian theologian to speak favorably of women, might insist that woman *was* created to be a companion to man and that marriage was instituted by God precisely for that companionship, but his Geneva was entirely male dominated, and women's role as a companion was confined to the domestic female world of the home. Protestantism shared fully the misogyny that the Fathers had bequeathed to the Catholic Church. When Lutherans at Wittenberg discussed the question whether women were really human beings at all, they were not discussing anything new. Theologians had always been perplexed about women's

place in God's plan. Thomas Aquinas was as puzzled as Augustine had been about why God had made her at all and decided that woman was a freak in nature:

> As regards the individual nature, woman is defective and misbegotten, for the active force in the male seed tends to the production of a perfect likeness in the masculine sex; while the production of woman comes from a defect in the active force or from some material indisposition, or even from some external influence.
>
> — (*Summa Theologica,* IV, Part I. Quaest. XCII, art 1, 2)

It does not help that Aquinas decides that womankind in *general* is human. The "individual nature" of women is a defect, an idea he picked up from Aristotle's biology. The norm is the male. Every woman is a failed man.

<center>⋖◉⋗</center>

Women are therefore emotionally excluded from the male world, for all that Paul had originally insisted upon sexual equality. Even now that we are breaking into the male preserves we still tend to feel ill at ease in it. Recent surveys show that college women are even more afraid of success today than they were when Betty Friedan did her original survey in the early 1960s. Dons at Oxford and Cambridge have complained about the quality of women who are gaining admission to the colleges that used to be all-male. They have asked schools to stop sending them girls who are polite, efficient and well-behaved, and instead send them students who will argue with them as aggressively as the boys do. Breaking into the male world is not simply a matter of opportunity. It is a question of attitude on the part of both men and women. Women are still ambiguous and fearful in these new male worlds that have recently been opened to them. They are still maintaining their guilty apologetic stance. For centuries they have been excluded not simply because they were supposed to be inferior but because they inspired sexual fear and disgust in men. Marilyn French's novel *The Women's Room* puts this humorously when she imagines the male world of Harvard terrified to admit women in case they drip menstrual blood all over this pure male preserve. Where Moslems have traditionally locked their women into harems inside their homes because they owned and valued them, men in the Christian West have locked their women outside their lives because they hate them, exiling women to a lonely, separate world.

POSTSCRIPT

Did Christianity Liberate Women?

The Bible and many other sources provide evidence of women's active roles during the early years of what would later be called Christianity. Eusebius (263–339 C.E.), a Greek Christian and an intimate friend of Emperor Constantine, wrote the only surviving comprehensive account of the first 300 years of Christian Church history. Sometimes called the Christian Herodotus, he certainly earned the title Father of Ecclesiastical (church) History. A translation of his work by G. A. Williamson, *The History of the Church* (Dorset Press, 1984) is easy to obtain.

During the first centuries of Christianity, different schools of what would later become theology existed side by side. One of these was Gnosticism, a mystical worldview that predominated in Greece and Rome. Remarkable for its androgynous view of God as father and mother, Gnosticism was the first heresy condemned by the Christian Church because some of its views clashed with what had become orthodoxy. Four Gnostic gospels, part of what scholars call the Nag Hammadi library, found in Egypt in the 1940s, are available in Marvin W. Meyer's translation in *The Secret Teachings of Jesus* (Vintage Books, 1986). Elaine Pagels, an authority in this field, has written a useful guide to Gnosticism in *The Gnostic Gospels* (Vintage Books, 1989). See also the PBS/FRONTLINE Web site recommended for this issue on the On the Internet page for Part I.

A documentary sampling of writings about women, from the ancient Greeks to the modern Victorians, may be found in *Not in God's Image* edited by Julia O'Faolain and Lauro Martines (Harper & Row, 1973), which places Western attitudes toward women in a broader context. Karen Jo Torjesen's *When Women Were Priests* (Harper-SanFrancisco, 1995) highlights women as deacons, priests, prophets, and bishops and documents their exclusion from many of these roles as the Christian Church joined the establishment and worship moved from private to public space.

During the Patristic Age, holy women paid a high price for their piety, energy, and talent. Gilian Close captures this time in *"This Female Man of God": Women and Spiritual Power in the Patristic Age, AD 350-450* (Routledge, 1995). Women were "the Devil's gateway," so anyone holy enough to be an exemplar of the faith could not actually be a woman. Feminine spirituality as a concept had no credibility. *Adam's Fractured Rib* (Fortress Press, 1970) by Margaret Sittler Ermarth, explores some sources of the fear and hatred of women. Former Boston College theologian Mary Daly in *The Church and the Second Sex* (Beacon Press, 1985), follows up on Simone de Beauvoir's feminist classic *The Second Sex* by documenting sexism in Christian Church history and the "otherness" of women.

On the Internet ...

The Content of Historic Same-Sex Unions

The Content of Historic Same-Sex Unions Web site includes a question-and-answer session that concentrates on the late John Boswell's book, *Same-Sex Unions in Premodern Europe*.

http://home.aol.com/DrSwiney/unions.html

Lost King of the Maya

The Lost King of the Maya Web site is based on a 2001 PBS special and contains written and visual information on Maya civilization.

http://www.pbs.org/wgbh/nova/maya/

The Crusades & Mediaeval Information Links

The Crusades & Mediaeval Information Links Web site is a United Kingdom–based site that contains 18 links related to a wealth of information on the Crusades.

http://www2.prestel.co.uk/church/chivalry/crusades.htm

High Medieval Europe

The High Medieval Europe Web site is a university-run site that provides an outline of the Middle Ages based on various themes, one of which is entitled "Medieval Universities and Intellectual Life."

http://www2.sunysuffolk.edu/westn/highmed.html

Women Artists of the Renaissance

The Women Artists of the Renaissance Web site contains a scholarly, readable essay that relates the experiences of women Renaissance painters to the overall question posed in the issue on whether women and men benefited equally from the Renaissance.

http://w3.arizona.edu/~ws/ws200/fall97/grp13/
part3.htm

Bushido: The Way of the Warrior

Bushido: The Way of the Warrior is a Web site that contains brief but useful information on the Japanese samurai, including origins, their creed, bushido, and links to Web sites related to the subject.

http://mcel.pacificu.edu/as/students/bushido/
bindex.html

The Medieval/Renaissance Worlds

*T*his section shows the world's civilizations building upon the world that the ancients created as they strove to produce better lives for themselves and their citizens. However, it also shows that some of the problems these civilizations faced early in their histories continued to plague them, and that greater problems occurred for them as they began to have increased contact with other civilizations.

- Did Same-Sex Unions Exist in Medieval Europe?

- Were Environmental Factors Responsible for the Collapse of Maya Civilization?

- Were the Crusades Primarily Motivated by Religious Factors?

- Does the Modern University Have Its Roots in the Islamic World?

- Did Women and Men Benefit Equally From the Renaissance?

- Was Zen Buddhism the Primary Shaper of the Warrior Code of the Japanese Samurai?

ISSUE 7

Did Same-Sex Unions Exist
in Medieval Europe?

YES: John Boswell, from *Same-Sex Unions in Premodern Europe* (Villard Books, 1994)

NO: Philip Lyndon Reynolds, from "Same-Sex Unions: What Boswell Didn't Find," *The Christian Century* (January 18, 1995)

ISSUE SUMMARY

YES: Professor John Boswell (1947–1994) states that same-sex unions, which dated back to pagan times, existed in medieval Europe until they were gradually done away with by the Christian Church.

NO: Reviewer Philip Lyndon Reynolds, while admitting that "brotherhood" ceremonies took place in the prescribed period, asserts that these ceremonies did not have the same authority as sacred unions and therefore cannot be equated with marriage rites.

Few topics are as controversial today as homosexuality. Newspapers are filled with stories involving the discomfort that individuals—and institutions—have in dealing with the subject. In the United States, violence against gay males and lesbians seems commonplace, as are debates within federal, state, and local governments regarding the initiation of policies and enactment of legislation regarding gay rights. The rancor that these debates engender tells us that the total acceptance of gay males and lesbians in society will likely be a controversial issue for years to come.

No segment of society has had more difficulty dealing with this subject than religious communities. All denominations seem to have divisions in their ranks with regard to how homosexuality is to be considered in canons and doctrines and how gay males and lesbians are to be treated as members of congregations. News accounts abound concerning clerics who challenge their church's stance on homosexuality and are reprimanded or censured for it. Occasionally, the debate reaches the highest orders of the denomination, when bishops or other high-ranking officials express doubts about existing church beliefs and concomitant practices regarding homosexuality. No religious group

seems immune to the divisions that exist concerning same-sex policies and practices.

Some scholars have attempted to seek out the historical roots of this prob lem, to discover if there are any historical antecedents that can be useful in creating a consensus of understanding in regard to homosexuality. They have discovered that what some today would refer to as homosexual practices have been in existence throughout recorded history and were not limited to the Western world. Examples of tolerance and acceptance for homosexual prac-tices have been found in such diverse areas as ancient Egypt and Mesopotamia, as well as classical Greece and Rome. Also, in some tribes in Africa and the Americas, similar practices and conditions were found.

There are those who believe that some of these may have resulted in same-sex unions, but the proof for this is more a matter of interpretation than fact. Nevertheless, the level of acceptance of such same-sex practices afforded in the past was a startling enough discovery.

Same-sex unions made their way into Europe during the Greco-Roman era. It is an acknowledged fact that Greeks accepted homosexuality as a natural state; it is less clear whether any relationships that emanated from it resulted in permanent unions. In Rome, however, the evidence was clearer, as emperors such as Nero and Egalabus—as well as many Roman citizens—participated in same-sex unions.

The example of Sergius and Bacchus serves to further the point. They were third–fourth century Roman soldiers who were gay and Christian. They were persecuted for their religious beliefs and not for their sexual orientation, and when they were both eventually martyred, they became a symbol for those who supported same-sex unions.

What significance do these historical antecedents have for the current de-bate? For one thing, they are vivid examples that societies can exist and thrive in times of open tolerance of homosexuality. Also, it is important for gay males and lesbians to find reaffirmation for their beliefs and practices in the past, as almost all groups have found some solace in their historical, ethnic, and religious roots.

If there was a wider acceptance of homosexuality in past religious histo-ries, can that acceptance be recreated today? Such hope is at the heart of the late John Boswell's book, from which the following selection has been excerpted. Researching into archives and manuscripts long ignored, he discovered that not only was there a wider acceptance of what some refer to today as homosex-ual practices in the past, but that there also existed in classical and medieval Christendom religious rites and ceremonies he refers to as "same-sex unions."

While Boswell's work was well received, it was not without its critics. Philip Lyndon Reynolds, in a lengthy review in *The Christian Century,* found that Boswell may have assigned a sacramental nature to these same-sex rites that did not exist. Also, Reynolds states that there has been a lack of clarity of pur-pose to Boswell's work. His review inspired rejoinders and counterrejoinders. What the outcome of this debate will be is in the hands of future historians and theologians.

John Boswell **YES**

Same-Sex Unions in Premodern Europe

The History of Same-Sex Unions in Medieval Europe

The historical setting of the [same-sex union] ceremony is a bit harder to track than its liturgical context and development. It is, for example, impossible to know whether it represents the Christianization of an ancient same-sex rite—and if so, which one—or a Christian innovation. Since most ancient nuptial and same-sex union rites involved sharing of wine and a feast, it is easy to imagine that these ancient customs were simply arrayed in Christian garb to keep up with the prevailing ethos, just as Roman heterosexual marriage customs were reinvested with Christian meaning and persisted throughout the Middle Ages, or pagan statuary (e.g., of Venus and Cupid) was reconsecrated to Christian use (the Virgin Mary and the baby Jesus).

Saint couples—especially military pairs like Serge and Bacchus or the Theodores—continued to fascinate and preoccupy the Christian public (or at least the males who left literary and artistic records), and provided a Christian voice for the same sentiments that had produced the Roman phenomenon of sexual or institutional "brotherhood." Churches continued to be built for and dedicated to Serge and Bacchus throughout the Eastern end of the Mediterranean all during the early Middle Ages. Many Christians may have understood such couplings simply as expressions of devoted friendship, while those whose own romantic interests were chiefly directed to their own gender doubtless understood them in a more personal way. Both views were probably correct: coupled saints like Peter and Paul may have been overinterpreted as romantic pairs, while Serge and Bacchus were probably correctly so understood. The oldest church in Egypt, widely believed to occupy a spot where the Holy Family lived for some time during their exile in Egypt, is dedicated to St. Serge. Justinian himself, the instigator of laws sharply penalizing homosexual behavior, was believed to have added a structure dedicated to SS. Serge and Bacchus to one already consecrated to SS. Peter and Paul.

Nor should the fact that an area became Christian be interpreted to mean that all of its inhabitants suddenly embraced and followed the most ascetic

teachings of the new religion. In many areas of Europe ancient practices persisted for centuries among a populace officially Christian. In Egypt, although Christianity was lively and often quite severe (as exemplified in the Didache, the Apostolic Canons, and the writings of Clement of Alexandria), there was also much variety, as appears in the Gnostic writings and the prominence of dissenting movements in the Egyptian church. Centuries after Christian doctrine had penetrated Egypt and long after the Theodosian Code had made the upper reaches of the Roman state a Roman Catholic theocracy, an Egyptian man wrote down a magical incantation seeking supernatural help to obtain the love of another male. The sixth-century African poet Luxorius, also living in a Christian world, nonetheless wrote a poem about a passively homosexual male who gave his property away to the men with whom he had sex.

The Roman custom of forming a union with another male by the legal expedient of declaring him a "brother" appears to have persisted into the early Middle Ages, although it became controversial for a somewhat unexpected reason related to the decline of urban culture and the range of lifestyles around the Mediterranean. Collateral adoption was declared invalid for some outlying provinces in a handbook of Roman law compiled (in Greek) in the fourth or fifth century and translated into Syriac, Armenian, and Arabic for Roman citizens living in regions of the East where Latin and Greek were not understood. . . .

It is, in addition, clear that same-sex unions were commonplace in early medieval Byzantine society, even among the prominent and notable. Strategios, an imperial treasurer, was twice said in the ninth century to have been the same-sex partner . . . centuries before of the emperor Justinian. No other information about this relationship survives. Procopius in his *History* mentioned Strategios as a trusted patrician, "a man of good sense and ancestry" . . ., but said nothing about this relationship, which may be apocryphal, although in Procopius, Strategios does seem to have been close to Justinian. In another text Severus, a patrician, is casually mentioned as the same-sex partner of another emperor, but no further details are given.

By contrast, details survive about some Byzantine cases of the early Middle Ages. St. Theodore of Sykeon, for example, a contemporary of Justinian (d. 613), was born in Galatia. He was the illegitimate son of a prostitute and an imperial messenger, Kosmas, who had been an acrobat and performed in the imperial circus on camels. Theodore became a hermit, lived for two years in a cave, and then for a time inhabited an iron cage. (This sort of flamboyant asceticism was common in the Christian East.) He became bishop of Anastasioupolis, but ultimately resigned to return to monastic life.

Theodore traveled widely (e.g., to Jerusalem and Constantinople), and was always under the special protection of St. George, whose intervention when he was a child appears to have been largely responsible for his holy life. (The Eastern St. George was invoked in the ceremony of same-sex union. . . .) While he was visiting Constantinople the patriarch Thomas became "so attached to him and had such confidence in him that he begged him to enter into ceremonial union with him and to ask God that he would be together with him in the next life."

Although it is hardly credible that such an energetically ascetic man would enter into *any* sort of carnal relationship, it is nonetheless possible that the union was based on passionate feelings, at least on Thomas' part. Indeed, it is difficult to interpret otherwise the latter's desire for them to be together in heaven, since traditionally the chief joy of paradise consisted in the beatific vision of God. This whole incident strongly recalls the story of Serge and Bacchus, one of very few other places in early Christian literature where a personal union in heaven was emphasized. Theodore might have consented to a relationship that ordinarily had sexual possibilities without any intention of partaking in them himself: his near-contemporary St. John the Almsgiver agreed to a heterosexual marriage even though he intended to remain a virgin, and had to be forced by his father-in-law to consummate the relationship.

A few centuries later Basil I (867–886), the founder of the Macedonian dynasty that ruled the Byzantine Empire from 867 to 1156, was reported to have been twice involved in ceremonial unions with other men. Although the most important sources for his life—composed under the rule of his descendants within a century of the events in question—are contradictory on some points and occasionally unreliable, their take on this matter is largely consistent. His biographers (including Western sources . . .) all agreed that when Basil arrived in Constantinople with nothing but a staff and a knapsack—a young man from the provinces with no connections in the capital—he was befriended by a certain Nicholas of the church of St. Diomede, who rescued him from sleeping in the streets, brought him into the church, bathed and clothed him, and supported him for some time, until the ambitious Basil was able to attract the attention of a well-placed courtier related to the imperial family.

In most accounts of their relationship Nicholas and Basil are united in a church ceremony. According to one tradition, on the morning after finding him Nicholas "bathed and dressed Basil and was ceremonially united to him, and kept him as his housemate and companion." Another version is more explicit about the ceremony: "and on the next day he went with him to the baths and changed [his clothes] and going into the church established a formal union with him, and they rejoiced in each other." The odd final phrase would probably recall to a Christian Greek reader the biblical "Rejoice with the wife of thy youth."

Given the wording in the chronicles . . . and the fact that the union is accomplished in a church, there can be little doubt that the writers have in mind some form of the ceremony published and translated in this text. There is no suggestion of any tribal or family aspect to the relationship, nor of the exchange of blood; it has no military or strategic aspect, nor are any circumstances adduced as requiring or occasioning it (e.g., rescue from danger, a serious illness, which would all be occasions in later Slavic relationships modeled on it). It is clearly a personal relation, undertaken for personal reasons. Both Basil and Nicholas had living biological brothers with whom they were in regular and close contact, so it could hardly have been inspired by a need for a sibling. Indeed, it was Nicholas' own natal brother, a physician, who was responsible for Basil's introduction at court, a fact adduced immediately after the union in all versions. Nor does the mention of rejoicing suggest a coldly calculated relationship. Taken with the statement by Hamartolos that the union led to a sharing

of home and hearth, it strongly evokes a wedding, followed by jubilation and a shared life.

It is striking that in a tradition about this relationship in which Nicholas is identified as a monastic, the ceremonial union is not mentioned. By contrast, the chroniclers who do discuss the union characterize Nicholas as a parish cleric in minor orders—hence, not prohibited by ecclesiastical law from entering into same-sex union. . . .

From the perspective of Basil, who would otherwise have been sleeping on the streets, formalizing Nicholas' benevolent interest in him could only have been advantageous, at least until he found a means of advancing his career more rapidly with someone more powerful and better connected. It is less clear what Nicholas gained from the impetuous union. Taking the story —including Nicholas' supernatural information about Basil's future greatness— at face value, one could conclude that Nicholas imagined he would ultimately profit from entering into a formal relationship with someone who would one day become emperor. . . .

While Basil was still in the service of Theophilos, they made a trip together to Greece. A wealthy widow in Achaia showered him with gifts of gold and dozens of slaves. In return for her generosity she asked nothing but that Basil should enter into ceremonial union with her son, John. At first he refused, because he thought it would make him look "cheap," but at length she prevailed and he agreed. "I seek and ask nothing from you," she assured him, "except that you love and deal kindly with us." A surviving medieval illustration of this incident shows Basil and John being united before a cleric in church, with the Gospel open before them and John's mother looking on. An accompanying frame depicts Basil, John, and Danelis (John's mother . . .) at a table—doubtless the artist's conception of the feast that would usually follow such a ceremony.

When he subsequently became emperor Basil immediately "sent for the son of the widow Danelis, honored him with the title *protospatarius,* and granted him intimacy with him on account of their earlier shared life in ceremonial union." The widow herself—now too elderly to ride—came to the emperor on a litter, but rather than requesting any munificence from him, she brought more extravagant gifts "than nearly any other foreign ruler had up to that time ever bestowed on a Roman emperor." In addition, she "who was worthy to be called the emperor's mother" made a large gift of her patrimony in the Peloponnese to her son and the emperor *together.* . . .

Were it not for the genders involved, this incident would seem quite a familiar feature of the premodern political landscape: a wealthy widow offers her marriageable child to a powerful young man on the rise, along with a substantial dowry, hoping to ally her fortunes to his. Basil's own father had been married to the daughter of a wealthy widow in a striking parallel. The previous Byzantine dynasty, the Amorian, had been established under similar, though apparently heterosexual circumstances: born of humble parents, uneducated and unconnected, its founder Michael II advanced himself through strength of arms and military skill until he was able to marry Thekla, the daughter of a high-ranking officer, and attracted the attention of the emperor Leo V, who made him *protostratarius*—the same position Basil had held in the service of

Theophilos—and became godfather to one of his sons. When Leo attempted to have Michael executed on charges of treason, he was himself assassinated and Michael was crowned emperor.

The widow Danelis was much richer than Basil and, when he became emperor, realized no material gain from the relationship, so it can hardly be viewed as a mercenary arrangement on her part. On the contrary, every year of Basil's life she sent *him* expensive gifts, and years later, when both Basil and her son had died, the widow came again on a litter to see Basil's son Leo, now emperor, and made him her heir, although she had a grandson and other relatives.

The two stories about Basil are similar: in each there is a divine revelation, to a cleric or monk, about Basil's future greatness; in each the relationship established is to Basil's material advantage. It is possible that in imperial circles it was later known that Basil had profited substantially as a young man from a formal relationship with another male, and different chroniclers simply supplied different details. Each of the biographies written within a century of the events contains *one or the other* of the same-sex unions; none contains both. On the other hand, Nicholas does appear in *all* of the most important accounts of Basil's life as his benefactor, even those that mention the union with John, and the wealth of detail about the widow Danelis (including her subsequent relations with Leo) makes it seem unlikely that she was pure invention. Possibly Basil was united to both men. It is not clear that this would have been improper in Basil's day—or that issues of propriety would have constrained his behavior. . . .

It is . . . clear that ceremonial same-sex unions were parallel to heterosexual marriage in the ninth century in a number of ways: they were relationships between individuals of a personal nature (rather than tribal, religious, or political); they entailed consequences for the immediate family (John's mother; Nicholas' brother) comparable to the obligations or rights of in-laws; they were recognized by society, and even respected by descendants.

It was most likely for this reason that monks were always and everywhere prohibited from entering into same-sex unions, just as they were forbidden to contract heterosexual marriage in both East and West, by both civil and ecclesiastical law (although in the East other members of the clergy could marry). Basil the Great (in the fourth century) had argued that no sexual relations . . . of persons in orders . . . could be regarded as "marriages," and that such unions . . . must by all means be dissolved. Around 580, monks were also forbidden to make "leagues" or "associations." This rule was presumably based on a provision aimed at the laity in the same collection. In the case of the laity the prohibition was certainly *not* aimed at same-sex unions, but it is conceivable that in the case of monks the same canon was interpreted as a blanket condemnation of *all* relationships requiring an oath. A more or less contemporary ruling for laypeople makes perfectly evident that same-sex unions were altogether legal.

The real context of the prohibition to monks is evident in a restatement of St. Basil's rule for monks (the equivalent of the Rule of Benedict in the West) by St. Theodore of Studium (759–826), in which the monks were told, "Do not contract same-sex unions with or become spiritual kin [i.e., godparents]

to the laity, you who have left behind the world and marriage. For this is not found among the fathers, or if it is, only rarely; it is not legal." This rule was often repeated in later ages (e.g., "It is prohibited for monks to form same-sex unions or be godparents, and the church recommends, by way of admonition, the same [prohibition] for leaders or heads of monasteries. The law does not recognize so-called same-sex unions altogether"). Such blanket condemnations inspire skepticism, both because of the historical evidence treated in this [selection] and because same-sex union is coupled in such texts with godparenting, which was not only legal but a key element of liturgical life for most Christians in the Middle Ages. . . .

The most obvious interpretation of such prohibitions is that they parallel the rule against monks marrying women. It would, however, be possible to understand them as stemming from a more general Christian antipathy to homosexuality of any sort. This ascetic tendency of Christian Rome—unknown before the advent of the new religion—was certainly plain in such Western legal compilations as the Theodosian Code and the Laws of the Visigoths, and in the great legal code of Justinian—all unprecedented efforts to make a Christian theocracy of the traditionally secular Roman state. But in fact sustained and effective oppression of those who engaged in homosexual behavior was not known in Europe until the thirteenth century, and was never common in the Byzantine East. Troianos notes somewhat loosely that in the High and later Middle Ages one finds fewer and fewer penalties for homosexual acts in civil and ecclesiastical sources from Byzantium, although "this circumstance in no way indicates that homosexual relations were not widespread in Byzantium." . . .

Roman law survived only fragmentarily in Europe after the collapse of the Roman state, and was usually replaced by Germanic law codes, which were not likely to take cognizance of same-sex relationships. Nonetheless, in Italy and Spain—comparatively urban societies by the standards of the times—the legal fiction of "brotherhood" was not complicated by questions of wife and children, since remaining a bachelor had long been a part of urban Roman life, and was enhanced by the social and financial rewards offered by the position of the diocesan clergy (i.e., as opposed to monks), who were pressured throughout the first millennium of Christian history to aspire to complete celibacy, but were not actually required to observe it until a bitter fight over the issue in the eleventh and twelfth century. In many communities, even where the ceremony of same-sex union was not known, informal relationships reminiscent of the Roman legal fiction of "brotherhood" between male lovers served many of the same functions as heterosexual unions—either legal marriages or long-term alternatives like concubinage—in their duration and legal ramifications.

The ambiguity of the few surviving texts precludes categorizing them unequivocally as same-sex marital contracts, but it equally rules out pretending that they were simply business contracts, as previous commentators have tried to do. It is, in fact, possible to interpret them as business documents, but it would also be possible (if utterly mistaken) to interpret most premodern heterosexual marriage agreements (especially prenuptial contracts among the wealthy) as business contracts. (Indeed, Roman law specifically spoke of heterosexual marriage as a "lifelong partnership.") Many aspects of the documents

and the arrangements they prescribe argue forcefully against a simple partnership. In most of them there is no quid pro quo: it is not that one party provides capital or labor or land and in return the other invests property or expertise or time. In each case it is simply a division of one person's estate with another, apparently for purely voluntary and personal reasons....

Epilogue

Although many questions remain about same-sex unions in premodern Europe, much has also emerged with reasonable clarity. Such unions, in various forms, were widespread in the ancient world, where heterosexual matrimony tended to be viewed as a dynastic or business arrangement, and love in such relationships, where it occurred, arose *following* the coupling. Ordinary men and women were more likely to invest feelings the twentieth century would call "romantic" in same-sex relationships, either passionate friendships or more structured and institutional unions, as exemplified by the recognized couples of Crete or Scythia, the swearing of perpetual love among other Greeks, and the social phenomenon and legal stratagem of "brotherhood" among the Romans.

Since the advent of Christianity only exacerbated doubts about the emotional significance of matrimony, there was little pressure (other than widespread heterosexual desire) to re-evaluate such attitudes. Christianity's main innovation was to privilege and make real widespread voluntary celibacy, implicitly or explicitly suggesting that heterosexual matrimony was a mere compromise with the awful powers of sexual desire, even when it was directed exclusively to the procreation of children, the one rationale Christians found convincing. But passionate friendships, especially among paired saints and holy virgins, continued to exercise a fascination over the early Christians—still residents of the ancient world—and in time were transformed into official relationships of union, performed in churches and blessed by priests.

In many ways from a contemporary point of view, the most pressing question addressed by this work is probably whether the Christian ceremony of same-sex union functioned in the past as a "gay marriage ceremony." It is clear that it did, although, as has been demonstrated at length, the nature and purposes of every sort of marriage have varied widely over time. In almost every age and place the ceremony fulfilled what most people today regard as the essence of marriage: a permanent romantic commitment between two people, witnessed and recognized by the community. Beyond this, it might or might not fulfill specific legal or canonical expectations predicated on the experience of the heterosexual majority (procreative purpose, transfer of property, dowry), but the extent to which particular heterosexual unions matched such niceties did not usually determine whether the neighbors regarded the couple (same-sex or heterosexual) as married. Indeed, in all times and places in its history (including the present) the official teaching of the Roman Catholic church (one of the two bodies in which the ceremony developed) has been that the two parties *marry each other;* the priest merely acts as a witness. If the couple intend to be married, they are. By contrast, in the Eastern Orthodox church the priest *does* perform the ceremony, and in all known cases priests performed the same-sex union.

NO ⤶

Philip Lyndon Reynolds

Same-Sex Unions:
What Boswell Didn't Find

\mathbf{F}ew works of historical scholarship are treated in *Time* and *Newsweek,* much less summarized in a syndicated cartoon strip. According to the digest of [Same-Sex Unions in Premodern Europe] that appeared in Gary Trudeau's *Doonesbury,* John Boswell reveals that the Catholic Church recognized gay marriages for a thousand years. The church even provided liturgies for such marriages, liturgies that included communion and in which kissing signified union, and that were in crucial respects "just like heterosexual marriages." Later in church history, a persecuting and homophobic culture suppressed this tradition of gay marriage.

One can readily understand why a book that seems to be saying something like this would attract attention. The issue of homosexuality is extremely vexed in most Christian denominations in North America. If gay marriage used to be a regular part of Christian tradition, then the official Roman Catholic prohibition of homosexual acts must be unfounded, for the prohibition rests chiefly on the argument from tradition. Tradition still counts for a great deal in the minds of most thoughtful Protestants as well. Because they usually regard homosexual unions as something novel and experimental, Christians tend to regard them as artificial and false. If they were to be convinced that, on the contrary, homosexual union was an ancient tradition within the church that was later suppressed, they should not only have to abandon the former view but should tend to regard homosexual union as something natural and authentic. Its suppression or marginalization in the churches today would appear baseless and contrived. Is this the conclusion toward which Boswell—who died ... at age 47—directs us?

Boswell's argument consists of pointing to certain liturgical forms, some written in Greek and some in Slavonic, from the tenth to the 16th centuries. These texts record an ecclesiastical ritual for the formation of a "brotherhood" of some kind between two men. The ritual belongs to the churches of the eastern Mediterranean and represents the Christianization of a custom much older than Christianity. The liturgical forms have been unfamiliar until now, although a few classical historians have studied and written about the custom of brotherhoods in Greek society (and have come to conclusions different from Boswell's).

From Philip Lyndon Reynolds, "Same-Sex Unions: What Boswell Didn't Find," *The Christian Century,* vol. 112, no. 2 (January 18, 1995). Copyright © 1995 by The Christian Century Foundation. Reprinted by permission of *The Christian Century.* Subscriptions: $49/yr. from P.O. Box 378, Mt. Morris, IL 61054.

Boswell provides the original texts and English translations for several of these liturgical forms. Let us consider the first text in his appendix of English translations, which comes from the manuscript Grottaferrata... VII. This form, which was written in Greek in the tenth century, consists of three prayers. In the first the minister, having invoked God as the one who made humankind in his image and likeness, calls to mind two exemplary male pairs who had God's blessing: the apostles Philip and Bartholomew and the martyrs Serge and Bacchus. The text then asks for God's blessing upon the two men, N. and N., who are the subject of the ritual, asking God to enable them "to love each other and to remain unhated and without scandal all the days of their lives." In the second, briefer prayer, the minister beseeches God to bless N. and N. so that they should know the Holy Spirit and "become united more in the spirit than in the flesh." The third and longest prayer is densely rhetorical and difficult to summarize. Suffice it to say that the minister beseeches God to grant that there should be between N. and N. the brotherly love and peace known to the Apostles.

Other examples indicate (chiefly in the rubrics) what ritual acts and non-verbal symbols were used. For example, Grottaferrata... II (in Greek from the 11th century) begins with the rubric: "The priest shall place the holy Gospel on the Gospel stand and they that are to be joined together place their (right) hands on it, holding lighted candles in their left hands. Then shall the priest cense them and say..." The rubric for the conclusion of this ceremony directs the two men to "kiss the holy Gospel and the priest and one another."

One should emphasize that these ceremonies were peculiar to the liturgical traditions of Greece and the Balkans. Boswell says that the ceremony "disappeared from most of Western (as opposed to Central and Eastern) Europe," and that "no Latin versions of the ceremony survive at all, although it must have been performed in Latin in Ireland, and probably sometimes in Italy." The heterogeneous bits of evidence (some of them colorful and anecdotal) that he presents do not convince me that there was ever anything akin to the Eastern ceremony in the Latin West.

The liturgical texts that Boswell brings to our attention are certainly very interesting, and their similarities to nuptial liturgies (though not as great as Boswell suggests) call for careful consideration and comment. Nevertheless, I have some profound problems with Boswell's treatment....

Boswell does not bring the ceremonies into focus until roughly half-way through the book, by which point a judgment has already been made as to what the ceremonies were. Prior to this, Boswell discusses the vocabulary of love and marriage; "heterosexual matrimony"; various forms of same-sex and homosexual relationships in the Greco-Roman world; the Christian understanding of marriage; and nuptial liturgies. All of this material seems to be provided by way of background, not marshaled on behalf of a thesis. Scholarly opinions on the alliances in question appear piecemeal in the course of the book, so that Boswell does not give us any clear impression of the interpretations that he rejects.

... What is Boswell trying to prove? What does he suppose the ceremonies in question to have been? The texts themselves use names such as *adelphopoiêsis*

("brother-making") to denote the ritual. What kind of "brotherhood" was really involved?

<center>⁕</center>

Boswell recounts discovering in Italy "many versions of the ceremony that were obviously the same-sex *equivalent* of a medieval heterosexual marriage ceremony" (my italics). A stronger form of the thesis would be the claim that the ceremony was a celebration of homosexual marriage. Actually, Boswell himself never claims this much. Indeed, when he at last raises the question, "Was it a marriage?" he replies that the "answer to this question depends to a considerable extent on one's conception of marriage." The discussion that follows is inconclusive. Moreover, Boswell adds that "the concept of someone innately and exclusively 'homosexual' was largely unknown to the postclassical world," and that "relationships of this sort were not understood in a sense comparable to modern 'gay marriage.'"

Nevertheless, Boswell implies in an indirect way that these were gay marriages. For example, he speaks of those (i.e., scholars who do not share his point of view) who are "reluctant to contemplate a *nuptial rite* for same-sex union." But elsewhere he observes: "The ambiguity of the few surviving texts precludes categorizing them unequivocally as *same-sex marital contracts*." (Italics are mine in these two quotations.) This implies that there were same-sex marital contracts in the East. Crucially, Boswell consistently refers to "heterosexual matrimony," which implies that there is a generic matrimony of which there are hetero- and homosexual species. The same implication is present (although less apparent) in the phrase "comparison of same-sex and heterosexual ceremonies of union" (which is the subtitle of chapter six). Thus Boswell declares the stronger form of his thesis only by innuendo.

Much of his argument depends upon ambiguity and equivocation. Perhaps the most serious case of conceptual slipperiness arises in the phrase "same-sex union," which Boswell uses to translate (even in the appendix of translations) terms such as *adelphopoiêsis*. Boswell argues that terms involving the word "brother" would have been confusing to English readers because of what "brother" connotes in our usage. But it is arguable that the term "same-sex union" is just as confusing for similar reasons. To any modern reader (such as Gary Trudeau, apparently), it suggests "gay marriage." Inasmuch as one assumes this, the translation of the term begs the entire question of the book.

Boswell claims that "union" is a neutral term:

> To retain this rich multiplicity of connotations [of the Greek and Slavonic words equivalent to "brother," "brotherhood," etc.]—sexual, asexual; transcending and incorporating sex—I have employed the most neutral terms I could devise in translating the original concepts, such as "union" for *adelphotês* (which could be rendered "brotherhood"), or "be united" instead of "become siblings," which would be overtly and distinctly misleading to most English speakers, since it would evoke notions of adoption.

But "union" is by no means a neutral term; it is a very strong term. Readers will inevitably assume that "union" means "marriage," and in this context the word seems to connote sexual union and the joining of "two in one flesh."

To buttress his case Boswell observes that prejudiced scholars will find the idea that the alliances in question are same-sex unions to be repellent. For example, he says that anthropologists and others are anxious to "explain away the ceremony of same-sex union" as a form of blood brotherhood. But if "same-sex union" is a neutral term, what is there to explain away? Likewise, Boswell speaks of "the native and profound disinclination of most people brought up in modern Christian societies to believe that there could have been a Christian ceremony solemnizing same-sex unions." Again, regarding a curious Irish ceremony recorded by Gerald of Wales (from the late 12th or early 13th century), Boswell writes: "Its nature has long been obscured both by artful mistranslation and a general unwillingness to recognize something *as ostensibly improbable as a same-sex union*" (italics mine). But inasmuch as "same-sex union" is a neutral term, no one can find anything ostensibly improbable in the existence of such a union.

It seems to me, therefore, that "same-sex union" is an ill-chosen and dangerously slippery term. Nevertheless, let us stipulate that it is a neutral expression that means exactly what *adelphotês* or *adelphopoiêsis* means, whatever that may be. The existence of liturgies for same-sex unions is then incontrovertible. The question is: Were these ceremonies the "equivalent" of heterosexual marriages (to use the weaker form of Boswell's thesis)? What kind and what degree of equivalence are we looking for? Equivalence in what respect?

Boswell claims that the relation is evident (to those not blinded by their prejudices and preconceptions) in the liturgies themselves. He notes that the texts for brother-making ceremonies are often contiguous to nuptial liturgies in the manuscripts. When one compares the brother-making liturgies with nuptial liturgies, however, the similarities one finds, while interesting, are not enough to imply equivalence or to suggest that the brother-making ceremonies were in any sense nuptial.

<div style="text-align:center">⋅⦿⋅</div>

To exemplify the "heterosexual" nuptial liturgy, Boswell provides a translation of a Western rite: that of the Gelasian Sacramentary. (Why this choice? One would have supposed that an Eastern rite would have been more pertinent.) Conspicuous in this rite are references to procreation. Thus the minister invokes God as the one who instituted matrimony "so that in the multiplication of children of adoption the fecund chastity of the holy married may persist" (Boswell's translation). Again, the rite beseeches God that husband and wife "may see the children of their children unto the third and fourth generation." And as in all Western nuptial liturgies (and, indeed, as in the more elaborate early medieval dotal contracts), the rite commemorates how God fashioned Eve from Adam's side so that all humankind should descend from them. Petition for the "fruit of the womb" is equally conspicuous in the Eastern liturgies. Needless to say, there is nothing like this in the rites for "same-sex union."

Boswell notes that there are "interesting differences" in the choice of scriptural texts. These differences are not very surprising. Among the texts commonly used in marriage were Genesis 1:28 (on fecundity), Genesis 2:18 (on the formation of Eve from Adam's side), Matthew 19:1–6 (where Jesus deduces from marriage "in the beginning" and in particular from Genesis 2:23 that divorce is contrary to God's will), and John 2:1–11 (on the marriage at Cana). In same-sex unions, Boswell tells us, the most common texts were John 15:17, 17:1 and 18–26 (on love and harmony), 1 Corinthians 13:4–8 (on love), and Psalm 133 ("Behold, how good and how pleasant it is for brethren to dwell together in unity"). There is nothing to suggest equivalence here, and no hint of anything nuptial.

Boswell writes that "the most striking parallels have to do with visual symbolism," and that the "principal structural similarities between the ceremony of same-sex union and heterosexual nuptial offices were binding with a stole or veil, the imposition of crowns, the holding of a feast after the ceremony for the families and friends, the making of circles around the altar, the use of a cross, occasionally the use of swords, and—virtually always—the joining of right hands."

If it is true that crowning was regularly involved, this would indeed be very remarkable, for the ceremony of crowning was and is central to the Eastern nuptial rite, where it took on immense and specifically nuptial significance. Boswell provides just two pieces of evidence for this. One is an obscure Greek text that prohibits monks from receiving boys from baptism, "laying hold of the crowns of marriage," and forming brotherhoods with them. Since this is a set of things *prohibited* to monks, it is not clear which elements might be permissible to non-monks. Perhaps what is in question is an abuse of the traditional brotherhood.

The other piece of evidence offered seems to me to be a serious error. "An eleventh-century exemplar [for a ceremony of same-sex union] does not mention the *removal* of crowns, which necessarily implies their previous imposition." The exemplar in question is Grottaferrata ... II, which is in two parts. The first part, which is explicitly a ceremony for brother-making, appears to end with the rubric: "Then shall they kiss the holy Gospel and the priest and one another, and conclude ..." At this point, Boswell notes, a scribe has drawn a line across the manuscript. There follows a prayer beginning with the title "Ecclesiastical canon of marriage of the Patriarch Methodius." This prayer, which is very clearly from a nuptial rite, ends with a rubric that refers to the removal of crowns.

It should be obvious that the second prayer is from a different rite, and that this text mentions only the removal, not the imposition, of crowns because the early part of it is missing. It is likely that a scribe grafted on the second text by mistake, and that he or someone else noticed this and drew the line to alert the reader's attention to the error. In a long and difficult footnote, Boswell tries to show that the line does not have this significance, but the final, manifestly nuptial prayer is different from Boswell's other examples of brother-making prayers in crucial respects: its title refers to marriage; the prayer itself refers to the "bond of marriage" and to making "two into one"; and the concluding

rubric refers to the crowns. Even without the scribe's warning line, we should know that this does not belong to the brother-making ceremony.

꒰◦◦ꕤ◦◦꒱ ,

The genuine common elements are very interesting, but what may one deduce from them? None of them is specifically nuptial. The kiss, for example, acquired a specifically nuptial meaning in marriage ceremonies (where some regarded it as a kind of premonition of sexual consummation), but in itself it was a universal and asexual symbol of greeting and concord. Similarly, the joining of right hands was a token (then as now) of any kind of agreement. To make much of this evidence, one would need carefully to analyze the history and meaning of each element, which Boswell does not do.

Moreover, the similarities between the brother-making ceremonies and nuptial ceremonies are striking and even a little shocking to us *because* we have a concept of homosexual orientation and gay marriage. A culture that possessed no such notion would not have been struck in this way by the similarities. Lacking surface evidence, one needs to know what same-sex union was and what marriage was, so that one can compare the two or at least make sense of Boswell's claim. But Boswell does not even make clear what *he* takes same-sex union to have been.

Setting out his policies of translation at the outset, Boswell explains that where the Greek and Slavonic texts for the ceremonies use terms that might be literally translated "brother" or "become brothers," it would be misleading to translate them thus. This is because, on the one hand, "the meanings of the nouns to contemporaries were 'lover,' and 'form an erotic union,'" while on the other hand English readers will "relate such concepts more to feelings of goodwill and fraternal concern than to intimacy or romantic attachment."

Should we assume, then, that in Boswell's view same-sex unions were homoerotic? Not necessarily. Later in the book Boswell modestly claims that sexual relations between men "joined in some sort of ecclesiastical union... *probably* did not seem even mildly sinful" (my italics). (This is mere guess-work.) On the next page, he raises the question of whether same-sex unions were homosexual. Obviously (he points out), they were homosexual in the literal sense of the word, since the partners were of the same sex. But was the ceremony erotic? Boswell replies: "This is hard to answer for societies without a comparable nomenclature or taxonomy." Was the relationship intended to become erotic: "Probably, sometimes, but this is obviously a difficult question to answer about the past, since participants cannot be interrogated." Boswell then points out that "a sexual component is not generally what constitutes the definitive test of 'marriage,' particularly in premodern societies, where few people married for erotic fulfillment."

Just as Boswell fails to explain what same-sex unions were, he also fails to provide any clear account of what (heterosexual) marriage was. Statements like the one just quoted, as well as his frequent observation that in premodern societies, romantic love was (ideally) a consequence of marriage rather than its motive and origin, seem intended in part to loosen our sense of what

marriage was. But this merely negative approach, while very proper in itself, does not help Boswell's case. If one aims to prove that some new virus is a variety of influenza, one can do so only to the extent that one knows what influenza is.

To grasp the sense of Boswell's claim that the brotherhoods were equivalent to (heterosexual) marriage, one needs to have some account of what the latter was. In Christian Europe during the patristic and medieval periods, numerous exigencies—cultural, legal, theological, ascetic—caused the notion of marriage to be modified, analogically transposed, extended, stretched and delimited. Nevertheless, certain basic ideas remain visible beneath the surface.

First, marriage was by definition "the union of a man and a woman" (as the Roman jurist Ulpian said). If Boswell's implied notion of generic (homo- or heterosexual) matrimony ever existed in premodern European culture, there was never a name for it. Matrimony was a union of opposites (see Colossians 3:18–19). Second, marriage was a stable joining of a man and a woman for the sake of procreating and raising children. Hence the phrase *liberorum procreandorum causa* ("for the sake of procreating children"), which appeared on Roman nuptial documents as a way of distinguishing marriage from other relationships. The difference between marriage and concubinage, in Roman law, was that only a man's children by marriage were his own children: that is, his heirs, members of his family, and (in the case of males) the continuation of his paternal power.

More basic yet in the Judaic and Christian traditions was the notion of marriage as a union of two in one flesh. As it appears in Genesis 2:24, this is probably a complex notion, but 1 Corinthians 6:16 (where Paul, by a curious irony, applies the text to prostitution) suggests that sexual union is part of the idea. Despite the efforts of some medieval theologians, the notion of sexual consummation remained integral to the church's notion of marriage. Sex is integral to marriage in other ways—for example, in the Pauline conjugal debt (see 1 Cor. 7:2–5), which was hugely important in both Eastern and Western thinking about marriage, and in the impediments of relationship (since even an unconsummated marriage is invalid when its sexual consummation would be incestuous).

Subsuming all these elements was the nuptial symbolism that entered the Bible in the Book of Hosea and culminated in Ephesians 5:31–32, a text that compares the union of "two in one flesh" to the union between Christ and the church. This text and its theology did not appear much in the nuptial liturgies, but they were central to the theology of marriage. Moreover, the symbolism was manifest in the quasi-nuptial rite in which a woman took the veil to become a religious (a bride of Christ).

To claim that there were same-sex equivalents of marriage in this historical context is to claim that same-sex unions were supposed in some way to embody this model or something analogous to it. This does not seem possible, and in any case, I see no evidence for it. One should note that Boswell does not claim or offer any evidence to suggest that the brotherhoods were in any sense an alternative to (heterosexual) marriage or exclusive of marriage.

Buried in this very muddled book is an interesting and plausible thesis, which goes like this: On the one hand, premodern Christian culture knew nothing of gay marriage, had no concept of the homosexual person and condemned homosexual acts. On the other hand, institutionalized or otherwise socially recognized same-sex relationships, such as the brotherhoods studied here, provided scope for the expression of what we would now regard as homosexual inclinations—much more scope than was possible, for example, in the cultures of the late Middle Ages and the Reformation. They may even have occasionally provided cover for homosexual acts. (If this is what Boswell had been judged to be saying, however, the book would not have captured the media's attention.)

This book has very little bearing on the issue of gay union and gay marriage in churches today. A Christian proponent of gay marriage or even of tolerated gay unions must face the fact that such acts are a radical departure from traditional norms. One can make this departure either by honestly abandoning some or all of the tradition, or (much more tenuously) by using an historical, relativist hermeneutic to locate some deeper stream within the tradition. Both of these lines of argument have appeared in the discussion of women's ordination, which also represents a radical departure from traditional norms but which is now widely accepted. But one cannot find support either for the licitness of homosexuality or for the validity of gay marriage within the tradition of the premodern church.

POSTSCRIPT

Did Same-Sex Unions Exist in Medieval Europe?

There is little dispute that the same-sex unions that Boswell describes actually existed and were used as ritualistic ceremonies. A crucial factor in this issue is what these ceremonies represented. Were they considered the equivalent of heterosexual marriages? Or, were they merely "brotherhood" agreements, which had little religious sanction? The linguistic and textual difficulties involved in interpretations drawn from the actual ceremonies make this a difficult choice for historians.

Another problem to consider is to what extent have current conditions and exigencies powered this issue? Have present views of same-sex unions influenced the issue's construction? All scholars agree that current problems have historical antecedents, and the goal of historians is to illuminate these through historical analysis. What worries some is when it appears that a solution to the current problem seems more important than the facts that support its historical antecedents.

Historical sources on the subject of same-sex unions are far fewer than those that cover the contemporary end of the debate. Boswell's book, of course, is a necessary starting point. William N. Eskridge, Jr., provides a briefer account in "A History of Same-Sex Marriage," *Virginia Law Review* (vol. 79, 1993). A revised and updated version of this article can be found as a chapter in Eskridge's book, *The Case for Same-Sex Marriages: From Sexual Liberty to Civilized Commitment* (The Free Press, 1996). This chapter provides excellent historical background material for a book devoted to contemporary manifestations of the issue.

On the general subject of homosexuality throughout history, consult Martha Vicinus, George Chauncey, and Martin Duberman, eds., *Hidden From History: Reclaiming the Gay and Lesbian Past* (Penguin Books, 1990) and John Boswell, *Christianity, Social Tolerance, and Homosexuality: Gay People in Western Europe From the Beginning of the Christian Era to the Fourteenth Century* (University of Chicago Press, 1980). Since scripture is sometimes cited to affirm Christianity's opposition to homosexuality, Robin Scroggs, *The New Testament and Homosexuality* (Fortress Press, 1983) would be a useful source to explore.

Scholarly journals from 1994 to the present contain reviews of Boswell's books and rejoinders to them. An interesting example can be found in *The New Republic* (July 18, 1994) where Brent D. Shaw wrote a critical review that prompted a reply from Ralph Hexter in the October 3, 1994, edition of the magazine. Another review to seek out would be Robin Darling Young, "Gay Marriage: Reimagining Church History," *First Things* (vol. 47, 1994).

ISSUE 8

Were Environmental Factors Responsible for the Collapse of Maya Civilization?

YES: Richard E. W. Adams, from *Prehistoric Mesoamerica,* rev. ed. (University of Oklahoma Press, 1991)

NO: George L. Cowgill, from "Teotihuacan, Internal Militaristic Competition, and the Fall of the Classic Maya," in Norman Hammond and Gordon R. Willey, eds., *Maya Archaeology and Ethnohistory* (University of Texas Press, 1979)

ISSUE SUMMARY

YES: Professor of anthropology Richard E. W. Adams argues that although military factors played a role in the Maya demise, a combination of internal and environmental factors was more responsible for that result.

NO: Professor of anthropology George L. Cowgill states that although there is no monocausal explanation for the Maya collapse, military expansion played a more important role than scholars originally thought.

A notable civilization from long ago wrote in hieroglyphs, developed an accurate calendar, built pyramid-like structures to honor its gods, practiced polytheism with gods represented by animal imagery, and advanced in areas such as mathematics and astronomy. These characteristics could describe the ancient Egyptians. But here they are used to describe the Mayas of Mesoamerica, who established a New World civilization a millennium before the arrival of Europeans. Before this invasion, this Amerindian civilization was in a state of decline. The Spanish conquistadors, following in Christopher Columbus's footsteps, subdued all of Mesoamerica in the sixteenth century and completely destroyed what remained of its civilization. The result of this Spanish action, aided by uncontrolled ecological growth that covered what remained, was the disappearance of this once highly advanced civilization. It would remain obscured until it was rediscovered in the nineteenth century by explorers seeking to find the lost civilization of the ancient Mayas.

Within the last century, work by archaeologists, linguists, and scientists has not only exposed what remains of the Maya grandeur but, by deciphering their language, has uncovered the secrets of their advanced civilization. The continuing discoveries have inspired regular assessments of earlier theories. It was once thought, for example, that Mayas were peaceful people, with little interest in war as a means to achieving ends. Recent linguistic decypherments now tell us that this was not true. As far as the Mayas are concerned, today's theory is only as good as the latest archaeological discovery or linguistic translation, both ongoing processes.

In spite of the wealth of information on the Mayas we now possess, there are still questions that have not been definitively answered. One of the most important questions is, What caused the decline of Maya civilization? Maya scholars have developed theories regarding the decline using the best evidence presently available. However, a consensus has not yet been reached.

This issue seeks to explore the two major theories involving the Maya decline: (1) it occurred due to internal political, social, and environmental factors that the Mayas could not or would not control, and (2) the demise was brought about by factors caused by excessive militarism, which first resulted in territorial expansion and later to weakness and eventual decline. Complicating the search for answers to the cause(s) of the Maya demise are the local/regional differences present in the Maya city-states. Were factors present in the Northern Lowlands states present in their Southern counterparts? And what about their Highland brethren? Could different conditions and circumstances in each area have produced a variety of reasons for their decline? And within a region, can we be sure that the factors that led to one city-state's demise were also responsible for the collapse of others? The possibility exists that each political entity may have had its own unique set of circumstances that contributed to its decline and fall.

In spite of these instrinsic difficulties, Maya scholars continue to explore potential reasons for the civilization's collapse. Both the internal conditions and outside forces theories are considered by Richard E. W. Adams and George L. Cowgill, two noted Maya scholars. In the selections that follow, Adams considers internal stresses—overpopulation, agricultural scarcities, disease, and natural disasters—to be the major factors responsible for the collapse of the city-states of the Southern Maya Lowlands. Cowgill uses the Teotihuacan civilization, centered in the Mexican Highlands, as a "contrastive example" as to what may have happened to the civilization of the Southern Maya Lowlands. He asserts that the two areas "exhibit a similar developmental trajectory"—involving the time of their rise, growth, decline, and fall—and that the expansionist military policies that caused the eventual collapse of Teothihuacan may have also been responsible for the demise of the states of the Southern Maya Lowlands.

Future archaeological work in Central America is likely to shed more light on the reasons for the Maya decline.

Transformations

The Classic Maya Collapse

According to what we now know, Maya civilization began to reach a series of regional peaks about A.D. 650. By A.D. 830, there is evidence of disintegration of the old patterns, and by A.D. 900, all of the southern lowland centers had collapsed. An understanding of the Maya apocalypse must be based in large part on an understanding of the nature of Maya civilization. During the Terminal Classic period, A.D. 750 to 900, cultural patterns of the lowlands can be briefly characterized as follows. Demographically, a high peak had been reached at least as early as A.D. 600 and perhaps earlier. This population density and size in turn led to intensive forms of agriculture and the establishment of permanent farmsteads in the countryside. Hills were terraced, swamps were drained and modified, water impoundments were made by the hundreds, and land became so scarce that walls of rock were built both as boundaries and simply as the results of field clearance. These masses of people were also highly organized for political purposes into region-state units, which fluctuated in size. These states were more than simple aggregations of cities and were characterized by hierarchical and other complex relationships among them.

Society was organized on an increasingly aristocratic principle by A.D. 650. Dynasties and royal lineages were at the top of the various Maya states and commanded most of the resources of Maya economic life. Most of the large architecture of the cities was for their use. Groups of craft specialists and civil servants supported the elite, with the mass of the population engaged in either part-time or full-time farming. Trade was well organized among and within the states. Military competition was present but was controlled by the fact that it had become mainly an elite-class and prestige activity which did not greatly disturb the economic basis of life. Thus, Maya culture at the ninth century A.D. seems to have been well-ordered, adjusted, and definitely a success. Yet a devastating catastrophe brought it down.

Characteristics of the Collapse

It sometimes seems that the accumulation of weighty theoretical formulations purporting to explain the collapse of Maya civilization will eventually, instead,

cause the collapse of Maya archaeology. A refreshingly skeptical and clear-sighted book by John Lowe reviews the major theories and tests them as well. We will not be as thorough in the following section but, it is to be hoped, just as convincing. A brief characterization of the collapse includes the following features:

1. It occurred over a relatively short period of time: 75 to 150 years.
2. During it the elite-class culture failed, as reflected in the abandonment of palaces and temples and the cessation of manufacture of luxury goods and erection of stelae.
3. Also during the period there was a rapid and nearly complete depopulation of the countryside and the urban centers.
4. The geographical focus of the first collapse was in the oldest and most developed zones, the southern lowlands and the intermediate area. The northern plains and Puuc areas survived for a while longer.

In other words, the Maya collapse was a demographic, cultural, and social catastrophe in which elite and commoner went down together. Drawing on all available information about the ancient Maya and comparable situations, the 1970 Santa Fe Conference developed a comprehensive explanation of the collapse. This explanation depends on the relatively new picture of the Maya summarized above. That is, we must discard any notion of the Maya as the "noble savage" living in harmony with nature. Certainly, the Maya lived more in tune with nature than do modern industrial peoples, but probably not much more so than did our nineteenth-century pioneer ancestors. As we shall see, some dissonance with nature was at least partly responsible for its failure. More than this, however, data have been further developed since the conference which strengthen some assumptions and weaken others. Therefore, the explanation which follows is a modified version of that which appears in the report of the Santa Fe Conference.

Stresses

Maya society had a number of built-in stresses, many of which had to do with high populations in the central and southern areas. Turner's and other studies indicate that from about A.D. 600 to 900 there were about 168 people per square kilometer (435 per square mile) in the Río Bec zone. The intensive agricultural constructions associated with this population density are also found farther south, within 30 kilometers (19 miles) of Tikal. They are also to be found to the east in the Belize Valley, and there are indications elsewhere to the south that high populations were present. According to Saul's studies of Maya bones from the period, the population carried a heavy load of endemic disease, including malaria, yellow fever, syphilis, and Chagas's disease, the latter a chronic infection which leads to cardiac insufficiency in young adulthood. Chronic malnutrition is also indicated by Saul's and Steele's studies. Taken altogether, these factors indicate the precarious status of health even for the elite. Average lifespan in the southern lowlands was about thirty-nine years. Infant mortality was high; perhaps as many as 78 percent of Maya children never

reached the age of twenty. Endemic disease can go epidemic with just a rise in malnutrition. In other words, the Maya populace carried within itself a biological time bomb which needed only a triggering event such as a crop failure to go off.

With population pressing the limits of subsistence, management of land and other resources was a problem, and one which would have fallen mainly on the elite. If food were to be imported, or if marginal lands were to be brought into cultivation, by extensive drainage projects, for example, then the elite had to arrange for it to be done. There were certain disadvantages to this arrangement. Aristocratic or inherited leadership of any kind is a poor means to approach matters that require rational decisions. One need only consider the disastrous manner in which seventeenth-century European armies were mishandled by officers whose major qualifications were their lineages. There is a kind of built-in variation of the Peter Principle in such leadership: one is born to his level of incompetence. Maya aristocracy apparently was no better equipped to handle the complex problems of increasing populations than were European aristocrats. There were no doubt capable and brilliant nobles, but there was apparently no way in which talent could quickly be taken to the top of society from its lower ranks. Lowe's model of the collapse of Maya civilization emphasizes the management-administrative aspects of the problem and essentially considers the collapse as an administrative breakdown.

There are also signs in the Terminal Classic period of a widening social gulf between elite and commoners. At the same time, problems were increasing in frequency and severity. The elite class increased in size and made greater demands on the rest of Maya society for its support. This created further tensions. Intensive agriculture led to greater crop yields, but also put Maya food production increasingly at hostage to the vagaries of weather, crop disease, insects, birds, and other hazards. Marginal and complex cultivation systems require large investments of time and labor and necessitate that things go right more often than not. A run of bad weather or a long-term shift in climate might trigger a food crisis. Recent work on tree rings and weather history from other sources indicates that a Mesoamerica-wide drought may have begun about A.D. 850. In addition, there are periodic outbreaks of locusts in the Maya Lowlands.

These stresses were pan–Maya and occurred to a greater or lesser degree in every region. No matter whether one opts for the city-state or the regional state model, competition over scarce resources among the political units of the Maya resulted from these stressful situations. The large southern center of Seibal was apparently taken by a northern Maya elite group about A.D. 830. Evidence is now in hand of military intrusions from north to south at Rio Azul, at the Belize sites of Nohmul, Colha, and Barton Ramie, and at Quirigua in the Motagua Valley. At least at Rio Azul and Colha a period of trade preceded the raids, presaging the later Aztec *pochteca* pattern. The patterns and nature of the intrusions indicate that the raids were probably from the Puuc zone and that a part of the motivation, as suggested by Cowgill, was to capture populations. Warfare increased markedly along the Usumacinta River during the ninth century A.D., according to hieroglyphic texts and carved pictures from that area.

There are also hints that the nature of Maya warfare may have changed during this last period. A lintel from Piedras Negras appears to show numerous soldiers in standard uniforms kneeling in ranks before an officer. In other words, organized violence may have come to involve many more people and much more effort and therefore may have become much more disruptive. Certainly competition over scarce resources would have led to an increasingly unstable situation. Further, the resultant disorganization would have led to vulnerability to outside military intervention, and that seems to have been the case as well.

There were also external pressures on the Maya. Some were intangible and in the form of new ideas about the nature of human society as well as new ideologies from the Gulf Coast and Central Mexico. The northern Maya elites seem to have absorbed a number of these new ideas. For example, they included the depiction of Mexican Gulf Coast deities on their stelae as well as some Mexican-style hieroglyphs. Altar de Sacrificios was invaded by still another foreign group from the Gulf Coast about A.D. 910. These people may have been either a truly Mexican Gulf Coast group or Chontal Maya, who were non-Classic in their culture.

A progressive pattern of abandonment and disaster in the western lowlands is suggestive. Palenque, on the southwestern edges of the lowlands, was one of the first major centers to go under; it was abandoned about A.D. 810. The major Usumacinta cities of Piedras Negras and Yaxchilan (Bird-Jaguar's City) were the next to go. They put up their last monuments about A.D. 825. Finally, it was Altar de Sacrificios's turn about A.D. 910. Clearly, there was a progressive disintegration from west to east, and it seems likely that it was caused by pressures from militaristic non–Maya groups. These peoples, in turn, were probably being jostled in the competitive situation set up after the fall of Teotihuacan and may have been pushed ahead of peoples such as the Toltecs and their allies. Perhaps the Epi-Classic states discussed above were involved, as well as some mercenary groups. In any case, it appears certain that these groups were opportunists. They came into an area already disorganized and disturbed and were not the triggering mechanism for the catastrophe but part of the following process.

At any one Maya city or in any one region, the "mix" of circumstances was probably unique. At Piedras Negras there is evidence that the elite may have been violently overthrown from within. Faces of rulers on that site's stelae are smashed, and there are other signs of violence. Invasion finished off Altar de Sacrificios. Rio Azul was overrun by Maya groups from the north, perhaps including Toltec allies, as were a number of Maya centers along the Belize coast and down to Quirigua. At other centers, such as the regional capital of Tikal, the elite were apparently abandoned to their fate. Without the supporting populations, remnants of the Maya upper classes lingered on after the catastrophe. At Colha and Seibal, northern Maya acting as new elites attempted to continue the southern economic and political systems, but they abandoned these attempts after a relatively short time. The general demographic catastrophe and disruption of the agricultural systems were apparently too great to cope with.

In short, ecological abuse, disease, mismanagement, overpopulation, militarism, famines, epidemics, and bad weather overtook the Maya in various combinations. But several questions remain. What led to the high levels of populations which were the basis of much of the disaster?

The Maya were much more loosely organized politically during the Late Formative than during the Classic period. The episodes of interstate competition and of Teotihuacan's intervention seem to have led them to try new, more centralized political arrangements. These seem to have worked well for a time, in the case of the Early Classic expansion of Tikal. After the suggested civil wars of the sixth century there seems to have been a renewed and still stronger development of centralized states, which were probably monarchical.

Using general historical and anthropological experience, Demitri Shimkin observed that village-level societies approach population control very differently than do state-level societies. Relatively independent villages are oriented plainly and simply toward survival. There are many traditional ways of population control, female infanticide being a favorite practiced widely even in eighteenth-century England. Use of herbal abortion, late marriage, ritual ascetisicism, and other means keep population within bounds for a village. A state-level society, on the other hand, is likely to encourage population growth for the benefit of the directing elite. The more manpower to manipulate, the better. In the case of the Maya, we have noted a certain megalomania in their huge Late Classic buildings. Unfinished large construction projects at Tikal and Uaxactun were overtaken by the collapse. Such efforts required immense manpower reserves and a simultaneous disregard for the welfare of that workforce. The Maya appear to have shifted gears into a more sophisticated and ultimately maladaptive state organization.

Another question to be considered is, Why did the Maya not adjust to cope with the crises? The answer may lie in the nature of religiously sanctioned aristocracies. Given a crop failure, a Maya leadership group might have attempted to propitiate the ancestors and gods with more ritual and more monuments. This response would have exacerbated the crisis by taking manpower out of food production. Inappropriate responses of this sort could easily have been made, given the ideology and worldview that the Maya seem to have held. On the other hand, if the crisis were a long-term drought, with populations dangerously high and predatory warfare disrupting matters even more, perhaps any response would have been ineffectual.

The rapid biological destruction of the Maya is an important aspect of the collapse. From a guessed-at high of 12 million, the population was reduced within 150 years to an estimated remnant of about 1.8 million. The disease load and the stress of malnutritional factors indicate that a steady diminishment of Maya population probably started by A.D. 830 and rapidly reached a point of no recovery. An average increase of 10 to 15 percent in the annual mortality rate will statistically reduce 12 million to 1.8 million in 75 years. Obviously there was not anything like a steady decline, but the smoothed-out average over the period had to have been something of that order, or perhaps the decline began earlier, at A.D. 750, when Maya civilization reached its peak.

The disruptive nature of population declines can be easily understood if one considers the usual effects of epidemics. In such catastrophic outbreaks of disease, those first and most fatally affected are the young and the old. Even if the main working population survives relatively untouched, the social loss is only postponed. The old take with them much of the accumulated experience and knowledge needed to meet future crises. The young will not be there to mature and replace the adult working population, and a severe manpower shortage will result within fifteen to twenty years. Needless to say, much more work on population estimates and studies of the bones and the general health environment of the ancient Maya needs to be done to produce a really convincing statement on this aspect of the collapse.

A last, although not by any means final, question concerns the failure to recover. This feature may involve climatic factors. If shifts of rainfall belts were responsible for triggering the collapse, then the answer might be the persistence of drought conditions until there were too few people left to sustain the Classic cultural systems. As now seems probable, the Maya were confronted with the situation of having overcultivated their soils and having lost too much surface water. Temporary abandonment of fields would have led to their being rapidly overrun by thick, thorny, second-growth jungle, which is harder to clear than primary forest. Thus, a diminished population may have been faced with the problem of clearing heavily overgrown, worn-out soils, of which vast amounts were needed to sustain even small populations. Second-growth forest springs up overnight and is even today a major problem in maintaining archaeological sites for tourists.

Another possible answer to the question of recovery is that the Maya may have been loathe to attempt the sort of brilliant effort that had ultimately broken them. Just as they preferred to revert to swidden agriculture rather than maintain intensive techniques, they probably found it a relief to live on a village level instead of in their former splendid but stressful state of existence.

The above is an integrated model of the Maya collapse. It explains all the features of the collapse and all the data now in hand, but it is not proved by any means, and in some respects is more of a guide to future research than a firm explanation. If the model is more or less correct, however, it should be largely confirmed within the next ten years of research. Indeed, this process of confirmation has already begun. The 1970 conference which developed the model could explain certain features of the archaeological record only by assuming much higher levels of ancient population than were otherwise plausible at the time. The 1973 Rio Bec work of Turner and Eaton turned up a vast amount of data which indicate that higher levels of ancient populations indeed had been present. Recent work at Colha and Rio Azul has indicated the importance of militarism in the process. All of these findings lend credibility to the model.

Delayed Collapse in the North

The vast and very densely distributed centers of the Puuc area survived for a time. These Puuc cities, possibly a regional state with a capital at Uxmal, appear to have turned into predators on the southern cities. As noted before, part

of the motivation may have been for the capture and enslavement of southern populations. Even so, it seems that large centers such as Uxmal, Kabah, Sayil, and Labna lasted only a century longer than the southern cities. Northern Maya chronology is much more disputed than that in the south, but it now seems likely that outsiders, including Toltec, were in Yucatan by A.D. 900 and perhaps earlier, and there are clear indications that Uxmal was absorbing Mexican ideas much earlier. Certain motifs, such as eagles or vultures, appear on Puuc building facades late in the Classic period.

We are now faced with at least three possible explanations of the Puuc collapse: they may have succumbed to the same combination of factors that brought down the southern Maya centers; the Toltec may have conquered them; or a combination of these factors may have been at work. At this time, it appears that the northern florescence was partly at the expense of the southern area.... [E]vidence for Toltec conquest now appears even stronger, and this is presently the favored explanation for the Puuc collapse.

Chichen Itza, in north central Yucatan, is a center which was culturally allied with the Puuc cities in architecture and probably politically as well. Puuc centers have been found even in the far northeast of the peninsula. At Chichen Itza, Puuc architecture is overlaid and succeeded by Toltec architecture. Unmapped defensive walls surround both Chichen and Uxmal. The data available now make it likely that the Toltec and other groups may have appeared in Yucatan by A.D. 800 and thereafter, perhaps brought in as mercenaries, as so often happened later in Maya history. In whatever capacity they arrived, they appear to have established themselves at Chichen Itza by A.D. 950 as the controlling power. As has happened in history elsewhere, the mercenaries became the controlling forces. Toltec raids, battles, and sieges, combined with the internal weaknesses of Classic Maya culture and perhaps with changing environmental factors, brought about a swift collapse in the Puuc.

The aftermath of the collapse was also devastating. Most of the southern Maya Lowlands have not been repopulated until the last fifty years. Eleven hundred years of abandonment have rejuvenated the soils, the forests, and their resources, but modern man is now making inroads on them. Kekchi Maya Indians have been migrating into the lowlands from the northern Guatemalan highlands as pioneer farmers for the past century, and the Mexican government has colonized the Yucatan, Campeche, and Quintana Roo area with dissatisfied agriculturists from overpopulated highland areas. The forests are being logged and cut down. Agricultural colonies have failed in both Guatemala and Mexico, and some zones are already abandoned. In other areas, the inhabitants have turned to marijuana cultivation. Vast areas have been reduced to low scrub jungle, and large amounts of land are now being converted to intensive agriculture. One looks at the modern scene and wonders. Fortunately, in 1988 a movement began to set aside the remnants of the once immense monsoon forests, and it may be that a series of protected zones in the form of contiguous national parks will soon be in existence in Guatamala, Mexico, and Belize.

NO ⤶

George L. Cowgill

Teotihuacan, Internal Militaristic Competition, and the Fall of the Classic Maya

In very broad terms, the Teotihuacan civilization, centered in the Mexican Highlands, and the Classic civilization of the Southern Maya Lowlands exhibit a similar developmental trajectory. That is, both enjoyed a period of development, flourished for a time, and then collapsed. But as soon as one looks beyond these gross generalities, the evidence from each region shows striking differences in the pace and timing of events. These differences are of interest in their own right, and one of my objectives is to call attention to them. In addition, however, they help to direct our attention to some of the distinctive features of the Maya trajectory which are relevant for understanding the functioning of Late Classic Maya society and for explaining its collapse. My main concern is to point out difficulties in some recently proposed explanations... and to suggest that escalating internal warfare may have been more a cause than a consequence of serious trouble for the Maya. I do not suggest warfare as a mono-causal explanation for the Maya collapse, but I do think it may have been an important contributing factor, and old evidence should be re-examined and new evidence sought with this possibility in mind.

Emphasis on Maya warfare is part of a widespread recognition that the Maya were not the gentle pacifists that some archaeologists would have them be. But there is a difference between sporadic raiding, with occasional enslavement or sacrifice or captives, and what David Webster calls *militarism*: institutionalized warfare intended for territorial aggrandizement and acquisition of other capital resources, with military decisions part of the conscious political policy of small elite, semiprofessional warriors, and lethal combat on a large scale. Webster and I both argue that the Late Classic Maya may have become militaristic in this sense, but we differ about the probable dynamics and consequences of Maya militarism.

Although it is clear that there were important contacts between the Highlands and the Southern Maya Lowlands, I should stress that I am *not* arguing that either Teotihuacan intervention or the withdrawal of Teotihuacan contacts played a decisive role in the Maya collapse. Direct or indirect contacts with

From George L. Cowgill, "Teotihuacan, Internal Militaristic Competition, and the Fall of the Classic Maya," in Norman Hammond and Gordon R. Willey, eds., *Maya Archaeology and Ethnohistory* (University of Texas Press, 1979). Copyright © 1979 by University of Texas Press. Reprinted by permission. References omitted.

Teotihuacan are important and extremely interesting, but I doubt if they explain much about either the rise or the fall of the Lowland Maya. In any case, my use of the Teotihuacan data here is purely as a contrastive example.

It is often assumed that Teotihuacan developed rather steadily up to a distinct peak somewhere around A.D. 500 to 600, after which it soon began a fairly rapid decline.... [L]argely through the data obtained by the comprehensive surface survey and limited test excavations completed by the Teotihuacan Mapping Project, under the direction of René Millon, evidence for a very different pattern has emerged....

Briefly, it appears that the city of Teotihuacan enjoyed an early surge of extremely rapid growth, followed by a four-to-five-century "plateau" during which growth was very much slower or may even have ceased altogether. Then, probably not before the eighth century A.D., the city collapsed, apparently rather rapidly. This pattern is most clearly suggested by the dates of major monumental construction in the city, but it is also suggested by the demographic implications of quantities and areal spreads of ceramics of various periods, both in the city itself and in all parts of the Basin of Mexico which have been systematically surveyed. Further support comes from data on Teotihuacan obsidian industry.

In contrast, the Maya site of Tikal was settled at least as early as Teotihuacan but developed more irregularly to a modest Late Preclassic climax, followed apparently by something of a pause. There seems to have been a second peak in Early Classic times, and then a distinct recession for a century or so. Then there was a relatively brief burst of glory in the seventh and eighth centuries, immediately followed by rapid decline and very drastic population loss. Tikal population may have been relatively stable from about A.D. 550 until after A.D. 800, or it may have shot up rapidly during the 600's to a short-lived maximum in the 700's. In either case, however, it seems clear that the Late Classic population of Tikal was larger than that at any previous time. Other major sites in the Southern Maya Lowlands had rather different trajectories, but they also generally peaked during the Late Classic and collapsed during the ninth or tenth centuries.

There are also striking contrasts in spatial patterns. The early growth of Teotihuacan is concomitant with rapid and marked decline in the number and size of other settlements in the Basin of Mexico. Teotihuacan quickly achieved, and for several centuries maintained, a size probably twenty or more times larger than any other known Basin of Mexico settlement. Even Cholula, in the Valley of Puebla some ninety kilometers away; does not seem to have covered more than a sixth of the area of Teotihuacan, and other settlements in the Tlaxcala–Northern Puebla area were much smaller. In the Southern Maya Lowlands there were other major centers comparable in size to Tikal, and below these there was a hierarchy of other sites ranging from fairly large secondary centers to small hamlets and individual households. (In contrast to Marcus, Hammond argues that present evidence is insufficient for assigning specific sites to specific hierarchical levels, although hierarchies probably existed. The very fact of the controversy points up the contrast with Teotihuacan, where there is no dispute at all about its primacy in the settlement hierarchy.) There

is no suggestion that Tikal or other major centers ever drew people away from other sites or monopolized power to anywhere near the extent that Teotihuacan did in central Mexico. . . .

Implications of the Teotihuacan Evidence

Several implications of the Teotihuacan pattern suggest themselves. The long duration of Teotihuacan seems unreasonable unless economic and political power were quite strong and quite effectively centralized in the city, and much other evidence also suggest this. In contrast, both the more or less concomitant development of many Lowland Maya centers and the dynastic evidence so far gleaned from inscriptions indicate that no single Southern Lowland Maya center ever gained long-term firm political or economic control of any very large region, although there is plenty of evidence for brief domination of one center by another, and of political alliances often bolstered by dynastic marriages.

The obvious next step is to suggest that Teotihuacan was long-lived and highly centralized because it was a "hydraulic" state, based on intensive irrigation agriculture in a semiarid environment, while the Southern Maya Lowlands was politically less centralized and enjoyed a much briefer climax because of critical deficiencies in its tropical forest environment. I do not think that environmental considerations are unimportant, but I do feel that there are extremely serious difficulties with these explanations.

Discussions of Teotihuacan irrigation usually do not deal adequately with its *scale.* Evidence for pre-Toltec irrigation in the Teotihuacan Valley remains circumstantial rather than direct, but it seems quite likely that canal irrigation there does date back to Patlachique or Cuanalan times. But the maximum area available for permanent canal irrigation is less than four thousand hectares. This is not a very large area, nor does it call for large or complex canals, dikes, or flood-control facilities. Assuming a peak population of 125,000, there would have been about one irrigated hectare for 30 people. It is clear that the city grew well beyond any population limits set by irrigation agriculture, and a substantial fraction of its subsistence must have come from other sources, including riskier and much less productive alternative forms of agriculture, and collecting and hunting wild plants and animals. Faunal analyses and paleoethnobotanical studies provide evidence that Teotihuacanos ate a wide variety of wild as well as domesticated plants and wild animals.

It seems unlikely that there were any environmental or purely technical factors which would have made it impossible for the Teotihuacanos to have practiced intensive chinampa agriculture in the southern part of the Basin of Mexico. Chinampas were an important subsistence source for the Aztec population, which was much larger than the Teotihuacan population. Yet there is no evidence for extensive use of chinampas in Teotihuacan times. It is tempting to speculate that technical difficulties in assembling food for more people in one place may be at least part of the reason that Teotihuacan grew so little after Tzacualli times (a point also made by J. R. Parsons). If indeed there were environmental reasons, such as a change in lake levels, which prevented extensive chinampa exploitation in Teotihuacan times, then Teotihuacan is an instance

of a population which expanded until it approached a perceived subsistence limit and then stabilized, rather than disastrously exceed that limit. If, as seems more likely, there was no environmental reason why the Teotihuacanos could not have fed more people by simply moving part of the population down to the chinampa area and investing in chinampa developments, their apparent failure to do so must have been for social or political reasons. If so, Teotihuacan population growth in the Basin of Mexico halted at a level well below the number of people it would have been technically possible to feed.

Teotihuacan's behavior has particular significance for the Maya because Culbert suggests that the Maya collapsed because they were unable to control runaway expansion which caused them to "overshoot" disastrously the productive limits of their environment.

Whether or not I am right in suspecting that Teotihuacan population growth leveled off before environmental limits were approached, it is logically inescapable that it was biologically possible for Teotihuacan population to have continued to expand until it "overshot" all technically feasible subsistence possibilities. If it were simply the case that rapid development tends to acquire a sort of momentum which carries it beyond environmental limits and into disaster before it can be stopped, then the ability of the Teotihuacanos to slow down and stop short of disaster would be puzzling.

An extended discussion of Teotihuacan's eventual collapse is not possible here, but I should add that I do not know of any convincing evidence that even the end of Teotihuacan was primarily due to climatic deterioration or other environmentally generated subsistence difficulties. Growing competition from other Highland centers was probably important, and I suspect that Teotihuacan may have collapsed for political, economic, and military reasons, rather than purely ecological reasons.

Proponents of either "population pressure" or "hydraulic" explanations for early states may perhaps argue that Teotihuacan "plateaued" instead of overshooting because the power of the state was very much stronger and more centralized than in the Maya cities, so that when the disastrous consequences of further expansion of the city became evident, the state had the power to intervene effectively and halt further population growth. Possibly this may be part of the explanation, but I do not think this explanation is required. The main reason may have been that there was simply no advantage in further expansion that would have offset attendant inconveniences. There is much evidence that population growth rates are very responsive to shifts in other variables. Assuming the Southern Lowland Maya did indeed "overshoot" their environment, even in the face of growing subsistence difficulties, it is the Maya behavior which is puzzling—far more puzzling than Culbert assumes—and it is the Maya "overshoot" rather than the Teotihuacan "plateau" which is most in need of explanation.

Culbert's "overshoot" explanation of the Maya collapse is one of the least unsatisfactory suggestions made so far. Culbert himself cogently disposes of most previous explanations. And archaeological evidence for the Southern Maya Lowlands in the eighth century does suggest a population so large that, in spite of evidence for terraces, ridged fields, and tree and root crops in addition to

swidden, a subsistence crisis seems a real possibility. Nevertheless, there are serious problems with Culbert's explanation. He speaks of many causal factors, but inspection shows that excessive population growth plays a central role in his model. And, in his 1974 book, he offers no particular explanation for the population growth itself. More recently he has attributed population growth to economic development. But the question remains: what would have driven the Maya to expand population and/or environmental exploitation to the point where a subsistence crisis was produced? And if, instead, there was little population growth after about A.D. 550, as Haviland (1970 and personal communication) argues, then the postponement of collapse for some 250 years seems even more puzzling.

A different explanation for the Maya collapse suggests that the eighth-century Maya "florescence" was not, in fact, a time of Maya prosperity at all, but instead an attempt to cope with already serious troubles. This theory, if I understand it correctly, suggests that ability to obtain foreign goods by trade was critical for elite Maya prestige, for the power that derived from that prestige, and as a means of providing incentives for local production. Exclusion of central Peten elites from developing Mesoamerican trade networks supposedly precipitated a crisis for these elites, in which they attempted to offset their sagging prestige by even more ambitious monumental construction projects. But clearly nothing indispensable for subsistence was lacking, and prestige games can be played with whatever one defines as status markers, as Sanders points out. Goods need not be obtained by long-distance trade in order to be scarce and valuable. Furthermore my guess is that the decline of Teotihuacan, if anything, expanded the possibilities for profitable trade by Southern Lowland Maya elites. Webb's postulated development of new Mesoamerican trading networks following the decline of Teotihuacan seems, in very broad outline, a reasonable possibility. But I am much less persuaded than either Webb or Rathje that, at least at first, the Southern Lowland Maya were unable to participate in these new developments. The scale and substance of Late Classic Maya material civilization argues that they *were* able to profit from the situation, at least for a time. To be sure, there is some evidence for poor nutritional status for some Lowland Maya, but the same was probably true for much of the English and Western European population at the height of rapid economic growth in the early decades of the Industrial Revolution. It may well be that Late Classic Maya wealth was very unevenly distributed, and it also may be that the Late Classic Maya of the Southern Lowlands were increasingly "living off ecological capital," but this does not mean that the elites were already badly off, or were doing what they did in order to cope with resource pressures or an unfavorable balance of trade. The argument that the Late Classic Maya were already in serious trouble in the seventh or eighth centuries is unconvincing. Exclusion from trade networks does seem a good explanation for nonrecovery after the collapse, but not for the collapse itself....

It seems likely that in Late Classic times there was general economic development in a number of regional centers in the Southern Maya Lowlands, perhaps at least in part because of the weakening of Highland states such as Teotihuacan and Monte Alban. More speculatively, the elites of the individual

centers may have increasingly seen it as both feasible and desirable to extend strong control over a relatively large surrounding area—a control based more on conquest and annexation than on political alliance and elite intermarriage. Population growth may well have been a concomitant of this economic and political development. My argument here and previously is not that population growth rarely occurs, nor that population growth does not have important reciprocal effects on other variables. My objections, instead, are to the idea that population can be counted on to increase for no reason except human procreative proclivities, and to the idea that competition and militaristic warfare would intensify mainly as a response to subsistence shortages. Instead, I suggest that if population was increasing, it was because it was useful either to elites, to peasant households, or to both. And I suggest that intensified militaristic competition is a normal extension of intensified economic competition.

Mayanists are accustomed to assuming that the political institutions of the Classic Maya Lowlands were marginally statelike. I suggest that we should seriously consider the possibility that by the seventh and eighth centuries the combination of economic development, population growth, and social changes was leading to the emergence of more highly developed and more centralized governmental structures—the kinds of structures which would make the incorporation of many small states into a single reasonably stable empire seem a realistic possibility. I would not venture to make further conjectures about the specific forms of these new political and economic developments. However, archaeological and epigraphical evidence promises not only to test the general proposition, but also to shed a great deal of further light on the precise forms of Maya political and economic organization.

What I suggest, then, is that eventually the major Maya centers may have begun to compete for effective political mastery of the whole Southern Lowlands. This postulated "heating up" of military conflict, for which there is some support in Late Classic art and inscriptions, may have played a major role in the Maya collapse. If, indeed, population growth and/or utilization of the environment expanded beyond prudent limits, the spur may have been provided by militaristic competition. And even if population and production did not expand beyond feasible steady-state values (under peaceful conditions), intensified warfare may have precipitated disaster through destruction of crops and agricultural facilities and through disruption of agricultural labor cycles. Clearly, internal warfare is not "the" single cause of the Maya collapse, but I believe it deserves renewed consideration as a contributing factor.

Webster also places new stress on the role of warfare in Maya history, but our views and emphases differ in several important ways. First, he is mainly concerned with Preclassic and Early Classic warfare as one of the causes of the *rise* of Maya civilization. This is a topic I have not discussed here. My feeling is that Webster makes some good points—there is certainly clear evidence for some Maya warfare quite early—but he probably overestimates the explanatory importance of early warfare. Second, Webster tends to see warfare largely as a response to shortages in land or other subsistence resources. I believe that this underestimates other incentives for warfare, especially for large-scale militaristic warfare. Third, Webster places much less stress than I do on Late Classic

economic development, and he differs sharply on the matter of political integration. He feels that even the largest autonomous political units were never more than forty to sixty thousand people and that incorporation of further large increments of population, especially at considerable distances, proved unworkable. Presumably, although Webster does not explicitly discuss the matter, he would assume that serious attempts to incorporate many more people and more land and other resources within single states did not play a significant role in Maya history. He does feel that warfare may have contributed to the Maya collapse, but he explains intensified warfare mainly as a consequence of the manipulation of militarism by the Maya elite for bolstering their control of their own subject populations, rather than for any extensive conquests of other states. He says that conflicts may also have intensified over strategic resources, especially capital improvements for intensified agriculture, in the intermediate zones between major centers, but he does not suggest that there may have been major attempts to expand beyond the intermediate zones to gain control of the other centers as well. He does not suggest, as I do, that an important contributory element in the Maya collapse may have been a struggle—violent, protracted, and unsuccessful—to bring into being something like the kind of polity Teotihuacan had succeeded in creating several centuries earlier.

POSTSCRIPT

Were Environmental Factors Responsible for the Collapse of Maya Civilization?

In studying the decline of civilizations, it is generally easy to see that, in most instances, a combination of internal and external factors are responsible for their demise. This is certainly true for the Mayas. Both Adams and Cowgill would agree that there is no single explanation for the Maya collapse; the question seems to be, Which set of factors was more responsible for the demise? Complicating the search for answers to the Maya collapse are the regional and individual differences that existed within the myriad of city-states that provided the civilization with its political base. It should be noted that the reasons for their collapse could differ due to regional or local conditions. Today's research seems to bear out the existence of this dichotomy.

Studying the reasons for the Maya collapse offers an opportunity to compare/contrast Maya civilization with another civilization that experienced a similar rise/decline/fall trajectory. The Indus Valley civilization, whose collapse has been covered in Issue 2, exhibited many of the same characteristics as the Mayas and with the same catastrophic results. Historians have noticed these similarities. A book entitled *Harappan Civilization: A Contemporary Perspective*, Gregory L. Possehl ed., contains an article entitled "Did the Maya Collapse? A New World Perspective on the Demise of Harappan Civilization." In this article Robert Sharer examines whether the two civilizations made similar errors that led to their collapse and eventual disappearance. In Normal Yoffee and George L. Cowgill, eds., *The Collapse of Ancient States and Civilizations* (University of Arizona Press, 1988), similar comparisons are made betweeen Mesopotamia, Rome, and ancient China's rise and fall and those of the Mayas. Can what is learned from such comparisons offer any clues regarding the possible collapse of contemporary nation-states, including our own?

There are many highly recommendable books on the Mayas. A good starting point is *The Classic Maya Collapse*, edited by T. Patrick Culbert (University of New Mexico Press, 1983), which contains a series of essays by Maya scholars, each covering an aspect of the civilization's demise. Charles Gallenkamp's *Maya: The Riddle and Rediscovery of a Lost Civilization* (Penguin Books, 1987) offers a short, readable account of the civilization's history. The second edition of John Henderson's *The World of the Ancient Maya* (Cornell University Press, 1997) presents a handsome, up-to-date account of Maya civilization. The work of the late Linda Schele has contributed enormously to our knowledge of the Mayas. *The Code of Kings: The Language of Seven Sacred Maya Temples and Tombs* (Scribner, 1998), written with Peter Mathews, is the most recent work.

ISSUE 9

Were the Crusades Primarily Motivated by Religious Factors?

YES: Hans Eberhard Mayer, from *The Crusades*, 2d ed., trans. John Gillingham (Oxford University Press, 1988)

NO: Ronald C. Finucane, from *Soldiers of the Faith: Crusaders and Moslems at War* (St. Martin's Press, 1983)

ISSUE SUMMARY

YES: German historian Hans Eberhard Mayer states that although there were other factors important to the development of the Crusades, the strongest motivation was a religious one.

NO: British historian Ronald C. Finucane counters that although the religious influence on the Crusades was significant, political, social, economic, and military factors in medieval Europe also played a role in their origin, development, and outcome.

One of western European history's defining moments occurred in Clermont, France, in 1095 C.E. when Pope Urban II delivered an address in which he urged Christian Europe to support a movement to wrest the Holy Land from Moslem forces, which had been in control for almost 500 years. This speech set in motion a series of events, which were to span more than two centuries, and caused results that would dramatically shape the future not only of Western Europe but of the Muslim world as well. The name given to this movement was the Crusades.

From the onset, the Crusades were shrouded in myth and mystery. For example, although there are four known versions of Urban's speech, none of them has a real claim on authenticity. So the exact words Urban used to stir the crowd are not known. It has been up to historians to discern the pope's intentions from the accounts of his speech as well as his subsequent writings and actions. Even 1,000 years later there are more questions about the Crusades than answers. And, as historian Ronald C. Finucane has stated, many of the questions raised are perhaps unanswerable.

There are many important questions about the Crusades for historians to ponder: What was the physical composition of the Crusades? What social

classes were represented? To what extent did women participate? How good was the leadership? How organized were those who participated in the Crusades? What immediate and long-range effects did the Crusades have on Western Europe and the Muslim world?

In spite of the significance of these questions, the one that seems to be of paramount importance to historians is the question of motivation. What caused thousands of people from all countries in Europe, representing a cross section of the continent's class structure, to leave their lives behind and make a perilous journey from which they might not return? What did they hope to gain?

At first glance, the answer seemed simple: the Crusaders embarked on their quest for religious reasons, to wrest the Holy Land from the Muslim world, thus allowing Christians to participate in the ultimate pilgrimage. Stories abounded of Muslim desecration of Christian holy sites and Muslim mistreatment of Christians. And with Western Christendom's primary leader urging the Crusaders on—even offering indulgences (full or partial remission of one's sins) as an incentive—the question seemed to have a logical answer.

But historical questions seldom have simple answers, and further study brought several other possibilities. Could the feudal system with its insistence on primogeniture (the inheritance of family lands by the oldest son, leaving younger sons with few opportunities, and possibly encouraging the younger sons to seek fame and fortune elsewhere) have been a factor? Were economic factors involving trade and commerce important? And how much was the militaristic nature of medieval society responsible for the Crusades?

In a millennium of Crusade historiography, motivation seems to revolve around two different interpretations—the religious and the secular. The former seeks the answers to Crusader incentive in sacred dimensions, pilgrimages, indulgences, and participation in a just war against despised infidels. The latter discovers interpretations in the economic, social, political, and military worlds of Western Europe, with impetus coming from potential upward mobility, the possible revival of trade and commerce, the search for new kingdoms in the East, and the martial spirit that characterized the Middle Ages.

From all of this, one certainty can be deduced: it is impossible to separate the two factors—the sacred and the profane—with regard to Crusader motivation. Thus, most historians consider both motivations as important to our understanding of the Crusades. For example, in the following selections, Hans Eberhard Mayer stresses the role of the "other-worldly," while Finucane spotlights the influence of secular motivations.

Hans Eberhard Mayer

 YES

The Origins of the Crusades

Pope Urban II opened the Council of Clermont on 18 November 1095—the moment that has gone down in history as the starting point of the crusades....

The success of the Clermont appeal has still not been fully explained and probably never can be. Nor will any definitive interpretation be offered here; after all, the reasons for taking the cross varied considerably from one individual to another. All one can do is to examine a whole range of spiritual and worldly motives of different kinds which coalesced not only to produce the spark of that unique and spontaneous success at Clermont but also to light a fire which burned for two hundred years.

Originally the object of the crusade was to help the Christian Churches in the East. However unnecessary such help may, in fact, have been, it was in these terms that Urban is supposed to have spoken at Clermont. But very soon men had a more definite object in mind: to free the Holy Land and, above all, Jerusalem, the Sepulchre of Christ, from the yoke of heathen dominion.... Jerusalem cannot have been used merely as a lure; the name was too potent and would inevitably have pulled the whole enterprise in this one direction. It is rather more likely in view of the evident lack of over-all planning that Urban had not in fact made much of Jerusalem while at Clermont but that during the course of the next year he gave in to public opinion which needed and created a concrete goal....

Even the mere sound of the name Jerusalem must have had a glittering and magical splendour for the men of the eleventh century which we are no longer capable of feeling. It was a keyword which produced particular psychological reactions and conjured up particular eschatological notions. Men thought, of course, of the town in Palestine where Jesus Christ had suffered, died, been buried, and then had risen again. But, more than this, they saw in their minds' eye the heavenly city of Jerusalem with its gates of sapphire, its walls and squares bright with precious stones—as it had been described in the Book of Revelation and Tobias. It was the centre of a spiritual world just as the earthly Jerusalem was, in the words of Ezekiel 'in the midst of the nations and countries'. It was a meeting place for those who had been scattered, the goal of the great pilgrimage of peoples where God resides among his people; the place

at the end of time to which the elect ascend; the resting place of the righteous; city of paradise and of the tree of life which heals all men. . . .

Counting for just as much as the images conjured up by a child-like, mystical faith was the long tradition of pilgrimage to Jerusalem. As early as 333 a pilgrim from Bordeaux reached Palestine; and not much later a Gallic noblewoman named Egeria visited the Holy Places leaving to posterity a report which is as important a monument of a Latin changing from ancient to medieval as it is for the topography of the *loca sancta*. In 386 Saint Jerome settled in Bethlehem; half a century later the Empress Eudocia went into retreat at Jerusalem. Monasteries and hospices were built to receive the travellers who, following the new fashion—as it can fairly be called—came to Palestine. The stream of pilgrims never dried up, not even after the Arab conquest of the Holy Land in the seventh century. The growing east-west trade in relics played some part in awakening and sustaining interest in the Holy Places, but more important was the gradual development of the penitential pilgrimage. This was imposed as a canonical punishment and for capital crimes like fratricide it could be for a period of up to seven years and to all the great centres: Rome, San Michele at Monte Gargano, Santiago di Compostella and, above all, Jerusalem and Bethlehem. With the belief that they were effective ways to salvation the popularity of pilgrimages grew rapidly from the tenth century onwards. Saint John of Parma journeyed no less than six times to the Holy Land—given the conditions of travel at the time an astonishing achievement. Men of violent passions like Fulk Nerra, Count of Anjou, or Robert the Devil, Count of Normandy, went on pilgrimages to Jerusalem when their consciences plagued them on account of the crimes they had committed against church and monastery, so sometimes they had to go more than once. Returning from one of these pilgrimages Fulk founded the abbey of Beaulieu near Loches and gave it as its chief relic a piece of stone which he was said to have bitten off the Holy Sepulchre while kneeling before it in ecstatic prayer. The new Cluniac order, gaining all the time in prestige and influence, used its far-flung net of contacts and its genius for organization both to urge men to go on pilgrimages and to improve facilities for those who did. For many pilgrims in the eleventh century the journey to Jerusalem took on a still deeper religious meaning; according to Ralph Glaber, himself a Cluniac monk, it was looked upon as the climax of a man's religious life, as his final journey. Once he had reached the Holy Places he would remain there until he died.

It is clear that in the middle of the eleventh century the difficulties facing pilgrims began to increase. In part this was a result of the Seldjuk invasions which made things harder for travellers on the road through Anatolia—a popular route because it permitted a visit to Constantinople. But it was also a consequence of the growing number of pilgrims, for this worried the Muslim authorities in Asia Minor and Palestine, just as the Greeks in south Italy looked sceptically upon the groups of Norman 'pilgrims' who were all too easily persuaded to settle there for good. It has been suggested that the Muslims may have had a commercial interest in promoting pilgrimages but, except perhaps in Jerusalem itself, the income from this source cannot have been very significant—poverty was, after all, one of the ideals of the pilgrim. So there was

little or no incentive for them to make the journey any easier. Conditions were, of course, nothing like as bad as they had been during the persecution of the Christians under the mad caliph, Hakim, who, in 1009, had had the Church of the Holy Sepulchre in Jerusalem destroyed; but neither were they as favourable as they had been during the great days of the Byzantine Empire or in the time of Charlemagne who had himself taken a keen interest in the pilgrimage to Palestine. Yet despite the occasional trouble the number of pilgrims grew steadily. In 1064–5 Bishop Gunther of Bamberg led a party over 7,000 strong into the Holy Land. Near Ramleh in Palestine they were suddenly attacked by Muslims and for several days they had to fight a defensive battle. It is not easy to explain how they managed this since pilgrims were always unarmed.

Here we have reached the critical point of difference between crusader and pilgrim. The crusader carried weapons. A crusade was a pilgrimage, but an armed pilgrimage which was granted special privileges by the Church and which was held to be specially meritorious. The crusade was a logical extension of the pilgrimage. It would never have occurred to anyone to march out to conquer the Holy Land if men had not made pilgrimages there for century after century. The constant stream of pilgrims inevitably nourished the idea that the Sepulchre of Christ ought to be in Christian hands, not in order to solve the practical difficulties which faced pilgrims, but because gradually the knowledge that the Holy Places, the patrimony of Christ, were possessed by heathens became more and more unbearable. If the link between pilgrimage and crusade is obvious, the credit for bringing it about belongs to Urban II. Although historians today are less inclined to argue that the crusades were caused by increasing difficulties in the way of pilgrims, it still remains true that pilgrimages were of decisive importance in the rise of the crusading movement. In Erdmann's words, Urban 'took the popular but, in practical terms, unfruitful idea of pilgrimage and used it to fertilize the war upon the heathen'. It is significant that contemporaries were at first unable to distinguish clearly between the two things. Not until the mid-thirteenth century was there a Latin word for 'crusade' and even then it was seldom used. (The English word crusade, like the German word *Kreuzzug,* was only invented in the eighteenth century.) In the Middle Ages men almost always used circumlocutions like *expeditio, iter in terram sanctam* (journey into the Holy Land) and—especially early in the crusading period—*peregrinatio,* the technical term for pilgrimage. The line between crusade and pilgrimage was obviously a blurred one....

One more motive for taking the cross remains to be considered; and this one was to put all the others in the shade. It was the concept of a reward in the form of the crusading indulgence. In modern Roman Catholic doctrine the indulgence comes at the end of a clear process of remission of sins. First the penitent sinner must confess and receive absolution so that the guilt of the sin is remitted and instead of suffering eternal punishment he will have to suffer only the temporal penalties due to sin. (It is important to note that these penalties may take place either in this world or the next and will include purgatory.) Then in return for indulgence-earning works the Church may grant him remission of all or part of the penalty due to sin, depending on whether the indulgence is a plenary one or not. This is a judicial act of grace based on the

authority of the Church's power of the keys and is entirely separate from the sacrament of penance. The indulgence would affect both the canonical punishment imposed by the Church—the penitential punishment—and the temporal punishment imposed by God, since the Church could offer God a substitute penance from the 'Treasury of Merits'—an inexhaustible reservoir of merits accumulated by Christ and added to by the saints on a scale far in excess of what they themselves needed. Undoubtedly then the indulgence has a transcendental effect before God (*in foro Dei*). Where the theologians disagree with one another is on the question of whether one can absolutely guarantee that this judicial act will have a positive result *in foro Dei* or whether it runs up against the problem of God's freedom. In this case the positive result is only indirectly and morally assured in as much as the Church guarantees that the offer of a substitute penance is sufficient to discharge the whole of the punishment due, i.e. the sinner could not have achieved any better result even if he had himself done full penance. But when considering early indulgences, especially the first crusading indulgences, it is vital to remember that this logical doctrine was a later construction designed to give theological authority to customs which, in practice, already existed.

Not until after the First Crusade did the theologians of the twelfth century, first among them Hugh of St. Victor, work out—in practical, if not yet in formal terms—the distinction between the guilt of sin and the punishment due to sin which is crucial to the theory of indulgences. And not until *c.*1230 was the important doctrine of the 'Treasury of Merits', which provided the equivalent substitute necessary if punishment were to be remitted, formulated by Hugh of St. Cher. The detailed problems of the precise nature of an indulgence and the justification for it were hotly disputed in the twelfth and thirteenth centuries. Even St. Thomas Aquinas was clearly hard put to it to explain the indulgence because he began his proof of it by producing a classic logical fallacy (*petitio principii*): 'Everyone agrees that indulgences are effective because it would be godless to say that the Church does anything in vain.' Where even theologians found much obscure, there was little chance of popular opinion being well-informed. Any discussion of the crusades must take this point more fully into consideration than has hitherto been customary. In assessing the effect of the crusading indulgence what matters is what people understood or believed they understood by it, not what it actually was. And it is worth noting that the debate about indulgences which started *c.*1130 was sparked off by the fact that they were being abused. As long as the abuses were not too blatant, people looked upon the indulgence as an acceptable innovation without bothering too much about the theology of the matter. We must always remember that the publicizing of the first crusading indulgence took place in an atmosphere which was free of the limitations imposed either by an official Church pronouncement or by a proper theological debate. The only way the new elements could be defined was by comparing them with earlier penitential practices.

The indulgence must, in fact, be seen as a development of the Church's earlier penitential discipline. This was originally divided into three stages: confession, satisfaction, and reconciliation (i.e. being readmitted to communion). Satisfaction was looked upon as the element which earned extinction of sins

and thus made the reconciliation possible. At this time no distinction would have been made between remission of guilt and remission of punishment. In principle, the penance had to be equivalent to the sin committed. One had to pay, as it were, pound for pound. But obviously it was only a matter of chance whether or not a precisely equivalent penance was found; thus in addition there had to be the temporal penalties due to sin which, being imposed by God, could measure exactly any guilt that was still remaining. Since God's temporal punishment was feared far more than any earthly penance, a penitential system of draconic severity was developed on the theory that the harsher the penance in this world, the smaller would be the settlement in the next. The fact that up until the sixth century only serious offences were subject to the penance of the Church helped to establish the severity of penitential practice. Yet when, for reasons which cannot be gone into here, this changed so that penance had to be done for venial sins as well, the old system at first remained in force. But now harsh tasks and long penances during which the sinner remained excluded from the sacraments were no longer always appropriate, so inevitably there developed a trend towards a milder and a more differentiated system of punishment. At first this was done by the use of commutation and redemption, i.e. one form of punishment was exchanged for another which theoretically was still equivalent to the sin committed. Thus if it were shorter, it was also supposed to be harder; but in practice it tended to be more lenient. Lists of the penalties due to various sins were drawn up tariff-fashion in the 'Penitentials', together with the appropriate redemptions. In these redemptions we have one of the main roots of the crusading indulgence. In the eleventh century the system became still milder when it became customary to allow reconciliation to take place as soon as a man had begun his penance, though of course he still had to complete it. Thus long-term excommunication—one of the most feared consequences of sin—was in effect abolished. This change also meant the end of the old custom of total reconciliation. Its place was taken by an absolution granted immediately after confession. This involved reconciliation with God and the Church, i.e. forgiveness of the guilt of sin, but it did not mean full remission of the punishment due to sin. Nevertheless absolution went further than redemption and thus came closer to the indulgence in that the Church made a powerful plea for pardon; so a transcendental effect was at least intended. This was still not a judicial act, however, nor was it a remission of punishment granted independently of the sacrament of penance. But from here it was only a short step to the indulgence, i.e. to a more clearly defined and more certainly effective remission of the penance imposed by the Church. By an act of grace allowance was made for the transcendental effect *in foro Dei* of the Church's plea. This then made it possible to curtail the penance imposed by the Church. According to Poschmann, one of the leading Catholic experts on the subject, 'the indulgence was no longer just a part-payment on the time after death, it was also a most welcome relief during this earthly life'. The special feature of the indulgence was that the ideal of equivalence was no longer adhered to in practice. Later on the doctrine of the 'Treasury of Merits' was developed in order to justify this practice.

It is revealing that the idea of indulgence only became really effective when it was linked with the pilgrimage to Jerusalem. Papal pronouncements rather similar to indulgences were occasionally made before the crusades, but these were, in fact, usually absolutions. Alexander II, for example, promised a remission of penance to the soldiers who had joined the Barbastro expedition of 1063. In addition he also offered them the *remissio peccatorum,* the remission of the temporal penalties due to sin. It has been argued that the pope's letter is a forgery, but in fact it is a perfectly genuine plenary indulgence. Yet for various reasons it had very little effect. For one thing, it was addressed to a much smaller group than was the crusading indulgence of 1095. Alexander's offer applied only to those who had already decided to take part in the Spanish campaign; and he left it open whether he would extend the terms of the indulgence to include those who joined later. Furthermore normal penitential practice was adhered to in that a penance had first to be imposed, at least formally, before it could be considered as cancelled by the indulgence. Finally a campaign in Spain did not have the same mass-appeal as an expedition to the Holy Land. This example shows clearly why the full effects of the indulgence were felt only when it became linked with the pilgrimage to Jerusalem.

In this context it was important that the penitential journey to Jerusalem was thought to be especially meritorious and salutary. In theory the Church had always taken the view that movement from one place to another did not bring a man any nearer to God; but it was impossible to extinguish the popular belief in the value of a pilgrimage to Jerusalem. Its popularity was assured from the moment when the reconciliation with the Church was moved forward to the beginning of the work of penance, in this case the pilgrimage. This applied, of course, to any penitential pilgrimage; what gave Jerusalem its special significance was the tradition of the Holy Places. There is evidence from as early as the eighth century for the belief that remission of sins could be earned by a visit to the Church of the Holy Sepulchre. But those who shared this belief in the value of pilgrimages were denounced at the Council of Chalons in 813. The Council was relying on the authority of Jerome who had said that it was not seeing Jerusalem that was praiseworthy, but living a good life there. Indeed, in Jerome's eyes, even this had no special purifying value. He wrote that he had gone to Palestine in order to understand the Bible better, not to obtain spiritual advantages. But since the Council quoted only Jerome's first statement and not his commentary on it, it was possible to believe that both Jerome and the Council were prepared to concede an indirect purifying value to the journey to Jerusalem—i.e. when it led to a long period of residence there. Later on the Church quite patently failed to combat the belief that the pilgrimage to Jerusalem was worth an indulgence. Indeed it formally granted partial indulgences for it, like the year's indulgence allowed by Alexander III. This was during the heyday of the crusades, when the crusader was granted an unlimited plenary indulgence; understandably the peaceful pilgrim obtained just a partial indulgence. . . .

It would, of course, be wrong to assert that the crusade propagandists avoided a more spiritual approach and worked only in . . . blatantly commercial terms. Nevertheless a great deal was done by such methods; we should remem-

ber that it was an age which witnessed a tremendous boom in long-distance trade. St. Bernard, though he used the vocabulary of merchants, did, of course, also say very different things, but he too did not want to renounce this effective propaganda theme.

It is perhaps better to put aside the question of whether or not the Church gave the impression that a complete remission of sin, both guilt and punishment, was possible through the indulgence and therefore through a procedure outside the Church's sacrament of penance. It is certainly possible that sometimes contemporaries did so interpret the Church's ambiguous terminology. But in any case the difference between remission of penance and remission of the temporal punishment due to sin, a difference which existed in the Church's traditional doctrine of indulgences, was of itself quite enough to explain the success of Clermont. There had been nothing new about being able to obtain remission of penance by going to fight the heathen. But that the penalties due to sin could be remitted simply as a result of taking the cross—as the crusade propagandists suggested—this was an unheard of innovation. Previously both the reconciliation granted at the start of the penance and the redeeming commutation had affected only the penances and had had no transcendental effect upon the penalties due to sin. It was indeed hoped that absolution would have such an effect, but it could certainly not be guaranteed. The indulgence on the other hand availed before God in a certain and in a quantitatively measurable fashion so that both the temporal penalties due to sin and the earthly penances were remitted and, in the case of a plenary indulgence, fully cancelled. Only Alexander II had promised as much as this for the war against the heathen and his promise, being addressed only to a small group, had met with little response. It was when linked with the universally popular idea of pilgrimage to Jerusalem that the explosive force of the crusading indulgence was revealed. Ekkehard of Aura spoke of 'a new way of penance' now being opened up. Here lies the secret of the astonishing success of Urban's summons, a success which astonished the Church as much as anyone else. Imagine a knight in the south of France, living with his kinsmen in the socially and economically unsatisfactory institution of the *frérêche*. His feuds and the 'upper class' form of highway robbery which often enough went with them, were prohibited by the Peace of God. Suddenly he was offered the chance of going on a pilgrimage—in any event the wish of many men. This pilgrimage was supervised by the Church; it was moreover an armed pilgrimage during which he could fulfil his knightly function by taking part in battle. There would be opportunities for winning plunder. Above all there was the entirely new offer of a full remission of all the temporal penalties due to sin, especially of those to be suffered in purgatory. The absolution given in the sacrament of penance took from him the guilt; taking the cross meant the cancellation of all the punishment even before he set out to perform the task imposed. Not to accept such an offer, not—at the very least—to take it seriously, would indeed have been mad. The 'shrewd businessman' seized his chance. And who did not want to be numbered among the shrewd?

Taking the cross in these circumstances was, of course, an act of faith just as much as an act of naive trust in the promises made by Church publicists. Naturally not all crusaders were moved by piety. In the Middle Ages too there were

sceptics and the motives for going on crusade were many, various, and tangled, often social and economic in character. But the offer of indulgence must have had an irresistible attraction for those who did not doubt the Church's teaching, who believed in the reality of the penalties due to sin, or at least accepted the possibility of their existence. Such believers must have made up a great part of those who went on the First Crusade—whatever proportion of the total population of Europe they may have been. And, of course, the crusaders of 1095 could not have guessed that the offer which they were accepting was in reality much more limited than the one promised them by the 'fishers of men'.

Soldiers of the Faith:
Crusaders and Moslems at War

The Crusades: An Overview

'He who fights so the word of God may prevail is on the path of God.' The sentiments embodied in this saying attributed to Mohammad do much to explain the amazing success of Islam, which, through the zeal for *jihad* or holy war, extended from the borders of France to those of India by the early eighth century. Religious enthusiasm also lies behind the equally amazing accomplishments of the Christian warriors of the First Crusade. In both Moslem expansion and Christian conquest, however, luck was just as important as zeal. The Moslems were able to profit from the weaknesses of early seventh-century Christendom just as the crusaders, when they entered Jerusalem in bloody triumphs four and a half centuries later, were able to attribute their victory in part to dissension and weakness among the Moslems.

Because of assassinations and rivalry which could be traced back to the period following Mohammad's death, by the tenth century the Moslem world had fallen into two major (and several minor) rival camps. One of these, the Shi'ite faction, was supported by the successors of Ali, Mohammad's cousin and son-in-law. By the later tenth century, they had gained control in Egypt as the Fatimids; a fanatical offshoot, the Assassins, would spill the blood both of Christians and other rival Moslem groups. The other faction, the Sunnites, originally supported the succession of Abu Bakr, one of Mohammad's closest allies. On both sides the picture is further confused by the establishment of semi-independent emirates and caliphates of varying political and religious allegiances. Moslem Spain, for example, began to go its own way as early as the eighth century. Not only was there internal rivalry, but also, from the tenth and early eleventh centuries, the Moslem world was shaken by progressive incursions of the Seljuk Turks. These people, having become Sunnites, brought to the Near East a vitality and fervour that were reminiscent of the earliest stages in the rise of Islam. They were proud, warlike, zealous and—more to the point—very successful: in the 1050s, they captured Baghdad; by the 1070s, Asia Minor (with the defeat of the Byzantines at Manzikert in 1071), Palestine and

Damascus; and by the 1080s, Antioch and Edessa. After one of their strongest leaders, Sultan Malik Shah, died in 1092, Turkish unity was dissipated by the establishment of several rival emirates, particularly in Asia Minor and Syria. This was why, during the 1090s, even as crusader swarms were moving from western Europe, the Holy Land was the scene of internal conflict and rivalry; why the crusaders often found themselves, from practical considerations, willing to accept or ask for the assistance of one or other of the Moslem parties in the ever-shifting sands of near-eastern politics. The fact that Greek Constantinople was to many westerners suspect as a perfumed den of vice and treachery, only complicated matters. . . .

The crusaders, then, were aided not only by their own religious zeal, cupidity, curiosity and many other motives that pushed them eastwards, but also by the turmoil and rivalries among the Moslems themselves. Though this may help to explain how they succeeded in their extraordinary venture, an even more interesting problem involves timing: why, since Jerusalem had been continuously occupied by Moslems since the seventh century, did the Christian West only attempt recovery at the end of the eleventh century? What had changed in European society and thought? One way to approach this question is through an examination of earlier military relations between the Moslem and Christian worlds, beginning, for convenience, with Spain. Visigothic Spain was attacked in 711 by Tarik and his converted Berbers in a campaign which, according to legend, was brought on when the daughter of Julian, a local lord, was abducted and impregnated by King Rodrigo of Toledo. In revenge, Julian is supposed to have invited the Moslems from North Africa to overthrow Rodrigo. Finding the job so easily accomplished, they went on to take over Spain itself, though there was resistance; by tradition the first important battle launched against the invaders by the Christians occurred in 718. Though they were eventually pushed into a narrow coastal lair behind the northern mountains, by the ninth century the Christians had begun their *Reconquista*. They had also provided themselves with a supernatural champion in St. James, at Compostella, which would become one of Europe's premier pilgrimage centres, as Jerusalem was at the other end of the Mediterranean. By the middle of the eleventh century, determined Christian kings had extended their hegemony southwards, bringing many Moslem princelings under their control. This success at last united the Moors and persuaded them to invite more ruthless co-religionists from north Africa, who reversed many of the Christian conquests. This was the confusing milieu for El Cid's sometimes unchristian adventures. In any case, on the eve of the First Crusade, Spain had already witnessed more than three centuries of warfare with the Moslems.

It was from Spain, about 720, that the Moslems moved on into south-west France. Historians still debate the extent of this threat and its potentialities, though in the short term many cities and towns undoubtedly suffered its harmful effects. Charles Martel, the 'hammer', earned his epithet by turning back in 732 or 733 near Poitiers this Moslem advance, the start of a long tradition of Frankish resistance to the Saracens. By about 770, most of the enemy had been pushed from Gaul, though they continued to harass Charlemagne and his successors. The Frankish *Annals* report that around 799 Moslem insignia captured

while defending the Balearics were sent to Charlemagne, and, in 801, at the fall of Barcelona, it is said that many Saracen prisoners were taken. Heroic deeds in the Spanish March or borderlands gave rise to one of the seminal works of medieval literature, the *Chanson de Roland;* though nominally-Christian Basques seem to have attacked the proud Roland, the ultimate enemy was the Moslem. Charlemagne's son, Pepin, King of Italy (d. 810), sent a fleet against Moslems pillaging Corsica in 806, but this did not stop their overrunning both Sardinia and Corsica in 810. Even before Charlemagne's death, the *Annals* compiler mentions the ravaging of Nice—a hint of unpleasant things to come, for later in the ninth century enterprising Moslems set up a bandits' nest some fifty miles along the coast from Nice, near Fréjus, from which they terrorized the neighbourhood, the Alpine passes and the north Italian seaports. There were other robbers' dens, but Fréjus was particularly troublesome. The stronghold was destroyed in the later tenth century when a league of aggrieved parties finally captured it.

It is not surprising that Moslem pirates should show an interest in Italian ports, since the peninsula and Sicily jutted out so invitingly into what the Moslems could call, with almost as much justification as the Romans, *Mare Nostrum.* Mohammad had been dead a mere twenty years, for example, when the first (recorded) attack on Sicily occurred. Things became serious during the ninth century, and, by 902, Sicily belonged to the Moslems. Southern Italian cities also suffered during the ninth century, and Naples often found it more expedient to ally itself with the Moslems than to fight them. Even the Eternal City itself was lusted after by the infidel, though they had to content themselves with a rampage through the suburbs, including St Peter's basilica. Pope Leo IV, in consequence, threw a wall around the saint's church and thereby laid the foundations—in the figurative sense only, considering the extensive resisting and rebuilding of later centuries—of the Vatican mini-city. Another casualty of ninth-century Moslem activities in Italy was Monte Cassino, the venerable home of Benedictine monasticism. At last the Italians began to organize resistance, and by the early tenth century managed to expel the Moslems from Italy proper. Pope John X himself took the field in 915, successfully adding spiritual to martial forces. From this point on, Italian cities turned to offensive tactics: Pisa and Genoa in particular began launching aggressive raids against Moslem ports and, by the early eleventh century, were attacking the enemy in north Africa itself. These two cities were interested in protecting their western Mediterranean trade. On the other side of the peninsula, Venice was equally concerned about maintaining commercial ties with rich Byzantium to the east.

The Byzantines were just as anxious about the Moslem threat; when Pope John X defeated the Moslems at the Garigliano in 915, it was with the help of Byzantine military power, whose encounters with the Moslems stretched back to the seventh century, with Emperor Heraclius. In fact, Roman emperors were sending troops out to skewer Saracens long before Mohammad's birth....

Among the more successful of mercenary troops hired by the Byzantines were the Varangian Guard of Scandinavians, who were established in service in Constantinople about AD 1000. After the conquest of England in 1066, many displaced or dispossessed Anglo-Saxon warriors joined them. One of the key figures and victims of that 1066 conflict, Harald Hardradi, had taken service

with the Varangians for a short time in the 1030s. According to his *Saga,* on this tour he attacked the lands of the Saracens and captured eighty towns, some of which surrendered, the rest being taken by assault. Even as Harald was spilling Moslem blood, however, the Seljuk Turks were moving westward, thus creating a new, formidable enemy whose incursions would compel Emperor Alexius Comnenus to call upon the West for help and set the scene for the First Crusade.

Long before this, western Christians had acquired centuries of experience battling Moslems in Spain, France and Italy. This aggression had been encouraged by the Church in its articulation of a doctrine of holy war. Warfare presented early Christians with yet another problem through the continuous process of accommodating their ideals to the 'real' world.... By the early fifth century, that giant who helped to shape medieval thought, St Augustine, had formulated a doctrine of just war in Christian terms. Provided that a war were declared by legitimate authority, for a just cause, and fought with the right intention, Christians should have no qualms about participating. In addition to this, even during Augustine's lifetime Europe was being transformed by incoming peoples whose leaders held prowess and *virtus* in battle of great importance and needed no excuses for rushing into battle. These Germanic tribes were eventually converted, thereby bringing to Christianity their own sublimation of the warlike virtues. With the rise of the Moslems, these new Europeans, and especially the Franks, stood out as defenders not only of their kingdoms, but also of Christianity itself. And yet, this was not holy war—though it may have been just—for the rewards of victory or valour were not yet envisaged as essentially spiritual....

The Church helped to prepare the ground for... holy wars in yet another way,... through the application of a sacramental mystique to knighthood. By the early eleventh century, religious ceremonial sometimes accompanied bestowal of the sword. At the same time, knights were encouraged to observe the growing Peace and Truce of God movements. The Church, and papacy, thereby (in theory) turned this potentially dangerous lynchpin of feudalism into an ally, a knight of St Peter. Before the First Crusade, these free-ranging fighters, trained to battle but exposed (at least) to religious exhortation, formed a corps which the Church was on occasion able to direct against her enemies....

Besides these spiritual and theoretical predispositions, eleventh-century men and women were also being 'prepared' for the first great crusading outburst of 1095–99 by changing conditions within their society and economy. Decades ago Henri Pirenne used words like 'optimism', 'native strength', 'fecundity' and 'revival' to describe eleventh-century Europe, while another equally famous medievalist (Marc Bloch) spoke of a new feudal age beginning about 1050. In general, this is still the fashion among most historians, who date the inception of the 'High Middle Ages'—the flowering of medieval society—to the eleventh century. Obviously the crusades cannot be understood without reference to this general awakening of western Europe, any more than they can be 'explained' only by the factors mentioned above. Perhaps the most important and correlated developments, in a strictly material sense, were the economic as well as the demographic expansion that affected all social levels. After the external invasions of western Europe had come to an end by about AD 1000,

life was less precarious, food production rose, families increased in size, new arable fields were created in forest and waste land, and more and more merchants plied their trades in and between the growing towns. About 1080, the monks of St Aubin of Angers issued the following regulation, among others, for their peasants at Meron:

> If several men have loaded an ass with different kinds of merchandise, they shall owe toll for the ass, save if it is foreign or costly merchandise.
> For [these] other things, the toll shall be paid according to its value...

The good monks were not about to ignore possible profits from these small-time business ventures by their villeins. Something similar was happening to more and more villagers throughout western Europe. An obvious motive was the desire for immediate personal gain from new and growing markets; another, especially for peasants, was the wish to escape the sometimes crushing obligations of manorial regimes. Many others would take up the generous offers of their lords—medieval land developers—and, especially in the twelfth century, pack up their families and rude furnishings and move off as colonists to take advantage of the lighter rents and work-loads. In the eleventh century, then, social and geographical mobility were distinct possibilities.

But larger families, especially among the middle-range nobility (of feudal Normandy for instance), created problems. As the medieval tradition of primogeniture spread, hunger for land and lordship drove many frustrated younger sons far from their home territories. Even where primogeniture was not the rule, many sought escape from the limitations of too many siblings and too little land by venturing into Spain, Italy and the Balkans. The enthusiastic knights of the First Crusade were aware of the practical opportunities, as well as spiritual advantages, awaiting them in the Holy Land. These conditions may also have complicated relations between neighbouring aristocratic families, who now would have to guard constantly against trespass (while, of course, encroaching against neighbours whenever possible). Often, the Church and peasantry suffered more than anyone else in these petty feudal wrangles. It was in the interests of both that the middling nobility should curb their appetites for contention, or at least satisfy them elsewhere. This was the background to another set of conditions, which led to the crusades—the part played by the Church not only in controlling the behaviour of the laity, but in imposing its own ideals upon ordinary men and women of high and low estate....

As the foregoing suggests, the crusading movement developed out of different sets of conditions laid down before and during the eleventh century. At least this seems to be the consensus today, when the political-colonial motives and immediate papal stimulus tend to be played down, while the socio-psychological background to the movement is emphasized. [Pope] Urban II is no longer thought of as the 'founder' of the crusading surge, but as a catalyst acting upon preformed sentiments and social circumstances. Yet there is no doubt that his sermon of 1095 was crucial. Also, in the decades leading up to 1095, military conflicts with the Moslems accelerated and thereby intensified pre-existing attitudes. In Spain, for example, the army of King Alfonso VI suffered overwhelming defeat in 1086 at the hands of the north African Murabits

(or Almoravids, the Veiled Ones). Christian knights from France and elsewhere in western Europe were encouraged to attempt to regain lost Spanish territory. 'My Cid plies his lance until it breaks and then takes his sword and slays Moors without number, blood dripping from his elbow down ' In Italy at about the same time—1087—several cities collaborated in launching attacks against a north African Moslem base; the successful foray was led by a papal legate. In southern Italy, the ambitious Roger and his brother Robert Guiscard—products of a large, ambitious Norman family—were active as early as mid-century. By 1072, the two had successfully blockaded, besieged and conquered Sicily's Moslem capital, Palermo. The job was completed by Roger in 1091, when the island, as well as Malta and southern Italy, came under Norman control, a southern pendant to the Norman conquest of England a generation earlier. . . .

By [October 1097] rivalries had split the crusader armies. Some of the leaders detached their contingents and went off on their own, like Baldwin of Boulogne, who travelled east to establish himself as ruler of the Armenian Christians at Edessa by March 1098. Meanwhile, the bulk of the crusader army besieged Antioch, captured in June 1098. Bohemond of Taranto (southern Italy) took over as Prince of Antioch, with the backing of Genoese merchant-shippers who gained concessions in the city. Raymond, Count of Toulouse and *soi-disant* leader of the crusade, after bickering with Bohemond about Antioch, finally gave in to pressure from the rank-and-file and pushed on in January 1099. Jerusalem was reached and taken in mid-July 1099; Godfrey, Duke of Lower Lorraine, became 'advocate' of the Holy Sepulchre, claiming to be unworthy of any higher honour in Christ's city. On his death in 1100, his less fastidious brother, Baldwin of Edessa, took the title King of Jerusalem. Thus, on the eve of the twelfth century, the crusaders had taken the Holy Land and had established the Kingdom of Jerusalem, Principality of Antioch, County of Edessa and (by 1109) County of Tripoli, held by Bertrand, son of Raymond, Count of Toulouse. These were the so-called Crusader States. The capture of Jerusalem renewed interest in the West and resulted in three crusades in 1101, which ended in victories for the Turks and worsening Western-Byzantine relations. In fact, by 1105, Bohemond of Antioch, fearing Byzantine pressure, convinced Pope Paschal II to preach a crusade against Byzantium itself. Nothing came of this, but it was an ominous foretaste of things to come. Meanwhile, King Baldwin of Jerusalem managed to extend crusader control by taking Acre in 1103 with Genoese help and Sidon in 1110 with Norwegian and Venetian assistance. But his attack on Tyre failed, and a raid into Egypt accomplished little. Yet by 1118 when he died, most of Palestine and much of Syria were under Christian control, the crusaders now assisted by the sometimes mutually antagonistic military orders, the Templars and Hospitallers. . . .

Conclusion

Though it is difficult to summarize and draw conclusions about such a varied and long-lasting movement as the crusades, certain generalizations are unavoidable. For instance, it is apparent that the expression 'the crusades' must be

qualified, for the First Crusade differed in many ways from those which followed. Thousands of Europeans, affected by the emotional and social upheavals of the eleventh century, undertook a long, dangerous trek towards a mystical goal which was, for them, both a place and a state of salvation. During the next two centuries, crusades became increasingly structured, moving from general to specific aims and means; the idealism of the First Crusade was superseded by sometimes incompatible ideologies imposed from above by the papacy, by the noble and royal leaders of later expeditions, and by the secular rulers of *Outremer.*

Concurrently, Christendom itself was changing: the crusades exemplified these changes, revealing much about the dynamics of religious, economic and political realignments and alterations in western Europe. To take the religious aspect as an example, the crusades encouraged a growing concern about gaining indulgences, first by service abroad, then eventually by purchase of exemption from such service; the papacy attracted more and more criticism—from thirteenth-century poets who castigated Roman greed, for instance—because of what appeared to be diversions from the crusading impulse. By the sixteenth century, such matters would become important issues in the breakdown of European religious unity. Certainly this is not to suggest that the crusades led to the Reformation, but merely that the later crusades disclosed ominous stresses within a Europe that would ultimately undergo a Reformation. In the same way, conflict between French and English crusaders during the Third Crusade was a harbinger of that later confrontation known as the Hundred Years' War. Crusader activities and interrelationships in the Holy Land, then, as well as European responses to calls for crusades, provide models of wider, more deeply rooted attitudes, ambiguities and animosities within western Europe; in this sense, each crusade was a microcosm, a diminished image of Christendom.

Another inevitable conclusion to any general study of the crusades is the fact that many questions remain unanswered, perhaps unanswerable. The sorting out of motivations, for instance, still engages the interest of scholars, as does the very composition of the groups called 'crusaders': for each knightly or noble participant, for each foot-soldier or archer, how many unarmed pilgrims, women, clergymen, went along as 'crusaders'? Did the lower classes, as [Benjamin] Kedar suggested, continue to participate as avidly in the thirteenth century as they did in the twelfth century? How many women were actively, and how many passively, 'crusaders'? Such problems, considered individually, may seem to be mere froth that floats on the surface, puzzles propounded for the delectation of scholars. Yet every clue that can be found is meaningful, every attempt to answer such questions is worth considering because, as suggested above, each crusader band that detached itself from Europe reveals to the historian varying aspects of contemporary society.

Another conclusion to be drawn from a study of the crusades is that Moslem reactions to and interactions with the crusaders, who were intrusive elements, is a topic that is usually relegated to secondary status by western historians. Yet the Islamic viewpoint is as deserving of study as the Christian; fortunately, some western scholars (who are not primarily Orientalists) are forcefully and convincingly presenting the crusades in an Islamic context,

pushing us away from the Christian-centered world into a wider universe, instigating a long-overdue Copernican revolution in Christian-Moslem studies. There is a practical side to this as well: the need to understand Islam and the various peoples who call themselves Moslems is as pressing today as it ever was; and yet modern western European Christians seem in general to be as ignorant of the fundamentals of Islam as their twelfth-century predecessors. The words of a thirteenth-century Jew, Ibn Kammūna of Baghdad, concerning the lack of comprehension between Jews and Moslems of his day, apply equally well to modern Christians and Moslems:

> (D)espite numerous contacts of the bulk of the Jews with the Muslims, many Jews still do not know the basic Islamic tenets known by the rank and file Muslims, let alone the elite. It is even more natural that a similar situation should obtain on the Muslim side...

The question of Christian-Moslem interaction naturally includes the problem of the Christian attitude towards war. An examination of the course of the crusades has led some historians to suggest that Church doctrine was deliberately manipulated to suit specific ends: though committed to condemning bloodshed, the Church itself promoted it. Keith Haines even goes so far as to remark that in Europe

> It is impossible to discern a totally pacifist ideology amongst virtually any of the leading moral, theological or political philosophers of the twelfth and thirteenth centuries...

Another leading crusade historian has also recently emphasized how the fundamental message of Christian charity was reinterpreted to suit crusade exigencies. Crusade preachers, for instance, must have deliberately presented Christian *caritas* to their audiences in such a way as to play upon the xenophobia of the masses.

One final conclusion to be drawn from the crusading experience is the futility—in practical terms—of the Christian attempt to co-exist with Moslems peacefully in the Holy Land, while trying to maintain political control of the area. Permanent peace between Moslems and Christians, in Moslem territory, was not feasible: caught between an Islam newly dedicated to *jihad* (from Saladin's time) on the one side, and mistrusting, uncomprehending westerners on the other, the Christian Europeans of *Outremer* were, as [Jonathan] Riley-Smith points out, in an untenable position. Christian residents in the Holy Land, then, were surrounded by hostile forces, harassed by problems of logistics and military support and by divisions of opinion in Europe about crusader policy; difficulties of a similar nature would confront many modern European states in their own colonial enterprises. Eventually expelled from positions of political and military power in the Levant, Christians were allowed to return to the Holy City only as pilgrims and suppliants at the Tomb of Christ, as they had been for centuries before that fateful sermon preached by Urban II in 1095.

POSTSCRIPT

Were the Crusades Primarily Motivated by Religious Factors?

With the emergence of Islamic revivalism in the modern world, the historical relationships between the West and the Muslim world have attained a renewed level of interest. The relevance of the Crusades to this contemporary situation provides some interesting food for thought. The Islamic world has always viewed the Crusades as an invasion of its territory by a foreign power; it appears the West has not viewed them in the same light. An interesting question with contemporary applicability is: To what extent can the Crusades be viewed as a Christian jihad (holy war)? As the West responds to Islamic-inspired terrorism today with shock and outrage, is it not possible that a millennium ago, Middle Eastern Muslims responded in the same manner to the European Crusaders?

Another example of the ties between past and present is the religious motivation present in both the Crusades and current Islamic revivalism. The former were at least partially motivated by several religious factors: fighting a just war in the service of God; gaining indulgences for services rendered; and the ultimate prize, gaining the right to eternal salvation. The latter for Muslims is motivated by fighting a war against the infidels in the name of Allah; participating in a fierce struggle between the forces of good and evil; and ultimately acquiring a special place in heaven as martyrs of the faith. Is this an example of repeating the past without learning any lessons from it?

As far as sources on the Crusades are concerned, start with Steven Runciman's three-volume work *A History of the Crusades,* 4th ed. (Cambridge University Press, 1954). Karen Armstrong's *Holy War* (Macmillan, 1988) is a Western source, which speaks of the Crusades in an objective and critical manner, especially as they relate to contemporary problems between Muslims, Christians, and Jews in the Middle East. Jonathan Riley-Smith's *The First Crusaders, 1095–1131* (Cambridge University Press, 1997) represents current scholarship. Smith states that the Crusades "drew on the tradition of Pilgrimage to Jerusalem... and pious violence" as motivating forces. He also points out that many of the Crusaders from the times he researched came from the same families and clans, and concludes that the sustenance they received from these ties helped make the Crusades possible. For an Arab perspective on the Crusades, see Amin Maalouf, *The Crusades Through Arab Eyes* (Schocken Books, 1985) and Carole Hillenbrand, *The Crusades: Islamic Perspectives* (Routledge, 2000). A readable, popular account of the Crusades, which features interesting illustrations and useful maps, is W. B. Bartlett, *God Wills It: An Illustrated History of the Crusades* (Oxford University Press, 1999).

ISSUE 10

Does the Modern University Have Its Roots in the Islamic World?

YES: Mehdi Nakosteen, from *History of Islamic Origins of Western Education* A.D. *800–1350* (University of Colorado Press, 1964)

NO: Charles Homer Haskins, from *The Rise of Universities* (Great Seal Books, 1957)

ISSUE SUMMARY

YES: Professor of history and philosophy of education Mehdi Nakosteen traces the roots of the modern university to the golden age of Islamic culture (750–1150 C.E.). He maintains that Muslim scholars assimilated the best of classical scholarship and developed the experimental method and the university system, which they passed on to the West before declining.

NO: The late historian Charles Homer Haskins (1870–1937) traces the university of the twentieth century to its predecessors in Paris and Bologna, where, he argues, during the twelfth and thirteenth centuries the first universities in the world sprang up.

In the seventh century of this era, the prophet Muhammad united the Arab world under the banner of a new monotheistic religion, Islam, which means "surrender" to Allah or God. In 622 Muhammad left the city of Mecca for the city of Medina. Since he was fleeing persecution, this flight is known as *Hijra,* or "breaking of former ties." Muslims, the followers of Islam, adopted that date as the first year in their calendar. Using that lunar calendar, the year 2000 according to the Christian calendar is 1420 A.H. (*anno Hegirae*). Christians began their calendar with the birth of Jesus, calling everything after that date A.D. for *anno Domini* (in the year of our Lord) and everything before that date B.C. (before Christ). Taking into account that much of the world is not Christian, Western scholars have begun to use the designations C.E. (for common era) to replace A.D. and B.C.E. (for before the common era) to replace B.C. You will find the A.H. and A.D. designations used in the following selections.

United under Islam, Arab warriors conquered the Persian Empire, took some Byzantine cities, crossed North Africa, and invaded Europe. Stopped at

732 in Tours, France, the Islamic conquest ushered in a "golden age" of learning centered in Cordoba, the capital of Muslim Spain. At that time, Muslims claim that the largest monastery library in Europe contained fewer than 100 books, whereas the library in Cordoba contained over 500,000 volumes. At a time when Europe had lost much of its Greco-Roman intellectual heritage and learning was at a low point, Muslim scholars were translating Greek works from the Persian and Byzantine cultures into Arabic and commenting on them. This learning, along with their original contributions in mathematics, medicine, science, and philosophy, was passed on to the West when Islamic culture was conquered first by the Seljuk Turks and later by Genghis Khan and the Mongols of Central Asia.

The Western intellectual debt to Islamic scholars is accepted widely. However, what about the college or university as an institution of higher learning? Were Western scholars able to take the world's heritage of learning and use it to fashion the modern world because they invented the university or because it, too, was borrowed from the Islamic world? It has been said that where you stand determines what you see. In the following selections Mehdi Nakosteen and Charles Homer Haskins stand within different cultural and academic traditions. Taking the "golden age" of Islamic culture into account permits Nakosteen to build a case for the Islamic origins of the univeristy. However, if civilization began with the Greeks, as Haskins assumes, and the Greeks had no universities, then the institution must have been invented by Europeans in the Western world.

Nakosteen argues that the language barrier and general inaccessibility of historical material to Western scholars, along with religious prejudice and the decline of Islamic culture, have made it easy for Europeans and Americans to assume credit for the modern university. In actuality, he maintains, the university is rooted in the Islamic world. Haskins, however, sees the medieval European universities in Paris, France, and Bologna, Italy, arising spontaneously in response to an influx of new knowledge. Although he credits the Muslim scholars of Spain with much of that new knowledge, he does not trace the roots of the university as an institution to the Islamic world.

Haskins delivered the lectures on which his selection is based in 1923. The challenge put forth by Nakosteen is part of the revisionist process that has been going on in history for the last 30 or so years. Part of that process is challenging assumptions that have gone unchallenged for centuries. In 1937, the year that Haskins died, Western historians often credited Europe and America with all that was worthwhile in modern life. Our heritage was Greek, and the line was assumed to be unbroken. As other issues in this book have demonstrated, modern scholars are examining the influence of Africa on the Greeks and considering the contributions from Asia and the Arab world with a new openness. This is all part of the ongoing refinement of historical knowledge and may be expected to continue as long as there are scholars.

Mehdi Nakosteen

 YES

The Nature and Scope of Muslim Education, 750–1350

All dates refer to A.D. unless otherwise specified.

Europe was in its medieval period when the Muslims wrote a colorful chapter in the history of education. Many of their greatest contributions, particularly to Western education, have gone unnoticed because of religious prejudice, language barriers, the decline of Islamic culture, and inaccessibility of historic materials for Western historians of education. The Muslims assimilated through their educational system the best of classical cultures and improved them. Among the assimilated fields were philosophy and Hellenistic medical, mathematical, and technological sciences; Hindu mathematics, medicine, and literature; Persian religions, literature, and sciences; and Syrian commentaries on Hellenistic science and philosophy. By applying the classical sciences to practical pursuits, the Muslims developed the empirical-experimental method, although they failed to take full advantage of it. Later the method was adopted in Europe. They encouraged free inquiry and made available to the public the instruments of research and scholarship. They opened their public and even private libraries to public use, not only regionally but internationally. At a time when books were "published" only through the tedious labor of copyists, they made hundreds, even thousands, of copies of reference materials and made them available to all caring to learn from them. Often they allowed scores of books—sometimes more than a hundred per person—to be borrowed for an almost indefinite time for special studies and prolonged research. They provided food, lodging, and even incidental money for scholars from far away; they made their great teachers internationally accessible by encouraging the concept of the travelling scholar.

In the golden age (750–1150) of their cultural-educational activities they did not permit theology and dogma to limit their scholarship. They searched into every branch of human knowledge, be it philology, history, historiography, law, sociology, literature, ethics, philosophy, theology, medicine, mathematics, logic, jurisprudence, art, architecture, or ceramics. They respected learning; they honored the scholar. They introduced the science and philosophy of the Greeks, Persians, and Hindus to Western Christian schoolmen. But the story of Western education's debt to Islam is still to be written with fullness of

From Mehdi Nakosteen, *History of Islamic Origins of Western Education* A.D. *800–1350* (University of Colorado Press, 1964), pp. 37–42, 52–53, 61–63. Copyright © 1964 by University of Colorado Press. Reprinted by permission. Some notes omitted.

knowledge and without prejudice and predetermination of results. What kind of education was responsible for so much in so short a time?

Muslim education went through two distinct periods. First was the period covering the ninth and tenth centuries, when schools developed spontaneously with private endowments interested in public enlightenment; and second the period beginning in the eleventh century and developing through the twelfth and thirteenth centuries, when education became the function of the state, and schools were institutionalized for purposes of sectarian education and political indoctrination.

Madrasahs and Nizamiyyas

A new type of school was conceived as a state institution to promote religious indoctrination of the Sunnite Islamic faith and political indoctrination of a Turkish-Persian style, aside from general learning and particular training. Nizam-al-Mulk (d. 1092; 485 A.H.), the founder and popularizer of these *madrasahs* (schools of public instruction), was a famous vizier (prime minister) in the administration of the Seljuq sultans in the eleventh century. He established the madrasah about the middle of that century, which, though not the first school in Islam, was the first system of special schools geared to that state and Sunnite Islam. The madrasahs had, aside from their zest for learning, both political and religious purposes—the moulding of public opinion in Sunnite orthodox Islam against the Shi'ah branch. Large sums of money were allotted for the establishment and maintenance of these schools with generous scholarships, pensions, and rations granted to all worthy students. In fact, Nizam arranged for regular stipends to all students. The schools were institutionalized under state control and support, and standardized madrasahs were established in all large cities within Islam, with the exception of Spain and Sicily. The greatest of these academies was the one established by Nizam in Baghdad, the famous *Nizamiyyah,* which opened for teaching in 1066-67 (459 A.H.) and continued as a center of learning for several centuries, motivated primarily by religious and literary pursuits. Altogether, Nizam-al-Mulk made the greatest single contribution to education in founding and extending an almost universal system of schools (madrasahs) throughout Eastern Islam.[1] He was one of the most learned men of his time, greatly versed in Muslim hadith, or tradition, and one of the great political theorists of Islam, as shown in his famous *Siyasat-Namah.* His passion for universal education was limited only by the means at his disposal. The schools he founded all over the empire were endowed generously. He supplied them with libraries, the best professors he could find, and a system of scholarships to aid all the students. Let us look into his educational enterprise in some detail.

Nizam-al-Mulk and Muslim Education

The opening of the first school carrying the name of the Persian statesman, Nizam-al-Mulk, took place in 1066 (459 A.H.). It marks the transition from the

mosque schools and the beginning of a system of public schools, or madrasahs, throughout the vast area of the Muslim world, which was under strong Persian cultural and administrative influence. This influence continued, first under Arab political supremacy under the Abbassides from the middle of the eighth century to the ninth, and again during the long period of Turkish (Ottoman) politico-religious supremacy, to the early decades of the sixteenth century (1517). It is true that the earlier Turks had a simple culture and were given to warfare and conquest. But settling down to administer their empire, they learned from the superior cultures of the Persians and the Arabs, adopted the Arabic alphabet, and accepted Islam. In time they adapted the foreign cultures to their own needs and tastes, and encouraged the establishment throughout their empire of schools to perpetuate Sunnite Islam and Turkish politics and policies. Tarikh Zaidan, in his *Al-Tamaddun al-Islami (History of Islamic Civilization),* states that the Turkish princes encouraged learning and increased the number of schools in their empire, guided by three motives: The type of heavenly reward; the fear of losing their fortunes to more greedy superiors or antagonists, so that they utilized their wealth in establishing schools; finally, but most important of all, the desire to indoctrinate religious beliefs of the founder and to combat opposing religious views.

It was the employment of the school for sectarian indoctrination and political influence and propaganda that led the famous Seljuk Sultan Saladin to found madrasahs and also to close the college of Dar al-Ilm (The House of Learning) in Cairo in order to eliminate its Shi'ite influence. In fact it was not uncommon to dismiss professors during this period from the madrasahs because of their religious beliefs, particularly Shi'ite. Muslim scholasticism (*Ilm al-Kalam*) developed in these sectarian colleges of Sunnite or Shi'ite beliefs.

The Sunnite belief received its most sweeping expression under Nizam-al-Mulk. Before his day, there were several institutions of learning in the Islamic world which resembled a college, such as Al-Azhar in Cairo, Egypt, in the last quarter of the tenth century; Dar al-Ilm and Dar al-Hikmah, also in Cairo, in the early decades of the eleventh; Bait-al-Hikmah in Baghdad during the reign of al-Ma'mun; and Baihaqiyyah at Nishapur in Khrasan, Persia. But to Nizam-al-Mulk goes the distinct credit for having founded an institution for instruction and indoctrination under government and religious control, for political and religious ends—a sectarian system of public education with secular emphasis and political motivation.

With these objectives in mind, Nizam-al-Mulk established schools in every city and village of Iraq and Khorassan. Even a small place, such as "Kharn al-Jabal near Tus ... had its teacher and school." These schools were well distributed from Khorassan in the east to Mesopotamia in the west. These so-called madrasahs soon became standardized, and many of them were built after the example of the one in Baghdad, which was built by Nizam-al-Mulk himself, and named Nizamiyyah (or Nidhamiyyah) in his honor.

> Nizamiyyahs ... were founded not only in Baghdad, but in Nisabur, Balkh, Herat, Isfahan, Marw, Basrah and Mosul. Not only did Nizam-al-Mulk establish these academies or colleges, but he endowed them. It is estimated

that $1,500,000 was spent annually on educational, semi-educational and religious institutions.

Nizamiyyah University, the most famous of the chain of madrasahs, was built in Baghdad in 1065 under the educator's personal supervision. The earliest account of this university is given by ibn Khaldun, the great Arab philosopher-historian, who says:

> Nizam-al-Mulk ordered that Abu Is'haq al-Shirazi should be its professor, but when the people were assembled to hear him he did not appear. He was searched for, but was not to be found; so Abu Nasir ibn-al-Sabbagh was appointed to the post. Later Abu Is'haq met his classes in his mosque, but his students showed their dissatisfaction with his action and threatened to go over to ibn al-Sabbagh unless he accepted the professorship at the Nizamiyyah. Finally he acceded to their wishes, and ibn al-Sabbagh was dismissed after having lectured for only twenty days.

The chief reason for Abu Is'haq's refusal to teach at the Nizamiyyah was, according to ibn Khallikan, that he was "informed that the greater part of the materials employed in the construction of the college have been procured illegally." But the foregoing quotation is of extreme interest for the information it gives us that the mosques were the chief places of learning before the foundation of universities. There were over one hundred such mosques in Baghdad alone.

The principal motive in founding the Nizamiyyah was religious. Its objective was the teaching of "The Shafi'ite (Sunni) school of law," its sole emphasis being upon the teaching of theology and Islamic law, and it stood as a university of Islamic theological learning for several centuries. The great mystic al-Ghazzali taught there twenty-five years after its founding. Al-Abiwardi (d. 1104; 498 A.H.) and ibn Mubarak (d. 1184; 580 A.H.) were associated with it. Ibn Jubair who visited the school about the middle of the fourteenth century, said of it: "And in the midst of Suq al-Thalatha (Tuesday market) is the wonderful madrasah Al-Nizamiyyah, whose beauty has become proverbial."

Aims of Muslim Education

The aims of Muslim education in "medieval" times may be defined as follows:

1. Religious aims, based on (a) *Qur'an* as source of knowledge, (b) spiritual foundation of education, (c) dependence upon God, (d) sectarian morals, (e) subordination of secular subjects to religion, (f) equality of all men before God and man, (g) supremacy of Muhammad over all other prophets, (h) belief in the six articles of Imam or Creed (God, angels, scripture, prophets, judgment, decrees) and (i) belief (and application) in A'amal or religious duties, including confession of faith (There is no God but God), prayers, alms, fasting, and pilgrimage.

2. Secular aims, the importance of which is well suggested by a Muslim tradition, attributed to Muhammad, which says, "The best among you are not those who neglect this world for the other, or the other world for this. He is the one who works for both together." Among these aims were pursuit of all

knowledge, as the revelation of the nature of God; education open to all on equal terms, limited only by ability and interest; and guidance and teaching as essential to promote (initiate) knowledge and education.

The *Mutakallimun (Loquentes)*, the Muslim scholastic teachers (speakers of truths), stressed the importance of teachers whose knowledge may be traced back to relevation or may have been made manifest directly by intuition. This was the view of the theologian-philosopher-educator al-Ghazzali, who believed in three degrees of knowledge: (a) Common-sense knowledge, restricted by undisciplined sense-experience and dependent upon external authority; (b) scientific knowledge; (c) intuitive knowledge.

It is of interest to note that al-Ghazzali's concept of scientific knowledge includes seven basic principles or conditions: Stimulation of the search for scientific knowledge; application of scientific arts; advancement of applied sciences and extensive application of them; development of laboratory and experimental pursuits; encouragement of arts and crafts (It was Aristotle in particular, from among the Greeks, who appealed to Islam. This was because of the Greek master's application of philosophy and science to the arts and needs of everyday living and because of the adaptability of his philosophic and scientific concepts to the art of living and the necessities of individual and civic life); encouragement of individual initiative and academic freedom for both teachers and pupils (in the college of Baghdad an inquiring student, who greeted the great teacher with devoted *salams* [bows], often ended the day with an intellectual fist fight with his master in defense of some principles, refutation of others, or hairsplitting argument over insignificant details); attainment of excellence, to produce great men of learning and leaders in public affairs. The pragmatic spirit of their education is indicated by development of textile fabrics, of irrigation systems, of iron and steel products, of earthenwares, and leather products, by architectural innovations, weaving of rugs and carpets, manufacture of paper and gunpowder, maintenance of a merchant marine of a thousand ships, and advancement of commercial activity.

Although Muslim education aimed at practical training, such training was a rule based upon instruction in fundamental sciences. Thus, in the system, practice was sustained by theory; theory verified in practice. Even in commercial training, economics as a science was a foundational training.

It is of interest to note that as Islam began to decline after the end of the eleventh century, the number of its schools of higher learning increased and flourished. These colleges were, however, almost all denominational schools opened and supported by leaders of various Islamic religious factions. Each denominational college was open, with few exceptions, only to followers of a given sect. Religious and literary studies and Arabic language and grammar dominated the subject matter at the expense of philosophy, science, and social studies. The very abundance of these religious schools indicated the gradual decline which was under way. These colleges were intolerant of innovations, suspicious of secular studies, and aloof from creative scholars. Some of these colleges survived destruction by the Mongols in the thirteenth century and remained centers of dogmatic theological instruction to the fourteenth and fifteenth centuries.

There was competition among these denominational schools, particularly between the Shi'ite and Sunnite (Hanafite) religious factions. This competition proved healthy in the increase of these colleges and in their facilities, endowments, and the like, and would have been a tremendous educational power except for their limitations because of their religious nature.

It is of interest also to note that during this same period new universities were beginning to develop in western Europe, particularly in Italy, Germany, France, and England. But unlike the Islamic denominational schools, the Western universities were preserving the best intellectual elements that Islamic research and scholarship had developed during its creative centuries, from the ninth to the twelfth centuries. Islamic works were reaching Europe at about the same period (twelfth and thirteenth centuries) when secular learning was declining in Islam. The works of hundreds of translators not only enriched and created or enlarged many Western universities but brought about the Western Renaissance of the fourteenth and fifteenth centuries. One reason for this, of course, was the revival of secular interest and research in the West, which, though curtailed by religious passion until the seventeenth and eighteenth centuries, was left relatively free from then on to discover new knowledges and usher in the modern world....

The Curriculum of Muslim Schools

The curriculum of Muslim education at that time reminds us in its extensive and intensive nature of curricular programs of modern advanced systems of education, particularly on higher levels of education. It was not unusual to find instruction in mathematics (algebra, trigonometry, and geometry), science (chemistry, physics, and astronomy), medicine (anatomy, surgery, pharmacy, and specialized medical branches), philosophy (logic, ethics, and metaphysics), literature (philology, grammar, poetry, and prosody), social sciences, history, geography, political disciplines, law, sociology, psychology, and jurisprudence, theology (comparative religions, history of religions, study of the *Qur'an,* religious tradition [*hadith*], and other religious topics). They offered advanced studies in the professions, for example, law and medicine.

Their vocational curriculum was varied and founded on the more general studies; in fact, it appears generally to have been as comprehensive as their education was universal. The extent and depth of Muslim curriculum can be detected by references to a number of encyclopedias of general knowledge and specific disciplines, among them the celebrated *Encyclopedia of the Ikhwan al-Safa* (the *Brethren of Purity* or *Sincerity*), which was known to and respected by European schoolmen.

Another indication of the extent of Muslim curriculum is manifested in the fact that one Arabic dictionary contained sixty volumes, with an illustration for each definition. Again, its richness may be determined by its practical and useful consequences, leading to such ventures as calculating the angle of the ecliptic, measuring the size of the earth, calculating the procession of the equinoxes, inventing the pendulum clock, explaining in the field of optics and physics such phenomena as "refraction of light, gravity, capillary attraction

and twilight," using the globe in teaching the geography of a round earth, developing observatories for the empirical study of heavenly bodies, making advances in the uses of drugs, herbs, and foods for medication, establishing hospitals with a system of interns and externs, improving upon the science of navigation, introducing new concepts of irrigation, fertilization, and soil cultivation, discovering causes of certain diseases and developing correct diagnoses of them, proposing new concepts of hygiene, making use of anesthetics in surgery with newly innovated surgical tools, introducing the science of dissection in anatomy, furthering the scientific breeding of horses and cattle, and finding new ways of grafting to produce new types of flowers and fruits. In the area of chemistry, the curriculum led to the discovery of such substances as potash, alcohol, nitrate of silver, nitric acid, sulphuric acid, and corrosive sublimate. It also developed to a high degree of perfection the arts of textiles, ceramics, and metallurgy....

Some Muslim Contributions to Education

Before concluding this brief summary of "medieval" Muslim education, it may be well to point out some of its basic contributions to educational theory and practice, and state also its basic shortcomings.

1. Throughout the twelfth and part of the thirteenth centuries, Muslim works on science, philosophy, and other fields were translated into Latin, particularly from Spain, and enriched the curriculum of the West, especially in northwestern Europe.
2. The Muslims passed on the experimental method of science, however imperfect, to the West.
3. The system of Arabic notation and decimals was introduced to the West.
4. Their translated works, particularly those of men such as Avicenna in medicine, were used as texts in classes of higher education far into the middle of the seventeenth century.
5. They stimulated European thought, reacquainted it with the Greek and other classical cultures and thus helped bring about the Renaissance.
6. They were the forerunners of European universities, having established hundreds of colleges in advance of Europe.
7. They preserved Greco-Persian thought when Europe was intolerant of pagan cultures.
8. European students in Muslim universities carried back new methods of teaching.
9. They contributed knowledge of hospitals, sanitation, and food to Europe.

The strength of the Muslim educational system lay in the following areas: It produced great scholars in almost every field. It developed literacy on a universal scale when illiteracy was the rule in Europe. It transmitted the best features of classical cultures to the West. It led the way in the development of libraries and universities. Its higher education in its creative centuries was open

to rich and poor alike, the only requirements being ability and ambition. It held teachers and books in reverence, particularly on higher levels of instruction. The teacher, the book, the lecture, the debate—these were the nerve centers of its educational system.

The curriculum, which was in the early centuries balanced between sectarian and secular studies, became in the later centuries scholastic, making all or practically all secular studies subject to religious and theological approval. The curriculum became formal, fixed, traditional, religious, dogmatic, backward-looking. It encouraged static minds and conformity. It became authoritarian and essentialist.

Whereas in its early centuries Muslim education encouraged debates, experimentation, and individualism, in its later stages it encouraged formal methods, memorization, and recitation. A system which was in its early stages rather spontaneous and free, encouraging individuals to pursue learning and inspire others to enlightenment, lost in the later stages this sense of intellectual adventure and its direction became superimposed from the top (the state and church) rather than inspired by the people. This led in time to an elite and aristocratic concept of education, replacing its early democratic educational spirit. Muslim education did not, and with its scholastic disciplines could not, take advantage of the tools of science and experimentation which it had inherited and improved upon. Rather, it passed on these tools to European men of science, who utilized them effectively after the Renaissance and thus initiated and developed the modern world of science.

Note

1. Among the leading founders of schools in Islam should also be mentioned al Ma'mun (d. 833; 218 A.H.), who supported and endowed the first great Muslim educational center in Baghdad, the famous *Bait-al-Hikmah,* and was instrumental in having Greek, Persian, and Hindu translations made into Arabic by the greatest scholars of the time; Nur-al-Din (d. 1173; 569 A.H.), the Sultan of the kingdom of Syria who, after the dissolution of the Seljuq Empire, founded schools in Damascus and throughout his kingdom, including Egypt; Saladin (d. 1193; 589 A.H.), who extended the school systems in Syria and Egypt.

The Earliest Universities

U niversities, like cathedrals and parliaments, are a product of the Middle Ages. The Greeks and the Romans, strange as it may seem, had no universities in the sense in which the word has been used for the past seven or eight centuries. They had higher education, but the terms are not synonymous. Much of their instruction in law, rhetoric, and philosophy it would be hard to surpass, but it was not organized into the form of permanent institutions of learning. A great teacher like Socrates gave no diplomas; if a modern student sat at his feet for three months, he would demand a certificate, something tangible and external to show for it—an excellent theme, by the way, for a Socratic dialogue. Only in the twelfth and thirteenth centuries do there emerge in the world those features of organized education with which we are most familiar, all that machinery of instruction represented by faculties and colleges and courses of study, examinations and commencements and academic degrees. In all these matters we are the heirs and successors, not of Athens and Alexandria, but of Paris and Bologna.

The contrast between these earliest universities and those of today is of course broad and striking. Throughout the period of its origins the mediaeval university had no libraries, laboratories, or museums, no endowment or buildings of its own; it could not possibly have met the requirements of the Carnegie Foundation! As an historical text-book from one of the youngest of American universities tells us, with an unconscious touch of local color, it had "none of the attributes of the material existence which with us are so self-evident." The mediaeval university was, in the fine old phrase of Pasquier, "built of men"— *bâtie en hommes.* Such a university had no board of trustees and published no catalogue; it had no student societies—except so far as the university itself was fundamentally a society of students—no college journalism, no dramatics, no athletics, none of those "outside activities" which are the chief excuse for inside inactivity in the American college.

And yet, great as these differences are, the fact remains that the university of the twentieth century is the lineal descendant of mediaeval Paris and Bologna. They are the rock whence we were hewn; the hole of the pit whence we were digged. The fundamental organization is the same, the historic continuity is unbroken. They created the university tradition of the modern world,

From Charles Homer Haskins, *The Rise of Universities* (Great Seal Books, 1957). Copyright © 1923 by Brown University; renewed 1957 by Cornell University. Reprinted by permission of Cornell University Press.

that common tradition which belongs to all our institutions of higher learning, the newest as well as the oldest, and which all college and university men should know and cherish. . . .

<center>⚜</center>

In recent years the early history of universities has begun to attract the serious attention of historical scholars, and mediaeval institutions of learning have at last been lifted out of the region of myth and fable where they long lay obscured. We now know that the foundation of the University of Oxford was not one of the many virtues which the millennial celebration could properly ascribe to King Alfred; that Bologna did not go back to the Emperor Theodosius; that the University of Paris did not exist in the time of Charlemagne, or for nearly four centuries afterward. It is hard, even for the modern world, to realize that many things had no founder or fixed date of beginning but instead "just grew," arising slowly and silently without definite record. This explains why, in spite of all the researches of Father Denifle[1] and Hastings Rashdall[2] and the local antiquaries, the beginnings of the oldest universities are obscure and often uncertain, so that we must content ourselves sometimes with very general statements.

The occasion for the rise of universities was a great revival of learning, not that revival of the fourteenth and fifteenth centuries to which the term is usually applied, but an earlier revival, less known though in its way quite as significant, which historians now call the renaissance of the twelfth century. So long as knowledge was limited to the seven liberal arts of the early Middle Ages, there could be no universities, for there was nothing to teach beyond the bare elements of grammar, rhetoric, logic, and the still barer notions of arithmetic, astronomy, geometry, and music, which did duty for an academic curriculum. Between 1100 and 1200, however, there came a great influx of new knowledge into western Europe, partly through Italy and Sicily, but chiefly through the Arab scholars of Spain—the works of Aristotle, Euclid, Ptolemy, and the Greek physicians, the new arithmetic, and those texts of the Roman law which had lain hidden through the Dark Ages. In addition to the elementary propositions of triangle and circle, Europe now had those books of plane and solid geometry which have done duty in schools and colleges ever since; instead of the painful operations with Roman numerals—how painful one can readily see by trying a simple problem of multiplication or division with these characters—it was now possible to work readily with Arabic figures; in the place of Boethius, the "Master of them that know" became the teacher of Europe in logic, metaphysics, and ethics. In law and medicine men now possessed the fulness of ancient learning. This new knowledge burst the bonds of the cathedral and monastery schools and created the learned professions; it drew over mountains and across the narrow seas eager youths who, like Chaucer's Oxford clerk of a later day, "would gladly learn and gladly teach," to form in Paris and Bologna those academic gilds which have given us our first and our best definition of a university, a society of masters and scholars.

To this general statement concerning the twelfth century there is one partial exception, the medical university of Salerno. Here, a day's journey to the south of Naples, in territory at first Lombard and later Norman, but still in close contact with the Greek East, a school of medicine had existed as early as the middle of the eleventh century, and for perhaps two hundred years thereafter it was the most renowned medical centre in Europe. In this "city of Hippocrates" the medical writings of the ancient Greeks were expounded and even developed on the side of anatomy and surgery, while its teachings were condensed into pithy maxims of hygiene which have not yet lost their vogue—"after dinner walk a mile," etc. Of the academic organization of Salerno we know nothing before 1231, and when in this year the standardizing hand of Frederick II regulated its degrees Salerno had already been distanced by newer universities farther north. Important in the history of medicine, it had no influence on the growth of university institutions.

If the University of Salerno is older in time, that of Bologna has a much larger place in the development of higher education. And while Salerno was known only as a school of medicine, Bologna was a many-sided institution, though most noteworthy as the centre of the revival of the Roman law. Contrary to a common impression, the Roman law did not disappear from the West in the early Middle Ages, but its influence was greatly diminished as a result of the Germanic invasions. Side by side with the Germanic codes, Roman law survived as the customary law of the Roman population, known no longer through the great law books of Justinian but in elementary manuals and form-books which grew thinner and more jejune as time went on. The *Digest,* the most important part of the *Corpus Juris Civilis,* disappears from view between 603 and 1076; only two manuscripts survived; in Maitland's phrase, it "barely escaped with its life." Legal study persisted, if at all, merely as an apprenticeship in the drafting of documents, a form of applied rhetoric. Then, late in the eleventh century, and closely connected with the revival of trade and town life, came a revival of law, foreshadowing the renaissance of the century which followed. This revival can be traced at more than one point in Italy, perhaps not first at Bologna, but here it soon found its centre for the geographical reasons which, then as now, made this city the meeting-point of the chief routes of communication in northern Italy. Some time before 1100 we hear of a professor named Pepo, "the bright and shining light of Bologna"; by 1119 we meet with the phrase *Bononia docta.* At Bologna, as at Paris, a great teacher stands at the beginning of university development. The teacher who gave Bologna its reputation was one Irnerius, perhaps the most famous of the many great professors of law in the Middle Ages. Just what he wrote and what he taught are still subjects of dispute among scholars, but he seems to have fixed the method of "glossing" the law texts upon the basis of a comprehensive use of the whole *Corpus Juris,* as contrasted with the meagre epitomes of the preceding centuries, fully and finally separating the Roman law from rhetoric and establishing it firmly as a subject of professional study. Then, about 1140, Gratian, a monk of San Felice, composed the *Decretum* which became the standard text in canon law, thus marked off from theology as a distinct subject of higher study; and the pre-eminence of Bologna as a law school was fully assured.

A student class had now appeared, expressing itself in correspondence and in poetry, and by 1158 it was sufficiently important in Italy to receive a formal grant of rights and privileges from Emperor Frederick Barbarossa, though no particular town or university is mentioned. By this time Bologna had become the resort of some hundreds of students, not only from Italy but from beyond the Alps. Far from home and undefended, they united for mutual protection and assistance, and this organization of foreign, or Transmontane, students was the beginning of the university. In this union they seem to have followed the example of the gilds already common in Italian cities. Indeed, the word university means originally such a group or corporation in general, and only in time did it come to be limited to gilds of masters and students, *universitas societas magistrorum discipulorumque.* Historically, the word university has no connection with the universe or the universality of learning; it denotes only the totality of a group, whether of barbers, carpenters, or students did not matter. The students of Bologna organized such a university first as a means of protection against the townspeople, for the price of rooms and necessaries rose rapidly with the crowd of new tenants and consumers, and the individual student was helpless against such profiteering. United, the students could bring the town to terms by the threat of departure as a body, secession, for the university, having no buildings, was free to move, and there are many historic examples of such migrations. Better rent one's rooms for less than not rent them at all, and so the student organizations secured the power to fix the prices of lodgings and books through their representatives.

Victorious over the townsmen, the students turned on "their other enemies, the professors." Here the threat was a collective boycott, and as the masters lived at first wholly from the fees of their pupils, this threat was equally effective. The professor was put under bond to live up to a minute set of regulations which guaranteed his students the worth of the money paid by each. We read in the earliest statutes (1317) that a professor might not be absent without leave, even a single day, and if he desired to leave town he had to make a deposit to ensure his return. If he failed to secure an audience of five for a regular lecture, he was fined as if absent—a poor lecture indeed which could not secure five hearers! He must begin with the bell and quit within one minute after the next bell. He was not allowed to skip a chapter in his commentary, or postpone a difficulty to the end of the hour, and he was obliged to cover ground systematically, so much in each specific term of the year. No one might spend the whole year on introduction and bibliography! Coercion of this sort presupposes an effective organization of the student body, and we hear of two and even four universities of students, each composed of "nations" and presided over by a rector. Emphatically Bologna was a student university, and Italian students are still quite apt to demand a voice in university affairs. When I first visited the University of Palermo I found it just recovering from a riot in which the students had broken the front windows in a demand for more frequent, and thus less comprehensive, examinations. At Padua's seventh centenary in May 1922 the students practically took over the town, with a programme of processions and ceremonies quite their own and an amount of noise and tumult which al-

most broke up the most solemn occasions and did break the windows of the greatest hall in the city.

Excluded from the "universities" of students, the professors also formed a gild or "college," requiring for admission thereto certain qualifications which were ascertained by examination, so that no student could enter save by the gild's consent. And, inasmuch as ability to teach a subject is a good test of knowing it, the student came to seek the professor's license as a certificate of attainment, regardless of his future career. This certificate, the license to teach (*licentia docendi*), thus became the earliest form of academic degree. Our higher degrees still preserve this tradition in the words master (*magister*) and doctor, originally synonymous, while the French even have a *licence*. A Master of Arts was one qualified to teach the liberal arts; a Doctor of Laws, a certified teacher of law. And the ambitious student sought the degree and gave an inaugural lecture, even when he expressly disclaimed all intention of continuing in the teaching profession. Already we recognize at Bologna the standard academic degrees as well as the university organization and well-known officials like the rector.

Other subjects of study appeared in course of time, arts, medicine, and theology, but Bologna was preeminently a school of civil law, and as such it became the model of university organization for Italy, Spain, and southern France, countries where the study of law has always had political and social as well as merely academic significance. Some of these universities became Bologna's competitors, like Montpellier and Orleans as well as the Italian schools nearer home. Frederick II founded the University of Naples in 1224 so that the students of his Sicilian kingdom could go to a Ghibelline school at home instead of the Guelfic centre in the North. Rival Padua was founded two years earlier as a secession from Bologna, and only in 1922, on the occasion of Padua's seven-hundredth anniversary, I saw the ancient feud healed by the kiss of peace bestowed on Bologna's rector amid the encores of ten thousand spectators. Padua, however, scarcely equalled Bologna in our period, even though at a later age Portia sent thither for legal authority, and though the university still shines with the glory of Galileo.

In northern Europe the origin of universities must be sought at Paris, in the cathedral school of Notre-Dame. By the beginning of the twelfth century in France and the Low Countries learning was no longer confined to monasteries but had its most active centres in the schools attached to cathedrals, of which the most famous were those of Liège, Rheims, Laon, Paris, Orleans, and Chartres. The most notable of these schools of the liberal arts was probably Chartres, distinguished by a canonist like St. Ives and by famous teachers of classics and philosophy like Bernard and Thierry. As early as 991 a monk of Rheims, Richer, describes the hardships of his journey to Chartres in order to study the *Aphorisms* of Hippocrates of Cos; while from the twelfth century John of Salisbury, the leading northern humanist of the age, has left us an account of

the masters.... Nowhere else today can we drop back more easily into a cathedral city of the twelfth century, the peaceful town still dominated by its church and sharing, now as then,

> the minister's vast repose.
> Silent and gray as forest-leaguered cliff
> Left inland by the ocean's slow retreat,
> patiently remote
> From the great tides of life it breasted once,
> Hearing the noise of men as in a dream.

By the time the cathedral stood complete, with its "dedicated shapes of saints and kings," it had ceased to be an intellectual centre of the first importance, overshadowed by Paris fifty-odd miles away, so that Chartres never became a university. The advantages of Paris were partly geographical, partly political as the capital of the new French monarchy, but something must be set down to the influence of a great teacher in the person of Abelard. This brilliant young radical, with his persistent questioning and his scant respect for titled authority, drew students in large numbers wherever he taught, whether at Paris or in the wilderness. At Paris he was connected with the church of Mont-Sainte-Geneviève longer than with the cathedral school, but resort to Paris became a habit in his time, and in this way he had a significant influence on the rise of the university. In an institutional sense the university was a direct outgrowth of the school of Notre-Dame, whose chancellor alone had authority to license teaching in the diocese and thus kept his control over the granting of university degrees, which here as at Bologna were originally teachers' certificates. The early schools were within the cathedral precincts on the Ile de la Cité, that tangled quarter about Notre-Dame pictured by Victor Hugo which has long since been demolished. A little later we find masters and scholars living on the Little Bridge (Petit-Pont) which connected the island with the Left Bank of the Seine —this bridge gave its name to a whole school of philosophers, the Parvipontani —but by the thirteenth century they have overrun the Left Bank, thenceforth, the Latin Quarter of Paris.

At what date Paris ceased to be a cathedral school and became a university, no one can say, though it was certainly before the end of the twelfth century. Universities, however, like to have precise dates to celebrate, and the University of Paris has chosen 1200, the year of its first royal charter. In that year, after certain students had been killed in a town and gown altercation, King Philip Augustus issued a formal privilege which punished his prévôt and recognized the exemption of the students and their servants from lay jurisdiction, thus creating that special position of students before the courts which has not yet wholly disappeared from the world's practice, though generally from its law. More specific was the first papal privilege, the bull *Parens scientiarum* of 1231,[3] issued after a two years' cessation of lectures growing out of a riot in which a band of students, having found "wine that was good and sweet to drink," beat up the tavern keeper and his friends till they in turn suffered from the prévôt and his men, a dissension in which the thirteenth century clearly saw the hand

of the devil. Confirming the existing exemptions, the Pope goes on to regulate the discretion of the chancellor in conferring the license, at the same time that he recognizes the right of the masters and students "to make constitutions and ordinances regulating the manner and time of lectures and disputations, the costume to be worn," attendance at masters' funerals, the lectures of bachelors, necessarily more limited than those of fully fledged masters, the price of lodgings, and the coercion of members. Students must not carry arms, and only those who frequent the schools regularly are to enjoy the exemptions of students, the interpretation in practice being attendance at not less than two lectures a week.

While the word university does not appear in these documents, it is taken for granted. A university in the sense of an organized body of masters existed already in the twelfth century; by 1231 it had developed into a corporation, for Paris, in contrast to Bologna, was a university of masters. There were now four faculties, each under a dean: arts, canon law (civil law was forbidden at Paris after 1219), medicine, and theology. The masters of arts, much more numerous than the others, were grouped into four "nations": the French, including the Latin peoples; the Normans; the Picard, including also the Low Countries; and the English, comprising England, Germany, and the North and East of Europe. These four nations chose the head of the university, the rector, as he is still generally styled on the Continent, whose term, however, was short, being later only three months. . . .

It is, then, in institutions that the university tradition is most direct. First, the very name university, as an association of masters and scholars leading the common life of learning. Characteristic of the Middle Ages as such a corporation is, the individualistic modern world has found nothing to take its place. Next, the notion of a curriculum of study, definitely laid down as regards time and subjects, tested by an examination and leading to a degree, as well as many of the degrees themselves—bachelor, as a stage toward the mastership, master, doctor, in arts, law, medicine, and theology. Then the faculties, four or more, with their deans, and the higher officers such as chancellors and rectors, not to mention the college, wherever the residential college still survives. The essentials of university organization are clear and unmistakable, and they have been handed down in unbroken continuity. They have lasted more than seven hundred years—what form of government has lasted so long?

Notes

1. H. Denifle, *Die Enstehung der Universitäten des Mittelalters bis 1400,* vol. I (Berlin, 1880).

2. H. Rashdall, *The Universities of Europe in the Middle Ages,* 2 vols. in 3 (Oxford, 1895); rev. ed., 3 vols. (Oxford, 1936). . . .

3. Trans. by L. Thorndike, *University Records and Life in the Middle Ages* (New York, 1944), pp. 35–39.

POSTSCRIPT

Does the Modern University Have Its Roots in the Islamic World?

It is tempting to think that all modern institutions, especially all those that we find admirable, have come down to us in a direct line from our Western intellectual forebears, the Greeks. To take the university as a case in point, however, we cannot trace its origins to Greece. As Haskins points out, the Greeks and Romans had no universities. Higher education was a much less organized enterprise of student-teacher interaction. There were no diplomas, courses of study, examinations, or commencements—at least not as we understand these terms today. Agreeing that we cannot trace the Western university to the Greeks, Haskins and Nakosteen part company on where its roots actually lie. Haskins finds universities springing up in Bologna, Paris, Salerno, and Oxford in response to an infusion of new knowledge brought about by the restoration of trade routes after the Crusades. Nakosteen finds an unbroken line from the eighth-century Islamic world to the late European Middle Ages. The university system, he argues, was formed in an Islamic context and made its way unchanged into a European one.

If we begin a history of education from within the Islamic world, new patterns will emerge. For an introduction to Islam as providing a way to perceive reality, *Islam and the Cultural Accommodation of Social Change* by Bassam Tibi (Westview Press, 1991) offers a clear introduction to the Sunni/Shi'a split in Islam, which persists today, and a discussion of language (in this case Arabic) as the medium in which cultural symbols are articulated. Students may also be interested in Francis Robinson, ed., *The Cambridge Illustrated History of the Islamic World* (Cambridge University Press, 1996), especially chapter 7, "Knowledge, Its Transmission, and the Making of Muslim Societies." In chapter 9, "The Iranian Diaspora: The Edge Creates a Center," of *Islam: A View From the Edge* (Columbia University Press, 1994), Richard W. Bulliet describes the role of Iranian scholars in the spread of *madrasa,* or Islamic colleges.

For additional background on European universities of the Middle Ages, see *The Medieval University* by Helene Wieruszowski (Van Nostrand Reinhold, 1966) and *The Scholastic Culture of the Middle Ages: 1000–1300* by John W. Baldwin (D. C. Heath, 1971). The movie *Stealing Heaven* tells the story of Heloise and Abelard. Set in twelfth-century France, it also offers a very realistic portrayal of the emerging European university system of disputation between professors and students. Finally, Norman F. Cantor's *The Civilization of the Middle Ages* (HarperCollins, 1993) has a chapter entitled "Moslem and Jewish Thought: The Aristotelian Challenge," which summarizes the influence of Islamic thought on Europe.

ISSUE 11

Did Women and Men Benefit Equally From the Renaissance?

YES: Margaret L. King, from *Women of the Renaissance* (University of Chicago Press, 1991)

NO: Joan Kelly-Gadol, from "Did Women Have a Renaissance?" in Renate Bridenthal, Claudia Koonz, and Susan Stuard, eds., *Becoming Visible: Women in European History*, 2d ed. (Houghton Mifflin, 1987)

ISSUE SUMMARY

YES: Historian Margaret L. King surveys Renaissance women in domestic, religious, and learned settings and finds reflected in their lives a new consciousness of themselves as women, as intelligent seekers of a new way of being in the world.

NO: Historian Joan Kelly-Gadol discovered in her work as a Renaissance scholar that well-born women seemed to have enjoyed greater advantages during the Middle Ages and experienced a relative loss of position and power during the Renaissance.

In 1974 Joan Kelly-Gadol published a pathbreaking essay that challenged traditional periodization. Before that, virtually every publication on the Renaissance proclaimed it to be a great leap forward for everyone, a time when new ideas were widely discussed and the old strictures of the Middle Ages were thrown off. The difficulty for Kelly-Gadol was that her own work on women during the medieval and Renaissance periods told a different story. She was one of the first to raise this troubling question: Are the turning points in history the same for women as they are for men? Kelly-Gadol found that well-born women lived in a relatively free environment during the Middle Ages. The courtly love tradition allowed powerful, property-owning women to satisfy their own sexual and emotional needs. With the arrival of the Renaissance, however, the courtly love tradition was defined by powerful male princes who found it desirable for women to be passive and chaste in order to serve the needs of the rising bourgeoisie.

The field of women's history has a history of its own. Beginning with the pioneering work of historians such as Mary Ritter Beard, *Woman as Force in*

History: A Study in Traditions and Realities (Collier Books, 1946), scholars first engaged in what Gerda Lerner has called "compensatory history"—compensating for past omissions by researching and writing about the great women of history. In a second phase, women's history moved to "contributory history." Looking past the great women, historians took all the traditional categories of standard male history and found women who filled them—women who spent their lives as intellectuals, soldiers, politicians, and scientists. The current phase of women's history parallels more general trends in social history, concentrating on the ordinary people who lived during historical epochs. In this more mature phase, the emphasis is on women's culture—how women saw the world from within their own systems and ways of doing things. If Beard was doing compensatory history, Kelly-Gadol might be said to be engaging in contributory history. The women she writes about led lives similar to those of men in their class during the Middle Ages, but Kelly-Gadol contends that they had a different experience during the Renaissance—a contraction of their sphere of influence and a loss of freedom in the expression of their sexual and emotional needs. For the first time, a sexual double standard appeared—men could engage in extramarital liaisons, whereas women had to remain chaste.

One caution to keep in mind is that people are not aware of the times in which they live in terms of the historical periods that scholars later use for identification. People of the past, like people today, are more concerned with their personal lives and fortunes than with historical trends. Periodization, or the marking of turning points in the past, can be useful. It can help to identify broad trends and forks in the road as we explore the past. What women's history has taught us, however, is that looking at the experiences of men may or may not tell us what the experiences of women were like during the same time periods.

Beard's book and the field of women's history that it inspired made possible the work of later scholars such as Kelly-Gadol. Beard challenged traditional notions about the role of women in history; Kelly-Gadol challenged history itself. Margaret L. King's study, from which the first selection is taken, confronts Kelly-Gadol's question directly and explores it in the light of all we now know about the richly diverse lives of women who lived during the Renaissance.

Margaret L. King

Virgo et Virago:
Women and High Culture

Women of Might, Power, and Influence

On the stake that supported the burning corpse of the peasant Joan of Arc, who had donned armor and rallied a king, a placard bore the names that the people of the Renaissance gave to the women they hated: heretic, liar, sorceress. The mystery of that hatred has preoccupied the many tellers of the tale of the life of this patron saint of France. Their answers cannot be recounted here, but without simplifying too much they can be summed up in this way: she was hated because she did what men did, and triumphantly. The men who planted stakes over the face of Europe would not tolerate such a transgression of the order they imagined to be natural. In the age of emblems, Joan of Arc is an emblem of the Renaissance women who attempted to partake in the civilization of the Renaissance: not as bearers of children or worshippers of God, but as forgers of its cultural forms. These women did not share her fate, but a few of them understood it.

Foremost among these women, in the records that that age has left us, are those who had no choice about the role they played. Like Joan, they bore arms, or wielded powers still more formidable. They were the queens and female rulers who ruled as the surrogates of their absent husbands, dead fathers, and immature sons. Extraordinary in their personal strengths and achievements, they have left no residue: their capital passed through the male line of descent and not to female heirs—at least not in the centuries of which we speak. But as women who held command, even if briefly and without issue, they deserve our attention.

In Italy later in the same century that Joan illumined with her strength, Caterina Sforza posed a more traditional but still boldly independent figure. The illegitimate granddaughter of Francesco Sforza, who was in turn the illegitimate usurper of the dynasty of the Visconti in Milan, Caterina was propelled into the political maelstrom of quattro-cento Italy by her marriage to Girolamo Riario, nephew of Pope Sixtus IV. After her husband's assassination in 1488, she fiercely defended her family's interests and the cities of Imola and Forli. Greatly

outnumbered by her besiegers, she defended Forli against the enemy who held her six children hostage. Twelve years later, she again commanded the defense of those same walls, was defeated, possibly raped, and was brought captive to Rome by Cesare Borgia.

While Sforza, like Joan of Arc, assumed a military role, she secured no power; few women, even of the most exalted noble and royal families, ever did. Two major exceptions were the Italian-born Catherine de'Medici, who as the widow of France's King Henri II was the regent for his successors, François II and Charles IX, and Elizabeth, daughter of the Tudor king of England. Both molded a Renaissance identity for a female sovereign that expressed the ambiguity of their roles. The former adopted for herself the emblem of Artemisia (the type of armed-and-chaste maiden to be considered at greater length below), who was known for her dutiful remembrance of her predeceased husband, Mausolus. Wielding this device, Catherine de'Medici could both act assertively and demonstrate piety to the male rulers between whom she transmitted power. The more independent and bolder Elizabeth was a master builder of her public image and presented herself to her subjects in a variety of feminine identities: Astraea, Deborah, Diana. At the same time, to win support in moments of crisis for the unprecedented phenomenon of a female monarch, she projected androgynous images of her role (man woman, queen-king, mother-son), and haughtily referred to herself as "prince," with the body of a woman and heart of a king. She defied the identification of her sex with instability and incompetence. In 1601, the elderly Elizabeth asked Parliament in her Golden Speech: "Shall I ascribe anything to myself and my sexly weakness? I were not worthy to live then"; "my sex," she said a few weeks before her death, "cannot diminish my prestige." Had she married, she might have borne an heir. But had she married, she would have fallen under the influence of a male consort. Instead, a complete dyad in herself, she took no husband and declared herself married to England. Her heroic virginity, more in the pattern of the great saints than of a modern woman, set her apart from the other women of her realm who continued to marry and dwell within the family. Her sexual nature was exceptional, just as her kingly authority was anomalous. In and of herself, she insisted on her right to rule, and was the only woman to hold sovereign power during the Renaissance.

Much of the culture of the late sixteenth-century Tudor court revolved around this manlike virgin whose name still identifies it: Elizabethan. Subtly, the poets, playwrights, and scholars of the age commented on the prodigy among them. Foremost among these commentators was William Shakespeare; in the androgynous heroines of his comedies can be found versions of the monarch, sharp-witted and exalted beyond nature. These female characters, played by boys dressed as women who often dressed as boys to create beings of thoroughly confused sexuality, charmed and entranced like the queen herself. The Shakespearean genius also understood how deeply the phenomenon of a queen-king violated the natural order. In the seemingly lighthearted "Midsummer Night's Dream" he spoke about the abnormality of a political order ruled by a woman when the Amazon Hippolyta was wedded at the last to the lawful male wielder of power. Like Joan of Arc, Elizabeth was perceived (and

perceived herself) as an Amazon, and deep in the consciousness of the age she dominated was the discomfiture caused by an armed maiden, a rational female, an emotional force unlimited by natural order.

The phenomenon of enthroned women like Catherine and Elizabeth provoked controversy about the legitimacy of female rule. No one was more outspoken than the Presbyterian John Knox, who charged in his *First Blast of the Trumpet Against the Monstrous Regiment of Women* of 1558 that "it is more than a monster in nature that a woman shall reign and have empire above man." "To promote a woman to bear rule, above any realm, nation, or city, is repugnant to nature, contumely to God, . . . and, finally, it is the subversion of good order, of all equity and justice." When a woman rules, the blind lead the sighted, the sick the robust, "the foolish, mad and frenetic" the discreet and sober. "For their sight in civil regiment is but blindness, their counsel foolishment, and judgment frenzy." Woman's attempt to rule is an act of treason: "For that woman reigneth above man, she hath obtained it by treason and conspiracy committed against God. . . . [Men] must study to repress her inordinate pride and tyranny to the uttermost of their power." God could occasionally choose a woman to rule, John Aylmer wrote a year later, refuting Knox; but most women were "fond, folish, wanton flibbergibbes, tatlers, triflers, wavering witles, without counsell, feable, careless, rashe proude," and so on.

Most defenders of female rule in the sixteenth century could not transcend the problem of gender. While Knox was driven to fury by the accession of Mary Tudor to power, the behavior of her successor Elizabeth the Great enraged the French Catholic political theorist Jean Bodin. In the sixth book of his *Six Books of the Republic,* Bodin explored thoroughly the emotional dimension of female rule. A woman's sexual nature would surely, he claimed, interfere with her effectiveness as ruler. As Giovanni Correr, the Venetian ambassador to France, said of another Queen Mary, the unfortunate monarch of Scotland, "to govern states is not the business of women." Other Venetian ambassadors to the court of Elizabeth's successors were more impressed: that queen by her exceptional wisdom and skill had "advanced the female condition itself," and "overcome the distinction of sexes." Male observers thus viewed the sex of the female monarch as an impediment to rule or considered it obliterated, overlooking it altogether, as though the woman was no woman. Spenser simply made his monarch an exception to the otherwise universal rule of female subordination: "vertuous women" know, he wrote, that they are born "to base humilitie," unless God intervenes to raise them "to lawful soveraintie" (*Faerie Queene* 5.5.25).

Although this problem was agonizing for the few women who ruled, there were only a handful who had to face it: it was rare for a woman to inherit power as did these English queens. It required, in fact, the timely death of all power-eligible males. Most women in the ruling classes did not rule, but only shared some of the prerogatives of sovereignty. In the vibrant artistic and intellectual climate of the Renaissance, particularly in Italy, this meant that they exercised the power of patronage. Women who did not rule or direct with their armies the forces of destruction could wield their authority and wealth to shape thought and culture.

Wherever courts existed as centers of wealth, artistic activity, and discourse, opportunities abounded for intelligent women to perform in the role of patroness of the arts and culture. In France, Anne of Brittany, Queen of Charles VIII, commissioned the translation of Boccaccio's *Concerning Famous Women (De claris mulieribus)*, and filled her court with educated women and discussions of platonic love. The same king's sister-in-law Louise of Savoy tutored the future king François I and his sister, Marguerite, according to the principles of Italian humanism. The latter—Marguerite d'Angoulême, later of Navarre—was the director of cultural matters at her brother's royal court and the protector of a circle of learned men. Influenced by the evangelism of Lefèvre d'Etaples and Guillaume Budé, guided in matters of spirit by the bishop Guillaume Briçonnet, she was at the center of currents of proto-reform. An original thinker herself, her collection of stories, the *Heptaméron,* raised questions about the troubled roles of women in a man's world. From this court circle of active patronesses and educators there derived other women of some power and influence: among them the Calvinist Jeanne d'Albret, Marguerite's daughter and the mother of the future king Henry IV, a valiant fighter for her family and religion; and Renée, the heir of Louis XII who was bypassed in favor of her male cousin François I and made wife instead to the Duke of Ferrara, who chose as a companion for her own daughter the adolescent Italian humanist Olimpia Morata.

In Spain the formidable Isabella guided religious reform and intellectual life, while in England, her learned daughter Catherine of Aragon, King Henry VIII's first queen, was surrounded by the leading humanists of the era. It was for her that Erasmus wrote his *Institution of Christian Matrimony (Christiani matrimonii institutio)* and Juan Luis Vives his *Instruction of a Christian Woman (Institutio foeminae christianae)* and other works. She sought Vives as a tutor for her own daughter, the future queen Mary Tudor. A generation earlier, the proto-figure of the royal patroness and learned woman in England was Margaret Beaufort, Countess of Richmond, already noted as the mother of that country's first Tudor monarch. At the courts of Edward IV and Richard III, she had surrounded herself with minstrels and learned men, supported the art of printing (then in its early stages), endowed professorships of divinity at Oxford and Cambridge (where she founded two colleges), supervised the education of her son and grandchildren, and herself translated from the Latin the devotional *The Mirror of Gold of the Sinful Soul.*

In Italy, where courts and cities and talented men clustered, opportunities abounded for the cultivated woman to help shape the culture of the Renaissance. Notable among such patronesses was Isabella d'Este, daughter of the rulers of Ferrara, sister of Beatrice, who was to play a similar but paler role in Milan, and of Alfonso, Ferrante, Ippolito, and Sigismondo, whom she was to rival in fame. Trained by Battista Guarini, the pedagogue son of the great humanist Guarino Veronese, she had mastered Greek and Latin, the signs of serious scholarship, alongside such skills as lute-playing, dance, and witty conversation. Married to the ruler of Mantua, she presided at that court over festivities and performances, artists, musicians and scholars, libraries filled with elegant volumes; she lived surrounded everywhere by statues, ornate boxes, clocks, marbles, lutes, dishes, gowns, playing cards decorated with paintings, jewels,

and gold. Ariosto, Bernardo da Bibbiena, and Gian Giorgio Trissino were among those she favored. She studied maps and astrology and had frequent chats with the ducal librarian, Pellegrino Prisciano. Her *Studiolo* and *Grotta,* brilliantly ornamented rooms in the ducal palace, were her glorious monuments. For these and other projects, she designed the allegorical schemes, consulting with her humanist advisers. Ruling briefly when her husband was taken captive during the wars that shook Italy after the invasion of the forces of France, Spain, and Empire, she was repaid with anger for her bold assumption of authority. Her great capacity was left to express itself in patronage.

Also dislodged from the limited tenure of sovereignty was the wealthy Venetian noblewoman Caterina Cornaro. Born to an ancient Venetian noble family with interests in the eastern Mediterranean—her own mother was from a Greek royal family—Cornaro was married in 1472, at age eighteen, to the King of Cyprus, James II. Her city was concerned with her royal marriage from the start: the island of Cyprus was strategically important, and the Serenissima was jealous of its citizens' involvement in consequential foreign affairs. Venetian concern was justified, for Cornaro became queen of Cyprus a year later, after her husband's sudden death, and held unstable sway, racked by conspiracies, for sixteen years. When Cornaro was tempted by a marriage into the Neapolitan royal house, Venice exerted its authority mightily to force her to abdicate the Cypriot throne. A Neapolitan connection would have meant the alienation of Cyprus from Venetian control. The legate dispatched to the island and charged to persuade her to step down was none other than her brother. He came with offers of an annual salary of 8,000 ducats and a small fiefdom on the Venetian terra firma: she would win fame for herself, he promised, and be known forever as Queen of Cyprus, if she donated her husband's island to her *patria.* Thus compensated by fame and wealth, Cornaro left her rich island kingdom for the miniature one at Asolo. In that court she reigned as queen over a coterie of *letterati:* not the least of them Pietro Bembo, who memorialized the activities over which Cornaro presided in the Arcadian dialogue *Gli Asolani.* Published in 1505 by Aldo Manuzio in Venice, ten years after the conversations that sparked Bembo's imagination had taken place, it circulated in twenty-two editions, Italian as well as Spanish and French. Perhaps more significantly, it influenced the even more famous and complex dialogue of Baldassare Castiglione, commemorating a court presided over by another patroness of letters.

Cornaro's court as described by Bembo prefigures the one in Urbino which Castiglione described. There two women—the Duchess, Elisabetta Gonzaga, and her companion, Emilia Pia—guided and inspired the discussions of proper behavior for both sexes that made up the age's principal handbook of aristocratic values, circulated in some hundred editions and translated into all the major vernaculars: *The Book of the Courtier (Il libro del cortigiano).* For both sexes, that behavior is sharply defined by the phenomenon of the court: men were not to be too boisterous; women were to be occasions of beauty and delight. No court "however great, can have adornment or splendor or gaiety in it without ladies"; in the same way, no courtier can "be graceful or pleasing or brave, or do any gallant deed of chivalry, unless he is moved by the society and by the love and charm of ladies." "Who learns to dance gracefully for

any reason except to please women? Who devotes himself to the sweetness of music for any other reason? Who attempts to compose verses... unless to express sentiments inspired by women?"

The virtues that women had to possess to inspire these male achievements were manifold. The courtly lady shares some virtues possessed also by the gentleman—she should be well born, naturally graceful, well mannered, clever, prudent, and capable—but also others which are distinctively hers. If married, she should be a good manager of her husband's "property and house and children," and possess "all qualities that are requisite in a good mother." Beauty is a necessity for her, though not for her male counterpart: "for truly that woman lacks much who lacks beauty." Above all, she must be charming: "she will be able to entertain graciously every kind of man with agreeable and comely conversation suited to the time and place and to the station of the person with whom she speaks, joining to serene and modest manners, and to that comeliness that ought to inform all her actions, a quick vivacity of spirit whereby she will show herself a stranger to all boorishness; but with such a kind manner as to cause her to be thought no less chaste, prudent, and gentle than she is agreeable, witty, and discreet." The qualities the court lady possesses are distinct from those of the courtier she is set to amuse: "above all... in her ways, manners, words, gestures, and bearing, a woman ought to be very unlike a man, for just as he must show a certain solid and sturdy manliness, so it is seemly for a woman to have a soft and delicate tenderness, with an air of womanly sweetness in her every movement, which, in her going and staying, and in whatever she says, shall always make her appear the woman without any resemblance to a man." Unlike the queen who bears the power and the glory of the males who otherwise occupy her throne, according to Giuliano de' Medici, Castiglione's spokesman by no means hostile to the female sex, the aristocratic lady must be taught to be something other than a man. The same was true of her humbler counterpart in the bourgeois or artisan classes....

A final question remains—the one implied in the title of a work aiming to describe "Women of the Renaissance." Was there a Renaissance for women? Joan Kelly wrote boldly in 1977 that there was not: "at least, not during the Renaissance." At the time, her insight was powerful. For she was the first historian to point unremittingly to the dismal realities of women's lives in the Renaissance centuries. Within the family, they were subject to fathers and husbands and their surrogates in modes that did not relent before the end of Renaissance centuries. They bore special burdens of economic hardship, which limited their dowries and determined their destinies if they were of the elite, or which condemned them (much as it condemned their brothers) to lives of servitude if they were not. Within the church, they were powerless as well. In Roman Catholic countries, those women who chose or were consigned to the religious life were increasingly enclosed, scrutinized, and constrained. In Protestant countries, they were denied the option of convent or anchorage and placed under the spiritual supervision of the same men who decided their social destiny. In both settings, they could seize, at their peril, the option of nonconformity: they could be heretics, prophets, sectaries, or witches. In the world of learning, women remained suspect throughout the period. They snatched an

education, in a few cases, from affectionate fathers, brothers, uncles, and grand-fathers. But if they wrote, they were declared to be unwomanly; and if they wrote very well, they were labeled Amazons, fearsome and unnatural beings. This does not look like a Renaissance, a rebirth into a new life, but a contin-uation and in some ways an intensification of the disabilities and prejudices inherited from the Middle Ages and from antiquity.

Yet an argument can be made to the contrary, and has been, for instance, by the splendid historian of Italian society, David Herlihy. Woman's charismatic role, her astonishing success as intermediary with the divine, rooted in her fe-male role as mother projected on a cosmic scale, gave her special prominence precisely in the Renaissance centuries. As it did, in the case of a few excep-tional women. One might wonder if the far greater numbers of those who burned and suffered the torments of the torture chamber might overshadow the figures of spiritual prominence; or if the ordinary suffering of the great mass of women overshadows them, for though these women were subject to the same harsh austerities as men of the age, they were deprived, unlike men, of all autonomy. Nevertheless, Herlihy's suggestion is persuasive. Something changed during the Renaissance in women's sense of themselves, even if very little changed or changed for the better in their social condition. That change did have its roots in the spiritual experience of women, and it culminates in the consciousness put into words by the first feminists of the Renaissance. Not monsters, not defects in nature, but the intelligent seekers of a new way, these women wielded the picks of their understanding to build a better city for ladies.

NO ↵

Joan Kelly-Gadol

Did Women Have a Renaissance?

O ne of the tasks of women's history is to call into question accepted schemes of periodization. To take the emancipation of women as a vantage point is to discover that events that further the historical development of men, liberating them from natural, social, or ideological constraints, have quite different, even opposite, effects upon women. The Renaissance is a good case in point. Italy was well in advance of the rest of Europe from roughly 1350 to 1530 because of its early consolidation of genuine states, the mercantile and manufacturing economy that supported them, and its working out of postfeudal and even postguild social relations. These developments reorganized Italian society along modern lines and opened the possibilities for the social and cultural expression for which the age is known. Yet precisely these developments affected women adversely, so much so that there was no renaissance for women —at least, not during the Renaissance. The state, early capitalism, and the social relations formed by them impinged on the lives of Renaissance women in different ways according to their different positions in society. But the startling fact is that women as a group, especially among the classes that dominated Italian urban life, experienced a contraction of social and personal options that men of their classes either did not, as was the case with the bourgeoisie, or did not experience as markedly, as was the case with the nobility.

Before demonstrating this point, which contradicts the widely held notion of the equality of Renaissance women with men, we need to consider how to establish, let alone measure, loss or gain with respect to the liberty of women. I found the following criteria most useful for gauging the relative contraction (or expansion) of the powers of Renaissance women and for determining the quality of their historical experience: 1) the regulation of *female sexuality* as compared with male sexuality; 2) women's *economic* and *political roles,* that is, the kind of work they performed as compared with men, and their access to property, political power, and the education or training necessary for work, property, and power; 3) the *cultural roles* of women in shaping the outlook of their society, and access to the education and/or institutions necessary for this; 4) *ideology* about women, in particular the sex-role system displayed or advocated in the symbolic products of the society, its art, literature, and philosophy. Two points should be made about this ideological index. One is its rich

From Joan Kelly-Gadol, "Did Women Have a Renaissance?" in Renate Bridenthal, Claudia Koonz, and Susan Stuard, eds., *Becoming Visible: Women in European History,* 2d ed. (Houghton Mifflin, 1987). Copyright © 1987 by Houghton Mifflin Company. Reprinted by permission. Notes omitted.

inferential value. The literature, art, and philosophy of a society, which give us direct knowledge of the attitudes of the dominant sector of that society toward women, also yield indirect knowledge about our other criteria: namely, the sexual, economic, political, and cultural activities of women. Insofar as images of women relate to what really goes on, we can infer from them something about that social reality. But, second, the relations between the ideology of sex roles and the reality we want to get at are complex and difficult to establish. Such views may be prescriptive rather than descriptive; they may describe a situation that no longer prevails; or they may use the relation of the sexes symbolically and not refer primarily to women and sex roles at all. Hence, to assess the historical significance of changes in sex-role conception, we must bring such changes into connection with all we know about general developments in the society at large.

This essay examines changes in sex-role conception, particularly with respect to sexuality, for what they tell us about Renaissance society and women's place in it. At first glance, Renaissance thought presents a problem in this regard because it cannot be simply categorized. Ideas about the relation of the sexes range from a relatively complementary sense of sex roles in literature dealing with courtly manners, love, and education, to patriarchal conceptions in writings on marriage and the family, to a fairly equal presentation of sex roles in early Utopian social theory. Such diversity need not baffle the attempt to reconstruct a history of sex-role conceptions, however, and to relate its course to the actual situation of women. Toward this end, one needs to sort out this material in terms of the social groups to which it responds: to courtly society in the first case, the nobility of the petty despotic states of Italy; to the patrician bourgeoisie in the second, particularly of republics such as Florence. In the third case, the relatively equal position accorded women in Utopian thought (and in those lower-class movements of the radical Reformation analogous to it) results from a larger critique of early modern society and all the relations of domination that flow from private ownership and control of property. Once distinguished, each of these groups of sources tells the same story. Each discloses in its own way certain new constraints suffered by Renaissance women as the family and political life were restructured in the great transition from medieval feudal society to the early modern state. The sources that represent the interests of the nobility and the bourgeoisie point to this fact by a telling, double index. Almost all such works—with certain notable exceptions, such as Boccaccio and Ariosto—establish chastity as the female norm and restructure the relation of the sexes to one of female dependency and male domination.

The bourgeois writings on education, domestic life, and society constitute the extreme in this denial of women's independence. Suffice it to say that they sharply distinguish an inferior domestic realm of women from the superior public realm of men, achieving a veritable "renaissance" of the outlook and practices of classical Athens, with its domestic imprisonment of citizen wives. The courtly Renaissance literature we will consider was more gracious. But even here, by analyzing a few of the representative works of this genre, we find a new repression of the noblewoman's affective experience, in contrast to the latitude afforded her by medieval literature, and some of the social and cultural

reasons for it. Dante and Castiglione, who continued a literary tradition that began with the courtly love literature of eleventh- and twelfth-century Provence, transformed medieval conceptions of love and nobility. In the love ideal they formed, we can discern the inferior position the Renaissance noblewoman held in the relation of the sexes by comparison with her male counterpart and with her medieval predecessor as well.

Love and the Medieval Lady

Medieval courtly love, closely bound to the dominant values of feudalism and the Church, allowed in a special way for the expression of sexual love by women. Of course, only aristocratic women gained their sexual and affective rights thereby. If a knight wanted a peasant girl, the twelfth-century theorist of *The Art of Courtly Love,* Andreas Capellanus, encouraged him "not [to] hesitate to take what you seek and to embrace her by force." Toward the lady, however, "a true lover considers nothing good except what he thinks will please his beloved"; for if courtly love were to define itself as a noble phenomenon, it had to attribute an essential freedom to the relation between lovers. Hence, it metaphorically extended the social relation of vassalage to the love relationship, a "conceit" that Maurice Valency rightly called "the shaping principle of the whole design" of courtly love.

Of the two dominant sets of dependent social relations formed by feudalism—*les liens de dépendance,* as Marc Bloch called them—vassalage, the military relation of knight to lord, distinguished itself (in its early days) by being freely entered into. At a time when everyone was somebody's "man," the right to freely enter a relation of service characterized aristocratic bonds, whereas hereditability marked the servile work relation of serf to lord. Thus, in medieval romances, a parley typically followed a declaration of love until love freely proffered was freely returned. A kiss (like the kiss of homage) sealed the pledge, rings were exchanged, and the knight entered the love service of his lady. Representing love along the lines of vassalage had several liberating implications for aristocratic women. Most fundamental, ideas of homage and mutuality entered the notion of heterosexual relations along with the idea of freedom. As symbolized on shields and other illustrations that place the knight in the ritual attitude of commendation, kneeling before his lady with his hands folded between hers, homage signified male service, not domination or subordination of the lady, and it signified fidelity, constancy in that service. "A lady must honor her lover as a friend, not as a master," wrote Marie de Ventadour, a female troubadour or *trobairitz.* At the same time, homage entailed a reciprocity of rights and obligations, a service on the lady's part as well. In one of Marie de France's romances, a knight is about to be judged by the barons of King Arthur's court when his lady rides to the castle to give him "succor" and pleads successfully for him, as any overlord might. Mutuality, or complementarity, marks the relation the lady entered into with her *ami* (the favored name for "lover" and, significantly, a synonym for "vassal").

This relation between knight and lady was very much at variance with the patriarchal family relations obtaining in that same level of society. Aware of

its incompatibility with prevailing family and marital relations, the celebrants of courtly love kept love detached from marriage. "We dare not oppose the opinion of the Countess of Champagne who rules that love can exert no power between husband and wife," Andreas Capellanus wrote (p. 175). But in opting for a free and reciprocal heterosexual relation outside marriage, the poets and theorists of courtly love ignored the almost universal demand of patriarchal society for female chastity, in the sense of the woman's strict bondage to the marital bed. The reasons why they did so, and even the fact that they did so, have long been disputed, but the ideas and values that justify this kind of adulterous love are plain. Marriage, as a relation arranged by others, carried the taint of social necessity for the aristocracy. And if the feudality denigrated marriage by disdaining obligatory service, the Church did so by regarding it not as a "religious" state, but an inferior one that responded to natural necessity. Moreover, Christianity positively fostered the ideal of courtly love at a deep level of feeling. The courtly relation between lovers took vassalage as its structural model, but its passion was nourished by Christianity's exaltation of love.

Christianity had accomplished its elevation of love by purging it of sexuality, and in this respect, by recombining the two, courtly love clearly departed from Christian teaching. The toleration of adultery it fostered thereby was in itself not so grievous. The feudality disregarded any number of church rulings that affected their interests, such as prohibitions of tournaments and repudiation of spouses (divorce) and remarriage. Moreover, adultery hardly needed the sanction of courtly love, which, if anything, acted rather as a restraining force by binding sexuality (except in marriage) to love. Lancelot, in Chrétien de Troyes's twelfth-century romance, lies in bed with a lovely woman because of a promise he has made, but "not once does he look at her, nor show her any courtesy. Why not? Because his heart does not go out to her.... The knight has only one heart, and this one is no longer really his, but has been entrusted to someone else, so that he cannot bestow it elsewhere." Actually, Lancelot's chastity represented more of a threat to Christian doctrine than the fact that his passion (for Guinevere) was adulterous, because his attitudes justified sexual love. Sexuality could only be "mere sexuality" for the medieval Church, to be consecrated and directed toward procreation by Christian marriage. Love, on the other hand, defined as passion for the good, perfects the individual; hence love, according to Thomas Aquinas, properly directs itself toward God. Like the churchman, Lancelot spurned mere sexuality—but for the sake of sexual love. He defied Christian *teaching* by reattaching love to sex; and experiencing his love as a devout vocation, as a passion, he found himself in utter accord with Christian *feeling*....

The Renaissance Lady: Politics and Culture

In his handbook for the nobility, Baldassare Castiglione's description of the lady of the court makes [the] difference in sex roles quite clear. On the one hand, the Renaissance lady appears as the equivalent of the courtier. She has the same virtues of mind as he, and her education is symmetrical with his. She learns everything—well, almost everything—he does: "knowledge of letters,

of music, of painting, and... how to dance and how to be festive." Culture is an accomplishment for noblewoman and man alike, used to charm others as much as to develop the self. But for the woman, charm had become the primary occupation and aim. Whereas the courtier's chief task is defined as the profession of arms, "in a Lady who lives at court a certain pleasing affability is becoming above all else, whereby she will be able to entertain graciously every kind of man" (p. 207).

... The Renaissance lady is not desired, not loved for herself. Rendered passive and chaste, she merely mediates the courtier's safe transcendence of an otherwise demeaning necessity. On the plane of symbolism, Castiglione thus had the courtier dominate both her and the prince; and on the plane of reality, he indirectly acknowledged the courtier's actual domination of the lady by having him adopt "woman's ways" in his relations to the prince. Castiglione had to defend against effeminacy in the courtier, both the charge of it (p. 92) and the actuality of faces "soft and feminine as many attempt to have who not only curl their hair and pluck their eyebrows, but preen themselves... and appear so tender and languid... and utter their words so limply" (p. 36). Yet the close-fitting costume of the Renaissance nobleman displayed the courtier exactly as Castiglione would have him, "well built and shapely of limb" (p. 36). His clothes set off his grace, as did his nonchalant ease, the new manner of those "who seem in words, laughter, in posture not to care" (p. 44). To be attractive, accomplished, and seem not to care; to charm and do so coolly—how concerned with impression, how masked the true self. And how manipulative: petitioning his lord, the courtier knows to be "discreet in choosing the occasion, and will ask things that are proper and reasonable; and he will so frame his request, omitting those parts that he knows can cause displeasure, and will skillfully make easy the difficult points so that his lord will always grant it" (p. 111). In short, how like a woman—or a dependent, for that is the root of the simile.

The accommodation of the sixteenth- and seventeenth-century courtier to the ways and dress of women in no way bespeaks a greater parity between them. It reflects, rather, that general restructuring of social relations that entailed for the Renaissance noblewoman a greater dependency upon men as feudal independence and reciprocity yielded to the state. In this new situation, the entire nobility suffered a loss. Hence, the courtier's posture of dependency, his concern with the pleasing impression, his resolve "to perceive what his prince likes, and... to bend himself to this" (pp. 110–111). But as the state overrode aristocratic power, the lady suffered a double loss. Deprived of the possibility of independent power that the combined interests of kinship and feudalism guaranteed some women in the Middle Ages, and that the states of early modern Europe would preserve in part, the Italian noblewoman in particular entered a relation of almost universal dependence upon her family and her husband. And she experienced this dependency at the same time as she lost her commanding position with respect to the secular culture of her society.

Hence, the love theory of the Italian courts developed in ways as indifferent to the interests of women as the courtier, in his self-sufficiency, was indifferent as a lover. It accepted, as medieval courtly love did not, the double standard. It bound the lady to chastity, to the merely procreative sex of political marriage,

just as her weighty and costly costume came to conceal and constrain her body while it displayed her husband's noble rank. Indeed, the person of the woman became so inconsequential to this love relation that one doubted whether she could love at all. The question that emerges at the end of *The Courtier* as to "whether or not women are as capable of divine love as men" (p. 350) belongs to a love theory structured by mediation rather than mutuality. Woman's beauty inspired love but the lover, the agent, was man. And the question stands unresolved at the end of *The Courtier*—because at heart the spokesmen for Renaissance love were not really concerned about women or love at all.

Where courtly love had used the social relation of vassalage to work out a genuine concern with sexual love, Castiglione's thought moved in exactly the opposite direction. He allegorized love as fully as Dante did, using the relation of the sexes to symbolize the new political order. In this, his love theory reflects the social realities of the Renaissance. The denial of the right and power of women to love, the transformation of women into passive "others" who serve, fits the self-image of the courtier, the one Castiglione sought to remedy. The symbolic relation of the sexes thus mirrors the new social relations of the state, much as courtly love displayed the feudal relations of reciprocal personal dependence. But Renaissance love reflects, as well, the actual condition of dependency suffered by noblewomen as the state arose. If the courtier who charms the prince bears the same relation to him as the lady bears to the courtier, it is because Castiglione understood the relation of the sexes in the same terms that he used to describe the political relation: that is, as a relation between servant and lord. The nobleman suffered this relation in the public domain only. The lady, denied access to a freely chosen, mutually satisfying love relation, suffered it in the personal domain as well. Moreover, Castiglione's theory, unlike the courtly love it superseded, subordinated love itself to the public concerns of the Renaissance nobleman. He set forth the relation of the sexes as one of dependency and domination, but he did so in order to express and deal with the political relation and its problems. The personal values of love, which the entire feudality once prized, were henceforth increasingly left to the lady. The courtier formed his primary bond with the modern prince.

In sum, a new division between personal and public life made itself felt as the state came to organize Renaissance society, and with that division the modern relation of the sexes made its appearance, even among the Renaissance nobility. Noblewomen, too, were increasingly removed from public concerns—economic, political, and cultural—and although they did not disappear into a private realm of family and domestic concerns as fully as their sisters in the patrician bourgeoisie, their loss of public power made itself felt in new constraints placed upon their personal as well as their social lives. Renaissance ideas on love and manners, more classical than medieval, and almost exclusively a male product, expressed this new subordination of women to the interests of husbands and male-dominated kin groups and served to justify the removal of women from an "unladylike" position of power and erotic independence. All the advances of Renaissance Italy, its protocapitalist economy, its states, and its humanistic culture, worked to mold the noblewoman into an aesthetic object: decorous, chaste, and doubly dependent—on her husband as well as the prince.

POSTSCRIPT

Did Women and Men Benefit Equally From the Renaissance?

Once we begin to consider the experiences of women in history as separate from those of men, we meet a new set of challenges. Women are not a universal category, and their experiences throughout history are as varied as their race, social class, ethnicity, religion, sexual orientation, and a host of other categories make them. In recent years historians have begun to consider both the ways in which women's historical experiences are more or less the same (with regard to childbirth, access or lack of access to birth control, and female sexuality, for example) and the ways in which one woman's experience differs radically from another's (because of race, class, or a host of other differences).

The periodization question remains a fascinating one. Following Kelly-Gadol, other scholars began to look at historical periods with which they were familiar with an eye to using women's experiences as a starting point. In *Becoming Visible* (from which Kelly-Gadol's selection was excerpted), William Monter poses this question: Was there a Reformation for women? This anthology offers a number of good points of departure for exploring the issue of periodization. For a fuller explanation of the differences among compensatory, contributory, and other approaches, see Gerda Lerner's essay "Placing Women in History," in *Major Problems in Women's History*, 2d ed., edited by Mary Beth Norton and Ruth Alexander (D. C. Heath, 1996). This collection also contains Gisela Bock's "Challenging Dichotomies in Women's History"—which considers nature versus culture, work versus family, public versus private, sex versus gender, equality versus difference, and integration versus autonomy—and "Afro-American Women in History," by Evelyn Brooks Higginbotham, which questions the concept of a universal womanhood by exploring the varying experiences of African American women.

For a Marxist analysis of women in history, see the chapter entitled "Four Structures in a Complex Unity," in Juliet Mitchell's *Woman's Estate* (Pantheon Books, 1972). In it, Mitchell argues that production, reproduction, sexuality, and the socialization of children must all be transformed together if the liberation of women is to be achieved; otherwise, progress in one area can be offset by reinforcement in another. This links the question of women's roles in history to economic forces such as production and social forces such as sexuality and childrearing.

ISSUE 12

Was Zen Buddhism the Primary Shaper of the Warrior Code of the Japanese Samurai?

YES: Winston L. King, from *Zen and the Way of the Sword: Arming the Samurai Psyche* (Oxford University Press, 1993)

NO: Catharina Blomberg, from *The Heart of the Warrior: Origins and Religious Background of the Samurai System in Feudal Japan* (Japan Library, 1994)

ISSUE SUMMARY

YES: Religious scholar Winston L. King credits the monk Eisai with introducing Zen to the Hōjō samurai lords of Japan who recognized its affinity with the warrior's profession and character.

NO: Japanologist Catharina Blomberg emphasizes the diversity of influences on the samurai psyche—Confucianism, Shinto, and Zen—stressing the conflict between a warrior's duty and Buddhist ethical principles.

The word *Zen* means meditation. From India Buddhist meditation masters brought their method of practice first to China (where it was known as Ch'an) and in the seventh century to Japan, where the school of Buddhism known as Zen began to flourish during the twelfth and thirteenth centuries. What Western thinkers call truth and salvation lay within the person, according to Zen masters, not in sacred texts, rituals, or doctrines. The realization of satori, or enlightenment, was a visceral rather than an intellectual experience and it could be achieved existentially, through a life of action.

From the time of the Hōjō regent Hōjō Tokiyori (1227–1263), Zen and the samurai class became closely allied. However, Buddhism and its Zen offshoot was not the only religious alternative in Japan. The influences of Confucianism, imported from China, and Shinto, the indigenous faith of Japan, were both significant. Like the Chinese, who found themselves Confucian on state occasions, Taoist on matters of health, and Buddhist at the time of death, Japanese people did not feel these religious traditions were mutually exclusive.

The warrior class that developed in Japan between the ninth and twelfth centuries and supported the shogunates that ruled Japan prior to the nineteenth-century Meiji Restoration (see *Taking Sides: Clashing Views on Controversial Issues in World History, Volume II, Issue 4*) was also called bushi, and the code by which they lived and died became known as bushido—the way of the warrior. As skilled fighting men, the samurai were, above all, loyal to the emperor, to his overlord or daimyo, and to other samurai of higher rank. Skilled in swordsmanship, horsemanship, and hand-to-hand combat, many were often also adept at painting, calligraphy, and poetry. They lived spartan lives marked by honor, pride, patriotism, and honesty. Prepared at any moment to lay down their lives for their lord, the samurai preferred ritual suicide (known as seppuku or hara-kiri, meaning disembowelment) to capture in battle or to dishonor. Later scholars have found elements of Buddhism, Confucianism, and Shinto in the bushido code and disagree about which influence predominated.

From Shinto comes reverence for the emperor as a god-like father of the nation. Out of this loyalty to the imperial family flows an intense patriotism as well as the promise that to die for one's country in battle is to become god-like oneself. This absolute fidelity of the samurai may be seen continuing into the modern era. Kamikaze pilots and suicide torpedoists who willingly sacrificed their lives for the success of their nation and to honor the emperor during World War II were following their own version of the bushido code.

Confucianism draws attention to the Five Constant Relationships—between parent and child, husband and wife, older and younger sibling, older and younger friend, and ruler and subject—as models for achieving harmony with the Way of Heaven. To know one's place, to do one's duty, to honor those above and act kindly toward those below, this was the way to live a life of balance, to serve the common good, and to please the ancestors. Samurai loyalty to emperor and overlord may be understood within this context of properly lived human relationships.

Buddhism focuses on how to become enlightened—to see things as they actually are—and, thus, to escape the continual round of birth/death/rebirth known as samsara. Zen Buddhism emphasizes meditation as a path to true seeing into the heart of the cosmos and into the Buddha-nature that is within all things. It makes no hard distinctions between sacred and secular, understanding that the way of enlightenment involves the reconciliation of all apparent opposites. Once these artificial distinctions collapse, a genuine experience of things as they are becomes possible.

Each lifetime arises out of the karma of previous lifetimes. Whatever the person desires, whatever the person does not yet understand, these are the karmic predispositions that travel from birth to birth and govern the agenda of a present lifetime. So, despite the Buddhist prohibition against killing (not only other humans but all living things endowed with Buddha-nature), a samurai might see himself as destined by karma to live a warrior's life. As you read the following selections, decide for yourself which influence—Shinto, Confucianism, Zen—predominated in forming the inner life of the samurai warrior.

 YES

The Japanese Warrior Adopts Zen

Zen Buddhism first became an important factor in the training and life of the Japanese warrior class in the thirteenth century. During the late-twelfth-century struggle of the Genji and Heike clans, Jōdo (Pure Land) Buddhism—in which Amida and his infinite mercy and forgiveness were paramount— was perhaps the soldier's favorite religious loyalty, especially in the hour of death. But with the coming of the Hōjō regency to power, Zen Buddhism increasingly took the leading role.

Eisai: "Founder" of Zen

Eisai (1141–1215) is the first name to reckon with in this Zen ascendancy. Sometimes he is called the founder of Zen Buddhism in Japan. This is not strictly true. The Zen practice of meditation, imported from China (where it was known as Ch'an), had been practiced in Japan since the seventh century, where it was considered one of several types of Buddhist spiritual training and given a home at Enryakuji by Tendai Buddhism.

The situation is rather that Eisai (also called Yōsai), a Tendai monk at Enryakuji, attempted to give Zen a more independent status than Enryakuji leaders were willing to allow it. Eisai, wishing to study with some of the masters of the more venerable Chinese tradition, made two trips to China to "renew" and deepen his understanding of Buddhism, and there he came into contact with the respected masters of the independent Ch'an (Zen) school. At the end of his second visit, from 1187 to 1191, he was given ordination as a Rinzai Zen master, and on his return to Japan he sought to establish a temple in Kyoto in which specific Zen training and meditation—of course, Zen means just that, "meditation"—would be given a central place. To the day of his death, Eisai still considered himself to be a Tendai monk. But Enryakuji would have nothing to do with his "new" Tendai Buddhism and frustrated his efforts. Eisai then journeyed to the shogunal headquarters in Kamakura, where he gained the favor of the widow of the first shogun, Minamoto Yoritomo; Eisai was installed as the head of a newly built temple at her behest. Somewhat later he returned to Kyoto by invitation and spent his last years there as an honored monk-teacher.

Rather curiously, Eisai has been memorialized in a very concrete way: the drinking of tea, bitter green tea (*matcha*) that is "brewed" by stirring the powdered tea leaves into boiling hot water in a tea bowl and whipping it to a froth with a special "feathered bamboo" whisk. He held it to be ideal for keeping the meditator awake and good for the health in general. Later, tea drinking was made into a ritualized fine art with skilled tea masters being much sought after and munificently rewarded by such as Toyotomi Hideyoshi, Tokugawa Ieyasu's predecessor in military and political power. Sometimes the tea drinking was a lavish and ostentatious ceremony—as with Hideyoshi, who used it as a means of political maneuver and dominance. In other versions, the emphasis was on perfect (highly polished) simplicity and "naturalness," as befitting its Zen origins. In modern Japan, there are both the genuinely simple-natural drinking of tea in the Zen monastery and an assiduously cultivated commercialized form carried on by modern tea masters.

To return to Eisai: His accomplishments on behalf of Zen were two. First, though he himself remained a Tendai-Zennist, his special emphasis on Zen practice as a somewhat distinctive and independent religious discipline began the process of establishing Zen as a separate sect. Thus his "new" Zen Buddhism became a part of what is known as the Kamakura period populist Buddhism, which brought Buddhism out of its high-class elitism into the life of the common people. His "companions" in this were Honen and Shinran, who taught the sufficiency for salvation of the repetition (in faith) of Amida Buddha's name, and Nichiren, who proclaimed the full efficacy of the Lotus Sutra's name as a mantric chant.

The second accomplishment of Eisai was his bringing of Zen practice in its own independent right to the attention of the new lords of Japan, the Hōjō regency samurai government. It was their interest in Zen, their perception of it as congenial to the warrior's profession and character, that brought Zen and the samurai together. However, even though the Hōjō regents gave Zen a friendly interest and preferential treatment, it was some time before Zen freed itself completely from the Tendai qualifications and Shingon esoteric practices imposed on it by Eisai and came to be defined by its own specific genius and quality. This was accomplished by various of Eisai's disciples and by Dōgen (1200–1253), who also studied Ch'an in China from 1223 to 1228 and returned to Japan to found a competing school of Zen, the Sōtō. There was also a continuing stream of Ch'an masters from the mainland who forwarded the process of developing the distinctive independent character of Zen teaching and practice.

Zen as the Warrior's Religion

The fourth Hōjō regent, Hōjō Tokiyori (1227–1263), nearly fifty years after Eisai's death, was the first to give more than a merely general official friendliness to Zen; he became personally interested in Zen practice and was certified by a Chinese master as having attained to enlightenment. From this time on, Zen and the new warrior-masters of Japan were closely related to each other; this personal interest and discipleship carried on over to the Ashikaga shoguns who

governed Japan—or the greater part of it—from 1333 to 1573 and who moved the shogunal headquarters from Kamakura back to Kyoto.

Thus it was that from Tokiyori onward, Zen was the unofficial–official religion of the rulers and ruling class. As a matter of course, Zen prospered as sect and institution. The later Hōjō regents, particularly several of the Ashikaga shoguns, were generous patrons of Zen. By the time of Soseki Musō (1275–1351), the most prominent Zen monk of his time, and nearly a century after Eisai, Zen had grown into a nationwide establishment—courtesy of the Hōjō regents and the shogunate. Zen temples were constructed in all the prefectures. The Five Mountain (*gozan*) system of precedence was established, by which five large temples around Kyoto, with Nanzenji at their head, and another five in Kamakura (one of them Eisai's special temple) were given first-rank status. A second-level class (subordinate to the first class), consisting of some sixty temples, was also established. Finally, there were some two hundred local temples scattered through most of Japan. Again, be it repeated, to this establishment the shogunal authorities gave their full backing and support.

And not only did the Zen sect prosper in terms of the favor of high officials, but also among the rank-and-file samurai themselves. It seems that from the beginning of Zen's "new" presence, its meditation and discipline commended themselves to the samurai, of both high and low rank. One samurai vassal counseled his son, "The duty of a warrior like that of a monk, is to obey orders. . . . He must consider his life not his own but a gift offered to his lord." Indeed, the samurai so "adopted" Zen, for practice in meditation and as a Buddhism suited to them, that it became a proverb in the Kamakura era that "Tendai is for the imperial court, Shingon for the nobility, Zen for the warrior class, and Pure Land for the masses."

But the alliance between the Ashikaga shogunate, now settled in Kyoto, led to far more than the nationwide founding of Zen temples. With Ashikaga Takauji, the first of the Ashikaga shoguns, Zen priests became the official advisers to the shogunate. Because Zen monks were the leading scholars of the day, and numbers of them had been to the Chinese mainland, their advisory role had a great influence on many aspects of official policy and national life. Many of them were traveled men of the world whose ordination as Buddhist monks gave them a high social standing and did not exclude them from the world or from taking part in secular life. (It may be remarked in passing that Zen draws no sharp line between the "sacred" and the "secular"; to the enlightened person, the two are one—it is the inner-personal quality of life that is the domain of virtue and holiness. The Buddha-nature is in everything without essential distinction.) Hence they rendered important diplomatic services, were often negotiators with mainland Chinese officials and other foreigners, and were sent as shogunal emissaries. The Shōkokuji Zen temple in Kyoto was the government's operative foreign-relations center for a considerable period of time.

There was another important aspect of Zen influence, one whose marks still remain in the Japanese cultural and artistic tradition. As Heinrich Dumoulin observes: It was the Zen monk-scholar-artist who opened the world of "*haute* culture" to the warrior clans. The Hōjō regency in Kamakura kept

its deliberate distance from the Kyoto court circles—the better to keep its po-
litical power intact and to avoid the enervating, effeminizing influence of the
imperial and aristocratic circles. The rough, stern warrior clans of the north
and east disdained and distrusted the soft and cultured life as corruptive of the
more stalwart virtues. But this attitude changed with the passing years, espe-
cially under the Ashikaga regime when the shogunate moved its headquarters
to Kyoto. The warrior leaders found themselves hungry for the literacy and aes-
thetic attainments they came in contact with in Kyoto. Zen monks as chosen
advisers to the shogunate—disciplined in living, skillful in language and a new
style of painting, some of them writers, poets, and men of the world as well
as redoubtable warriors—thus became tutors to the warrior-class leaders and
influential in setting new cultural styles.

So, too, the influence of Zen, direct and indirect, on the art of the day
was substantial. There was painting, for example. Zen set a new style of direct,
spontaneous, and spare "painting." Zen artist-monks disdained the colorful
and decorative for the most part and opted for *sumie* (India ink drawings), also
called *suiboku* ("water and ink" creations). There were self-portraits (almost car-
icatures, designed to express one's personal essence), persons, animals, birds,
vegetation, as well as calligraphy. Much of it was a sheerly black-on-white style
of instant art—jet-black indelible ink on porous white paper. Such work required
complete poise and decisiveness, for the first stroke was also the last; there could
be no patching, no alteration. Its production was fully visceral, a disciplined
spontaneity. The starkly simple result admirably expressed the Zen "view" of
life.

There was also the Noh play, not originated but strongly influenced by
Zen in the days of the Ashikaga Shogun Yoshimitsu (1368–1394), who took a
strong personal interest in Noh development. Again, as with sumie, the sparse
action and enigmatic, suggestive symbolism suited the Zen genius, even though
the themes of the plays were Shintoist and Amidist. Yoshimitsu also built the
famous "worldly" Golden Pavilion (Kinkakuji); his successor, two generations
later, Shogun Ashikaga Yoshimasa, built the Silver Pavilion (Ginkakuji) in 1473
into which to retire for a Zen meditator's life.

Despite all the personal and official favor shown to Zen by individual
regents and shoguns and the semiofficializing of Zen as the government's reli-
gion, Zen as a sect avoided the political embroilments that were characteristic
of the Nara and Enryakuji temples and the Pure Land Ikkō sect. Zen monks
counseled shogunal officials and, as already observed, acted as government rep-
resentatives in international affairs. But there was never a Zen lobbying group
at head shogunal quarters or Zen groups or temples maneuvering to gain power
at the expense of competitors.

If we ask why this should be the case, three possible factors may be
mentioned. The first and most obvious is: Why *should* Zen enter the always-
dangerous field of religious–political intrigue? It was already the personal
practice of several shoguns; within a hundred years after Eisai, its temples had
been established throughout Japan, and Zen had been adopted by the shogunal
government as a near-official religion; its monks were advisers to the shoguns,
and the samurai looked on it as their special religious faith. Besides this, in

Zen's heyday of cultural popularity, Zen scholar-monks set the tone and the pace of new cultural styles. What more was there to ask for? What need to intrigue at court?

Another factor of at least some importance in this connection was what might be called Zen anti-institutionalism. In religious terms, Zen was a rejection of many creedal and ritual elements of the Buddhist tradition embodied in most of the other sects; this allowed considerable freedom of action and practice on its part. On the sectarian-institutional level, Zen favored individual rather than factional or organizational action. Some of the leading Zen monasteries were physically large—the Hōjō regents and Ashikaga shoguns had been generous in their support of the Zen "establishment." Despite this, the relationships between Zen and the government, as well as with other groups, tended to be on the level of the personal—influential individuals rather than organizational muscleflexing. Thus no given Zen temple—paralleling Enryakuji of the Tendai, Kōya-san of the Shingon, or the great fortress-temple of the Pure Land Honganji near Osaka—ever became a powerful and belligerent institution seeking to gain political advantages.

The third factor to be noted is only partially explanatory of this situation. The great sectarian temples that were now and again embroiled in conflict with the civilian government—the Nara sects, Enryakuji, and Kōya-san—had been established centuries before Zen came on to the scene as a sect; and in those centuries they had accumulated their great estates, their vested interests, and their armies of soldier-monks. Thus Zen missed out on this enfeudalizing of the religious establishment and the politicizing of its role. Of course, it must be said that so, too, had the Honganji Jōdo Shinshū (Pure Land) sect, for the Pure Land sects were established at roughly the same time as Zen, in the thirteenth century. Yet Honganji Buddhism gave birth to Ikkō militancy. In any case, Zen's nonpolitical character saved it from the bloody purges that Oda Nobunaga inflicted on Enryakuji and the Ikkō barons in the sixteenth century.

There is another aspect of the religious and political situation that is of importance here: the historical framework of the relation of both Shinto and Buddhism to the state. Shinto, as Japan's first and basic religion, had the emperor as its high priest; as guardian of the Three Sacred Treasures and performer of annual fertility-prosperity rituals, his first concern and main function were the preservation of his people in safety and prosperity. Therefore, in times of crisis, such as the Mongolian invasions in the late thirteenth century, Shinto priests assiduously prayed to the gods and believed that they had responded by sending the gales (*kami kaze*) that had wrecked the Mongol fleets.

But it must also be recollected that Buddhism was first brought into Japan in the sixth century primarily as a more potent means to the same end —preservation of the nation. All the Buddhist sects—with the possible partial exception of the Pure Land—well understood this to be their role in times of crisis. When the Mongols attacked, Buddhist clergy joined their sutra chanting to the ritual efforts of the Shinto priests to bring victory—and were rewarded accordingly. Clans often endowed their local Buddhist monasteries and temples to provide prayers in times of crisis or sickness. And with the transformation of Hachiman, the Shinto god of war, into a bodhisattva [a being whose actions

promote unity or harmony; one who vows to postpone one's own enlightenment in order to help all sentient beings realize liberation] of high rank. Buddhist warriors could pray to him for victory as well as Shintoists could. Nor did Zen totally escape this influence. It is significant that Eisai entitled his first major writing *Treatise on the Spread of Zen for the Protection of the Nation.*

As an inevitable and natural result, the nonviolent message of Buddhism was qualified, modified, or overlaid by duty to clan lord, so that Buddhist warriors fought other Buddhist warriors to the death, it is to be presumed with only minor twinges of conscience. Of course, this is not unique to Buddhism. After the officialization of Christianity in Europe by the emperor Constantine in 330 C.E. [Christian Era], the followers of the Prince of Peace not only launched massive crusades against the infidel Muslims, but also fought one another savagely over the truth of their differing doctrines.

It should be said in all fairness that many Buddhist warriors did retire to monasteries, in their later years usually, to pursue their spiritual welfare and in some measure atone for their un-Buddhist conduct in killing their fellow men. But there was an inbuilt factor in Buddhism itself that worked against the teaching that all life, especially human life, is sacred. This was the Buddhist teaching of karmic destiny. For instance, some of the warriors portrayed in the *Heike Monogatari* (Tale of the Heike) lamented the fact, at reflective moments or when they had committed some militarily necessary cruelty, that they had been born into a warrior family and thus must carry on with a warrior's bloody career. And free as Zen may have been in some respects from the bonds of the Buddhist tradition, it was not free from the bonds of the teaching of karma.

To this must be added a peculiarly Japanese factor: the strong sense of family loyalty and tradition, especially in the upper classes. Reflecting the Chinese reverence for ancestors, the family—and its role, occupation, business—is a "sacred" inheritance, entailing the son's—especially the eldest son's—following in his father's footsteps. (One contemporary Shinto priest proudly notes that he is the twenty-eighth in the family who has occupied the headship of a particular shrine.) When this is added to, or is seen as the vehicle of, karmic predetermination, the individual is required, even fated, to accept the role that has been given him—for instance, as a samurai whose destined duty was to be a fighting, life-destroying "Buddhist."

For all its freedom from some of the liabilities of the other sects and despite its emphasis on individual freedom and opposition to institutional bonds, Zen did not escape these doctrinal and historical influences. When it was becoming a distinct and independent sect in the thirteenth century, the institutional format of religion in the service of the state and of warlike sects and monk-warriors had been long set. What could be more natural under the circumstances than for Zen monks, favorites of the Hōjō regents and their successors, the Ashikaga shoguns, and as valued spiritual tutors of the fighting forces, to put themselves completely at the service of the state.

Although he belonged to a subsequent period when Zen no longer occupied its privileged and somewhat exclusive position in government circles, Sūden (Den-chōrō, d. 1633) beautifully illustrates the qualities, accomplishments, and diverse roles characteristic of talented Zen monks. He was head

of two Kyoto Zen temples, Konchi-in and, the most prestigious temple of all, Nanzenji, to whose restoration he devoted two years. Then in 1608, Tokugawa Ieyasu called Sūden into the service of the shogunate. (He had previously served as a field secretary in Ieyasu's campaigns.) Sūden handled all documents dealing with foreign relations and was placed in general charge of the Tokugawa religious policy—continuing in that post for another seventeen years after Ieyasu's death—working for the regulation and subordination of Buddhist sects to government control and for the exclusion of Christianity.

In his earlier years, just before he entered a monastery on his father's death, he had fought in his father's forces, taking the heads of three enemies as trophies. Hence Ieyasu allowed the temple built at his own place of retirement in Sumpu for Sūden, to display three black stars on its banner in honor of Sūden's prowess as a warrior. Thus was Sūden the warrior, "executive secretary" in the field to the man who became Japan's de facto ruler in 1600, then his "secretary of state" and the director of religious affairs for the shogunate—all the while presumably retaining his standing as a Zen monk. One is reminded of some of medieval Europe's priest-statesmen such as Armand-Jean Cardinal Richelieu.

In the light of these intimate connections between Zen and the ruling warrior class and also the apparent great popularity of Zen meditation among the rank-and-file samurai, especially during the warring centuries (1200–1600), it is necessary to know something of the samurai class to which Zen would prove of such value in their mode of life. That is, their use of Zen in their martial calling can make sense only if something of their history; their weapons —especially the sword—and their manner of using them; their hopes, fears, and ideals; their social role; and their conceptions of themselves and their "calling" are also known to us.

Warrior Ethics East and West

[A] *bushi* was trained from childhood for his future position in society by being taught to observe his father and his male elders and imitate their behaviour. Formal education consisted of the teaching of the Confucian Classics, but *bushi* of low rank were often illiterate until the time of the Tokugawa *Bakufu*, when literacy became exceptionally widespread in Japanese society. The military arts were the most important part of the training of a *bushi,* and were constantly practised from boyhood. Horsemanship, archery and sword-fighting techniques were taught to males, whereas girls of *bushi* stock learned how to use the *naginata,* a halberd with a curved blade, in self-defense. *Bushi* women were also instructed in the use of the dagger which they always carried about their person, in order to be able to commit suicide by severing the jugular vein should the need for such action arise. The education of the *bushi* was referred to from the early Kamakura *Bakufu* by the term *Bun-Bu* (Letters and military arts). The study of letters encompassed the five traditional Chinese Classics and the four Confucian books.

The study of martial arts included a theoretial side as well as a practical one. The nature of the theory of *Bushidō* before it was recorded in the seventeenth century can only be gauged from literary references, and as we have seen the *Gunki Monogatari* provide many instances of the *bushi*'s philosophy of life and death. First of all he was aware of the fact that by fulfilling his duties as a professional warrior he was acting against the central principles of both Buddhism and Shinto. By taking life the *bushi* condemned himself to the existence of an *asura,* infernal spirit, in one of the Buddhist hells, of which there are ten cold and ten hot varieties, instead of being able to gain a favourable rebirth and eventual salvation in the Western Paradise of Amida Buddha. The knowledge of this certain damnation did not deter the samurai from giving loyal service to his lord, however, and it was frequently stressed by the authors of the *Gunki Monogatari* that the carrying out of duty was its own reward. This attitude was considerably elaborated upon and much discussed in later writings on *Bushidō*.

The *kuge* [court nobility] and *buke* [warrior family of the samurai social class] continued to lead separate lives after the establishment of the Kamakura *Bakufu,* although members of the *kuge* and the Imperial family occasionally were impressed or influenced by the warlike spirit of the new rulers. Jien wrote with evident disapproval in his *Gukanshō* of the abdicated Emperor Go-Toba

From Catharina Blomberg, *The Heart of the Warrior: Origins and Religious Background of the Samurai System in Feudal Japan* (Japan Library, 1994). Copyright © 1994 by Catharina Blomberg. Reprinted by permission of Taylor & Francis Books Ltd. Notes omitted.

(1180–1239, regnavit 1183–1198) who displayed an unusual interest in such pastimes as archery and horsemanship. Go-Toba established his own guard force, the *Saimen Bushi* (Westface Warriors) modelling it on the *Hokumen Bushi* (Northface Warriors) of Go-Shirakawa, a private guard which had been disbanded by Minamoto Yoritomo. These imperial guard forces became a disruptive element which tended to disregard the *Bakufu*. There were instances of *Bakufu* officials being arrested in Kyoto, and of court titles being conferred directly, without the customary recommendation and approval of the Kamakura government.

The author of the *Tsurezure Gusa,* a title which can be translated as 'Idle Jottings' or 'Adiafora', Yoshida no Kaneyoshi, also known as Kenkō, (1283–1350?) was a *kuge*, descended from the ancient clan of Court diviners, *Urabe.* Having served at the court of Emperor Go-Uda, he took the tonsure on the death of the Emperor in 1324 and lived as a recluse in a hermitage in the country for many years, although he is said to have returned to Kyoto for a period. His book contains a random collection of anecdotes, miniature essays on various topics, and reflexions on the state of the world. Yoshida clearly deplored the tendency of his contemporaries among the *kuge* to take an interest in warlike pursuits. 'Any man is soldier enough to crush the foe when fortune favours him, but War is a profession where he cannot make his name until, his forces exhausted, his weapons at an end, he seeks death at the hands of the foe rather than surrender. So long as he is living he cannot boast of warlike fame. What then does it profit, unless one is of a military family, to devote oneself to conduct removed from human principles and approaching that of the beasts? Such behavior did not suit the *kuge*'s station in life, and should be left to those born into the ranks of the *bushi*.

He could not, however, refrain from expressing admiration for those who lived and died as befitted warriors, as is evident from an anecdote he recorded. This concerned a party of *komusō,* Zen monks of the Fuke school, who were praying in an Amida temple. Another *komusō* entered, demanding to know whether a man whose name he gave was among them, and explaining that he wanted to avenge the death of his master. The man who had killed his master was present, answered in the affirmative, and arranged to meet his challenger outside the temple, so as not to pollute it or disturb the service in progress. The two men met outside, sword in hand, and fought a duel in which both of them died. 'Wilful and determined, they appear to be devoted to the Way of the Buddha, but they make strife and quarrel their business. Though dissolute and cruel in appearance, they think lightly of Death, and cling not at all to Life. The bravery of such men having impressed me, I set this down as it was related to me.' This, albeit somewhat reluctant, expression of admiration is rather far removed from the unmitigated disdain shown by the Heian literary ladies four centuries previously. It demonstrates how by this time the attitudes of the *bushi* had at least become accepted as a viewpoint which, even if it was not to be emulated, was regarded as worthy of consideration as an alternative to the *kuge* way of life. The *kuge* continued to regard themselves as the only true nobility, while the *buke* saw them as exponents of the remote and largely inconsequential court system.

The ethics and morals governing the life and thought of the *bushi,* and forming the guidelines for warrior comportment, bore a striking resemblance to contemporary European codes of chivalry. If we examine one of the most famous European works on the subject, *Libre del Orde de Cauayleria* (The Book on the Order of Chivalry), written in Catalan by Raymond Lull around 1280, we find a way of reasoning which is similar to many of the ideas and sentiments expressed in the *Gunki Monogatari* and the legal codes of the Hōjō and Ashikaga rulers. These similarities are entirely fortuitous, but nevertheless interesting and illuminating when we take the widely differing background and development of the two feudal systems into account.

Not unlike different religions, which display affinities of ideas arrived at from diametrically opposed standpoints, the ethical and practical demands of the two types of chivalry demonstrate a certain universality in human thought and endeavour. It must be remembered also that when dealing with European chivalry as well as *Bushidō* we are contemplating an ideal whose attainment might vary quite considerably, according to circumstances, and from one individual to another, and that far from every knight or *bushi* even attempted to attain this ideal although he was certainly aware of its requirements.

Religion was at the back of both kinds of chivalrous behaviour. The European knight was constantly reminded that he was a Christian knight, and that his duty at all times was to uphold the principles of charity, loyalty, truth, justice and virtue, protecting the weak against the strong and defending widows and fatherless children. Lull went to great lengths in his treatise to explain the religious and symbolic significance of the knight's arms, pointing out the resemblance of both his sword and dagger to a cross. The *bushi,* on the other hand, was not expected to uphold justice, truth and virtue *ad majorem Dei gloriam,* but because the quality of *gi* 'duty' or 'righteousness' was demanded of him by the Confucian doctrine to which he adhered.

Whereas the Christian knight could obtain absolution from his sins, e.g. of taking life, through confession, the *bushi* accepted with fortitude that he was condemned according to the tenets of Shinto as well as Buddhism. When we consider the sword of the *bushi* we find that it also had religious connotations, being dedicated to and protected by Buddhas, Bodhisattvas and minor Buddhist deities. The most significant difference between Europe and Japan, however, lay in the fact that not every man born of a knightly family in Europe actually entered an order of knighthood, while in Japan every male of the warrior nobility was a *bushi* by birth. In Europe the new knight was invested in a religious ceremony, usually held on one of the major feast days of the church, and we may compare this ceremony with the *genbuku* (coming of age) ceremony of the young *bushi.* . . .

In Japan the only refuge for a man of *bushi* stock who did not wish to lead the life of an active warrior was to take holy orders and enter the Buddhist priesthood. Buddhist temples and monasteries served as sanctuaries for young survivors of clan feuds, such as Minamoto Yoshitsune, whose life was spared by Taira Kiyomori after the execution of his father on the condition that he enter the Buddhist priesthood where he would be unable to avenge the death of his father. The same course of action was not infrequently taken also in Eu-

rope. Although Christianity and Buddhism are religions devoted to peaceful pursuits and spiritual needs, there existed in Japan as well as in Europe a powerful *ecclesia militans*. In Japan the so-called 'warrior monks', *sōhei*, who first appeared in the Heian period, were a notable feature in the *Gempei* War as well as during the *Sengoku jidai*. Already in 970, Ryōgen, the abbot of the Hieizan monastic complex, laid down rules designed to curtail the activities of armed monks who disrupted the religious services. These regulations seem to have been largely ineffective, if we consider the amount of political power wielded by the armed clerics toward the end of the Heian period, and also the very serious disturbances created during the *Sengoku jidai* by the *Ikkō-ikki*.

The *sōhei* appear to have originated as a result of disputes over the ownership of land rather than over matters of doctrine, and many fights took place between two monasteries belonging to the same school of Buddhism. The warrior monks were not recruited among the high-ranking ecclesiastics, and quite a few laymen were also employed by the temples and monasteries to provide armed protection. Prior to the Kamakura period the *sōhei* wore the ordinary habit of a Buddhist monk, with the addition of a long scarf-like piece of cloth which was wound around the head and neck, covering the face and leaving only a space open for the eyes. They originally carried a staff and a sword, and only during the *Gempei* War did they begin to wear armour and other weapons. The *Heike Monogatari* provides vivid pictures of warrior monks, especially of one who took part with distinction in the Battle on Uji Bridge in 1180, fighting on the Minamoto side. 'Among the warrior-monks was one Tsutsui no Jōmyō Meishū. He wore armour laced with black leather over a deep blue battle robe. The thongs of his helmet with five neck-plates were tied tightly under his chin. He carried a sword in a black lacquered sheath, twenty-four black-feathered arrows, a bow thickly bound with lacquered rattan, and his favourite wooden-shafted sickle-bladed halberd. He stepped forward onto the bridge and thundered: "You have heard of my fame as a valiant warrior. Take a good look at the pride of Mii-dera, I am Tsutsui no Jōmyō Meishū—among the dōju I am worth a thousand soldiers. Is there any among you who thinks himself a great warrior? Let him come forward!"'

The *Heike Monogatari* then goes on to tell how he performed outstanding feats of marksmanship, killing twelve enemies and wounding eleven more with as many arrows, and swordsmanship, cutting down five men with his halberd and eight more with his sword. After these extraordinary exploits Jōmyō retired to the Byōdōin temple nearby, where he counted the sixty-three dents in his armour and his five wounds, which he cauterised by applying burning grass to them. 'Then', says the *Heike Monogatari*, 'he wrapped a piece of cloth around his head, donned a white robe, and took up a broken bow for a staff. Chanting "Hail Amida Buddha", he went off toward Nara.'

We may compare the important part played by the warrior monks in the Japanese civil wars with the not dissimilar phenomenon in Medieval Europe of the spiritual orders of knights, notably the Templars, Hospitallers, and the Teutonic Order. The Order of the Knights of the Temple was founded in 1118 for the protection of pilgrims on their way to Jerusalem, and the other orders soon followed. They established a network of hospices and churches all over

Europe and the Near East, and became a factor of the utmost importance in the Crusades through their knowledge of the countries around the Mediterranean and their languages and customs. Although their origins and the conditions which brought about their foundation were widely different, the Japanese warrior monks and the military orders of Europe shared one fundamental trait, namely the fact that they had to justify the taking of life. The *sōhei* were either laymen serving in a temple or monastery, or low-ranking monks, and the Knights Templar and Hospitaller were members of religious orders within the Roman Catholic church, and subject to rules of poverty, chastity and obedience like monks and clerics.

The problem was one of morals and ethics, and the main question was whether the ultimate end could be said to justify the use of means which were theoretically forbidden. Buddhism, like Christianity, categorically forbids the taking of all life, going indeed a step further than Christianity by forbidding also the killing of animals, including insects. The person who instigates, or even condones, a killing, is as guilty as the person who carries it out, according to Buddhist doctrine, and in war all soldiers are equally guilty of taking life, whether they actually kill an enemy or not. The negativism of Buddhism, however, which teaches that all is suffering and that nothing really exists, can easily be interpreted as inimical to life itself. The idea of reincarnation may seem to favour the ending of the present existence in order to try again under different and perhaps better circumstances. This is not possible, however, owing to the belief in *karma,* the sum total of the individual's actions, which adheres to its bearer throughout the cycle of reincarnations. There is no getting away from the influence of *karma,* and only by leading a virtuous and pious life and refraining from sinning, can the individual hope to improve his chances of a more favourable rebirth in the next existence.

In Buddhism, as in Christianity, however, there is a considerable divergence between philosophical speculation on doctrine and dogma and popular ideas, and it is not difficult to see that the taking of life could be condoned under special circumstances, even among members of the clergy. The *sōhei* developed parallel to the *bushi* in a society which became increasingly dependent on warlike qualities for maintaining stability, and in the end the *bushi* were forced to eliminate the *sōhei* in order to gain political supremacy and unify the country.

Most of the *sōhei* appear to have been recruited from the popular Amidist schools of Buddhism. Zen Buddhist monks played a more ambivalent part. The Zen schools were introduced in Japan in the early years of the Kamakura *Bakufu,* and Zen monks seem to have taken an active part in the power struggles between the Hōjō *Shikken,* the Imperial court, and the Ashikaga *Shōguns.* As we have seen, the mental discipline taught by Zen came to influence the art and techniques of fighting, especially swordsmanship, to a very large extent. The Zen masters seem to have gone in for theory rather than practice, however, and Zen monasteries did not figure prominently among the religious institutions which were annihilated in Oda Nobunaga's purge of the politicised clergy of the *Sengoku jidai.*

One line of defence adopted by the Buddhist clergy to justify their taking up arms was the simple and apparently irreproachable fact that they were defending their religion against the enemies of the faith. Since they were fighting against their co-religionists of other Buddhist schools, this meant that they considered themselves as defenders of the true religion against false or heretical doctrines. In Europe, the religious orders reasoned in a similar vein, and in the Crusades they felt called upon to rescue one of the most sacred monuments of Christendom, the Holy Sepulchre, from infidel dominance. There is a comprehensive Buddhist tradition of armed divinities protecting the faith against all forms of evil influences, including the *Niō-ō*, the *Shitennō*, and the *Myō-ō*, as well as Bodhisattvas like *Monju*. The profound influence of the *bushi* on the militant side of Buddhism did not fail to impress the Buddhist clergy, and the prevailing atmosphere was one of warlike exploits rather than peaceful pursuits, however pacifist the Buddhist doctrine may have been originally....

The most important and influential Buddhist monasteries, nunneries or temples, as well as the major Shinto shrines, as a rule chose their abbots and abbesses or chief priests and priestesses among junior members of the Imperial family until modern times. Among the *bushi*, for whom lineage was of the utmost importance, the possibility of entering their ranks from below did however exist until the late sixteenth century. Later, in the latter half of the Tokugawa *Bakufu*, adoption for men and marriage for women became other means of gaining admittance into a *bushi* family. Even such a very powerful man as the autocrat Toyotomi Hideyoshi, who was given a family name and pedigree by Imperial decree, was never able to forget or conceal his plebeian origins. He was greatly feared and in complete command, but nevertheless despised by the old *kuge* and *buke* families. There is no doubt that some families over the centuries managed to get away with spurious and newly fabricated pedigrees, but despite the prevalence of natural disasters such as earthquakes and typhoons, Japan is a country where families have managed to preserve their documents and records from the early Heian period until this day to a remarkable degree.

POSTSCRIPT

Was Zen Buddhism the Primary Shaper of the Warrior Code of the Japanese Samurai?

Because it insists on "no reliance on words or concepts," Zen is difficult to approach by way of printed texts. However, *Zen Flesh, Zen Bones: A Collection of Zen and Pre-Zen Writings,* compiled by Paul Reps (Doubleday, 1989) introduces us to monks who drop sacred texts into the fire, spend years facing walls in silent meditation, and even cut off their own arms to show zeal. This brings us closer to what in Zen might have touched the heart of a samurai.

Two other classics are Miyamoto Musashi, *A Book of Five Rings* (Overlook Press, 1974) and Yamamoto Tsunetomo, *Hagakure: The Book of the Samurai* (Kodansha International, 1983), both easily accessible. Musashi's guide to strategy was based on kendo, or sword fighting, but is consulted by business people who find the challenges faced and the tactics needed today little changed in 350 years. *Hagakure* (*In the Shadow of Leaves*) is a series of anecdotes and reflections, once a sacred text known only to a small group of warriors. Its central contention is that bushido is a way of dying and that only a samurai prepared and willing to die at any moment can be totally faithful to his lord. Stephen Turnbull's *Samurai Warriors* (Blandford Press, 1987) paints a picture of samurai life using words and pictures and including history, armor, and weapons.

In *The Modern Samurai Society: Duty and Dependence in Contemporary Japan* (Amacom, 1982), Mitsuyuki Masatsugu traces the evolution of the loyal samurai warrior of the past into the devoted samurai executive of today. A similar aim motivates Eiko Ikegami's *The Taming of the Samurai: Honorific Individualism and the Making of Modern Japan* (Harvard University Press, 1995). However, her emphasis is on Japan's tradition of competitive individualism, which Ikegami sees as stemming from samurai honor consciousness. Haru Matsukata Reischauer's *Samurai and Silk: A Japanese and American Heritage* (Harvard University Press, 1986) honors her two grandfathers—one a provincial samurai who became a founding father of the Meiji government, and the other from a wealthy peasant family who almost singlehandedly developed the silk trade with America.

Finally, Akira Kurosawa's 1954 film *The Seven Samurai* has inspired hundreds of imitators. Seven ronin (freelance samurai, not in service to a feudal lord) are called upon to aid villagers at an isolated outpost who are beleaguered by invading bandits. The honor code of the samurai, even in an out-of-the-ordinary mission, is a key theme in this classic film as well as in one of its most popular descendants, John Sturges's *The Magnificent Seven.*

On the Internet ...

Columbus and the Age of Discovery

Columbus and the Age of Discovery is a university-run Web site that includes a "computerized informational retrieval system," which contains 1,100 text articles related to Christopher Columbus.

http://muweb.millersville.edu/~columbus/

Traditional History: The Ming Voyages

Traditional History: The Ming Voyages is a Web site that provides a brief account of the Ming voyages of Zheng He, including what went into the implementation of these voyages and what eventually caused their demise.

http://afe.easia.columbia.edu/teachingaids/china/
trad/disc_q.htm

The Life of Martin Luther

The Life of Martin Luther Web site contains a detailed timeline of Luther's life in four parts, as well as a series of links for all major aspects of Europe's Reformation movements.

http://www.geocities.com/Athens/Atlantis/4691/
luther1/luther.htm

European Witch Hunts (15th–17th Century)

The European Witch Hunts (15th–17th Century) Web site provides brief information about the witch-hunts and their ramifications.

http://www.kings.edu/womens_history/witch.html

The Scientific Revolution: Readings, Resources, Links

The Scientific Revolution: Readings, Resources, Links is a Web site that explores every facet of the movement. This site includes essays written by professors.

http://www.clas.ufl.edu/users/rhatch/pages/03-
Sci-Rev/SCI-REV-Home/

Internet Modern History Sourcebook: The Early Modern World

The Internet Modern History Sourcebook: The Early Modern World Web site contains an abundance of primary source material on a variety of Age of Discovery topics, including the world's continents, mercantilism, capitalism, and reflections on the trade and the new economy.

http://www.fordham.edu/halsall/mod/modsbook03.html

The Premodern World

*U*sing the Age of Exploration as a starting point, this section shows how and why the newly created nations of Western Europe began to expand and influence the development of their continent and the rest of the world, as well as what resulted from this process.

- Were Christopher Columbus's New World Discoveries a Positive Force in the Development of World History?

- Was China's Worldview Responsible for Its Failure to Continue Its Commercial and Maritime Efforts During the Ming Dynasty?

- Did Martin Luther's Reforms Improve the Lives of European Christians?

- Were European Witch-Hunts Misogynistic?

- Was the Scientific Revolution Revolutionary?

- Did the West Define the Modern World?

ISSUE 13

Were Christopher Columbus's New World Discoveries a Positive Force in the Development of World History?

YES: Felipe Fernández-Armesto, from *Columbus* (Oxford University Press, 1991)

NO: Kirkpatrick Sale, from *The Conquest of Paradise: Christopher Columbus and the Columbian Legacy* (Plume, 1991)

ISSUE SUMMARY

YES: Historian Felipe Fernández-Armesto states that although Columbus was far from perfect, the overall results of his work merit consideration as having helped to shape the modern world.

NO: Writer Kirkpatrick Sale sees Columbus as a product of a sick, dispirited Europe and concludes that the selfish nature of his work and what resulted from it prevented Europe from using the New World discoveries as an opportunity for the continent's salvation.

In October 1998 a *New York Times* article covered a dispute between Hispanic-Americans and Italian-Americans with regard to which ethnic group should play the more important role in the organization of New York's Columbus Day Parade. While both groups had legitimate claims to the Columbus legacy (after all, Columbus was a Genoese Italian, but he did his most important work for the Spanish nation), the dispute must have drawn an ironic response from those who witnessed the revisionist bashing that the "Admiral of the Ocean Sea" had received in recent years.

In the five centuries since Columbus "sailed the ocean blue," his historical reputation and the significance of his accomplishments have undergone a series of metamorphoses. In the distant past, an eclectic collection of Columbus critics would number French essayist Michel Montaigne, English writer Samuel Johnson, philosopher Jean-Jacques Rousseau, and French historian and philosopher Abbé Guillaume Raynal, some of whom believed that the world would have been better off without the admiral's discoveries.

It has only been in the last two centuries that Columbus's stock has risen in the theater of public opinion and historical significance. There were many reasons for this change, including (1) the United States acting as a model for democratic government in a nineteenth/twentieth century world living under monarchial/autocratic rule, (2) the part played by the United States in the Allied victory during World War I, which ended the German, Austrian, Ottoman, and Russian Empires and brought a greater level of democracy to many parts of Europe, and (3) the role assumed by the United States in saving Europe and the world from the specter of fascist militarism during World War II. All affected the reversal of Columbus's historical fortunes, as many wondered what the world would have become if the United States had not been there to provide inspiration and assistance in these times of need. Thus, some of the credit America accrued was passed on to Columbus, whose work had made our nation possible. Samuel Eliot Morison's 1942 book, *Admiral of the Ocean Sea: A Life of Christopher Columbus,* marked the climax of this laudatory view of Columbus and his accomplishments.

Historians and publishers love anniversaries and the publicity such occasions generate, and, next to a millennial celebration, none may be more significant than a quincentennial one. Thus, on the 500th anniversary of Columbus's first voyage, the requisite number of tomes on Columbus and his accomplishments were made ready for an eager market. But the world of 1992 was different than the world of Morison's "Admiral of the Ocean Sea," and the historical profession had changed along with it.

The end-of-the-millennium generation of historians treated Columbus differently than had their immediate predecessors. Operating from a different worldview, Columbus became to many of them a flawed figure responsible for the horrors of the transatlantic slave trade, the annihilation of Native American civilizations through cruelty and disease, and the ecological destruction of a continental paradise.

The recently published books about Christopher Columbus opened a national dialogue on the subject. A national Columbus exhibition in Washington, D.C., was received with skepticism by some and quiet reverence by others. While some participated in the national Columbus Day celebration on October 12, 1992, others declared it a day of mourning in honor of those who lost their lives as a result of Columbus's enterprises. A cultural hornet's nest was broken open, and any who entered into the Columbus fray had to have the thickest of skin.

Fortunately, as is usually the case, time has a soothing effect, and we will have to wait until the year 2092 for the next major Columbus debate. For now, we have the opportunity—with cooler heads and calmer temperaments—to examine the Columbus legacy.

Felipe Fernández-Armesto presents a balanced account of Columbus and his accomplishments that leans toward a favorable interpretation of the admiral. Kirkpatrick Sale evaluates Columbus as a representative of the forces that missed out on an opportunity to use the New World discoveries as a regenerative force in the development of European and world civilizations.

 YES

Columbus

Preface

Considered from one point of view, Columbus was a crank. Even in his own lifetime he had a cranky reputation. His patrons smiled at his scheme for a crusade and courtiers treated it as a joke. On his first crossing of the Atlantic, mutineers plotted to pitch him overboard during his abstracted machinations with new-fangled and unwieldy navigational instruments. He claimed to hear celestial voices. He embarrassed the court of the Spanish monarchs by appearing provocatively attired in public, once in chains and regularly in a Franciscan habit.

These eccentricities are easy to excuse or even to applaud as such imps as often attend genius. They have had, however, one regrettable effect. Columbus has attracted cranks, as crag calls forth to crag; and if one of the many committees convened to honour the fifth centenary of the discovery of America were to offer a prize for the silliest theory about him, the competition would be keenly contested. Readers wanting to know about Columbus might be almost as badly misled by the many well-meaning amateurs who have been induced by his presumed importance to write up his life: most books about Columbus have been biographies, which even at their best can seem to abstract their protagonist from his proper context. Overwhelmingly the effect has been to project, into popular books, versions of a Columbus who was 'ahead of his time'—a Columbus inaccessible to an imagination disciplined by respect for the sources and by knowledge of the period. If scholarly biographies so far, with few exceptions, have not yielded any more convincing general impression of Columbus, misleading influence from sixteenth-century writers, loosely treated as primary sources, is probably to blame. For five hundred years, Columbus historiography has been afloat without heeding the need for a good long spell in dry dock. Like a well-barnacled bottom, it needs a vigorous scrape to get rid of the glutinous concretion of errors and false impressions. When restored to deep water, it has to be steered cautiously to elude the cranky theories and undisciplined speculations alike. In the Sea of Darkness, Siren voices rise on every side....

The Columbus who emerges may not be much more objective than any other, as his image bounces flickeringly between the reader's retina and my

own. The Columbus I detect—the socially ambitious, socially awkward parvenu; the autodidact, intellectually aggressive but easily cowed; the embittered escapee from distressing realities; the adventurer inhibited by fear of failure—is, I believe, consistent with the evidence; but it would no doubt be possible to reconstruct the image, from the same evidence, in other ways. Other students have imagined him essentially as a practical tarpaulin, or a ruthless materialist, or a mystic seer, or an embodiment of bourgeois capitalism; the springs of his motivation have been perceived in an evangelical impulse, or in some more generalized religious conviction, or in crusading zeal, or in scientific curiosity, or in esoteric or even 'secret' knowledge, or in greed. I find these versions unconvincing, but I have not written in order to advance my view at their expense —only to satisfy readers who want to make their own choices from within the range of genuine possibilities.

There are, however, three traditions of Columbus historiography which I actively defy. The first is the mystifying tradition, concerned to reveal allegedly cryptic truths which the evidence cannot disclose. Works of this type argue either that Columbus was not what he seemed, or that his plan for an Atlantic crossing concealed some secret objective. For instance, the rationally unchallengeable evidence of Columbus's Genoese provenance has not prevented mystifiers from concocting a Portuguese, Castilian, Catalan, Majorcan, Galician, or Ihizan Columbus, sometimes with the aid of forged documents. At a further level of mystification, a persistent tradition has insisted on a Jewish Columbus. His own attitude to Jews was not free of ambivalence: at one level he treated them with respect and professed, for instance, that, like Moors and pagans, they could be accessible to the operations of the Holy Spirit; at another level he shared the typical prejudices of his day, condemning the Jews as a 'reprobate' source of heretical depravity and accusing his enemies of the taint of Jewish provenance. The theory that he was of Jewish faith or origins himself can only be advocated *ex silentio,* in default—and sometimes defiance—of evidence.

Believers in Columbus's 'secrets' thrive on lack of evidence, because, like every irrational faith, theirs is fed on indifference to proof. Thus otherwise creditable scholars have argued, for instance, that all the evidence which proves that Columbus sailed in 1492 on a mission to Asia should be 'decoded' to demonstrate the opposite; or that his plan can be explained only by access to secret foreknowledge, transmitted by an 'unknown pilot', or by means of a fortuitous pre-discovery of America by Columbus himself, or even as the result of a chance encounter with American Indians. Readers of this [selection] can rely on being spared any such rash speculations.

The second objectionable tradition treats paucity of evidence as a pretext for intuitive guesswork. Imaginative reconstructions of what Columbus 'must' have been thinking or doing at moments when the sources are silent or ignored are made the basis for vacuous conclusions. On the strength of such musings, in highly popular books, Columbus has been credited with a strenuous love-life, with visionary glimpses of America from Iceland or Porto Santo, with undocumented visitations by his 'voices', and with a plan to conceal his presumed Hebraic ancestry. Sometimes the method is defended by frank contempt for the essential resources of historical enquiry, by an appeal to 'leave the dusty docu-

ments on the shelf and come back to the flesh and the spirit' or to speculation licensed on the grounds that 'there are no documents, only the real lives of these men and women, whose blood coursed through their veins as does ours through our own'. Yet, even if one were disposed to admit this obviously fallacious reasoning, the premiss on which it is based is false. We are extremely well informed about Columbus. No contemporary of humble origins or maritime vocation has left so many traces in the records, or so much writing of his own.

The last hazard I have tried to avoid is that of subscribing to a legend of the explorer's own making. The picture transmitted by the historical tradition of a uniquely single-minded figure is false, I am sure. Though Columbus could be obsessively pig-headed, his self-image, as I try to show in this [selection], was dappled by doubts. His sense of divine purpose grew gradually and fitfully and was born and nourished in adversity. His geographical ideas took shape slowly and were highly volatile in the early stages. His mental development proceeded by fits and starts and led at different times in different directions. The contrary view—that his ideas came suddenly, as if by revelation or 'secret' disclosure, or were sustained consistently, in defiance of contemporary derision, with an inflexible sense of purpose—goes back to a 'promotional' image which Columbus projected in his own writings in the latter part of his life. His aim was not only to dramatize his story and to emphasize the unique basis of his claims to material rewards but also to support a broader picture of himself as a providential agent. He was, he professed, divinely elected to execute a part of God's plan for mankind, by making the gospel audible in unevangelized parts of the earth. That tendentious reading of his own life was adopted by the authors of the detailed sixteenth-century narratives that have influenced all subsequent writers. Bartolomé de Las Casas, whose work has been fundamental to all modern studies of Columbus, accepted Columbus's self-evaluation as a divine messenger because he shared a providential vision of history and wrote to justify and celebrate an apostolate among the Indians in which he personally played no mean part; the next most influential narrative, the *Historie dell'Ammiraglio*, reflects much of the same view, either because it was derived from Las Casas's work, or perhaps because it was genuinely the work of Columbus's son, to whom it is attributed. Although few modern historians admit to a providential conception of history, almost all have accepted a secularized version of the legend, generally with misleading results. Some wild conclusions have been based, for instance, on the myth of Columbus's 'certainty', which goes back to Las Casas's vivid image: 'so sure was he of what he would discover, that it was as if he kept it in a chamber locked with his own key.' ...

'The Messenger of a New Heaven'

Decline, Death and Reputation...

That a weaver's son had died titular Admiral, Viceroy, and Governor; that he should have become the founder of an aristocratic dynasty and have established a claim to fame which has made and kept his name familiar to every educated

person in the western world: these are achievements which command the attention of any observer and the respect of most. But it can fairly be objected that Columbus's merits should be judged by his contribution to mankind, not his accomplishments for himself. His contemporaries had mixed views of that contribution. The New World did not shine for all beholders with the glow reflected in Columbus's gaze. For anyone who really wanted to get to Asia, it was a Stone-Age obstacle course. After its discovery in the sixteenth century, the New World tended to drift away again from the Old, developing internal economic systems, 'creole' identities, and finally independent states. When Rousseau totted up the advantages and disadvantages that accrued to mankind from the discovery of America, he concluded that it would have been better if Columbus had shown more restraint. Contemporaries as various as Abbé Raynal and Dr Johnson agreed. The fate of America has remained ever since, in a particular tradition, a paradigm of the despoliation of nature and the corruption of natural man. And if the influence of the Old World on the New was pejorative, that of the New upon the Old was slow to take full effect. Only with the improved communications and mass migrations of the nineteenth century, perhaps only with the transatlantic partnerships of the world wars in the twentieth, did the weight of America wrench the centre of gravity of western civilization away from its European heartlands. The potential of most of the continent is unrealized even today. Five hundred years after the discovery, America's hour has still not come.

Still, the sheer extent of the new lands across the Atlantic, and the large numbers of new peoples brought within the hearing of God's world, left the generation of Las Casas and Fernando Colón in little doubt of the potential importance of the events connected with Columbus's life. By 1552 the historian Francisco López de Gómara could characterize the discovery of the New World as the greatest happening since the incarnation of Christ. Yet the same writer denied that Columbus was truly the discoverer of those lands. This was a representative sentiment. Columbus had complained even in his own lifetime of being 'despoiled of the honour of his discovery' and though he was referring to the stintedness of his acclaim rather than to the elevation of the claims of rivals, it is true that his reputation has since suffered repeatedly from attempts to attribute the discovery of the New World to someone else.

The early history of the controversy was dominated by the legal wrangle between Columbus's heirs and the monarchs of Spain over the non-fulfilment of the royal promises of 1492. Any source of doubt that could be cast on Columbus's claim to have performed his side of the bargain was welcome in the prejudicial atmosphere of the first half of the sixteenth century. It was said, for instance, that the New World had formed part of the domains of King Hesperus or that the credit for the discovery belonged to Martín Pinzón, or that it rested with an 'unknown pilot' who had preceded Columbus to the New World by chance and confided his knowledge to the Genoese when on the point of death. It was this last story which López de Gómara repeated; Las Casas heard it treated as common knowledge when he was a young man in Hispaniola before 1516; in 1535 Gonzalo Fernández de Oviedo dismissed it as a vulgar rumour; and it has been echoed ever since. Testimony was even procured—almost certainly

not without deliberate perjury—to deny the amply verified fact that Columbus had visited the American mainland on his third voyage in 1498. The discoverer's sons, Diego and Fernando, strenuously resisted these allegations. Diego had the testimony of numerous favourable witnesses recorded on his father's side and Fernando wrote extensively in defence of his claims. It must be said that whatever Martín Pinzón's role on the first transatlantic voyage, of which we shall never know the whole truth, he joined the enterprise only at a late stage, when Columbus's plans were already well advanced. Though Columbus was familiar with many mariners' tales of unknown lands in the west, and recorded some of them along with other evidence in support of his theories, the story of the unknown pilot is unacceptable as it stands: it proceeds from biased sources; it is unwarranted by any contemporary authority; and it relies on the hypothesis of a freak crossing such as is otherwise unrecorded in the latitude on which Columbus sailed (although accidental crossings have happened further south, on routes not known to have been frequented before Columbus's time). The argument that the unknown pilot must have existed because Columbus would not otherwise have known where to go reminds one of Voltaire's ironic case in favour of God: if He did not exist, it would be necessary to invent Him. The unknown pilot is not required, even as a comforting fiction. Columbus had assembled sufficient indicators of lands in the west, according to his own standards, by his own researches, without recourse to secret sources. By his own admission, the materials he collected included seamen's yarns about Atlantic lands, which formed only one flimsy strand in the web of evidence. The 'certainty' he is supposed to have evinced, and which can alone be explained, it is said, by some pre-discovery of America, is, as we have seen, another myth. The presumed mariner cannot have helped very much, since his information was insufficient to preclude Columbus's belief that he had found Asia. The Admiral's doubts on that score, when they arose, were clearly attributable to his own observations....

An alternative argument, still connected with the Vikings, but voiced more often by admirers of Vespucci, is that Columbus's discovery of America was no better than that of the Icelanders, since he came upon the New World quite haphazardly and failed to recognize it correctly; one cannot be said to 'discover' something unless one recognizes it for what it is. It has also been said that neither Columbus nor anyone else up to his time anticipated the existence of a second world landmass and that it is therefore imprecise to speak of the 'discovery' of something which the European mind was not conceptually equipped to comprehend. Rather, the discovery of America happened gradually and cumulatively, as, under the influence of further explorations, men's presuppositions became adapted to the facts. Now it is agreed that one cannot be said to have 'discovered' a thing without recognizing it for what it is. Otherwise the event is a mere accident, which will pass unnoticed unless someone else happens to suggest the identification which the finder failed to make. The penicillin will stay in the crucible until it is washed up; the comet will shoot out of sight. Such was not the case, however, when Columbus stumbled on America.

In the first place, the possibilities of just such a discovery as Columbus made—that of a continent separate from the Eurasian landmass—were seriously

debated, actively canvassed, and, in some cases, excitedly anticipated among scholars prior to Columbus's departure. As soon as he returned to report, a considerable number of learned commentators jumped to the conclusion that he had found just such an antipodal world. Columbus himself on his third voyage correctly identified the mainland, which he then discovered for the first time, with this rumoured continent. During the virtual derangement brought on by his subsequent sufferings, he forsook the idea, and even while he still embraced it his opinion of the proximity of his discoveries to Asia was grossly exaggerated, but America did not have to be 'invented'; the discourse of the day included suitable terms for describing it and classifying it, and Columbus himself was among the first people to make use of them.

Of course the discovery of America was a process, which began with Columbus but unfolded bit by bit after his time, fitfully, without being fully complete until our own time. There has, after all, been a lot of America to discover. The outline of the coasts of South America was not fully complete until about 1540, and although the Atlantic and Pacific coasts of North America were roughly known by that time, the northern coast remained concealed beneath ice until Amundsen cut his way through it in 1905. On the main point at issue between Columbus and posterity—the relationship of America to Asia—Fernández de Oviedo pointed out in the 1530s that the whole truth was still unknown, and so it remained until the early eighteenth century, when the Bering Strait was explored. Many of the important physical features of the interior were still unknown late in the eighteenth century and unmapped until the early nineteenth; only the advent of aerial mapping in the present century —which did not encompass the last secrets of South America until the 1970s— penetrated the final areas to defy exploration. Long as the process has been, Columbus retains a primordial place as its initiator; and the extent to which he advanced it in the span of his own short career is all the more startling against the backdrop of the process as a whole: after alighting on some islands of the Bahamas, he explored much of the coast of Cuba, Hispaniola, Jamaica, Puerto Rico, the Lesser Antilles as far as Dominica, Trinidad, and the coast of the mainland from the mouth of the Orinoco to the Bay of Honduras.

The last argument against ascribing the discovery to Columbus also raises a conceptual problem. Only from the most crassly Eurocentric perspective, it is said, could one speak of the 'discovery' of land which had been well known to its native peoples for thousands of years. It has even been argued, by a highly creditable scholar, with only the faintest trace of detectable irony, that an American discovery of Europe preceded the European discovery of America, when a Caribbean canoe was misdirected across the Atlantic, and that the knowledge of this was Columbus's 'secret'. Whatever one thinks of this prank, it is hard to deny priority to the American discovery of America. This respectable argument would make 'discovery' an almost useless term, by limiting it to uninhabited lands. It misses the point that discovery is not a matter of being in a place, but of getting to it, of establishing routes of access from somewhere else. The peopling of the New World, which was followed by isolation, was conspicuously not a discovery in that sense. So vast a hemisphere naturally afforded scope for much internal exploration: it is proper to speak of exploration, recorded

in maps, by some Eskimo, North American Indian, and Mesoamerican peoples, and by the Incas, recorded in the latter case with mnemonic devices which we now barely understand. The reliance of early Spanish and Portuguese explorers on native guides, even in some cases over long distances, suggests that other histories of exploration happened in the New World, which we can only guess at. None of this makes the creation of routes which no one knew about before, such as Columbus's across the Atlantic, any less of a discovery.

Despite nearly five hundred years of assiduous detraction, his prior role in the discovery of America remains the strongest part of Columbus's credentials as an explorer. But we should recall some of the supporting evidence too: his decoding of the Atlantic wind system; his discovery of magnetic variation in the Western hemisphere; his contributions to the mapping of the Atlantic and the New World; his epic crossings of the Caribbean; his demonstration of the continental nature of parts of South and Central America; his *aperçu* about the imperfect sphericity of the globe; his uncanny intuitive skill in navigation. Any of these would qualify an explorer for enduring fame; together they constitute an unequalled record of achievement.

Columbus was a self-avowed ignoramus who challenged the received wisdom of his day. His servility before old texts, combined with his paradoxical delight whenever he was able to correct them from experience, mark him at once as one of the last torchbearers of medieval cosmography, who carried their lights on the shoulders of their predecessors, and one of the first beacons of the Scientific Revolution, whose glow was kindled from within by their preference for experiment over authority. The same sort of paradox enlivened every aspect of his character. His attraction towards fantasy and wishful thinking was ill accommodated in that hard head, half-full already with a sense of trade and profit. In his dealings with the Crown and his concern for his posterity, his mysticism was tempered by a materialism only slightly less intense —like the rich gurus who are equally familiar nowadays in spiritual retreats and business circles. Though religion was a powerful influence in his life, its effects were strangely limited; his devotional bequests were few; his charity began and almost ended at home. The Indians he discovered he contemplated with evangelical zeal and treated with callous disregard. He was an inveterate practitioner of deception, a perennial victim of self-delusion, but he was rarely consciously mendacious. In dealing with subordinates, he was calculating and ingenuous by turns. He craved admirers, but could not keep friends. His anxiety for ennoblement, his self-confessed ambition for 'status and wealth', did not prevent him from taking a certain pride in his modest origins and comparing the weaver-Admiral with the shepherd-King. He loved adventure, but could not bear adversity. Most paradoxically of all, beyond the islands and mainlands of the Ocean, Columbus explored involuntarily the marchlands between genius and insanity. Times of stress unhinged—sometimes, perhaps, actually deranged —him; in his last such sickness, he obsessively discarded his own most luminous ideas, and never recovered them.

It probably helped to be a visionary, with a flair for the fantastic, to achieve what he achieved. The task he set himself—to cross the Ocean Sea directly from Europe to Asia—was literally beyond the capacity of any vessel of

his day. The task he performed—to cross from Europe to a New World—was beyond the conception of many of his contemporaries. To have accomplished the highly improbable was insufficient for Columbus—he had wanted 'the conquest of what appeared impossible'. He died a magnificent failure: he had not reached the Orient. His failure enshrined what, in the long term, came to seem a greater success: the discovery of America.

One cannot do him justice without making allowances for the weakness that incapacitated him for ill fortune. He was too fearful of failure to face adverse reality—perhaps because he had too much riding on success: not only his personal pride, but also the claims to the material rewards on which his hopes for himself and his heirs rested. It is hard to believe, for instance, that his insistence on the continental nature of Cuba was other than perversely sustained in the face of inner conviction; or that he can really have felt, in his wild and self-contradictory calculations of the longitude of his discoveries, the confidence he claimed. The ambition that drove him was fatal to personal happiness. Almost anyone, it might be thought, would rest content with so much fame, so much wealth, so many discoveries, so dramatic a social rise. But not Columbus. His sights were always fixed on unmade discoveries, unfinished initiatives, imperfect gains, and frustrated crusades. Instead of being satisfied with his achievements he was outraged by his wrongs. Unassuaged by acclaim, he was embittered by calumnies. This implacable character made him live strenuously and die miserably. Without it, he might have accomplished nothing; because of it, he could never rest on his laurels or enjoy his success. It was typical of him to abjure his achievement in discovering a new continent because he could not face failure in the attempt to reach an old one. He wanted to repeat his boast, 'When I set out upon this enterprise, they all said it was impossible', without having to admit that 'they' were right.

The Oxford Union Society once invited an American ambassador to debate the motion, 'This House Believes that Columbus Went Too Far'. The eighteenth-century debate on the moral benefits of the discovery of America no longer commands much interest, but we can still ask the less solemn question, 'What difference did it make?' The brouhaha of the fifth centenary celebrations creates the impression of a generalized and unthinking acceptance that Columbus was the protagonist of an important event; yet it may still be worth asking what exactly makes it important and what, if any, is the justification for the fuss.

One of the most conspicuous changes to have overtaken the civilization in which we live—we usually call it 'Western civilization' or 'Western society' —in the course of its history has been the westward displacement of its centre of gravity, as its main axis of communication, the Mediterranean 'frog-pond' of Socrates has been replaced by an Atlantic 'lake' across which we traffic in goods and ideas and around which we huddle for our defence. The career of Columbus, which began in the Mediterranean and took Mediterranean mariners and colonists across the Atlantic for the first time, seems to encapsulate the very change which it can be said to have initiated. At present—and for as long as quincentennial euphoria lasts—the Admiral of the Ocean Sea is bound to seem significant for us. Historians and journalists will even acknowledge, without embarrassment, that he made the sort of personal contribution to

history which, in our awareness of the determining influence of the long and grinding 'structures' of economic change, we have become loath to concede to individuals. On the other hand, the judgements of history are notoriously fickle, and depend on the perspective of the time in which they are made. It may not be long now before 'Western civilization' is regarded as definitively wound up—not cataclysmically exploded, as some of our doom-fraught oracles have foretold, but merely blended into the new 'global civilization' which, with a heavy debt to the Western world but a genuinely distinct identity, seems to be taking shape around us. At the same time, the motors of the world economy are moving or have moved to Japan and California. The Pacific is likely to play in the history of 'global civilization' the same sort of unifying role which the Atlantic has played in that of the West. By 2020, when we come to celebrate the five hundredth anniversary of Magellan's crossing of the Pacific, those of us who are still alive may look back wistfully to 1992 with a feeling of *déjà vu,* and irresistible misgivings about the fuss.

NO ↰

Kirkpatrick Sale

The Conquest of Paradise: Christopher Columbus and the Columbian Legacy

Prologue

Surprising as it may seem from the present perspective, the man we know as Christopher Columbus died in relative obscurity, his passing not even recorded at the time on the subcontinent whose history he so decisively changed. But the true importance of his Discovery became clearer with every passing decade as the New World yielded up its considerable treasure to the Old, and as the historical significance became appreciated in scholarly, and then in popular, opinion. A half-century after his death it was certainly esteemed in the land that was its most obvious beneficiary—"the greatest event since the creation of the world," the Spanish historian Francisco López de Gómara called it in 1552, "excluding the incarnation and death of Him who created it"—and by the end of the sixteenth century even the French, notoriously stingy with praise for non-Gallic achievements, were ready to admit, in the words of one Louis Le Roy, that there was nothing "more honorable to our or the preceding age than the invention of the printing press and the discovery of the new world; two things which I always thought could be compared, not only to Antiquity, but to immortality." By the time two more centuries had passed, and the full incredible panoramas of the two new continents had become known (and in great measure exploited) by the nations of Europe, there were few who would have disagreed with the blunt assessment of the Scottish economist Adam Smith: "The discovery of America, and that of a passage to the East Indies by the Cape of Good Hope, are the two greatest and most important events recorded in the history of mankind."

Replete as those judgments are, however, it really has not been until the present century—indeed, until the retrospective provided by the quincentennial of the First Voyage—that a fully comprehensive measure of the Columbian achievement could be taken. Only now can we see how completely the Discov-

ery and its legacy over the last five centuries have altered the cultures of the globe and the life-processes upon which they depend:

- It enabled the society of the European subcontinent to expand beyond its borders in a fashion unprecedented in the history of the world, and to come today to dominate virtually every other society it touches, Westernizing the great bulk of humanity, imposing its institutions and ideas, its languages and culture, its technologies and economy, around the earth.
- It enabled Europe to accumulate wealth and power previously unimaginable, the means by which it created and developed the most successful synergy of systems ever known, a mixture of humanism and secularism, rationalism and science, materialism and capitalism, nationalism and militarism—in short, the very structures of what we know as modern civilization.
- It enabled the vast redistribution of life-forms, purposely and accidentally, that has changed the biota of the earth more thoroughly than at any time since the end of the Permian Period, in effect rejoining the continents of the earth that were separated so many geological eons ago and thereby causing the extinction, alternation, and even creation of species at a speed and on a scale never before experienced.
- And most significant, it enabled humanity to achieve, and sanctify, the transformation of nature with unprecedented proficiency and thoroughness, to multiply, thrive, and dominate the earth as no single species ever has, altering the products and processes of the environment, modifying systems of soils and water and air, altering stable atmospheric and climatic balances, and now threatening, it is not too much to say, the existence of the earth as we have known it and the greater proportion of its species, including the human.

After five centuries, then, we have come to a unique position from which to judge the consequences of the Columbian discovery in their fullest dimensions. We can now appreciate especially what it means that it was the particular culture of one small promontory of the Asian landmass, with its particular historical attributes and at that historical moment, that was the cause of this event and its opulent beneficiary, and what has been the effect of the implantation of that culture throughout the world. We can now perhaps even bring ourselves to look with new eyes at the Discovery itself and the processes it unfolded, to reassess, with the wisdom of hindsight, the values and attitudes inherent in that culture and in the industrial civilization it has fostered.

In that spirit of reassessment this inquiry was undertaken. Columbus is above all the figure with whom the Modern Age—the age by which we may delineate these past five hundred years—properly begins, and in his character as in his exploits we are given an extraordinary insight into the patterns that shaped the age at its start and still for the most part shape it today. He is the figure as well who was primarily responsible for the ways in which the culture

of Europe was implanted in the Americas, under not only Spanish flags but subsequent banners too, and his extraordinary career, very like his sailing routes, was the model for all those that came after. And he is the figure who, more than any other, provided the legacy by which European civilization came to dominate the American world for five centuries with consequences, we now realize, involving nothing less than issues of life and death.

This reassessment is particularly pertinent to the nation that not only is the foremost exemplar of the success of the transplanted culture but has lived out the Columbian legacy to its fullest, even taking as its greatest hero, as its very symbol, the Discoverer himself. For as Columbia, the personification invented for the newly formed United States at the end of the eighteenth century, he represents the soul and spirit of that nation and embodies what it takes to be its sense of courage and adventure, of perseverance and triumph, of brash indomitability. And thus it is in the United States that he is honored with more place names of all kinds—cities, counties, towns, rivers, colleges, parks, streets, and all the rest—than any other figure of American history save Washington, with more monuments and statues than have been erected to any other secular hero in the world. More than any other nation, the United States bears the honor, and the weight, of the Columbian achievement. More than any other nation, it is in a position to appreciate in the fullest its multiple, its quite consequential, meanings. . . .

1625–1992 . . .

That the Quincentennial that ends this latest century will be celebrated with more commotion and ceremony than ever before there is no question, though whether it will have much to do with the man it is supposed to commemorate there is real reason to doubt.

The official events, carefully planned, expensively mounted, and much ballyhooed, will involve every nation on both sides of the Atlantic and some few on the Pacific as well. As of 1989, thirty-two nations and twenty U.S. states and colonies had established official Quincentennial commissions, and they had authorized a bewildering array of celebrations, parades, pageants, fireworks displays, conferences, symposiums, exhibitions, projects, monuments, museum shows, contests, scholarships, grants, books, newsletters, magazines, scholarly compendiums, television programs, commemorative coins and stamps, memorabilia, sailing races, cruises, guided tours, and myriad other forms of observance, a great many hewing to the same spirit of gain that characterized the original voyage, though some of them guided by its sense of discovery and learning as well. . . .

Obviously this foofaraw will exceed, in length, money, fervor, technology, publicity, self-congratulation, and bathos, any previous commemoration; Father Charles Polzer of the U.S. Quincentenary Jubilee Commission has described the attention drawn to it as "widespread and monumental," an understatement.

It is not, however, without its dissenters. Many of those who know well the cultures that once existed in the New World have reason to be less than enthusiastic about celebrating the event that led to the destruction of much of that

heritage and the greater part of the people who produced it; some have insisted on labeling the events of 1492 an "encounter" rather than a "discovery" and having it so billed for 1992, some others have chosen to make it an occasion to direct attention to native American arts and achievements, and others still are planning to protest the entire goings-on as a wrongful commemoration of an act steeped in bloodshed, slavery, and genocide. The United Nations General Assembly, given several opportunities to endorse the Quincentennial, has been diplomatically stymied—by disputes about whether Colón was the first discoverer (Iceland and Ireland have both insisted on precedence), whether a commemoration that glorifies a colonialism from which many nations still suffer is apt, and whether West European world hegemony is a fit phenomenon for other continents to honor—and has taken no official action at all. And some of those who have sought to draw attention to the environmental destruction wrought in the aftermath of the Discovery, particularly members of various Green movements in the industrialized world, have decided to use the occasion to draw into question the nature of a civilization that could take the earth so close to ecocide.

In all of this, it seems certain, Cristóbal Colón will be quite lost, even Christopher Columbus quite hard to find, as his accomplishments are made the malleable and serviceable clay into which the breath of one cause or other, one patriotic mission or other, one testimonial to modernism or other, is blown. But that is in keeping, of course, for it is as the source of just such symbols that Colón has functioned through the five centuries of his life-after-death: from the time that he was made into a super-Hercules by Oviedo and Martyr to the time he became the early modern hero for the English who needed instigation and the Italians who needed inspiration; in the epics by which he became the personification of America as in the biographies that made him stand for wealth and progress; by the pageants that turned him into the image of this nation's skill or that one's genius and the celebrations that made him the agent of capitalist ingenuity and persistence . . . and beyond. It may be fitting, or only richly ironic, that, having seen the world as utilitarian, so has the world seen him.

Walt Whitman imagines Columbus on his deathbed, in Valladolid, in that May 1506, knowing the end is near, staring into the future:

> *What do I know of life? what of myself?*
>
> *I know not even my own work, past or present;*
>
> *Dim, ever-shifting guesses of it spread before me,*
>
> *Of newer, better worlds, their mighty parturition*
>
> *Mocking, perplexing me.*

Ah, but no, Colón, they do not mock and should not perplex: indeed, they live out your legacy, your destiny, more successfully and more grandly, if more terribly, than you ever could have dreamed.

⚜

1992 Worldwide population is estimated at more than 5.6 billion.

Rainforest area in the Western Hemisphere, originally 3.4 billion acres, is down to 1.6 billion, and going fast, at the rate of 25 million acres a year, or 166 square miles a day; U.S. forestland, originally more than a billion acres, is down to 500 million commercially designated acres, some 260 million having gone for beef production alone.

Topsoil depletion and runoff in the United States reaches a rate of 80 million feet per day, nearly 30 billion tons a year.

Twenty-five years after the U.S. Endangered Species Act went into effect, listing 500 of the several thousand threatened species in the country, twelve of the protected species have become extinct and 150 more are losing population at a rate that will lead to extinction within a decade. Two hundred threatened plants native to the United States have become extinct in the last five years. At least 140 major animal and bird species have become extinct since 1492, including four species of whales, seventeen varieties of grizzly bears, seven forms of bats, Eastern and Oregon buffalo, great auks, sea otters, sea minks, Eastern elks, long-eared kit foxes, Newfoundland and Florida wolves, Eastern cougars, Arizona and Eastern wapiti, Badlands bighorn sheep, heath hens, passenger pigeons, Jamaica wood rails, spectacled cormorants, Puerto Rico blue pigeons, Eskimo curlews, Puerto Rican conures, Carolina parakeets, Antigua and Guadeloupe burrowing owls, Guadeloupe red-shafted flickers, ivory-billed woodpeckers, Berwicks wrens, Tecopa pupfish, harelip suckers, longjaw ciscos, and blue pike.

Wilderness areas, officially designated at 90 million protected and 50 million unprotected acres, have been reduced from about 2.2 billion acres in pre-Columbian times—a decrease of roughly 96 percent.

The population of the native people of North America is about 20 million, only 1.5 million outside of Mesoamerica.

Epilogue

By the 1780s, the question of the importance of the Discovery and its impact on the world had become a topic of some debate in the intellectual circles of France and in the writings of the reigning *philosophes,* an extension of the old *sauvage noble–bête sauvage* debates earlier in the century. It was so provocative a subject, in fact, that Abbé Guillaume Reynal, the author of a highly popular four-volume study, *A Philosophical and Political History of the Settlements and Trade of Europeans in the Two Indies,* decided to see if the matter could be set to rest, in appropriate *philosophe* tradition, by asking the learned men of the Academy of Lyons to hold an essay contest, invite entrants on all sides, and award a prize, which he would himself contribute, to the one they judged had made the best case. The topic of debate: "Was the discovery of America a blessing or a curse to humankind?"

Unfortunately the precise workings-out of that contest have not survived the ebb and flow of history, which was turbulent indeed in France, we may remember, at that time. It is known, however, that entries were submitted in

1787 and 1788, that the Lyons savants were unable to declare an outright winner, and that only eight essays, with a fair mixture of opinion on the several sides of the issue, survive. Of those survivors the one that is easily the most learned and lucid, as well as the most persuasive, is the one by the *abbé* himself.

Reynal was willing to concede some positive effects of the Discovery. "This great event hath improved the construction of ships, navigation, geography, astronomy, medicine, natural history, and some other branches of knowledge; and these advantages have not been attended with any known inconvenience." Moreover, the domains of the Indies "have given splendor, power, and wealth, to the states which have founded them," although it was true that great expenses had been lavished "to clear, to govern, [and] to defend them," and that eventually they would all inevitably assert their independence and be lost to the "country which has founded its splendor upon their prosperity." As well, "Europe is indebted to the New World for a few conveniences, and a few luxuries," but those were "so cruelly obtained, so unequally distributed, and so obstinately disputed" that they could not really be said to be worth the price in human lives and disruption—and "before these enjoyments were obtained, were we less healthy, less robust, less intelligent, or less happy?" And finally, although "the New World has multiplied specie amongst us," the cost was high for the peoples of the Americas, who still "languish in ignorance, superstition, and pride" and have lost "their agriculture and their manufactures" to boot, and even for Europe, where the benefits were largely overwhelmed by a concomitant inflation.

On the negative side, the effects loomed larger. For one, "the bold attempts of Columbus and of Gama" created "a spirit of fanaticism" for "making discoveries" in search of "some continents to invade, some islands to ravage, and some people to spoil, to subdue, and to massacre." Those who succumbed to such adventures became "a new species of anomalous savages" who "traverse so many countries and who in the end belong to none... who quit their country without regret [and] never return to it without being impatient of going out again," all so that they might "acquire riches in exchange for their virtue and their health." "This insatiable thirst of gold," moreover, had "given birth to the most infamous and the most atrocious of all traffics, that of slaves," the "most execrable" of crimes against nature. And with all that "the machine of government," overextended in resources both at home and in the Americas, had "fallen into confusion," with the poorest states being forced to languish "under the yoke of oppression, and endless wars," while those who were "incessantly renewed" by Indies treasure "harassed the globe and stained it with blood."

Such was the indictment from the learned philosopher. And here, in full, was his conclusion:

> Let us stop here, and consider ourselves as existing at the time when America and India were unknown. Let me suppose that I address myself to the most cruel of the Europeans in the following terms. There exist regions which will furnish you with rich metals, agreeable clothing, and delicious food. But read this history, and behold at what price the discovery is promised to you. Do you wish or not that it should be made? Is it to be imagined that there exists a being infernal enough to answer this question in the

affirmative! Let it be remembered that there will not be a single instant in futurity when my question will not have the same force.

Let it be remembered.

Reynal was not alone in his condemnation. The thought had haunted some few right from the start—Montaigne, for example, in the expansionary sixteenth century, who said he was afraid "that we shall have greatly hastened the decline and ruin of this new world by our contagion"—and was not absent even from some, such as Henry Harrisse, in the ebullient nineteenth century: "As to the sum of happiness which has accrued to humanity from Columbus' discovery, philosophers may deem it light and dearly purchased" ... It is even a mortal question whether the two worlds would not have been far happier had they remained forever unknown to each other." The vantage point of five hundred years allows us to appreciate the wisdom of such few far more acutely than their contemporaries ever could.

It may be that all such judgments, including Abbé Reynal's, are in the end fruitless: history is what happened, not what should have happened. Certainly there are those who argue, with some merit, that it is foolish to think that Europe could have been anything but what it was, done anything but what it did. Why should one suppose that a culture like Europe's, steeped as it was in the ardor of wealth, the habit of violence, and the pride of intolerance, dispirited and adrift after a century and more of disease and famine and death beyond experience, would be able to come upon new societies in a fertile world, innocent and defenseless, and not displace and subdue, if necessary destroy, them? Why should one suppose such a culture would pause there to observe, to learn, to borrow the wisdom and the ways of a foreign, heathen people, half naked and befeathered, ignorant of cities and kings and metal and laws, and unschooled in all that the Ancients held virtuous? That, according to J. H. Elliott, who had wrestled with just this question, would be asking "a great deal of any society," but certainly more than the society represented by Europe in the fifteenth or even the sixteenth century.

Of course one may still wonder, and wonder long, about what that says about this society, the one now dominant in America, and the West, and the world. And one may even legitimately wonder, if it is not too painful, about what might have been. Was not Europe in its groping era of discovery in the fifteenth century in fact in search of salvation, as its morbid sonnets said, or of that regeneration which new lands and new peoples—and of course new riches—would be presumed to provide? Was that not essentially the arrangement Colón sold to the Sovereigns, confirmed in the Capitulations?

And there *was* salvation there, in the New World, though it was not of a kind the Europeans then understood. They thought first that exploitation was salvation, and they went at that with a vengeance, and found new foods and medicines and treasures, but that proved not to be; that colonization and settlement was salvation, and they peopled both continents with conquerors, and it was not that either; that progress and power and technics wrested from the new lands was salvation, and they made mighty nations and towering cities in its service, but it was not even that.

The salvation there, had the Europeans known where and how to look for it, was obviously in the integrative tribal ways, the nurturant communitarian values, the rich interplay with nature that made up the Indian cultures —as it made up, for that matter, the cultures of ancient peoples everywhere, not excluding Europe. It was there especially in the Indian consciousness, in what Calvin Martin has termed *"the biological outlook on life,"* in which patterns and concepts and the large teleological constructs of culture are not human-centered but come from the sense of being at one with nature, biocentric, ecocentric, and where there was myth but not history, circular rather than linear time, renewal and restoration but not progress, imaginative apperception far more subtle than science, understanding without words or even ideation, sacred rather than material interpretation of things, and an interpenetration into earth and its life-forms that superceded an identification with self or species.

It was there then, when Colón first encountered what he intuited, correctly, to be "in all the world... no better people nor better country," and it is there even now, despite the centuries of batterment, for those who stop and bend and open to hear it. It was salvation then, it might possibly be salvation now. Certainly there is no other.

An Irokwa woman in New York City, Doris Melliadis, said fifteen years ago:

> Now they come to gather for the coming disaster and destruction of the white man *by his own hands,* with his own progressive, advanced, technological devices, that only the American Indian can avert. Now the time is near. And it is only the Indian who knows the cure. It is only the Indian who can stop this plague. And this time the invisible will be visible. And the unheard will be heard. And we will be seen and we will be remembered.

So we may hope. There is only one way to live in America, and there can be only one way, and that is as Americans—the original Americans—for that is what the earth of America demands. We have tried for five centuries to resist that simple truth. We resist it further only at risk of the imperilment—worse, the likely destruction—of the earth.

There exists a nineteenth-century "bible" with the title *Oahspe,* said to have been influential among the Irokwa of the last century, which purports to be the words of "Jehovih" transmitted through a Dr. John Ballou Newbrough in 1881, in which Christopher "Columbo" is mentioned as playing a special part in the Design of God. In "one of the plans of God for redeeming the world" —a world which He acknowledged had fallen upon sinful times—Columbo was visited by the heavenly hosts and inspired by them "to go with ships to the westward, across the ocean," there to find for Europe "a new mortal anchorage," "a new country, where only the Great Spirit, Jehovih, is worshipped." He makes the momentous voyage, but the news of it is discovered by the agents of Satan, "the false Kriste," and his angels "did set the rulers of Spain against Columbo, and had him cast in prison, thus breaking the chain of inspiration betwixt Columbo and the throne of God"—and it is these evil spirits that instead lead the people of Europe across the ocean "to the countries Columbo had discovered" and there, to the consternation of Heaven, did "evil take its course."

So it may have been. However one may cast it, an opportunity there certainly was once, a chance for the people of Europe to find a new anchorage in a new country, in what they dimly realized was the land of Paradise, and thus find finally the way to redeem the world. But all they ever found was half a world of nature's treasures and nature's peoples that could be taken, and they took them, never knowing, never learning the true regenerative power there, and that opportunity was lost. Theirs was indeed a conquest of Paradise, but as is inevitable with any war against the world of nature, those who win will have lost—once again lost, and this time perhaps forever.

POSTSCRIPT

Were Christopher Columbus's New World Discoveries a Positive Force in the Development of World History?

Poring over the many Columbus-oriented works that were products of the quincentennial anniversary is likely to leave one bewildered and perplexed. One wonders how many writers can take the same information and come to diametrically opposed conclusions concerning Columbus and his place in history. Of course, as is usual in historical matters, one's experiences and the perspective derived from them are important determinants in drawing conclusions from the historical process.

It is worth noting that when the Columbus "iconography" was established in the West, the perspective on civilization was a Eurocentric one, and many of its potentially negative voices were muted or silent. As Western history became more "inclusionary," and a multicultural view of history made its way into the public consciousness, these voices began to be heard. They produced an alternative interpretation of Columbus's voyages and their impact on history, which was far different from their predecessors. What the future will hold for the subject remains to be seen.

One important question germane to the Columbus debate is: To what extent can Columbus be held personally responsible for the transatlantic slave trade, the annihilation of Native American populations, the ecological destruction of the Western Hemisphere, and other evils that were committed long after his death? Any assessment of Columbus's role in world history needs to explore answers to this question.

The post-quincentennial Columbus years have produced a large volume of works on the subject. Some of those on the negative side of the admiral's contributions to world history include Basil Davidson, *The Search for Africa: History, Culture, Politics* (Random House, 1994). This book contains a chapter entitled "The Curse of Columbus," which blames him for the horrors of the transatlantic slave trade. David Stannard, in *American Holocaust: Columbus and the Conquest of the New World* (Oxford University Press, 1992), goes so far as to hold Columbus responsible for the genocidal acts committed against Native American populations. Kirkpatrick Sale's *The Conquest of Paradise: Christopher Columbus and the Columbian Legacy* (Plume, 1991) takes a more philosophical approach, but still considers Columbus's legacy to be a negative one, especially as far as the environment is concerned.

Columbus has not been without support. The late Italian historian Paolo Emilio Taviani (1913–2001), in *Columbus: The Great Adventure: His Life, His*

Times, and His Voyages (Orion Books, 1991), makes a passionate plea for history to view the positive side of the Columbus legacy. Several articles do the same, including Robert Royal, "Columbus as a Dead White Male: The Ideological Underpinnings of the Controversy Over 1492," *The World and I* (December 1991); Dinesh D'Sousa, "The Crimes of Christopher Columbus," *First Things* (November 1995); and Michael Marshall, "Columbus and the Age of Exploration," *The World and I* (November 1999).

ISSUE 14

Was China's Worldview Responsible for Its Failure to Continue Its Commercial and Maritime Efforts During the Ming Dynasty?

YES: Nicholas D. Kristof, from "1492: The Prequel," *The New York Times Magazine* (June 6, 1999)

NO: Bruce Swanson, from *Eighth Voyage of the Dragon: A History of China's Quest for Seapower* (Naval Institute Press, 1982)

ISSUE SUMMARY

YES: Journalist Nicholas D. Kristof states that China's worldview, shaped by centuries of philosophical and cultural conditioning, was responsible for its decision to cease its maritime ventures during the Ming dynasty.

NO: Naval historian Bruce Swanson acknowledges that China's worldview played a role in its decision to cease its maritime programs, but maintains that there were other, more practical considerations that were responsible for that decision.

Few historical figures of the last 500 years can match the name recognition of Christopher Columbus, whose voyages and what resulted from them forever altered the course of history. But what about Zheng He? Does his name have the same evocative power as Columbus's? Probably not, and yet in the same century, Zheng He led more and longer naval expeditions, commanded larger ships and more men, and was within the Asian world as popular and as noteworthy as Columbus. An interesting historical lesson, replete with "what might have beens," can be learned from the life and career of the "Chinese Columbus."

Zheng He's life is in itself an interesting story. Born to Muslim parents living in China, he was a young boy when he was captured by the Chinese army and eventually castrated, a common practice for prisoners of war at that time. Eventually, he came into the service of Chinese royal prince Zhu Di, one of twenty-six sons of the Chinese emperor, whom he served with honor and

distinction. As a result of an internal power struggle, Prince Zhu Di seized the royal throne from his nephew and became the Ming dynasty's Emperor Yongle, who would rule China from 1402 to 1424. Zheng He played a significant role in this chain of events and would soon be rewarded for his meritorious service.

China's new emperor was an ambitious man who set out to establish his legacy as one of China's greatest rulers. As a means to achieve this exalted status, he emphasized the importance of China's need to re-establish its role in the commercial and maritime affairs of Asia. When it was time to select someone to command this project, the new emperor selected Zheng He.

For more than two decades Zheng He ran China's maritime operations for his emperor, and his plan included seven major voyages. In the process, "Admiral Zheng visited 37 countries, traveled around the tip of Africa into the Atlantic Ocean and commanded a single fleet whose numbers surpassed the combined fleets of all of Europe. Between 1405 and 1433, at least 317 ships and 37,000 men were under his command" (http://www.oceansonline.com/zheng.htm).

China's dominance of Asian waters brought the anticipated fame, wealth, and glory to Emperor Yongle and his eunuch admiral. However, when the former died suddenly in 1424, his successor decided to de-emphasize China's international maritime policies and ordered plans already under way for Zheng He's seventh voyage to be halted. This proved to be only a temporary setback when a new emperor, interested in reviving Yongle's maritime policies, ordered Zheng He's seventh voyage to proceed at once. It would prove to be China's last government-sponsored maritime venture.

Zheng He died in 1433, and soon after China began to lose interest in overseas exploration and eventually scrapped its maritime projects. This would have grave consequences for China when, later in the century, European countries began to send ships into Asian waters. What began as exploration eventually turned into domination, conquest, colonization, and imperialism—with dire consequences for China and the rest of Asia. Much of what follows is historical speculation, but one wonders what would have occurred if those first Western explorers who rounded Africa and headed toward Asia ran into a strong maritime force the size of Admiral Zheng's.

There are numerous reasons given for China's retreat from maritime excellence. Some state that a Ming court conflict between eunuchs and Confucian scholars, traditional rivals in court politics, occurred, and the latter eventually won by depicting China's maritime expeditions as costly, eunuch-induced extravagances and not in China's best long-range interests. Others stress a series of other factors, including those of an internal and external nature.

In the following selections, Nicholas D. Kristof argues that China gave up on its maritime efforts because these efforts contradicted the worldview that China had cultivated for thousands of years. Bruce Swanson counters that this was only one of many factors responsible for China's retreat from naval supremacy.

Nicholas D. Kristof

 YES

1492: The Prequel

For most of the last several thousand years, it would have seemed far likelier that Chinese or Indians, not Europeans, would dominate the world by the year 2000, and that America and Australia would be settled by Chinese rather than by the inhabitants of a backward island called Britain. The reversal of fortunes of East and West strikes me as the biggest news story of the millennium, and one of its most unexpected as well.

As a resident of Asia for most of the past 13 years, I've been searching for an explanation. It has always seemed to me that the turning point came in the early 1400's, when Admiral Zheng He sailed from China to conquer the world. Zheng He (pronounced jung huh) was an improbable commander of a great Chinese fleet, in that he was a Muslim from a rebel family and had been seized by the Chinese Army when he was still a boy. Like many other prisoners of the time, he was castrated—his sexual organs completely hacked off, a process that killed many of those who suffered it. But he was a brilliant and tenacious boy who grew up to be physically imposing. A natural leader, he had the good fortune to be assigned, as a houseboy, to the household of a great prince, Zhu Di.

In time, the prince and Zheng He grew close, and they conspired to overthrow the prince's nephew, the Emperor of China. With Zheng He as one of the prince's military commanders, the revolt succeeded and the prince became China's Yongle Emperor. One of the emperor's first acts (after torturing to death those who had opposed him) was to reward Zheng He with the command of a great fleet that was to sail off and assert China's pre-eminence in the world.

Between 1405 and 1433, Zheng He led seven major expeditions, commanding the largest armada the world would see for the next five centuries. Not until World War I did the West mount anything comparable. Zheng He's fleet included 28,000 sailors on 300 ships, the longest of which were 400 feet. By comparison, Columbus in 1492 had 90 sailors on three ships, the biggest of which was 85 feet long. Zheng He's ships also had advanced design elements that would not be introduced in Europe for another 350 years, including balanced rudders and watertight bulwark compartments.

The sophistication of Zheng He's fleet underscores just how far ahead of the West the East once was. Indeed, except for the period of the Roman Empire, China had been wealthier, more advanced and more cosmopolitan than any place in Europe for several thousand years. Hangzhou, for example, had a population in excess of a million during the time it was China's capital (in the 12th century), and records suggest that as early as the 7th century, the city of Guangzhou had 200,000 foreign residents: Arabs, Persians, Malays, Indians, Africans and Turks. By contrast, the largest city in Europe in 1400 was probably Paris, with a total population of slightly more than 100,000.

A half-century before Columbus, Zheng He had reached East Africa and learned about Europe from Arab traders. The Chinese could easily have continued around the Cape of Good Hope and established direct trade with Europe. But as they saw it, Europe was a backward region, and China had little interest in the wool, beads and wine Europe had to trade. Africa had what China wanted —ivory, medicines, spices, exotic woods, even specimens of native wildlife.

In Zheng He's time, China and India together accounted for more than half of the world's gross national product, as they have for most of human history. Even as recently as 1820, China accounted for 29 percent of the global economy and India another 16 percent, according to the calculations of Angus Maddison, a leading British economic historian.

Asia's retreat into relative isolation after the expeditions of Zheng He amounted to a catastrophic missed opportunity, one that laid the groundwork for the rise of Europe and, eventually, America. Westerners often attribute their economic advantage today to the intelligence, democratic habits or hard work of their forebears, but a more important reason may well have been the folly of 15th-century Chinese rulers. That is why I came to be fascinated with Zheng He and set out earlier this year to retrace his journeys. I wanted to see what legacy, if any, remained of his achievement, and to figure out why his travels did not remake the world in the way that Columbus's did.

Zheng He lived in Nanjing, the old capital, where I arrived one day in February. Nanjing is a grimy metropolis on the Yangtze River in the heart of China. It has been five centuries since Zheng He's death, and his marks on the city have grown faint. The shipyards that built his fleet are still busy, and the courtyard of what had been his splendid 72-room mansion is now the Zheng He Memorial Park, where children roller-skate and old couples totter around for exercise. But though the park has a small Zheng He museum, it was closed—for renovation, a caretaker told me, though he knew of no plans to reopen it. . . .

The absence of impressive monuments to Zheng He in China today should probably come as no surprise, since his achievement was ultimately renounced. Curiously, it is not in China but in Indonesia where his memory has been most actively kept alive. Zheng He's expeditions led directly to the wave of Chinese immigration to Southeast Asia, and in some countries he is regarded today as a deity. In the Indonesia city of Semarang, for example, there is a large temple honoring Zheng He, located near a cave where he once nursed a sick friend. Indonesians still pray to Zheng He for a cure or good luck.

Not so in his native land. Zheng He was viewed with deep suspicion by China's traditional elite, the Confucian scholars, who made sure to destroy the

archives of his journey. Even so, it is possible to learn something about his story from Chinese sources—from imperial archives and even the memoirs of crewmen. The historical record makes clear, for example, that it was not some sudden impulse of extroversion that led to Zheng He's achievement. It grew, rather, out of a long sailing tradition. Chinese accounts suggest that in the fifth century, a Chinese monk sailed to a mysterious "far east country" that sounds very much like Mayan Mexico, and Mayan art at that time suddenly began to include Buddhist symbols. By the 13th century, Chinese ships regularly traveled to India and occasionally to East Africa.

Zheng He's armada was far grander, of course, than anything that came before. His grandest vessels were the "treasure ships," 400 feet long and 160 feet wide, with nine masts raising red silk sails to the wind, as well as multiple decks and luxury cabins with balconies. His armada included supply ships to carry horses, troop transports, warships, patrol boats and as many as 20 tankers to carry fresh water. The full contingent of 28,000 crew members included interpreters for Arabic and other languages, astrologers to forecast the weather, astronomers to study the stars, pharmacologists to collect medicinal plants, ship-repair specialists, doctors and even two protocol officers to help organize official receptions.

In the aftermath of such an incredible undertaking, you somehow expect to find a deeper mark on Chinese history, a greater legacy. But perhaps the faintness of Zheng He's trace in contemporary China is itself a lesson. In the end, an explorer makes history but does not necessarily change it, for his impact depends less on the trail he blazes than on the willingness of others to follow. The daring of a great expedition ultimately is hostage to the national will of those who remain behind. . . .

The disappearance of a great Chinese fleet from a great Indian port symbolized one of history's biggest lost opportunities—Asia's failure to dominate the second half of this millennium. So how did this happen? While Zheng He was crossing the Indian Ocean, the Confucian scholar-officials who dominated the upper echelons of the Chinese Government were at political war with the eunuchs, a group they regarded as corrupt and immoral. The eunuchs' role at court involved looking after the concubines, but they also served as palace administrators, often doling out contracts in exchange for kickbacks. Partly as a result of their legendary greed, they promoted commerce. Unlike the scholars— who owed their position to their mastery of 2,000-year-old texts—the eunuchs, lacking any such roots in a classical past, were sometimes outward-looking and progressive. Indeed, one can argue that it was the virtuous, incorruptible scholars who in the mid-15th century set China on its disastrous course.

After the Yongle Emperor died in 1424, China endured a series of brutal power struggles; a successor emperor died under suspicious circumstances and ultimately the scholars emerged triumphant. They ended the voyages of Zheng He's successors, halted construction of new ships and imposed curbs on private shipping. To prevent any backsliding, they destroyed Zheng He's sailing records and, with the backing of the new emperor, set about dismantling China's navy.

By 1500 the Government had made it a capital offense to build a boat with more than two masts, and in 1525 the Government ordered the destruction of

all oceangoing ships. The greatest navy in history, which a century earlier had 3,500 ships (by comparison, the United States Navy today has 324), had been extinguished, and China set a course for itself that would lead to poverty, defeat and decline.

Still, it was not the outcome of a single power struggle in the 1440's that cost China its worldly influence. Historians offer a host of reasons for why Asia eventually lost its way economically and was late to industrialize; two and a half reasons seem most convincing.

The first is that Asia was simply not greedy enough. The dominant social ethos in ancient China was Confucianism and in India it was caste, with the result that the elites in both nations looked down their noses at business. Ancient China cared about many things—prestige, honor, culture, arts, education, ancestors, religion, filial piety—but making money came far down the list. Confucius had specifically declared that it was wrong for a man to make a distant voyage while his parents were alive, and he had condemned profit as the concern of "a little man." As it was, Zheng He's ships were built on such a grand scale and carried such lavish gifts to foreign leaders that the voyages were not the huge money spinners they could have been.

In contrast to Asia, Europe was consumed with greed. Portugal led the age of discovery in the 15th century largely because it wanted spices, a precious commodity; it was the hope of profits that drove its ships steadily farther down the African coast and eventually around the Horn to Asia. The profits of this trade could be vast: Magellan's crew once sold a cargo of 26 tons of cloves for 10,000 times the cost.

A second reason for Asia's economic stagnation is more difficult to articulate but has to do with what might be called a culture of complacency. China and India shared a tendency to look inward, a devotion to past ideals and methods, a respect for authority and a suspicion of new ideas. David S. Landes, a Harvard economist, has written of ancient China's "intellectual xenophobia"; the former Indian Prime Minister Jawaharlal Nehru referred to the "petrification of classes" and the "static nature" of Indian society. These are all different ways of describing the same economic and intellectual complacency.

Chinese elites regarded their country as the "Middle Kingdom" and believed they had nothing to learn from barbarians abroad. India exhibited much of the same self-satisfaction. "Indians didn't go to Portugal not because they couldn't but because they didn't want to," mused M. P. Sridharan, a historian, as we sat talking on the porch of his home in Calicut.

The 15th-century Portuguese were the opposite. Because of its coastline and fishing industry, Portugal always looked to the sea, yet rivalries with Spain and other countries shut it out of the Mediterranean trade. So the only way for Portugal to get at the wealth of the East was by conquering the oceans.

The half reason is simply that China was a single nation while Europe was many. When the Confucian scholars reasserted control in Beijing and banned shipping, their policy mistake condemned all of China. In contrast, European countries committed economic suicide selectively. So when Portugal slipped into a quasi-Chinese mind-set in the 16th century, slaughtering Jews and burn-

ing heretics and driving astronomers and scientists abroad, Holland and England were free to take up the slack. . . .

If ancient China had been greedier and more outward-looking, if other traders had followed in Zheng He's wake and then continued on, Asia might well have dominated Africa and even Europe. Chinese might have settled in not only Malaysia and Singapore, but also in East Africa, the Pacific Islands, even in America. Perhaps the Famao [a clan of people who live in Pate, an island off the coast of Africa, and who are rumored to be descendents of Chinese shipwreck survivors from countless generations ago] show us what the mestizos [racially-mixed people] of such a world might have looked liked, the children of a hybrid culture that was never born. What I'd glimpsed in Pate was the high-water mark of an Asian push that simply stopped—not for want of ships or know-how, but strictly for want of national will.

All this might seem fanciful, and yet in Zheng He's time the prospect of a New World settled by the Spanish or English would have seemed infinitely more remote than a New World made by the Chinese. How different would history have been had Zheng He continued on to America? The mind rebels; the ramifications are almost too overwhelming to contemplate. So consider just one: this [selection] would have been published in Chinese.

NO ↩

Continental and Maritime Ideologies in Conflict: The Ming Dynasty

In 1405, China's progressive attitude toward exploitation of the sea culminated in a series of naval expeditions into the South China Sea and the Indian Ocean. The latter expeditions included visits to Ceylon, India, the Persian Gulf, and Africa. These spectacular voyages, in fact, proved that China was the supreme world seapower whose shipbuilding techniques and navigational abilities were unmatched by any other nation.

But China's prominence as the world's greatest naval and maritime power was short-lived. The last of seven expeditions ended in 1433; never again were naval expeditions attempted by emperors. As a result, it is tempting to dismiss these voyages as a temporary aberration of the Chinese emperor who sponsored them. To do so, however, would be to ignore the ineluctable influence of the maritime spirit on China, particularly the growing awareness of the potential of seapower to expand and control the tribute system. At the same time, the subsequent cessation of the voyages clearly highlights the equally strong force of continentalism among members of the imperial court as they attempted to steer China away from maritime pursuits.

Early Ming Strategic Considerations

Before discussing the voyages and their itineraries, it is important to examine certain factors that reflected China's continuing struggle between supporters of continentalism on the one hand and the maritime ideology on the other.

The First Ming Emperor

The first Ming emperor, Zhu Yuanzhang, was an orphaned peasant from the riverine area near Nanjing. As a child, he had been taken in by Buddhist monks and educated in a monastery. Upon leaving the monastery, he was unable to gain employment and was soon begging for a living. At the age of twenty-five, the vagrant joined a rebel band that fought government soldiers for over a decade in the central China river valleys. Warfare

From Bruce Swanson, *Eighth Voyage of the Dragon: A History of China's Quest for Seapower* (Naval Institute Press, 1982). Copyright © 1982 by The United States Naval Institute, Annapolis, Maryland. Reprinted by permission. Notes omitted.

finally wore down the Mongol-backed local forces and the entire Yangzi Valley came under rebel control. In due course, Zhu assumed leadership of the rebels and defeated the government forces. He then established his capital at Nanjing in 1356. Twelve years later, after taking his rebel army north and capturing Beijing from the Mongols, Zhu founded the Chinese Ming dynasty.

Although Zhu, being from a riverine area, had presumably come into contact with many men who had knowledge of the sea, his initial concerns lay in consolidating Chinese rule and making China's borders and strategic cities safe from Mongol invasion. Accordingly, he took several actions that temporarily stifled maritime activities.

Walls, Canals, and Coastal Defense

With the Mongols only recently defeated, Zhu set about improving city defenses. For example, he directed the construction of a protective wall some 20 miles in length around Nanjing. The barrier was 60 feet high and nearly impenetrable by a force armed with the weapons of the time.

On the coast, Zhu faced the problem of piracy by Japanese and Chinese freebooters, which had increased alarmingly. He ordered that Chinese not be permitted to go overseas—those who violated his edict would be executed as traitors. In 1374 Zhu backed up his decree by abolishing the superintendencies of merchant ships at the ports of Ningbo, Quanzhou, and Guangzhou. Next, he strengthened coastal defenses by constructing forts; in the four-year period from 1383 to 1387, more than one hundred thirty forts were built in the Zhejiang-Fujian coastal zones. In Zhejiang alone, more than fifty-eight thousand troops were conscripted to man the provincial coastal forts.

Zhu also directed the Board of Works to undertake extensive reconstruction of the canal system, which had been damaged by flood and warfare. One of the long-term projects called for enlarging the Grand Canal, which upon completion was to replace the pirate-plagued sea route. The latter route had been reopened earlier when civil strife closed down the canal.

The Tribute System

The first Ming emperor wasted little time before trying to reestablish the tributary system. He ordered missions to proceed to peripheral states such as Japan, Annam, Champa, and Korea, where it was proclaimed that all who wished to enter into relations with China must acknowledge the suzerainty of the new emperor. Very soon some of these states sent reciprocal missions to Peking where Zhu received their kowtows acknowledging him as the Son of Heaven. These missions also served other purposes, such as providing the new Chinese dynasty with information on the current situations in border areas. . . .

The Mongol-Muslim Alliance

The first Ming emperor also had to deal with the continuing threat posed by the retreating Mongols. It took Zhu's armies until 1382 to drive remaining Mongol military units from Yunnan in southwest China. Moreover, during the next twenty years, periodic "mopping-up" operations continued beyond the Great Wall in northeast China and in Korea as well.

For the Ming government, the biggest threat lay westward. A Turkic nomad and Muslim named Timur, or Tamerlane, was conquering the entire central Asian region from Siberia to the Mediterranean and southward to the Indian Ocean. Included in the ranks of his fierce Muslim cavalry were remnants of the retreating Mongol armies.

According to an official Ming history, Zhu was anxious to bring Timur into the tribute system. He sent several small missions on the overland caravan route to seek out the Muslim leader. The Chinese apparently were unaware of just how paltry their offer of suzerainty appeared to the ferocious Timur. The Muslims, in fact, scorned the Chinese. "Because they believe [that] our people [are] wild and boorish, they do not hope for politeness, nor respect, nor honor, nor law from us; and apart from their own realms they do not know of a city [anywhere] in the world."

In 1394, after only a quarter century of Ming rule, an incident occurred that would seriously jeopardize the Chinese dynasty. At that time, Zhu received what he thought was a tribute mission from Timur that delivered a letter acknowledging the Chinese emperor as the ruler of all mankind. The letter, forged by an ambitious merchant or court official, led Zhu to send a return mission to central Asia in appreciation of Timur's vassalage. In 1395, when the Chinese embassy reached Timur and delivered Zhu's note, the Muslim leader became so enraged that he advised his staff to prepare for an invasion of China to bring down the Chinese "infidels." He took the Chinese mission hostage. By 1404 his plans were nearly complete, and he had massed two-hundred thousand Muslim and Mongol cavalrymen in the Pamirs, near modern-day Afghanistan.

Fortunately for the Chinese, Timur died in 1405, following an all-night drinking bout. On his deathbed he reportedly "expressed his regret in having neglected the conquest of such infidel countries as China and drawn his sword against Muslim armies." Two more years passed before the Chinese heard from the freed hostages that Timur had died.

Foreign Policy Under the Second Ming Emperor

While Timur was preparing to invade China, the death of Zhu Yuanzhang in 1398 produced another period of civil war lasting until 1403. Succeeding Zhu was his grandson, a young boy whose court remained in Nanjing. In the north, however, Zhu's fourth son, Chengzu, decided to overthrow his nephew from the southern capital. As the military commander responsible for anti-Mongol operations in the Peking area, he controlled some of the best troops in China. His ultimate success came in 1403, when he defeated the Nanjing forces loyal to

his father and assumed the throne with the name Yongle, meaning "perpetual happiness."

Clearly, Yongle's ambition and leadership ability forecast a dynamic reign. As with his father before him, one of Yongle's primary objectives was to establish his sovereignty throughout the tribute system by reinstilling the belief among all foreign states that China was supreme. In order to persuade the tributaries, however, Yongle had to work out a strategy that would both gain respect for Chinese power and enrich the imperial treasuries.

He dealt with Japan first. In 1403 the superintendencies of merchant shipping were reopened and new hostels were built to house Japanese tributary missions coming by sea. A system was devised whereby legitimate Japanese merchants were given trading passports that could be checked by Chinese authorities on each visit. In this way pirates could be identified, while honest Japanese and Chinese businessmen were free to carry on lucrative trade.

In Annam Yongle faced a critical problem. In 1400, while he was fighting to usurp the throne from his nephew, events there were coming to a head. Hanoi had fallen to Champa and the Annamese Tran dynasty was destroyed. The South China Sea was now in the hands of Cham and rebel Annamese pirates, and Chinese merchant shipping, both official and unofficial, was seriously disrupted. In 1406 Yongle decided to attack across the land border in order to pacify the two warring states and then reestablish Annam as a Chinese province. Hanoi was captured in 1406, but the Chinese armies soon bogged down in Annamese cities awaiting reinforcements and supplies. Before long nearly ninety thousand Chinese troops were in Annam attempting to control the countryside through a costly sinicization program.

Problems in inner Asia were developing concurrently with the Annam invasion. Word of the Muslim conquests in central Asia had reached Yongle, but the distance and harsh nature of that western area precluded the dispatch of a large army to confront Timur. Caution got the better of Yongle. He elected to send a small fact-finding mission to Timur in 1402 to inquire why the Muslim leader, since 1395, had failed to pay tribute. In a move that suggested that Yongle would settle for political equality with remote central Asia, he approved the construction of a Muslim mosque in Peking. This may have been done to induce the warring Muslims to keep open the silk route connecting western China with the cities of the Timurid empire (these included Gilgit and Herat, located in modern-day Pakistan and Afghanistan, respectively).

With the silk route used only sporadically, the wealthy classes, the court, and the treasury had become heavily dependent upon southern maritime trade for the import of precious stones, fragrant woods, spices, and rare objects. To ensure the safety of Chinese traders on the sea and the uninterrupted flow of luxury items, it was essential that Yongle build a navy that would convince the ocean states of China's "world supremacy." He devised a forceful plan calling for the aggressive use of seapower to underline Chinese suzerainty over the peripheral southern ocean states. Since the first expedition was to sail all the way to the Muslim states of Aden, Mecca, Djofar, and Hormuz, Yongle likely con-

cluded that the voyages would also be useful in countering Timur's influence in that area.

The Ming Ships and Expeditions

In 1403, a year of momentous decisions, Yongle directed Chinese shipyards in Fujian to undertake an aggressive shipbuilding effort that would result in the construction of more than two thousand large seagoing vessels over the next sixteen years.

The *baochuan,* or treasure ships, were the largest vessels constructed by the Chinese. Their size has been the subject of many arguments among scholars. Ming histories record that the treasure-ships were 440 feet long and 180 feet wide (an unlikely construction ratio of 5:2). At best, this configuration is an exaggeration, for such broad-beamed vessels would be unresponsive even under moderate sea conditions. In fact, acceptance of these figures degrades the reputation of Chinese shipbuilders of the period, who would have recognized that such vessels were impractical to build. Until research proves otherwise, it is this writer's opinion that the largest vessels were shaped much like the three largest junks, of which records are available. These, the Jiangsu trader, the Beizhili trader, and the Fuzhou pole junk, were built on a proportion of about 6.4:1—much closer to the modern naval architecture ratio of 9:1. The former was about 170 feet long and had five masts, while the latter two had lengths of 180 feet with a beam of 28 feet. It may be significant that Fujian shipyards were give the first-order calling for the construction of 137 ships, since these were the yards that probably developed the technique for building the Fuzhou pole junk. . . .

Zheng He

In addition to overseeing the construction of the Ming fleet, Yongle selected the senior officers who were to lead the expeditions. For overall commander the emperor picked a Muslim eunuch named Zheng He, who had been in his service since 1382. As a small boy, Zheng He had been taken prisoner in Yunnan during the final rout of the Mongols.

Following his capture, Zheng He, by custom, was castrated and subsequently made an officer in Yongle's army, where he distinguished himself during the successful usurpation campaign of 1403. For his loyal service, Zheng He, at age thirty-three, was made a grand eunuch and appointed superintendent of the Office of Eunuchs. His military prowess, along with his knowledge of Turku languages and Islam, made Zheng He the ideal choice for senior admiral of the Ming fleet. He was given the name Sanbao Taijian, meaning "three-jewelled eunuch."

During his voyages, Zheng He was accompanied by other Chinese Muslims, including one named Ma Huan, who came from the Hangzhou Bay area. Ma was knowledgeable in matters of the sea and in the Arabic and Persian languages. His chief distinction, however, was the account of three voyages he made with Zheng He.

From Ma Huan we learn that Zheng He's general procedure was to bring the fleet together in late spring near modern-day Shanghai, where a series of briefings and religious ceremonies was conducted. Once prayers had been offered, and the fleet had been organized and briefed, it sailed leisurely on a four- to eight-week "shakedown cruise" to an anchorage at the mouth of the Min River in Fujian Province. There the ships would carry out further intensive training throughout the late summer and early fall. Finally, in December or January, they would set sail during the favorable monsoon.

The Sea Routes

The sea routes followed by Ming naval captains had been known and used for several centuries. Since the Song dynasty, in fact, the routes had been systematized into two major sea lanes: the East Sea Route and the West Sea Route. Each was subdivided into a major and minor route. For example, the major East Sea Route extended to northern Borneo and the Philippines. The minor West Sea Route encompassed ports in Sumatra and the Malay Peninsula. The major West Sea Route was that route taken to the Indian Ocean via the Malacca Strait.

Following the period of intensive training, the fleet wound its way through the Taiwan Strait and sailed directly into the South China Sea, where land falls were made on Hainan Island and the Xisha Islands (Paracel Islands). From the Xishas the fleet turned westward and made for an anchorage at modern-day Qui Nhon on the Champa (southern Vietnam) coast. The total time of the Fujian-Champa transit was about ten days. Once there, provisions were taken aboard and the crews had "liberty" and "swim call." From Qui Nhon the fleet sailed southward toward the west coast of Borneo, making land falls on the various islands in the southern portion of the South China Sea.

After rounding Borneo, the ships entered the Java Sea and sailed to Sarabaja in Java. At this port Chinese crews were again rested for several months, until about July, when the period of favorable winds occurred. They then sailed through the Malacca Strait via Palembang and thence westward to Sri Lanka. From Sri Lanka the ships made their way to Calicut on the Indian coast, where the fleet was divided into smaller "task forces." Some went to Chittagong in modern-day Bangladesh; others went to Hormuz, Aden, and Jidda; and some visited the African coast near the mouth of the Red Sea. Hormuz usually was reached in January of the first year, and the Chinese returned to Malacca by March. They remained in Malacca only briefly, sailing northward to the Yangzi River by July of the second year....

The Decline of Maritime Spirit in the Ming

During the Ming expeditions, a number of political, military, social, and economic factors acted to slow and then finally halt the policies that had promoted maritime experimentation and growth.

The Grand Canal

One of the first indications of China's impending maritime collapse occurred when the Grand Canal was reopened in 1411, making it again possible to ship grain via the inland route. This event marked another closing of the coastal maritime route, and many personnel of the coastal fleets were reassigned to work on the canal. In 1415 the government officially banned grain transport by sea and authorized the construction of three thousand shallow-draft canal barges. This diversion of manpower and shipbuilding expertise was soon felt in the maritime industries. Oceangoing ship construction lagged and was halted altogether by Yongle's successor in 1436. At the same time, regulations were issued that reassigned the men of the Indian Ocean expeditionary force to canal duties as stevedores.

Population Shifts

Significantly, the conclusion of Ming voyages caused a shift of population away from the sea coast that, from 1437 to 1491, resulted in a loss of eight million people in the three principal coastal provinces of Zhejiang, Fujian, and Guangdong. Meanwhile, inland areas such as Yunnan and Hebei gained four million in population. Many coastal inhabitants also emigrated to southeast Asia.

Warfare and Border Pressure

During the fifteenth century China suffered several serious military setbacks along its land borders that deflected interest in maritime expeditions. In 1418 Annam, tiring of the Chinese presence, launched a war of independence. In a way similar to recent United States efforts, the Chinese tried to carry the fight for some nine years, but Annamese guerrilla tactics eventually prevailed. In 1420 the Ming navy lost a battle on the Red River; in 1427 the Chinese emperor finally grew weary of increased war costs and evacuated nearly one hundred thousand Chinese soldiers from Annam. Chinese suzerainty was maintained, however.

In the north, China faced a graver threat in the form of continued Mongol raids along the entire length of the Great Wall. In 1421, in an effort to counter the resurgent Mongols, Yongle moved the capital from Nanjing to Beijing. Troops were shifted from the seacoast to shore up the northern capital's defenses, which lay less than 100 miles from one of the strategic northern passes that intersected the Great Wall. Despite these precautions, the Chinese emperor was captured in 1449, and the Ming court was forced to resurrect its continental defense strategy completely. These policies did little to diminish the northern nomad threat, however; the critical northern frontier remained under nomad pressure for the next three hundred years. Martial law was periodically imposed, and senior military officials spent their careers defending the north rather than performing naval and coastal defense duties.

Corruption in Government

Politics within the Ming court also began to turn attention away from the sea, as eunuchs and Chinese bureaucrats vied for power. The praise and favors lavished on palace eunuchs in the early Ming period eventually led to their complete domination of governmental affairs. By the middle of the fifteenth century, the first in a series of eunuch strongmen ascended to power. Very quickly they set about sealing their hold over the most important government agencies, taking control of the army, the police, and finance ministries. When opposed, the eunuchs often resorted to terrorist tactics, arresting and executing those that dared question their authority. Many became quite corrupt, employing ships and crews to transport ill-gotten goods and transferring soldiers to palace construction work.

By 1480 the political intrigues had increased to such an extent that when a powerful eunuch initiated a request to prepare another series of maritime expeditions in emulation of Zheng He, he was greeted by fierce opposition within the ranks of government bureaucrats. Jealous officials within the Board of War conspired to have records of the Indian Ocean voyages destroyed, so as to frustrate any attempt to imitate the early Ming expeditions.

Piracy

As officials became more absorbed in intrigues at court, they too tended toward corruption, which carried over to coastal trade. Unscrupulous merchants regained control as the government's monopoly on foreign trade was relinquished, and smuggling and piracy flourished. The Ming histories record that "the powerful families of Fujian and Zhejiang traded with the Japanese pirates. Their associates at court protected them and carried out their bidding. . . . Palace attendants outfitted merchant ships and the criminal elements of the coast abetted them in making profit." In fact, while Zheng He and his companions were conducting their voyages, Japanese pirates successfully carried out five major incursions against the Chinese mainland. In 1419 the northern coastguard fleets were helpless in preventing a sizeable force of several thousand pirates from landing on the Liaodong Peninsula. It required a well-trained force of Chinese army troops to subdue the pirates. As an example of the magnitude of this action, the Chinese army commander captured 857 pirates alive and beheaded another 742.

Although Japanese piracy continued to plague the Chinese, it ceased in 1466 when Japan fell into civil war. By 1523, however, Japanese and Chinese raiders were again launching attacks along the coast. Ningbo was burned in that year, and in 1552 a flotilla sailed up the Yangzi, sacking cities without opposition. Natives of the coast fled further inland to escape the ravages of these attacks. In 1555 Nanjing came under seige and the port of Quanzhou in Fujian was plundered. In an attempt to stop these raids, Ming provincial administrators resorted to the Tang dynasty's practice of constructing beacon stations to give advance warnings of pirates. By 1562, 711 beacon stations lined the coast from Jiangsu to Guangdong. By 1563 the army had to be used to combat the sea rovers, who controlled nearly all of the Fujian coast.

Scholarship and Neo-Confucianism

Finally, a version of neo-Confucianism developed that was markedly idealistic and influenced by Buddhism, resulting in a loss of interest in geomancy and maritime expansion. As early as 1426, a minister memorialized the court, stating the following:

> Arms are the instruments of evil which the sage does not use unless he must. The noble rulers and wise ministers of old did not dissipate the strength of the people by deeds of arm. This was a farsighted policy.... Your minister hopes that your majesty... would not indulge in military pursuits nor glorify the sending of expeditions to distant countries. Abandon the barren lands abroad and give the people of China a respite so that they could devote themselves to husbandry and to the schools. Thus, there would be no wars and suffering on the frontier and no murmuring in the villages, the commanders would not seek fame and the soldiers would not sacrifice their lives abroad, the people from afar would voluntarily submit and distant lands would come into our fold, and our dynasty would last for ten thousand generations.

Such statements helped check Chinese maritime pursuits and force China to restore continentalist policies. Scholars who devoted their lives to the classics were again revered, while the military class was looked upon with great suspicion by the gentry and officials.

By the early fifteenth century, regulations were again in force that made it a capital offense to build a seagoing junk with more than two masts. By 1525 an imperial edict authorized coastal officials to destroy all ships of this kind and place the crews under arrest.

◄◉►

The timing of Chinese maritime decline could not have been worse, for it coincided with European maritime expansion into Asia. The Portuguese arrived in 1516, and although they were expelled in 1521, their exodus was short-lived. They returned and established settlements in Xiamen in 1544 and Macao in 1535. The Spanish occupied the Philippines in 1564 and established trade relations with China shortly thereafter. Then, in the seventeenth century, the Dutch arrived in Asia just as the Ming dynasty was being conquered by the Manchu cavalry that overran Beijing in 1644. Thus was the stage set for the last foreign imperial rulers in China—the Qing.

POSTSCRIPT

Was China's Worldview Responsible for Its Failure to Continue Its Commercial and Maritime Efforts During the Ming Dynasty?

This book provides material that can be used to compare and contrast Eastern and Western exploration efforts through the accomplishments of Christopher Columbus and Zheng He. Especially significant from a historical perspective is what did—and did not—happen as a result of their efforts and what may have happened if the Chinese did not end their maritime ventures. Also, William H. McNeill's selection in Issue 18 of this volume sheds some light on the Western Age of Exploration, including its causes and its effects on the course of world history.

The role of court eunuchs throughout Chinese history has been a turbulent one; sometimes they are portrayed as loyal civil servants, other times as despised outcasts. No one, however, can question their staying power, as during the reign of Pu Yi (1903–1912), who would be China's last emperor, they were still a troublesome court presence. In Bernardo Bertolucci's Academy Award–winning film, *The Last Emperor*, they are shown as having a corrupting influence on the court and are eventually banned from the Forbidden City. Although historically they were far from angelic, they have sometimes been blamed for conditions and events that were not of their making. Shih-Shan Henry Tsai attempts to correct the myths and stereotypes regarding eunuchs in *The Eunuchs in the Ming Dynasty* (State University of New York Press, 1996), which provides a badly needed new perspective concerning eunuchs in the period covered by this issue.

For other works on the subject, see Shih-Shan Henry Tsai, *Perpetual Happiness: The Ming Emperor Yongle* (University of Washington Press, 2001), which provides a fresh look at the man responsible for Ming China's maritime activities. Two important reference works on Ming China, both edited by Frederick W. Mote and Denis Twitchett, are *The Cambridge History of China: The Ming Dynasty, 1368–1644, Part I* (Cambridge University Press, 1988) and *The Cambridge History of China: The Ming Dynasty, 1368–1644, Part II* (Cambridge University Press, 1998).

The recent publication date on many of these books and the presence of numerous computer Web sites containing information about Zheng He show the timeliness of the subject, and give hope that more information on a neglected figure in Chinese and world history will be forthcoming.

ISSUE 15

Did Martin Luther's Reforms Improve the Lives of European Christians?

YES: Robert Kolb, from *Martin Luther as Prophet, Teacher, Hero: Images of the Reformer, 1520–1620* (Baker Books, 1999)

NO: Hans Küng, from *Great Christian Thinkers*, trans. John Bowden (Continuum, 1996)

ISSUE SUMMARY

YES: Religion and history professor Robert Kolb contends that Martin Luther was seen as a prophetic teacher and hero whose life brought hope, divine blessing, and needed correctives to the Christian church.

NO: Theologian and professor emeritus of theology Hans Küng views Martin Luther as the inaugurator of a paradigm shift and as the unwitting creator of both bloody religious wars and an unhealthy subservience by ordinary Christians to local rulers in worldly matters.

When Martin Luther was born in 1483, his father, Hans, hoped the boy would become a lawyer. Instead, a mystical experience during a thunderstorm led Martin to enter religious life as an Augustinian monk. Scrupulous in observing his religious duties, Luther became increasingly aware of his own sinfulness and his fear of divine justice. He came to believe that fallen humans, on their own, can never do anything to merit salvation; it is the grace of God alone that "justifies" them.

Sent by his order to teach philosophy at the University of Wittenberg, Luther was appalled at the selling of indulgences (pardons for sins) and denounced the practice, along with other abuses, in 95 theses of protest addressed to the Archbishop of Mainz in 1517. The newly invented printing press spread his ideas throughout the German states and beyond. Summoned to appear before the Imperial Diet at Worms in 1521, Luther clung to his beliefs, displeasing the emperor and earning himself a condemnation. Hidden from danger by his patron, the Elector Frederick of Saxony, Luther translated the Bible into German, unaware that he had launched a radical religious revolution.

Eager for reform rather than revolution, Luther sought to modify what he regarded as abuses within the Christian church. His intention was to strip the modern church of power and corruption and return it to its roots—the pristine days of early Christianity (see Issue 6 for another look at this period). Certainly he had no intention of founding a new religion. This theological conservatism was matched by his opposition to the Peasants' Revolt of 1524–1525. Siding emphatically with the forces of law and order, Luther urged the princes to put down the rebellion and safeguard the God-given social order. In many ways, he was a reluctant revolutionary.

Lutherans (as they called themselves against Luther's wishes) gathered to read the scriptures in their own language, sing, pray, and listen to sermons. Widespread anticlerical feeling inspired many to challenge the wealth and influence of what they saw as an Italian church. Luther's religious alternative was also attractive to those whose feeling of national pride in the semi-autonomous German states made them resent pronouncements from Rome. Violent conflict between Protestant princes and imperial Catholic forces broke out during Luther's lifetime, and people were instructed to follow the religion of their local prince—Lutheran or Catholic.

Luther married a former nun, Katherine von Bora, and fathered a number of children. Living a family life, like those in his congregation, rather than observing the Catholic requirement for celibacy, Luther may have seemed more approachable than the Catholic priests. Insisting on "the priesthood of all believers," he urged his followers to read the scriptures for themselves and find the truth within them. But as the Reformation spread to Switzerland, England, and beyond, thousands died in religious conflicts, and Christianity became increasingly fragmented. At the time of Luther's death in 1546, much of Western Europe was dissolving centuries-old ties that had bound people and nations into a spiritual and temporal unity called Christendom.

If we admit that reform was needed, the next question becomes, Was the reform movement initiated by Luther worth the theological, political, and, especially, human cost? For Robert Kolb, Luther was filled with the dynamism that sprang from his spiritual conviction. Regarded as divinely called to a holy mission, Luther was able to inspire others to an intense, personal relationship with the God of history and the redeemer of human frailty and despair. Luther's writings continued to inspire hope during the troubled century that followed his death.

Hans Küng asserts that Luther has the New Testament on his side in support of the key Reformation concepts of justification, grace, and faith. Also, Luther was a charismatic reformer, without whom there would have been no Reformation in Germany. Having broken with the distant authority of Rome, however, Luther was faced with challenges from both "enthusiasts" on the left and "traditionalists" on the right. Religious wars divided territories into those practicing the "old faith" and those following the reformist "Augsburg Confession." Far from guaranteeing freedom of religion, this division led instead to religion by region. Luther's doctrine of state and church as two realms led, unfortunately, to the subordination of churches to their local princes, who acted as "emergency bishops," and not all of whom were like Frederick "the wise."

Robert Kolb

 YES

Martin Luther as Prophet, Teacher, Hero

Introduction

In an attack published in 1529, Johannes Cochlaeus, Martin Luther's fierce foe and first biographer, characterized the Reformer as having seven heads. Throughout the almost five centuries since then, Luther has been depicted by friend and foe alike as having many more than seven faces. The image makers of his own age began immediately to project into public view a picture which reflected their experience of Luther. Their successors have taken the raw material of his life and thought and cast it into forms which would serve their own purposes—with varying degrees of historical accuracy. Few public figures have enjoyed and suffered the process of publicity as has Martin Luther.

Most ages seize historical personalities as clay from which they mold icons of mythical proportions to embody their values and aspirations. Into the apocalyptically charged atmosphere of late medieval Germany stumbled Martin Luther, whose career coincided with the invention of the medium of print. At the outset of his career, historical and religious conditions, medium, and man came together in a unique manner to begin fashioning a public persona which soon loomed larger than life over the German and western European ecclesiastical landscape. Read in the streets of towns and discussed in the taverns of villages, his own publications and the representations of his thought and person by other pamphleteers produced a cultural paragon which his followers in the sixteenth century put to use in several ways.

In the conclusion to his pioneering assessment of the changing views about the Reformer from Wittenberg, Horst Stephan observed that new images of Luther are always "born out of a new encounter with the testimony of the original image, and they are reflections of his form in water of different depths and different hues." To a degree perhaps unique in the history of the church since the apostolic age, the image of this single person, Martin Luther, has directly shaped the institutions and life of a large body of Christendom. He has influenced his followers both as churchman and as teacher of the church. Calvinist churches, of course, look to John Calvin as model and magister for their ecclesiastical life. John Wesley exercises a continuing role in the Methodist churches. To a far greater extent, however, Lutheran churches have found in

Luther not only a teacher but also a prophetic hero and authority. Heinrich Bornkamm's observation extends beyond the borders of the German cultural realm which he was sketching: "Every presentation and assessment of Luther and the Reformation means a critical engagement with the foundations of our more recent history. Like no other historical figure, that of Luther always compels anew a comprehensive reflection on the religious, spiritual, and political problems of our lives."

Since Stephan's study others have examined the interpretation of Luther's thought and work both within and outside Lutheranism. None of these, however, has focused in detail on the ways in which Luther's image and thought shaped Lutheran thinking and action during the century following his appearance on the stage of Western history. From the very beginning Luther's students and friends regarded him as a figure of more than normal proportions. Some saw him as an illustrious hero of the faith. Others regarded him as a powerful doctor of the church in line with Moses, Paul, and Augustine. Many also regarded him as a unique servant of God, a prophet and the eschatological angel who is depicted in Revelation 14 as the bearer of the gospel in the last days and whose authority could be put to use in governing and guiding the church, particularly in the adjudication of disputes over the proper and correct understanding of biblical teaching.

Without taking into account the conceptual framework of biblical humanism on the one hand, and that of late medieval apocalyptic on the other, such images seem strange to us moderns. Within the context of Luther's time, however, they provided vehicles by which people could make sense of Luther's impact on their lives and his role on the stage of human history. With such images of Luther in mind his followers set about to reshape the institutions and ideas which held their world together.

This inquiry will review how Luther's message and his career reshaped sixteenth-century German Lutherans' views of God and human history. Three conceptions of the Reformer emerge, reflecting a variety of needs in his society, which was organized around religious ideas and ecclesiastical institutions and practices. Although all three of these conceptions appeared in the first few years of public comment on Luther, they developed in different ways as the years passed. Their influence can best be presented through a chronological tracking of their evolution as exhibited in representative writings from the pens of his disciples. To be sure, historians' analyses always oversimplify: the categories are not so distinct and discrete that they can be neatly separated from each other. Thus our discussion of each motif will reveal aspects of the others.

First, for some of his followers during the subsequent decades, the Reformer functioned as a prophet who replaced popes and councils as the adjudicating or secondary authority (interpreting the primary authority, Scripture) in the life of the church. Like almost every age, the late Middle Ages were a period of crisis, and people were rethinking questions of authority in various aspects of life. Within the church Luther's challenge to the medieval papacy heightened the crisis by confirming doubts about the old religious system. Although Luther and his adherents did not discard the ancient fathers of the church nor disregard their usefulness, they did affirm the primacy of biblical authority; for

them Scripture was the sole primary source of truth. The church, however, always needs a more elaborate system of determining the meaning of the biblical message; and the tradition, in the hands of popes, bishops, and councils, could no longer suffice to adjudicate differences in interpretation of the Scripture. To replace the medieval authorities who had interpreted biblical dicta regarding truth and life, Luther emerged as a prophet of God in whose words a secondary level of doctrinal authority could be found. Those who believed that this Wittenberg professor was God's special agent—a voice of divine judgment upon the corruption of the old system—were able to ascribe such authority to him without difficulty. When the living myth had disappeared into his tomb, and could no longer adjudicate disputes by composing letters or formal faculty opinions, his writings—widely available in print—were used as a secondary authority by some of his disciples.

Second, over the years Luther functioned as a prophetic teacher whose exposition of the biblical message supported and guided the biblical exposition of his followers. Luther based his perception of life and truth upon his conviction that God has spoken reality into existence and shaped human life through his world. Teaching—the content of the Word—thus was paramount in Luther's conception of the way in which God came to people in the sixteenth century and functioned as their God. While the Reformer was still alive and writing, his vast literary output enabled him to influence a broad circle of readers and of non-readers who heard his ideas from them. When he died, his adherents continued to learn and to teach others through the published corpus of his thought. In elaborating Luther's role as teacher, we must pay attention to the ways in which his writings were reproduced and used in the Lutheran churches of Germany after his death. For his heirs not only reprinted his complete corpus and individual treatises in it; they also repackaged and organized Luther's thought topically for handy reference in the pastor's library. In this manner Luther continued his teaching activity after his death through citations, reprintings, and the organizing of his thought for consumption in a new era.

Third, for his German followers Luther remained above all a prophetic hero whom God had chosen as a special instrument for the liberation of his church—and of the German people—from papal oppression and deceit. As a heroic prophet, Luther symbolized the divine Word which brought God's judgment upon the old papal system, and he embodied the hopes of the people and the comfort of the gospel which brought new heavenly blessings upon the faithful children of God. In their troubled times his followers saw in Martin Luther the assurance that God would judge their enemies and intervene eschatologically on their behalf with the salvation he had promised....

Conclusion

Theander Luther

Five hundred years after his birth Martin Luther continues to engage and fascinate those who encounter him. The testimony of his biography and his writings continues to cast "reflections of his form in water of different depths and

hues," as Horst Stephan commented nearly a century ago. Modern scholars have formed their own judgments of Luther and have put his thoughts to their own use on bases different from those that motivated his contemporaries. Apt is Mark Edwards's observation that twentieth-century accounts often give a false representation of sixteenth-century perceptions, "not because the historian knows too little but because the historian knows too much." This is the case because historians have a view "from above"—a more comprehensive view of Luther's context, of his impact, even of the corpus of his writings—a view which none of Luther's contemporaries, nor Luther himself, could have had. For instance, as Edwards observes, "we forget that, except perhaps for a few of Luther's students, no contemporary read Luther's works in light of his pre-Reformation lectures on Psalms, Galatians, and Romans." In fact, the few who had read manuscript notes on these lectures preferred his later works, which more reflected what they had heard from him.

On the other hand, when modern historians come to what Luther wrote and wrought, they do not bring the yearnings and longings shaped by the spirit of medieval apocalyptic nor the humanistic adventure of return to the sources. Instead, we bring our own conceptual framework and our own questions and goals to the texts and story of Martin Luther. Further, it is impossible to return to the pristine sources of the 1510s, 1520s, and 1530s uninfluenced by the interpretations of Luther forged by his students and contemporaries and those who followed them in the succeeding two generations.

From the perspective of the sixteenth century, Luther had seven heads or more. To a remarkable if not unique degree this monk and professor became a fixation for foes and friends alike. Whatever the reasons (as assessed by twentieth-century scholars) may have been, this widespread fixation developed less on the strength of political power or economic resources or social status than on the strength of his ideas and through the public presentation and projection of these ideas. His disciples perceived him to be an authoritative prophet or an insightful teacher or a national and cultural hero, or one who combined two or all of these roles.

As Luther's supporters praised him by recounting his heroic deeds or by repeating his insightful instruction or by putting his image and ideas to use in the life of church and society, they inevitably cast the raw material of his life into forms dictated by the challenges and concerns of their own times. Around 1520 a host of images were marshaled to describe this prophetic figure. In the first decade of his emergence in public he was seen as an authority for determining the proper exposition of biblical truth, the new teacher of the church for the last times, and a hero who would end papal tyranny. All three representations of the Wittenberg professor continued to be in vogue throughout his life and in the years immediately after his death. Gradually, however, his role as adjudicatory authority, which was transferred from his person to his writings, appeared ever less able to serve effectively as a means of deciding and defining public teaching. The national hero he remained, ever more simplified and stylized but not less important because of that, particularly as the shadow of the Counter-Reformation grew heavier over evangelical Germany. His role as teacher continued as well, albeit in limited and adapted form. Changing times

meant changing use of the individual who had been thought to personify the message of God and to satisfy the longings of the people.

Not all of Luther's followers put him to use as a substitute for popes and councils, as a secondary authority who could adjudicate disputes over the gospel and the practice of the church. Many did, for the church always needs such a secondary authority. The conviction that the papacy was Antichrist and that councils and the Fathers were fallible produced a crisis of authority in the churches of the Reformation. Among Luther's followers biblical authority prevailed unchallenged as the primary authority for determining truth in the presentation of the gospel. The Fathers and councils had also schooled the thinking of the Wittenberg disciples, although they reckoned with the possibility of errors in patristic and conciliar writings and thus dismissed them as secondary authorities. Accordingly, some certain standard for adjudication of disputes over the interpretation of the biblical message was needed.

Luther's prophet-like appearance on the late medieval scene and his own dynamic concept of the Word of God—as it is repeated in the mouths of living speakers of the biblical message—prompted his contemporaries to attribute adjudicatory authority to him. Medieval apocalyptic hopes and humanist convictions regarding the power of effective oral communication combined with his own understanding of the power of God in the living voice of the gospel to create a belief that he was a special tool of God. As such, it was believed, he spoke God's word of condemnation against the deceiving tyrants of the papal system and announced God's word of grace and mercy in Jesus Christ, and he did so with an authority which he had received along with the gift of clear interpretation of the biblical message. But even while he lived, appeals to his authority were restricted to those circles that accepted him as God's authoritative prophet for the latter day. Furthermore, once he died and could no longer directly apply God's Word to current situations, and the church had to rely on the written works he had left behind, it ceased to be practical—and possible— to regard him as a secondary, adjudicatory authority in the church. The written corpus was too bulky. It contained contradictions. It became politically delicate to emphasize Luther so strongly.

The negative side of Luther's proclamation—in defense of the gospel and in opposition to papal oppression—had made him a hero of Herculean proportions to his contemporaries around 1520; and a hero for nation and people, for freedom and humanity, he remained, particularly as the Roman Catholic prelates and princes became increasingly aggressive and the political tensions within the empire mounted—culminating in the Thirty Years' War. In the following centuries, pressed into a variety of images and forms by the governments of divine-right monarchies and by fans of the Enlightenment, by theologians of diverse perspectives and by politicians of various ideologies, Luther's persona continued to prove itself a useful symbol—a hero of one kind or another —even when his authority and indeed his theology were rejected by his partisans. More often than not, misunderstanding of the hero—occasionally perhaps deliberate, often innocent—separated the historical figure of the Reformer from the Luther myths created ever anew for some purpose or another.

Luther has found enduring use as a teacher of the church as well. To a remarkable extent his thought continued to determine the agenda of theological discussion in many parts of Christendom in succeeding generations. Those who claimed his name could not escape addressing the emphases of his theology—justification, the Word of God as means of grace, the authority of Scripture, the nature and effect of the sacraments, to name but a few of his doctrinal accents. Nonetheless, from the beginning his followers' understanding of his teaching was influenced by the medieval heritage which continued to echo through the minds of his contemporaries, by the agenda of polemic set by his foes as well as his friends, by their individual pastoral or professorial concerns, and by the method and theology of his Wittenberg colleague Philip Melanchthon. Melanchthon's practice of theology schematized the thinking of students into the forms dictated by the loci method, and they could recognize no alternative to placing Luther's thought into these Melanchthonian forms.

The dogmatic tradition which ran from Melanchthon through Martin Chemnitz's commentary on his *Loci communes theologici* to Johann Gerhard and the dogmatic works of Lutheran orthodoxy became the standard expression of what Lutherans believed and taught. Other sources may have shaped preaching, catechetical instruction, and pastoral care, but the conceptual framework into which graduates of Lutheran theological faculties placed materials from Luther's pen and the pens of other theologians came from the Melanchthonian dogmatic tradition. Modern scholars may express chagrin or regret over this fact; indeed, they may find Luther more refreshing or relevant than the works of his followers. But his epigones did fulfil the calling of all theologians: they applied the biblical message and the tradition of their church to the lives of their parishioners in their own generation. And however they may have adapted Luther, they adopted what they understood the heart of his message to be, even if from later perspectives they may have sacrificed too much of its peculiar insights.

... [T]hat the hero Luther could be honored and celebrated by being cited in formulaic ways made it unnecessary for young pastors to read his writings and glean the fullness of his unique exposition of the biblical message. The dynamic of his homiletical teaching was placed into forms which limited the ways in which Luther could continue to teach his church. The sermonic ways in which he treated and conveyed the biblical message were set aside. The full scope of his teaching was channeled for the usage of a new day.

Indeed, Luther's teaching for the early sixteenth century needed to be reshaped and readdressed to changing patterns of church life and new issues as well as old. In the course of that inevitable process the vigor and vitality of the prophetic teacher were tamed even as the content of his teaching was preserved within the forms which his followers found useful for conveying his message in their generations. At the outset of the seventeenth century Luther continued to teach, particularly through the most practical of his writings: the postils and the commentaries which could aid preaching, his catechisms, his devotional meditations. His followers regarded him as the greatest of their teachers even if they received his teaching through a grid constructed by others, above all Philip Melanchthon. Luther's prophetic authority as a substitute

for popes and councils in adjudicating disputes over the biblical message had waned. Although its memory echoed through certain expressions of praise during the closing decades of the sixteenth century and the opening years of the seventeenth, the Book of Concord had become the secondary authority for a majority of Lutheran churches. The authority of Luther's person, and then the corpus of his writings, had been replaced by the authority of his church's confessional documents. Even those images which had given substance to the claim for his authority—above all, angel of the apocalypse and prophet—were by the end of the sixteenth century no longer used as grounds on which to justify his adjudication of doctrinal differences or to define public teaching, but were used instead to focus attention on his heroic deeds of resistance to papal oppression, deeds out of which the new and final revelation of the gospel had appeared.

Nonetheless, the vibrant interest in Luther's person and career, as well as the availability of much of the corpus of his writings, ensured that his voice continued to inform and form the faith and the life of the people of his church. Even though the extravagant appraisal of his contemporaries had been tamed, for most Lutherans of the early modern period this prophet and teacher loomed over their lives as a unique hero of the faith and of God's Word.

NO ⬅

Hans Küng

Martin Luther: Return to the Gospel as the Classical Instance of a Paradigm Shift

Why There Was a Lutheran Reformation

Hardly a single one of Luther's reform concerns was new. But the time had not been ripe for them. Now the moment had come, and it needed only religious genius to bring these concerns together, put them into words and embody them personally. Martin Luther was the man of the moment.

What had been the preparation for the new paradigm shift in world history immediately before the Reformation? Briefly:

- the collapse of papal rule of the world, the split in the church between East and West, then the twofold, later threefold, papacy in Avignon, Rome and Pisa along with the rise of the nation states of France, England and Spain;
- the lack of success by the reform councils (Constance, Basal, Florence, Lateran) in 'reforming the church, head and members';
- the replacement of the natural economy by a money economy, the invention of printing and the widespread desire for education and Bibles;
- the absolutist centralism of the Curia, its immorality, its uncontrollable financial policy and its stubborn resistance to reform, and finally the trade in indulgences for rebuilding St Peter's, which was regarded in Germany as the pinnacle of curial exploitation.

However, even north of the Alps, as a result of the Roman system, some of the abuses were quite blatant:

- the retrograde state of church institutions: the ban on levying interest, the church's freedom from taxation and its own jurisdiction, the clerical monopoly of schools, the furthering of beggary, too many church festivals;
- the way in which church and theology were overgrown with canon law;
- the growing self-awareness of university sciences (Paris!) as a critical authority over against the church;

From Hans Küng, *Great Christian Thinkers,* trans. John Bowden (Continuum, 1996). Translated by John Bowden from the German *Grosse Christliche Denker* copyright © 1994 by R. Piper GmbH & Co. KG. Translation copyright © 1994 by John Bowden. Reprinted by permission of The Continuum International Publishing Group, Inc. Notes omitted.

- the tremendous secularization even of the rich prince bishops and monasteries; the abuses caused by the pressure towards celibacy; the proletariat, which comprised far too many uneducated and poor people;
- the radical critics of the church: Wycliffe, Hus, Marsilius, Ockham and the Humanists;
- finally a terrifying superstition among the people, a religious nervousness which often took enthusiastic-apocalyptic forms, an externalized liturgy and legalized popular piety, a hatred of work-shy monks and clerics, a malaise among the educated people in the cities and despair among the exploited peasants in Germany... All in all this was an abysmal crisis for mediaeval theology, church and society, coupled with an inability to cope with it.

So everything was ready for an epoch-making paradigm shift, but there was need of someone to present the new candidate for a paradigm credibly. And this was done by a single monk, in the epoch-making prophetic figure of Martin Luther, who was born on 10 November 1483 in Eisleben in Thuringia. Although as a young monk and doctor of theology Luther certainly did not understand himself primarily as a prophet but as a teacher of the church, intuitively and inspirationally he was able to meet the tremendous religious longing of the late Middle Ages. He purged the strong positive forces in mysticism, and also in nominalism and popular piety, confidently centred all the frustrated reform movements in his brilliant personality, which was stamped with a deep faith, and expressed his concerns with unprecedented eloquence. Without Martin Luther there would have been no Reformation in Germany!

The Basic Question: How Is One Justified Before God?

But when did things get this far? As a result of acute fear of death during a violent thunderstorm and constant anxiety about not being able to stand in the final judgment before Christ, at the age of twenty-two, in 1505, Luther had entered a monastery against the will of his father (who was a miner and smelter by trade). But when did the Augustinian monk who loyally obeyed the rules and was concerned for righteousness by works become the ardent Reformer of 'faith alone'? Historians argue over the precise point in time of the 'breakthrough to the Reformation'.

Be this as it may, there is no disputing the fact that Martin Luther, who had a very similar scholastic training in philosophy and theology to Thomas Aquinas, was in deep crisis over his life. Being a monk had not solved any of his problems, but had accentuated many of them. For the works of monastic piety like choral prayer, mass, fasting, penitence, penance to which Luther submitted himself with great earnestness as an Augustine eremite could not settle for him the questions of his personal salvation and damnation. In a sudden intuitive experience of the gracious righteousness of God (if we follow the 'great testimony' of 1545), but presumably in a somewhat longer process (if we look

at his earlier works more closely), in his crisis of conscience a new understanding of the justification of the sinner had dawned on Luther. Whenever precisely the 'breakthrough to the Reformation' took place (more recent scholarship is predominantly for a 'late dating' to the first half of 1518), the 'shift to the Reformation' happens here.

So the starting point of Luther's reforming concern was not any abuses in the church, not even the question of the church, but the question of salvation: how do human beings stand before God? How does God deal with human beings? How can human beings be certain of their salvation by God? How can sinful human beings put right their relationship with the just God? When are they justified by God? Luther found the answer above all in Paul's Letter to the Romans: human beings cannot stand justified by God, be justified by God, through their own efforts—despite all piety. It is God himself, as a gracious God, who pronounces the sinner righteous, without any merits, in his free grace. This is a grace which human beings may confidently grasp only in faith. For Luther, of the three theological virtues faith is the most important: in faith, unrighteous sinful human beings receive God's righteousness.

That was the decisive theological factor. But there was a second one: starting from a new understanding of the event of justification Luther hit upon a new understanding of the church. This was a radical criticism of a secularized and legalized church which had deviated from the teaching and praxis of the gospel, and of its sacraments, ministries and traditions. But in this criticism had not Luther broken completely with the Catholic tradition? With his understanding of justification was he not *a priori* un-Catholic? To answer this question, for all the discontinuity one must also see the great continuity between Luther and the theology which preceded him. . . .

Where Luther Can Be Said to Be Right

Does Luther have the New Testament behind him in his basic approach? I can venture an answer which is based on my previous works in the sphere of the doctrine of justification. In his basic statements on the event of justification, with the 'through grace alone', 'through faith alone', the 'at the same time righteous and a sinner', Luther has the New Testament behind him, and especially Paul, who is decisively involved in the doctrine of justification. I shall demonstrate this simply through the key words:

- 'Justification' according to the New Testament is not in fact a process of supernatural origin which is understood physiologically and which takes place in the human subject, but is the verdict of God in which God does not impute their sin to the godless but declares them righteous in Christ and precisely in so doing makes them really righteous.
- 'Grace' according to the New Testament is not a quality or disposition of the soul, not a series of different quasi-physical supernatural entities which are successively poured into the substance and faculties of the soul, but is God's living favour and homage, his personal conduct as

made manifest in Jesus Christ, which precisely in this way determines and changes people.

- 'Faith' according to the New Testament is not an intellectualist holding truths to be true but the trusting surrender of the whole person to God, who does not justify anyone through his or her grace on the basis of moral achievements but on the basis of faith alone, so that this faith can be shown in works of love. Human beings are justified and yet always at the same time (*simul*) sinners who constantly need forgiveness afresh, who are only on the way to perfection. . . .

The Problematical Results of the Lutheran Reformation

The Lutheran movement developed a great dynamic and was able to spread powerfully not only in Germany but beyond, in Lithuania, Sweden, Finland, Denmark and Norway. Parallel to the events in Germany, in Switzerland, which had already begun to detach itself from the empire since the middle of the fifteenth century, an independent, more radical form of Reformation had been established by Ulrich Zwingli and later Jean Calvin which, with its understanding of the church, was to make more of an impact than Lutheranism in both the old world and the new. But it was Luther himself at any rate who in the 1520s and 1530s succeeded in establishing the Reformation movement within Germany.

Indeed, Germany had split into two confessional camps. And in view of the threat to the empire from the Turks, who in 1526 had defeated the Hungarians at Mohács and in 1529 had advanced as far as Vienna, Luther had even asked which was more dangerous for Christianity, the power of the papacy or the power of Islam; he saw both as religions of works and the law. At the end of his life Luther saw the future of the Reformation churches in far less rosy terms than in the year of the great breakthrough. Indeed in the last years of his life, although he was indefatigably active to the end, Luther became increasingly subject, on top of apocalyptic anxieties about the end of the world and illnesses, to depression, melancholy, manic depressions and spiritual temptations. And the reasons for this growing pessimism about the world and human beings were real—not just psychological and medical. He was not spared great disappointments.

First, the original Reformation enthusiasm soon ran out of steam. Congregational life often fell short of it; many who were not ready for the 'freedom of a Christian' also lost all church support with the collapse of the Roman system. And even in the Lutheran camp, many people asked whether men and women had really become so much better as a result of the Reformation. Nor can one overlook an impoverishment in the arts—other than music.

Secondly, the Reformation was coming up against growing political resistance. After the inconsequential Augsburg Reichstag of 1530 (the emperor had 'rejected' the conciliatory 'Augsburg Confession' which Melanchthon had the main part in drafting), in the 1530s the Reformation was able at first not only to consolidate itself in the former territories, but also to extend to further areas,

from Württemberg to Brandenburg. But in the 1540s the emperor Charles V, overburdened in foreign politics and at home constantly intent on mediation, had been able to end the wars with Turkey and France. Since the Lutherans had refused to take part in the Council of Trent (because it was under papal leadership: Luther's work *Against the Papacy in Rome, Founded by the Devil*, 1545), the emperor finally felt strong enough to enter into military conflict with the powerful Schmalkald League of Protestants. Moreover the Protestant powers were defeated in these first wars of religion (the Schmalkald wars, 1546/47), and the complete restoration of Roman Catholic conditions (with concessions only over the marriage of priests and the chalice for the laity) seemed only a matter of time. It was only a change of sides by the defeated Moritz of Saxony—he had made a secret alliance with France, forced the emperor to flee through a surprise attack in Innsbruck in 1522, and so also provoked the interruption of the Council of Trent—which saved Protestantism from disaster. The confessional division of Germany between the territories of the old faith and those of the 'Augsburg Confession' was finally sealed by the religious peace of Augsburg in 1555. Since then what prevailed was not religious freedom, but the principle *cuius regio, eius religio*, i.e. religion went with the region. Anyone who did not belong to either of the 'religions' was excluded from the peace.

Moreover, the Protestant camp itself was unable to preserve unity. At a very early stage Protestantism in Germany split into a 'left wing' and a 'right wing' of the Reformation.

The Split in the Reformation

Luther had roused the spirits, but there were some that he would only get rid of by force. These were the spirits of enthusiasm, which while certainly feeding on mediaeval roots, were remarkably encouraged by Luther's emergence. A great many individual interests and individual revolts began to spread under the cloak of Luther's name, and soon Luther found himself confronted with a second, 'left-wing' front. Indeed Luther's opponents on the left (enthusiastic turmoil, riots and an iconoclastic movement as early as 1522 in his own city of Wittenberg!) were soon at least as dangerous for his enterprise of Reformation as his right-wing opponents, the traditionalists orientated on Rome. If the 'papists' appealed to the Roman system, the 'enthusiasts' practised an often fanatical religious subjectivism and enthusiasm which appealed to the direct personal experience of revelation and the spirit ('inner voice', 'inner light'). Their first agitator and Luther's most important rival, the pastor Thomas Münzer, combined Reformation ideas with ideas of social revolution: the implementation of the Reformation by force, if need be with no heed to existing law, and the establishment of the thousand-year kingdom of Christ on earth!

But Luther—who politically was evidently trapped in a view 'from above' and has been vigorously criticized for that from Thomas Münzer through Friedrich Engels to Ernst Bloch—was not prepared to draw such radical social conclusions from his radical demand for the freedom of the Christian and to support with corresponding clarity the legitimate demands of the peasants (whose independence was manifestly threatened and increasingly exploited)

against princes and the nobility. Despite all the reprehensible outbursts, were not the demands of the peasants also quite reasonable and justified? Or was it all just a misunderstanding, indeed a misuse, of the gospel? Luther, too, could not deny the economic and legal distress of the peasants.

But a plan for reform would by no means *a priori* have been an illusion. Why not? Because the democratic order of the Swiss confederacy, for the peasants of southern Germany the ideal for a new order, could have been a quite viable model. However, all this was alien to Luther, trapped in his Thuringian perspective and now with his conservative tendencies confirmed. Horrified by news of the atrocities in the peasant revolts, he fatally took the side of the authorities and justified the brutal suppression of the peasants.

The Freedom of the Church?

As well as the left-wing Reformation there was the right wing. And here we must note that the ideal of the free Christian church, which Luther had enthusiastically depicted for his contemporaries in his programmatic writings, was not realized in the German empire. Granted, countless churches were liberated by Luther from the domination of secularized bishops who were hostile to reform, and above all from 'captivity' by the Roman Curia, from its absolutist desire to rule and its financial exploitation. But what was the result?

In principle Luther had advocated the dotrine of state and church as the 'two realms'. But at the same time, in view of all the difficulties with Rome on the one hand and with enthusiasts and rebels on the other, he assigned to the local rulers (and not all of them were like Frederick 'the Wise') the duty of protecting the church and maintaining order in it. As the Catholic bishops in the Lutheran sphere had mostly left, the princes were to take on the role of 'emergency bishops'. But the 'emergency bishops' very soon became 'summepiscopi' who attributed quasi-episcopal authority to themselves. And the people's Reformation now in various respects became a princes' Reformation.

In short, the Lutheran churches which had been freed from the 'Babylonian captivity' quickly found themselves in almost complete and often no less oppressive dependence on their own rulers, with all their lawyers and church administrative organs (consistories). The princes who even before the Reformation had worked against peasants and citizens for the internal unification of their territories (which had often been thrown together haphazardly) and a coherent league of subjects had become excessively powerful as a result of the secularization of church land and the withdrawal of the church. The local ruler finally became something like a pope in his own territory.

No, the Lutheran Reformation did not directly prepare the way (as is so often claimed in Protestant church historiography) for the modern world, freedom of religion and the French revolution (a further epoch-making paradigm shift would be necessary for this), but first of all for princely absolutism and despotism. So in general, in Lutheran Germany—with Calvin, things went otherwise—what was realized was not the free Christian church but the rule of the church by princes, which is questionable for Christians; this was finally to come to a well-deserved end in Germany only with the revolution after the

First World War. But even in the time of National Socialism, the resistance of the Lutheran churches to a totalitarian regime of terror like that of Hitler was decisively weakened by the doctrine of two realms, by the subordination of the churches to state authority which had been customary since Luther, and the emphasis on the obedience of the citizen in worldly matters. It can only be mentioned in passing here that in the sermons before his death Martin Luther had spoken in such an ugly and un-Christian way against the Jews that the National Socialists did not find it difficult to cite him as a key witness for their hatred of Jews and their antisemitic agitation. But these were not Luther's last words, nor should they be mine.

I would like to close with three great statements which are utterly characteristic of Luther.

First, the dialectical conclusion of his work 'The Freedom of a Christian': 'We conclude, therefore, that a Christian lives not in himself, but in Christ and in his neighbour. Otherwise he is not a Christian. He lives in Christ through faith, in his neighbour through love. By faith he is caught up beyond himself into God. By love he descends beneath himself into his neighbour. Yet he always remains in God and in his love ... As you see, it is a spiritual and true freedom and makes our hearts free from all sins, laws and commands. It is more excellent than all other liberty which is external, as heaven is more excellent than earth. May Christ give us liberty both to understand and to preserve.'

Then Luther's summary plea before the emperor and the Reichstag at Worms: 'Unless I am convinced by the testimony of the Scriptures or by clear reason (for I do not trust either in the Pope or in councils alone, since it is well known that they have often erred and contradicted themselves), I am bound by the Scriptures I have quoted and as my conscience is captive to the Word of God, I cannot and I will not retract anything, since it is neither safe nor right to go against the conscience. God help me. Amen.'

And finally, the last thing that Luther wrote: 'Nobody can understand Virgil in his *Eclogues* and *Georgics* unless he has first been a shepherd or a farmer for five years. Nobody understands Cicero in his letters unless he has been engaged in public affairs of some consequence for twenty years. Let nobody suppose that he has tasted the Holy Scriptures sufficiently unless he has ruled over the churches with the prophets for a hundred years. Therefore there is something wonderful, first, about John the Baptist; second, about Christ; third, about the apostle. "Lay not your hand on this divine Aeneid, but bow before it, adore its every trace." We are beggars. That is true.'

POSTSCRIPT

Did Martin Luther's Reforms Improve the Lives of European Christians?

For centuries after his death, Luther was either effusively praised or roundly condemned. Evangelicals extolled his reforms, whereas Catholics villified him for destroying the unity of Christianity. But passions have cooled, and an ecumenical spirit has taken the place of religious bickering. Thus, we are beginning to see more balanced accounts of Luther's life and work that credit him with bringing about needed reforms while acknowledging his personal and professional failings.

Roland Bainton's acclaimed biography *Here I Stand: A Life of Martin Luther* (Abingdon, 1950) is a good place to begin understanding this complex reformer. Bainton profiles Katherine von Bora and other women in *Women of the Reformation in Germany and Italy* (Augsburg Fortress Publishers, 1971). Jonathan W. Zophy's *A Short History of Renaissance and Reformation Europe: Dances Over Fire and Water,* 2d ed. (Prentice Hall, 1998) covers cultural, economic, religious, political, and social developments and includes gender as a significant subject for historical analysis.

Other biographies include Heiko Oberman's *Luther: Man Between God and the Devil* (Yale University Press, 1989) and Eric Gritsch's *Martin—God's Court Jester: Luther in Retrospect* (Augsburg Fortress Publishers, 1983). The latter title reflects Luther's name for himself—the sometimes-mocked instrument of God's will on earth—and contains an excellent historiographic chapter entitled "God's Jester Before the Court of History." Perhaps the most respected work is Martin Brechts' three-volume biography *Martin Luther,* translated by James L. Schaaf (Fortress Press, 1985). Richard Marius's *Martin Luther: The Christian Between God and Death* (Belknap Press, 1999) laments the carnage that resulted from Luther's reforms.

For background about the times that produced Luther and other reformers, Vivian Gren's *The European Reformation* (Sutton Publishing Limited, 1998) offers a helpful time line of dates and suggestions for further reading. Its opening chapter "The Medieval Background" sets the context for Luther, Zwingli, the English Reformation, and Calvin, which are discussed more extensively in later chapters. A massive collection of Luther's writings is available in the 55-volume *Luther's Works,* edited by Helmut Lehman and Jaroslav Pelikan (Concordia and Fortress Presses, 1955–1975).

Finally, the German political situation is discussed in Bob Scribner and Gerhard Benecke, eds., *The German Peasant War, 1525* (Humanities Press, 1991), which has an excellent collection of well-introduced primary source materials.

ISSUE 16

Were European Witch-Hunts Misogynistic?

YES: Anne Llewellyn Barstow, from "On Studying Witchcraft as Women's History: A Historiography of the European Witch Persecutions," *Journal of Feminist Studies in Religion* (Fall 1988)

NO: Robin Briggs, from *Witches and Neighbors: The Social and Cultural Context of European Witchcraft* (Penguin Books, 1998)

ISSUE SUMMARY

YES: History professor Anne Llewellyn Barstow asserts that the European witch-hunt movement made women its primary victims and was used as an attempt to control their lives and behavior.

NO: History professor Robin Briggs states that although women were the European witch-hunts' main victims, gender was not the only determining factor in this socio-cultural movement.

Virgins and whores, goddesses and devils, mystics and conjurers—historically, women have been perceived as "troublesome creatures." Their very existence has often been seen as a threat to human society, especially with regard to their sexuality. This has resulted in constant attempts on the part of the patriarchal system, which has so dominated the course of history, to control women's lives. Sometimes this system resulted in second-class status, shattered dreams, and crushed spirits for women; other times the treatment of women was downright hostile. The witch-hunt craze of early modern Europe was one such example.

Although belief in witches and witchcraft dates back to recorded history's earliest days, the persecution of those accused reached its apex in Europe's early modern period, especially the sixteenth and seventeenth centuries. In the northern, western, and central parts of the continent, witch trials became a frightening reality, as thousands were tried and many were executed for their evil doings and "pacts with the devil." Although exact figures are not known, a moderate estimate of 200,000 people tried with half of those executed, has been offered by Anne Llewellyn Barstow. And certainly germane to this issue is the fact that 80 percent of both groups, those brought to trial and those executed, were women.

What factors caused this wave of witch hysteria? First, the Protestant Reformation created a religious uncertainty, which gave the witch-hunts a *raison d'être*. Protestants and Catholics battled for the hearts, minds, and souls of Europe's populace, and religious wars became the order of the day. *Malleus Maleficarum (A Hammer of Witches)* by Heinrich Kramer and James Sprenger, two Dominican priests, attests to the volatile religious mood of the day. Published in 1487, it describes in graphic detail the evil committed by witches, instructions on how to thwart their powers, elicit confessions, and how to punish them, all in gruesome detail. With this mindset, the witch-hunts were a predictable outcome.

In the political realm, with the growth of national states in Europe and their creation of divine-right monarchies, political orthodoxy became as important as religious orthodoxy. Both had to be enforced to keep the dynastic ship afloat. Those who deviated had to pay the price.

Social factors also entered into the witch-craze fray. Tensions between and amongst classes permeated the era and led to violent behavior usually geared to keeping the lower classes subjugated. If women had any idea of using these conditions to assert themselves, the trials and resultant executions served as brutal reminders of the power of the status quo and the lengths to which those in power would go to maintain societal control.

Of course, one cannot escape the one constant of the multicentury witch-hunts: most of the victims were women. But was gender the only factor in determining the outcome of the witch-hunts? Were women singled out for prosecution solely on the basis of their sex? Or, were there other factors—political, economic, social, legal, or local—that influenced the witch-hunts? These questions had been raised in the historical debates of previous generations, but interest was renewed in the 1960s, presumably due to the increased attention given to women's studies. This included the study of violence against women, which has reached epic proportions in the contemporary world. Were there signs of such actions against women in the past? Was the witch craze just one extreme example of violence against women?

The two selections represent the best in recent witchcraft scholarship. Barstow makes a persuasive case for gender as the key factor in determining witch-hunt outcomes. She sees this as part of a long struggle to "keep women down." Robin Briggs admits that the large preponderance of the witch-hunts' victims were women and that gender certainly was a factor in the genesis of the craze. But he favors the presence of socioeconomic, political, religious, and legal factors as better means to understanding the witch craze; after all, misogyny has been present since the beginning of time.

Anne Llewellyn Barstow

 YES

On Studying Witchcraft as Women's History

On average, witchcraft, the ultimate in human evil, was sex-related to women in much the same proportion as sanctity, the ultimate in human good, was sex-related to men.

— Christina Larner, *Witchcraft and Religion*

After years of being relegated to folkloric and esoteric studies, European witchcraft is beginning to emerge as an important chapter in early modern history. In particular, the persecutions of the sixteenth and seventeenth centuries have become the subject of scholarly attention. One might assume that the persecutions have been seen as an integral part of women's history, but that is not the case. The witch craze has been interpreted by most historians as *not* a matter of gender.

Given that over 80 percent of the victims were women, this is a surprising and, I believe, a disturbing conclusion. I will therefore examine what difference it makes when one subjects this material to the insights of women's history.

Historians have in fact interpreted the witch-craze as the result of religious upheaval, of the growth of the nation-state, of the isolation of mountain folk—of anything, in short, rather than of what women were doing or were perceived as being. When one focuses on the roles women played in early modern society, and how those roles changed in the sixteenth century, a different picture emerges. This approach enables one to see that women had served as healers, midwives, and counsellors, using an age-old combination of experience ("common sense") and magical techniques to cure and advise. Long respected for these skills, they began to be attacked for them at the end of the Middle Ages. Further, one must ask the economic question: How were women coping with the increasing gap between poor and rich that emerged in the sixteenth century? When one sees how women's basic options narrowed, then one is ready to ask about other changes in sixteenth-century society that affected them, such as legal shifts.

One must remember that European women *as a group* were first subject to criminal persecutions on witchcraft charges. Having been kept out of the

From Anne Llewellyn Barstow, "On Studying Witchcraft as Women's History: A Historiography of the European Witch Persecutions," *Journal of Feminist Studies in Religion*, vol. 4, no. 2 (Fall 1988). Copyright © 1988 by Anne Llewellyn Barstow. Reprinted by permission of the author. Notes omitted.

courts because they were seen by law as minors, women suddenly were held legally responsible for their actions, once witch allegations were made. Seen as a group of independent adults, women thus entered European legal history by being accused of witchcraft. And those accusations were heavily negative about female sexuality: women were blamed for preventing conception, causing miscarriage, abortion, and stillbirth, making men impotent, seducing men, having sex with the devil, giving birth to demons. Underlying these charges lay the fact that women healers were the authorities on sexuality, which led to a deadly professional rivalry between folk healers and priests and university-trained doctors. Added to this rivalry was the conviction that women were more strongly sexed than men, which led to deep-seated fears in some males.

I believe that the sudden rise in prosecutions for witchcraft that began in Europe c. 1560 was related in part to attempts to take away women's control of their sexual and reproductive lives. This fitted into the strongly patriarchal concept of family for which the sixteenth century is known, and into the attack by doctors on midwives and folk healers, and by Reformers, both Catholic and Protestant, on traditional sexual mores.

Although men could be arraigned on the charge of witchcraft, and were prosecuted in small numbers, the craze was aimed mostly at women: 80 percent of the accused and 85 percent of those executed were female. Men were associated with witchcraft chiefly because they were related to women who were already suspect or because they had committed other crimes. And yet, although men "qualified," women were overwhelmingly singled out. The extent of the attack on women becomes clear when we recall that 92 percent of the accused in the English county of Essex were women, and that all but two of the female inhabitants of Langendorf in the Rhineland were arrested. In twelfth-century Kiev when periodic fears of witchcraft arose, all of the old women of the area were seized and subjected to the ordeal by cold water (thrown, bound hand and foot, into the Dnieper River). Christina Larner, the analyst of Scottish witchcraft, observed that there were periods "when no mature woman in Fife or East Lothian can have felt free from the fear of accusation." Given these cases, we see that the notorious examples of the two German villages left with only one female inhabitant apiece and of Rheinback, where one person, most often female, out of every two families was put to death, are not unbelievable. Christina Larner put the question precisely when she asked, "Was witch-hunting also woman-hunting?"

<center>⋅◈⋅</center>

Despite such evidence, historians have for the most part not dealt with the persecutions as an attack on women. And yet the first major research published on witchcraft, the documents book and analysis brought out by Joseph Hansen at the turn of the century, had offered a promising beginning. Hansen recognized that women had been singled out as victims, and he gathered some of the more misogynist materials to illustrate this discrimination. Hansen's insights were not entirely lost on Wallace Notestein, who in 1911 devoted one paragraph of his study of English witchcraft to the subject. Observing that about six

times as many women were indicted as men, he concluded that "this was to be expected." Implying that by nature women would be suspected of witchcraft, Notestein left it at that.

Hansen's insights had no further influence on research for the next half century. While the issue of gender virtually dropped out of the discussions, what remained was a disturbing glimpse of how historians saw women in history. L'Estrange Ewen's first analysis of the English Home Counties trials, for example, provided plenty of information about misogyny in the courts, but he did not mention women as a category at all. Four years later, however, while publishing further trial documentation, he briefly stated his thoughts about the victims:

> That many of the condemned women, although innocent of witchcraft, were really undesirable neighbours cannot be doubted. Mental institutes not being features of the social life, numbers of melancholics were at large, others again, mentally sound, ranked as thieves, cozeners, whores, blasphemers, blackmailers, abortionists, perhaps even poisoners. Mentally degraded, they allowed vermin and domestic animals to suck or lick their blood, although many of such recorded practices can have been nothing more than misunderstanding or hallucination.

Not only condescending to the victims, Ewen went on to libel them:

> At heart they were murderers, and morally as guilty as cutthroat or poisoner. But their confessions are not greatly to be relied upon, obtained as they were by deceit and duress, and, it may be supported, sometimes coloured by vanity.

Although he conceded that "occasionally the witches did possess abnormal power," he had little awareness of the positive role they had filled in premodern society as healers and diviners; instead, he perpetuated the worst of the "hag" stereotype about these women.

In disparaging the very nature of women, writers such as Ewen had of course a long tradition to draw on. In the 1480s when Kramer and Sprenger, authors of the witch-hunters manual, *Malleus Maleficarum,* described women as liars, unfaithful, immoderate, sexually insatiable, and downright evil, they quoted at length from biblical, classical, and medieval sources. As Barbara Walker observes, "From Terrible Crone to castrating witch was not a large step.... She had many guises: she-demon, witch, sorceress, succubus, Hag." The witch-hunters of the sixteenth century had models of castrating, death-dealing female types with which to demonize their own women, and many twentieth-century historiographers of the witch-craze have not demythologized their own attitudes toward the women they write about.

In the same category is Julio Caro Baroja's brief mention, at the end of his 1965 book on Basque witchcraft, of the sick, "slightly mad, weird" old women who are his typical witches. Seeing them as pathetic outsiders "with an overdeveloped sense of their own importance," he concluded that "a woman usually becomes a witch after the initial failure of her life as a woman, after frustrated or illegitimate love affairs have left her with a sense of impotence or disgrace," and he regretted that "those unfortunate sick people" were put to death because

their type of neurosis was not understood. I conclude from this that it is just as well that most historians did not attempt a gender analysis before we had the insights of women's history to guide us.

The 1967 essay which launched the recent revival of witchcraft studies, H. R. Trevor-Roper's "European Witch-Craze of the Sixteenth and Seventeenth Centuries," while utterly deficient in gender analysis, sheds some light on how historians were missing the point. While making an important analysis of how social tension was generated "by unassimilable social groups," he had a logical opening to discuss women and why some of them were seen as unassimilable. But he could not seem to think of "women" as a group, as a societal category. Sixty pages later, at the end of the essay, he finally identified the victims, calling them "hysterical women in a harsh rural world or in artificial communities —in ill-regulated nunneries ... or in special regions like the Pays de Labourd, where ... the fishermen's wives were left deserted for months." Again, we find the theory of the sexually deprived female. But for most of his essay, the victims have no identity. Trevor-Roper understood the dynamics of the medieval persecution of heretics, Jews, and Moors, and realized that the witch-craze was also a persecution of "unassimilable" groups—but thinking of women as either hysterical or as sex-starved individuals, he could not draw any conclusions about them as a group.

Trevor-Roper's controversial essay inspired a series of archival studies of witch trials, written in order to refute him but all showing their debt to him nonetheless. Alan Macfarlane's careful analysis of the Essex trials confirmed that 92 percent of the victims there were women, an extraordinarily high percentage, but he concluded that "there is no evidence that hostility between the sexes lay behind their prosecutions." Keith Thomas in his influential study of English folk religion concurred with Macfarlane. While denying that either misogyny or psychological factors mattered, he made the useful point that economic and social considerations are valid, because women "were the most dependent members of the community, and thus the most vulnerable to accusation." He also pointed out that charges of female sexual irregularities— illegitimacy, promiscuity, sexual voracity—figured in the trials, but he seemed not to realize that these are the stuff of which misogyny is made.

Both Macfarlane and Thomas said that the question of why women are singled out must be looked into—but neither of them did so. Succeeding works documented a vast amount of woman-hatred, making it all the more surprising that scholars still did not see gender as the central issue. Erik Midelfort's research on southwestern Germany is a case in point. While analyzing massive witch panics such as Wiesensteig where sixty-three women were burned to death, and Quedlinburg, where 133 witches, mostly female, were executed in one day, Midelfort suggested that "women seemed ... to provoke somehow an intense misogyny at times" and asked that we study "why that group *attracted to itself* the scapegoating mechanism." Not content with blaming the victims, Midelfort went on to deny that there had been a particular tradition of misogyny in the sixteenth century. Complaining that this alleged tradition had been documented "only in literary sources," he overlooked the fact that his own material was primary proof for it.

By this time in the development of witchcraft studies, a pattern of denial is clear. Historians were denying that misogyny and patriarchy are valid historical categories and were refusing to treat women as a recognizable historical group. Reading these works is like reading accounts of the Nazi holocaust in which everyone agrees that the majority of victims were Jewish, but no one mentions anti-Semitism or the history of violent persecution against Jews, implying that it was "natural" for Jews to be victims. Without mention of a tradition of oppression of women, the implication for the sixteenth century is that of course women would be attacked—and that it must somehow have been their fault. This is what historians conclude when they have no awareness of traditional misogyny or traditional oppression of women.

In 1948 in the work of the researcher of northern French witchcraft, Emile Brouette, misogyny was finally related again to the persecutions. Even if one believes that it is possible to be antifeminist without burning witches, he maintained, still it is theologically only one step from scorning a woman to believing that she is a servant of the devil. This perception was rejected by Brouette's successor there in witchcraft studies, Fr. Pierre Villette, who insisted that it was "psychologie féminine" and that alone which explained the large numbers of female victims; in other words, women do threaten men and drive them to attack. Villette even excused the virulent misogyny of the authors of the *Malleus Maleficarum,* in light of this frightening "female psychology."

Working twenty years later in the same northern French area as Villette had covered in the 1950s, Robert Muchembled drew quite different conclusions. Ascribing the preponderance of female victims (82 percent) partly to traditional misogyny, literary as well as theological, lay as well as clerical, Muchembled moved the argument along by tying female oppression to the general sexual repression of the two Reformations. His proofs were the increased punishment for prenuptial pregnancy, bastardy, and adultery, with heavier penalties against women than men. He also documented the intrusion of the state into village life, which brought elite fantasies about witches and an impersonal bureaucratic form of justice that seriously disturbed traditional village relationships. As society became more repressive, the charges against alleged witches became wilder: while some of the accused had had reputations·for lasciviousness, even women with good names were now accused of having sex with the devil or keeping a demon lover. Muchembled was right to broaden the scope and to see that the witch-hunt involved persecuting women for their sexuality.

The years after 1972, when Midelfort's work was published, show a change in scholars' interpretations of this evidence, a change which must be credited to the nascent movement for women's history. Midelfort himself took a different position nine years later, claiming that "one cannot begin to understand the European witch-hunt without recognizing that it displayed a burst of misogyny without parallel in Western history," and he even suggested that future research should investigate the fantasies of the bishops and university professors who presided over the German trials. This indicates a more sympathetic approach, one perhaps influenced by the work in women's history accomplished in the intervening decade.

In a general interpretation of early witchcraft up to 1500, Jeffrey Burton Russell made a major attempt to place women at the center of the problem. Russell understood one role of medieval women, namely their leadership in heretical groups, he appreciated the extent to which medieval heretical groups appealed to women by offering women roles from which they were excluded by the church. But he failed to see that folk religion (folk magic, witchcraft) was another valid alternative for women. Throughout, he accepted the demonologists' definitions of witchcraft, calling it a "violent form" of "feminine discontent" involving "criminal" activity. Because he insisted on associating witchcraft primarily with heresy, rather than with folk religion, and saw it as ultimately subversive, he was forced to conclude that the alleged witch engaged in violent, even criminal, activity, leaving the issue not far from the "woman as hag" position. In a more recent work, Russell connects suspected women with hags even more strongly: " . . . in Christian Europe, the hag image was projected upon human beings. The European witch, then, must be understood not just as a sorceress, but as the incarnation of the hag. She is a totally evil and depraved person under the domination and command of Satan."

Two new comprehensive studies that cover the entire witch-hunting period, go further in searching for gender factors. In Joseph Klaits's 1985 book, misogyny is dissected as part of theology, medical attitudes, law, art, ageism, and poverty. Woman-hatred is identified in familial attitudes and in sexual exploitation. That Klaits devotes half a chapter to "sexual politics," a discussion he placed early in the book, shows that he understands the institutional nature of the problem—that the social order felt threatened by nonconformist women, felt that church and family, and even the state, were threatened. And he is one of the few (Muchembled is another) who has analyzed the sadistic impulse in the witch-hunt.

But Klaits sees not women but the Reformation (meaning both Protestant and Catholic) as the main factor in the persecutions, blaming both the religious upheaval and, chiefly, the antisexual reformism of the Reformation period for the extremes of the witch-craze, and in doing so he shifts the focus away from women. Women, after all, were not the main actors in the Reformation drama, so Klaits brings us back to looking at what men did. It matters little to witchcraft studies whether one explains witchcraft by what lawyers, judges, doctors, theologians, bishops or Reformers did—all of these explanations miss the central point, because all pull the focus away from the victims, from the women themselves. And Klaits states categorically that women are not the central issue. Even his emphasis on them as sexual objects, true though it is to the trial material, has the effect of showing us the victims from the outside.

Brian Levack's study, intended like Klaits's to be used as a textbook, affirms at one point that witchcraft was sex related, and discusses the many ways in which women were more vulnerable than men to these charges. But Levack seldom mentions gender in the rest of his book.

A model of gender analysis finally appeared in 1976, E. William Monter's study of the witch-craze in the Swiss-French borderlands. Affirming the widespread use of black and white magic in preindustrial Europe, he is sympathetic to women's use of magic as a compensation for their legal and economic

disadvantages. He lays their persecution to their gender and maintains unequivocally that sex was the crucial factor, more important than poverty, age, or any other. Defining misogyny as more than the usual woman-hatred in family and in theology. Monter adds the important observation that witch prosecutions rose and fell with legal action against two other sex-linked crimes: infanticide and sodomy. Infanticide was resorted to almost entirely by single women, and both infanticide and sodomy were seen by sixteenth-century society as "unnatural." Since witchcraft was seen as "unnatural," sinful, and a single woman's crime, it is not surprising that the sixteenth century became "interested in executing women as witches." Concluding that "women were the specially designated victims," that "witchcraft, as the demonologists had repeatedly insisted, was sex-linked," Monter set the stage for the type of gender analysis which must be done on the witchcraft materials, but he did not follow through on these insights.

The late Scottish sociologist Christina Larner produced the most thorough gender investigation to date. Using her triple skills in sociology, history, and religion, Larner accepted the positive use of witchcraft by poor village females ("women embracing witchcraft"), saw the persecutions as motivated by a desire to control independent-minded (and -mouthed) women, and made male hatred of the female body into a real, believable factor in the craze. One expects her to conclude that gender is the central issue, and she does affirm that "all women were potential witches," that "the witch hunt was part of the sex war," and that "witch-hunting *is* woman-hunting." And yet she wasn't satisfied with these formulations, and repeatedly modified them: "the reasons why witches were hunted are not directly related to their being women, but to their being thought evil"; "the crime of witchcraft, while sex-related, was not sex specific"; the hunt was "no more a persecution of women than the prosecution of killers was a persecution of men." Finally concluding, that "witch-hunting is *not* woman-hunting." Larner maintained that at any rate the questions raised by the issue of woman-hunting were too narrow. Recommending instead that we ask broader, presumably more important questions of the craze, questions about Christianity as a political ideology, about crises in law and order—that is, the more political questions—she turned away from the theory of persecution by gender, which she more than anyone had validated.

Once again women as a gender group are seen not to matter and the questions of women's history are considered too narrow. Larner's conclusions are the most disappointing of all, for she had a keen awareness of how the oppression of women works in history. She doesn't make clear why one must forego questions about woman-hunting in order to work on the political issues, nor does she see that the woman-hunting questions *are* political. Material that shows women as "threatening to patriarchal order," or religion as "relentlessly patriarchal" is neither narrow nor apolitical.

To sum up: the problems one faces in studying witchcraft as a persecution by gender are many. First one must acknowledge that folk healers and diviners were useful, sought-after members of society, pre-1500. Although they were reperceived after that as suspect, even as evil, by elite groups, and eventually by villagers as well, the historian has no grounds to caricature them as hags.

Second the distinction between folk religious practices and witchcraft accusations must be observed. The latter were the grotesque distortions made by the European elite of the actual, useful functions of folk healers and counsellors, made in order to discredit them. Finally, one must distinguish between sex and gender. Despite the emphasis on female sexuality in the trial records and procedures, the historian is ill advised to interpret the victims, no matter how sympathetically, as sex objects. Women were more than sex objects in sixteenth-century society, they served as midwives, healers, counsellors, farmers, alewives, spinners, domestic servants, assistants to their husbands in craft work, etc., and their productive, as well as reproductive, roles shaped how they were seen. Only when the historian distinguishes between gender roles and sexuality can we properly evaluate why women were perceived as a threat.

A lack of understanding of patriarchy as a historical category and of how it functions in society is another weak point in most of the works cited here. Without this understanding one doesn't see that women were accused primarily by men, tried by male juries, searched by male prickers, sentenced by male judges, tortured by male jailers, burned to death by male executioners—while being prayed over by male pastors. The patriarchal system also explains why many women accused other females: if a woman displeased or threatened the men of her community, she would also be seen as dangerous by the women who depended on or identified with those men. The internalization of "who is not acceptable" goes even deeper than that: women—and other oppressed groups—sometimes try to outdo their oppressors in scorning persons perceived as outsiders, in hope of being accepted, or tolerated, themselves. In the witchcraft trials, the poor attacked those even poorer; and poor women attacked those women even further out of power than they.

How misogyny, the hatred of women, in addition to patriarchy, the rule over women, caused females to be singled out, needs to be made clear. It was antiwoman theology that turned the attention of the inquisitional courts to women *as women,* a process that was quickly taken up by secular courts as early as c. 1400. This was not caused by something innately evil about women, nor any change in their nature; the cause was the specific connection that Dominican inquisitors and theologians (de Savigliano, Nider, Jacquier, Kramer, Sprenger) made between witchcraft and women, based on ancient Christian beliefs about the defective, evil nature of women. When historians deal with this tradition of misogyny, rather than blaming the victim for somehow "attracting" hatred, then the persecutions can be understood. Both patriarchy and misogyny are valid, and in this case essential, historical factors.

Furthermore, this is not a one-issue topic. A number of false leads have been followed, and the concept of persecution by gender has been repeatedly denied, in order to narrow down the analysis to some one key factor: the Reformation(s), community tensions, proto-capitalist agriculture, more abstract forms of justice, demographic change (more single women), plague, etc. While all of the above are factors, none of them is *the* factor. I suggest that we stop looking for a central, unifying explanation for this very complex, messy, rich phenomenon. Witchcraft, far from being odd, esoteric, or disgusting, turns out to be a capital topic for studying the transition from medieval to early modern

society. By forcing the historian to focus on women's lives and how they were changed and limited by the greater power of the seventeenth-century churches and states, the witchcraft phenomenon illuminates the racism and imperialism that Europeans were beginning to export around the world. What European men and women did to the people whom they colonized, European men first did to European women. Traditional patriarchal structures and misogynistic attitudes were heightened by new legal, religious, and political arrangements. Women's lives *were* changed; some of their old roles were challenged, and as they resisted, they were made the new scapegoats for an expanding but insecure society.

This dynamic history cannot be reduced to a central cause. It must be dealt with as multifaceted, as filled with internal change and contradiction. The thread that runs through it, the only constant, is the gender of the victims. It is from the beginning, and becomes even more emphatically, a persecution of women, which sheds light on the history of persecution, criminality, poverty, religious teaching, the family, and how men and women relate to each other.

NO

Robin Briggs

Men Against Women:
The Gendering of Witchcraft

Theories and Realities

Familial problems lead inevitably into the fascinating, difficult and higher controversial question of gender. The one thing everyone 'knows' about witches is that they were women. Although every serious historical account recognizes that large numbers of men were accused and executed on similar charges, this fact has never really penetrated to become part of the general knowledge on the subject. The *Malleus Maleficarum* is routinely quoted to establish that witch-hunters were woman-haters, and one can hardly deny that its principal author, the Dominican Henry Institoris (Heinrich Kramer), blamed witchcraft largely on unbridled feminine sexuality. It is not often recognized, however, just how far this was a peculiarly misogynistic text, many of whose assertions are very misleading as a guide to what happened in typical trials. Later writers were often content to repeat such material uncritically, while their statements about gender are usually both sketchy and inadequate. Pierre de Lancre stated that the Devil 'wins over more women than men, because they are naturally more imbecile. And we see that among those brought before the *parlements* on charges of witchcraft, there are ten times more women than men'. Jean Bodin went further still: 'When we read the books of those who have written about witches, it is to find fifty female witches, or even demoniacs, for every man'. He did concede that women often endured torture with more resolution than men, only to continue with the assertion 'that it is the power of bestial desire which has reduced women to extremities to indulge these appetites, or to avenge themselves ... For the internal organs are seen to be larger in women than in men, whose desires are not so violent: by contrast, the heads of men are much larger, and in consequence they have more brains and prudence than women'. The identification of witches with women was already standard form, it would appear, in the decades when trials were at their height. The demonologists would have been shocked to find their confident assertions turned against them by modern writers who use the persecution as prime evidence for men's inhumanity to women, often seeming to assume that the sex ratio was not de Lancre's

From Robin Briggs, *Witches and Neighbors: The Social and Cultural Context of European Witchcraft* (Penguin Books, 1996). Copyright © 1996 by Robin Briggs. Reprinted by permission of Viking Penguin, a division of Penguin Putnam, Inc. Notes omitted.

90 per cent, or even Bodin's 98 per cent, but a stark 100 per cent. When this misconception has been coupled with vast exaggerations of the numbers executed it has proved all too tempting to create the image of an earlier holocaust, in which millions of women perished.

The best-informed recent estimates place the total number of executions for witchcraft in Europe somewhere between 40,000 and 50,000, figures which allow for a reasonable level of lost documentation. Men actually made up around 25 per cent of this total, although there were large variations from one area to another and between different types of trials. Bodin and de Lancre were simply wrong about the facts, before they proceeded to offer explanations which merely repeated the conventional wisdom of the day, and now appear remarkably feeble. Their inability to observe the reality around them is significant. It suggests that received opinions were blinding them to the obvious; in this they were actually typical of most traditional thinking, much more concerned with concept affirmation than with referential accuracy. What made their error so egregious was that their own country, France, was in fact a fascinating exception to the wider pattern, for over much of the country witchcraft seems to have had no obvious link with gender at all. Of nearly 1,300 witches whose cases went to the *parlement* of Paris on appeal, just over half were men. The appeal system may have been invoked more often by men in the years before it became automatic, yet there are many reasons to doubt that this has more than a modest effect on the figures. In around 500 known cases which did not reach the *parlement,* although there is a small majority of women, men still make up 42 per cent of the accused. Some local studies also show a predominance of men, as do the court decisions which de Lancre himself collected and printed in one of his works. There are variations within the *parlement*'s jurisdiction (covering nearly half the country), for towards the east the proportion of women rises towards 70 per cent, which fits very well with the picture just across the border, and suggests that the figures are trustworthy, while the central and western regions had a clear majority of male witches. The great majority of the men accused were poor peasants and artisans, a fairly representative sample of the ordinary population.

Relatively high proportions of male witches were common elsewhere, as the overall statistics would lead us to expect. In south-west Germany, the figures were typically rising towards 25 per cent by the 1620s, while in another sample of well over a thousand cases from the Jura and the Alps the proportion of men was 22.5 per cent. For the modern French department of the Nord, then mostly in the Spanish Netherlands, men comprised 18 per cent of a much smaller group of 294. The Saarland and Lorraine correspond closely with eastern France, around 28 per cent of those tried being men; for a sample of 547 in the neighbouring duchy of Luxembourg it was 31 per cent. There are some extreme cases in peripheral regions of Europe, with men accounting for 90 per cent of the accused in Iceland, 60 per cent in Estonia and nearly 50 per cent in Finland. On the other hand, there are regions where 90 per cent or more of known witches were women; these include Hungary, Denmark and England. The fact that many recent writers on the subject have relied on English and north American evidence has probably encouraged an error of perspective

here, with the overwhelming predominance of female suspects in these areas (also characterized by low rates of persecution) being assumed to be typical. Nor is it the case that the courts treated male suspects more favourably; the conviction rates are usually much the same for both sexes. These data create as many problems as they solve, not least because of the 'dark figure' familiar to criminologists. Formally accused witches were predominantly women, but was this also true of those suspected and never charged? Might men typically have found themselves better placed to stave off their accusers? How do we account for accusations being gender-biased, yet far from gender-specific? Is there any rational explanation for the massive variations between different regions? This last question is perhaps the most baffling of all, particularly in a case like the French one, where large differences are found within a single jurisdiction and there are no obvious cultural or social differences to invoke. Recent work on contemporary witchcraft beliefs in western France strongly suggests that the pattern has endured to the present day, without providing many clues to its rationale. It is possible that there may have been a particular tendency in these areas to see the cunning folk in very ambivalent terms, so that a high proportion of the men accused were 'good' witches reclassified as bad, but this only pushes the problem of explanation back another stage.

It remains true that most accused witches were women. Careful reading of the trial documents suggests that this was an accurate reflection of local opinion, in the sense that those tried were fairly typical of the wider group of suspects. Confessions include lists of those allegedly present at the sabbat, which obviously reflect local rumours about witchcraft, and some general statements about the attendance. Both of these usually (though not always) specify a majority of women, in line with the proportions found in the trials. Witchcraft was not a specifically feminine crime in the sense that infanticide and prostitution were, almost by definition; these offences, and domestic theft (the other crime often linked to women), were of course different in that there was something much more real to get a hold on. Infanticide and prostitution actually exemplify the double standard far better than witchcraft, since almost all those punished can fairly be depicted as the victims of male oppression, although this hardly exonerates them totally. Their seducers or clients, often from higher up the social scale, almost invariably escaped unscathed. A new punitive attitude towards these 'social' crimes, whose only direct victims were the new-born babies, was a striking feature of the sixteenth century; more women were probably executed for infanticide than for witchcraft. With very few exceptions they were denounced by other women, without whose participation the legislation would have remained a dead letter. The whole process is best seen not as the deliberate criminalization of women, but as part of a much broader drive to exercise greater moral and social control by labelling and punishing many kinds of deviant behaviour. This process was often deeply unfair and hypocritical, but patriarchy in this sense meant first and foremost the tyranny of the rich and powerful over the poor and weak. Social and gender hierarchies were naturally interlinked, so it comes as no surprise that harsher repressive policies had unfortunate consequences for women, as they did for vagrants, beggars and many others.

Historians who emphasize the social and psychological aspects of witch-craft beliefs are nevertheless bound to reject the idea that witchcraft persecution can be satisfactorily explained as the product of a great conglomerate of patriarchalism, absolutism and moral rigour. The point is not to deny all relevance to such factors, but rather to insist that witchcraft is much more than an elaborate delusion manufactured by outsiders, then misapplied to popular beliefs. It does rather seem that many interpretations imply, indeed require, such an underlying structure. At its crudest this can be seen in suggestions that clerics and judges diabolized feminine medical practice, or that women were the scapegoats for a variety of natural disasters. At a more respectable intellectual level, we have had attempts to show how a range of intellectual and symbolic devices (ranging from the equation of virtue with masculinity, through claims that women were biologically just incomplete men, to images of women as temptresses) were united by a persistent denigration of women. In its own terms there is much to be said for this view, provided we recognize the peculiar character and limited application of this kind of misogynistic language. What it cannot do is to provide a convincing explanation for persecutions which were largely initiated at village level, and whose motivation was quite clearly fear of witchcraft in the most direct sense. It is also very important not to confuse the rhetoric of justifications with the real motives for action. Another result of the tendency to see persecution as inspired from above is to give vastly exaggerated significance to the theories of the demonologists, attributing to them a causal role they simply did not possess. These approaches end up with the idea that witch-hunting was thinly disguised women-hunting, the diabolization of the feminine. In other words, here is the war between the sexes in a peculiarly violent form. Even if this were true, we would still have to account for change over time, since variables cannot be explained in terms of constants. The problem with these crude views goes deeper, for such generalized notions are too remote from the real world our ancestors inhabited. Gender did play a crucial role in witchcraft, but we will only understand this properly as part of the whole system, within which many other forces operated. What we need to explain is why women were particularly vulnerable to witchcraft accusations, not why witchcraft was used as an excuse to attack women. To achieve this, we must be constantly aware of gender as one of the crucial polarities within the vital frontier zone where beliefs and accusations interacted. Then we must tease out the ways in which it helped to structure the various operations which turned theory into action. In the process the information from the trials can tell us a great deal about gender, establishing a rewarding dialogue.

Counting heads is a useful way of shaking our ready assumptions, and of bringing a degree of rigour into the discussion. The figures can be broken down into numerous categories, to show distribution by age as well as gender, social and economic status, marital situation, childlessness and so forth. There has been no systematic work of this kind across Europe, and one would expect to find considerable variations by region. My own findings for Lorraine cannot therefore be regarded as a safer guide to general patterns, yet they do seem to conform to general impressions from several other regions. In this area of steady but very local persecution accused witches were on average much older

and slightly poorer than their neighbours. Around half the women accused were widows, of whom a fair number appear to have had no surviving children. Some men seem to have been tainted by association with a suspected wife, but they were a minority; overall the masculine group formed a diverse cross-section of the peasant community. Although this evidence might seem to offer limited support to the stereotype of elderly women as witches, a more careful look at the material tells a different story. Age at the time of the trial is an artefact of the whole process by which reputations were built up. Since it took fifteen or twenty years for the typical witch to get to court, most were first suspected when still in the prime of life. There are signs that for women this transfer into the pool of suspects had a modest tendency to coincide with the menopause or the end of childbearing; while it would be rash to build too much on this flimsy basis, there may prove to be an important relationship here. This was an important watershed for everyone, physically, emotionally and socially, and, if the change of roles were not successfully accomplished, might prove an alienating experience. Those who missed out in some sense were likely to resent this, something their neighbours were all too likely to perceive. John Demos has suggested that midlife—roughly between the ages of forty and sixty—was the time when the exercise of power usually became central to personal experience. Wealth, prestige and responsibility all typically reached their highest point in these decades; while this was most obviously true for men, it was bound to affect women as well. Many themes could be related to this one; if illegitimate and misused power was a key meaning of witchcraft, then it is not surprising to find this age group notably suspect....

Psychology, Misogyny and Witchcraft Persecution

These cases also provide a particularly rich context for investigating witchcraft from a psychological standpoint. As Lyndal Roper [a professor at the University of London whose research interests include witchcraft and gender history] states, 'witchcraft confessions and accusations are not products of realism, and they cannot be analysed with the methods of historical realism'. She draws out how individuals borrowed the language and stereotypical images of witchcraft to express their own psychic conflicts, which centred on the earliest stages of the mother-child relationship.... [However,] we need to question why, as witchcraft has receded almost entirely into the sphere of fantasy in the modern world, it has come to be completely sex-specific. The witch is the bad mother, a being who subverts the basic duties of her sex by direct hostility to fertility and nurture. She also embodies the envy which originates in early mother-child relations. Again and again the details of cases can be assimilated to these underlying patterns; they are not 'caused' by them so much as structured through them. Every individual carries around a permanent legacy from the formative period of life that includes negative elements capable of being activated under stress. Such reactions are very likely to employ the processes known to psychoanalysts as splitting and projective identification, both of which first

take shape in relation to the mother. Every individual's fundamental experience of love and hate is with a woman, in the mother-child relationship, or whatever surrogate takes its place. How far this creates a predisposition, perhaps independent of gender, to make women the target for murderous hostility, it is impossible to say with certainty. Nevertheless, the historical record suggests that both men and women found it easiest to fix these fantasies, and turn them into horrible reality, when they were attached to women. It is really crucial to understand that misogyny in this sense was not reserved to men alone, but could be just as intense among women. Behind it lay the position of mothers as primary objects who were felt to possess magically formidable qualities, and whose very intentionality (independent will) was perceived as dangerous.

Such analyses have severe limitations, above all because they are too general to offer useful explanations for change and local variations. We cannot suppose that child-rearing practices changed dramatically in ways which would even begin to account for the rise and fall of persecutions; no independent evidence suggests this, while only exceptional shifts would be likely to affect relations between mothers and babies significantly. Wet-nursing might seem to be a candidate here, but it simply does not correlate in any plausible way; it was characteristic of those urban and elite groups which seem to have been least involved in persecution. It is more helpful to think of numerous distinct factors meeting around a central void filled only by fantasy, a structure which related to the essential nature of witchcraft as a crime which never happened. Some people tried to practise it, although they were a minimal fraction among the accused; many more probably died of it, but in both cases the effects were only because of what people believed. The most enduring structures still persist in modern peasant societies, including some regions of Europe. They are to be found in parts of France, for example, as earlier variants of them doubtless were in Merovingian or pre-Roman Gaul. These include both social and psychological determinants, the elements which make all witchcraft beliefs fundamentally similar across great expanses of time and space. More ephemeral factors include the religious, legal and economic shifts which help to explain why persecution occurred when and where it did. It appears that certain combinations of the latter have been sufficiently powerful to deflect a normal tendency for witchcraft to be heavily—but not exclusively—attributed to women. We are unlikely to get much further on this last point until there has been a meticulous study of a region where men comprised the majority of the accused. A great deal might also be gained from a comparison between northern and southern Europe, with their strongly contrasted marriage systems. Mediterranean culture appears to have combined powerful witchcraft beliefs with very low rates of persecution, perhaps because older women were protected by their families, and enjoyed more power and esteem. This derived from a marriage pattern in which brides were much younger than their husbands, then commonly took over as effective heads of the household when they were widowed. Such women had to expect less power during their childbearing years, frequently dominated by mothers-in-law as well as husbands; it was only in mid-life that they acquired a new authority and status that

was widely regarded as legitimate. By contrast, the theoretically more equal marriages of north-western Europe actually left older women at a grave disadvantage, unless they had the good fortune to find a caring, long-lived and forceful husband. Although it would be absurd to claim that one marriage system is more 'natural' than another, one of the most obvious biological differences between the sexes lies in the ages at which they cease to be fertile. The pattern of very late marriages for women, which was an essential condition for the closely-matched ages of spouses in the north-west, has long been regarded as an exception by historical demographers, and a puzzling one at that. It is at least possible that it may have made its own contribution to 'fixing' witchcraft accusations.

There are still reasons for linking witchcraft persecution to the assertion of patriarchal values, which can be seen as one aspect of a search for order in a period when many established patterns underwent severe disruption. Temporal coincidence does not establish causal relationships, however, and it is only by adopting a quite implausible picture of persecution imposed from above that patriarchalism can be made to carry direct blame. It is much more a case of underlying causes producing parallel effects, which were only mildly self-reinforcing. In a period when all tensions were being magnified by extremely harsh and painful social and economic pressures, those between the sexes were bound to be among them. The idea of the female sex as scapegoat misdescribes a situation of this kind, in which anxieties might be displaced into the area of gender. It is also dangerous to put too much weight on the kind of discourse employed by the demonologists. Their referential system was self-confirming, with the positive and negative polarities used for rhetorical purposes. As Stuart Clark has pointed out, they took the link between women and witchcraft as a given, rather than spending much time debating it. Even the overt misogyny of the *Malleus Maleficarum* really falls into this category. Within the confines of an agrarian society and early modern intellectual styles, it was virtually impossible for anyone to rethink gender relations, because everything was referred to ideal types. Polarized binary classification was the dominant style of early modern thought, so that demonologists had no choice but to associate women with evil and inferiority. For them gender took the form of polarity, rather than a range of overlapping possibilities, because this was how it was always conceptualized. This was such a powerful 'mind-set' that it could override empirical observation, as it often did in the medical theory of the time. At the popular level such views were expressed in the form of proverbial wisdom, later reinforced by chapbooks and almanacs. The result was an unfortunate mixture of fear and aggression towards women, whose passions were seen as a grave threat to husbands and society alike. Deficiency in capacity to reason supposedly left women unable to control the baser part of their nature, while their mysterious cycles were evidence for the way they were dominated by the womb. Eve had been responsible for original sin, and women's attraction for men led to corruption and death; women's inconstancy and self-love made them natural allies of the Devil, an eternal danger of betrayal for the men they lured on. The commonplace idea that women were more sexually voracious than men was just one expression of

these attitudes, part of an association between women, original sin and sexual pollution.

Despite the pervasiveness of these grotesque misogynistic doctrines, it is not easy to find evidence that they functioned as a direct cause of action. They may indeed be evidence of a mixture of fear and ignorance which dominated gender relations, and whose roots are better sought in general psychological structures. Early modern Europe was a society in which women got a raw deal in many respects, but this did not often take the form of direct persecution; rather it operated through indirect pressures that frequently led to women accusing one another. It was of course inevitable that the courts which heard these charges would be male, but among the judges it was often those elite jurists most strongly linked to formal patriarchal theories who treated witches leniently. Ultimately witchcraft was a theory of power; it attributed secret and unnatural power to those who were formally powerless. In this way it allowed men to project their own aggression into women, notably those with whom they or their wives quarrelled. This tendency must have been strengthened because women typically responded with threats and curses, which then became part of the evidence for their malevolence. The evidence of the trials, however, suggests that quarrels between women followed much the same course as those between men and women, and often underlay subsequent direct accusations made by men as well as women. In this sense women too could use accusations as a vehicle to assert themselves and claim power against their enemies; seen in this light witchcraft did nothing to reinforce gender solidarities. The highly stressful circumstances experienced by early modern communities produced at least as much friction between those who were closest to one another as they did between those at opposite ends of the grids of wealth and gender. We do find peasant oligarchs accusing poor women, but only in a small minority of cases, compared to the significantly larger groups in which poor peasant households directed their suspicions against tiresome neighbours or persistent beggars.

It is all too easy to fall into anachronism when writing about witchcraft and gender. This is one reason why explanations should always be firmly bedded in the surrounding social realities. It should also warn us against the kind of knee-jerk reactions and facile assumptions which have too often resulted from failure to recognize the otherness of the past. We need to ask whether explanations that invoke gender as a motive could possibly apply in this period. It seems highly unlikely that any contemporary could have seen matters in this light. One must beware of false analogies between the past and the present. Gender is now an issue everyone has to confront, whereas at the time of witchcraft persecution it was a bundle of shared assumptions. Although there was a Renaissance debate about the status of women, it took place within strict limits, and hardly touched on the central questions as we might see them. In other words, modern views tend to be held consciously, whereas earlier ones were almost wholly unconscious. This did not necessarily make them less powerful, but it did mean that they were unlikely to motivate action directly. Gender differences are bound to remain a permanent and overt issue in our world, since the clock of consciousness cannot be put back. This also

applies in reverse, however, and we must not project modern ideas and feelings back on to our ancestors, nor make them fight our battles. In the specific case of witchcraft we have a phenomenon which was permeated by gender, yet in much more subtle ways than any simple argument can convey. Hostility to women did play a crucial part at several levels; no general interpretation of the subject can or should obfuscate this basic truth. At the same time, this can only ever be part of a much more complex set of causes and connections. As so often, witchcraft tells us as much about the context from which it sprang—in this case gender relations—as that context helps us to understand witchcraft.

POSTSCRIPT

Were European Witch-Hunts Misogynistic?

Violence against women, which is considered by many to be epidemic in this generation, has caused a reassessment of misogyny. Domestic violence, spousal abuse, sexual assault, rape, and sexual harassment have occupied recent headlines and created an acute awareness of woman-as-victim issues. In seeking the roots of such violent behavior, a search for historical antecedents is a logical place to start. Renewed interest in the witch-hunt phenomenon has enlivened interest in the subject of violence against women, a unique synthesis of two subjects with such far-reaching results.

Despite a plethora of available information and data, we are no closer today to definitive answers to some of the major questions involving early modern Europe's witch-hunt experiences. For example, were the witch-hunts a centralized movement initiated from society's "power elite," or did local variables play a more important role in their development and outcomes? If women's sexuality was a major force in the witch-craze phenomenon, who introduced it into the public record, and why? If socioeconomic factors were important to the movement, why did it last for more than three centuries? And if women were viewed as "creatures of God," how could the executions of witches be accompanied by such sadistic tortures? Was there another lesson being taught here?

On the generation-long historiography of the European witch craze, Trevor-Roper's essay, "The European Witchcraze of the Sixteenth and Seventeenth Centuries," *Encounter* (May/June 1967) is a good place to start. William Monter's *Witchcraft in France and Switzerland: The Borderlands* (Cornell University Press, 1969) and *Ritual, Myth, and Magic in Early Modern Europe* (Ohio University Press, 1984), along with his many articles, are important contributions to the study of the witch-hunts. Brian P. Levack's *The Witch-Hunt in Early Modern Europe* (Addison-Wesley, 1995) provides a thorough, textbook-like coverage of the subject. Anne Llewellyn Barstow's *Witchcraze: A New History of the European Witch Hunts* (HarperCollins, 1994) is a recent assessment of the relationship between the witch-hunts and gender. An alternative companion piece would be Robin Brigg's recent book, which is excerpted in this issue.

An excellent primary sourcebook that can be used to shed light on this issue is Alan C. Kors and Edward Peters, eds., *Witchcraft in Europe, 1100–1700: A Documentary Issue* (University of Pennsylvania Press, 1995). This book provides among its many primary source pieces opinions by Martin Luther, John Calvin, Cotton Mather, Michel de Montaigne, Baruch Spinoza, and countless others. See also Jonathan Barry, Marianne Hester, and Gareth Roberts, eds., *Witchcraft in*

Early Modern Europe: Studies in Culture and Belief (Cambridge University Press, 1998), which contains many articles on the subject written by leading European scholars. Finally, a recent article that brings the historiographical study of the witch hunts and gender up-to-date is Elspeth Whitney, "The Witch 'She'/The Historian 'He': Gender and the Historiography of the European Witch Hunts," *Women and Language* (Spring 2000).

Was the Scientific Revolution Revolutionary?

YES: Herbert Butterfield, from *The Origins of Modern Science, 1300–1800*, rev. ed. (Free Press, 1965)

NO: Steven Shapin, from *The Scientific Revolution* (University of Chicago Press, 1996)

ISSUE SUMMARY

YES: Historian of ideas Herbert Butterfield argues that the late sixteenth and early seventeenth centuries witnessed a radical break with the past and the emergence of dramatically new ways of understanding both knowledge and the world—in short, a Scientific Revolution.

NO: Professor of sociology and historian of science Steven Shapin questions the idea of a Scientific Revolution, suggesting that there was no radical break with the past and rejecting the existence of a single event that might be called a Scientific Revolution.

W hen you open a world history or Western civilization textbook, you will likely find that it is conveniently divided into chapters and units with titles that mark the major turning points of history. One of those titles is likely to be "The Scientific Revolution." Known as *periodization*, this tendency of historians to interpretatively group events has recently been subjected to reappraisal. If "where you stand determines what you see," then the very act of labeling periods of history makes judgments about what is important and valuable. Traditional schemes of periodization, for instance, have taken the experiences of white men as the standard and ignored the often quite different lives of women and minorities. However, if only the concerns of the powerful provide the interpretation of historical significance, then much of history will be left out.

The assumption behind periodization is that there are moments when the path of history is rerouted, when a sharp break with the past leads to a new kind of experience or a new way of understanding the world. One of the questions historians must ask, therefore, is whether a particular event or series of events

represents continuity with the past or discontinuity from it. Traditional periodization has seen the Scientific Revolution—a period in the late sixteenth and early seventeenth centuries in which the medieval Aristotelian model of scientific explanation was largely abandoned in favor of modern scientific methods —as a classic example of discontinuity, or as a sharp break with the medieval past and the ushering in of the modern world. Recently, however, historians have taken a fresh look at this period and wondered how scientific and how revolutionary it actually was.

A danger historians must also remain alert to is called *presentism*, the tendency to judge and interpret the past by the standards and concerns of the present. From the perspective of the late twentieth century, for example, we might be tempted to view the Industrial Revolution positively because it made it possible for backbreaking labor to be accomplished through the power of machines. People living through what we have come to call the Industrial Revolution, by contrast, might have focused on the negative consequences: the breakup of the family, as individuals left the home to do wage work, and the substitution of the factory for the productive unit in the home. The questions we must ask ourselves are these: Did the people living in the seventeenth century think that something revolutionary was going on? How much of a break with the past did the scientific discoveries represent?

For Herbert Butterfield there is no question that a Scientific Revolution occurred, even if that fact did not become obvious to historians until the twentieth century. In the following selection, he contends that there is a discrete entity called science and that scientists such as Francis Bacon and philosophers such as René Descartes broke with medieval Christendom to create the modern world. A strong sense of discontinuity with the past leads Butterfield to rate the Scientific Revolution as one of the strongest turning points in the periodization of world history.

Steven Shapin, in response, begins with a bold statement: "There was no such thing as the Scientific Revolution." Reflecting a postmodern view of the world, Shapin questions whether or not it is even possible to speak about an "essence" of something called "science." Instead of a single, discrete entity, he sees a wide variety of ways of understanding, explaining, and controlling the natural world. If we list the characteristics of the so-called revolution, Shapin believes, we will find that the experimental method, mathematical approaches, and even mechanical conceptions of nature were both advocated and rejected by people who thought of themselves as scientists. Furthermore, Shapin sees continuity with the medieval past rather than a radical break from it.

Both historians agree that some people living at the time certainly thought of themselves as doing something revolutionary. The question seems to be whether or not most people, even most educated people, shared the beliefs of this tiny minority. Is it possible for the world to be transformed in a dramatic way at any single moment in time?

Herbert Butterfield **YES**

The Origins of Modern Science, 1300–1800

Bacon and Descartes

It is comparatively easy for people today to accommodate their minds to changes that may take place in upper regions of the different sciences—changes which from year to year may add further weight to the curriculum of the undergraduate student of the subject. It is not clear what the patriarchs of our generation would do, however, if we were faced with such a tearing-up of the roots of science that we had to wipe out as antiquated and useless the primary things said about the universe at the elementary school—if we had even to invert our attitudes, and deal, for example, with the whole question of local motion by picking up the opposite end of the stick. The early seventeenth century was more conscious than we ourselves (in our capacity as historians) of the revolutionary character of the moment that had now been reached. While everything was in the melting-pot—the older order undermined but the new scientific system unachieved—the conflict was bitterly exasperated. Men were actually calling for a revolution—not merely for an explanation of existing anomalies but for a new science and a new method. Programmes of the revolutionary movement were put forward, and it is clear that some men were highly conscious of the predicament in which the world now found itself. They seemed to be curiously lacking in discernment in one way, however, for they tended to believe that the scientific revolution could be carried out entirely in a single lifetime. It was a case of changing one lantern-slide of the universe for another, in their opinion—establishing a new system to take the place of Aristotle's. Gradually they found that it would need not merely one generation but perhaps two to complete the task. By the close of the seventeenth century they had come to see that they had opened the way to an indefinitely expanding future, and that the sciences were only in their cradle still.

Before the seventeenth century had opened, the general state of knowledge in regard to the physical universe had been conducive to the production of a number of speculative systems—these not founded upon scientific enquiry

as a rule, but generally compounded out of ingredients taken from classical antiquity. Already in the sixteenth century, also, attention had been directed to the question of a general scientific method, and in the seventeenth century this problem of method came to be one of the grand preoccupations, not merely of the practising scientist, but, at a higher level, amongst the general thinkers and philosophers. The principal leaders in this seventeenth-century movement were Francis Bacon in the first quarter of the century, who glorified the inductive method and sought to reduce it to a set of regulations; and Descartes, whose work belongs chiefly to the second quarter of the century and who differed from Bacon not only in his glorification of mathematics as the queen of the sciences, but in the emphasis which he placed on a deductive and philosophical mode of reasoning, which he claimed to have screwed up to such a degree of tightness that it possessed all the discipline and certainty of mathematical reasoning. In the time of Newton and well into the eighteenth century, there was a grand controversy between an English school, which was popularly identified with the empirical method, and a French school, which glorified Descartes and came to be associated rather with the deductive method. In the middle of the eighteenth century, however, the French, with a charm that we must describe as Mediterranean, not only submitted to the English view of the matter, but in their famous *Encyclopédie* made even too ample a return, placing Bacon on a pedestal higher perhaps than any that had been given him before. It would appear that their excess of graciousness or charity brought some confusion into historical science at a later stage in the story.

Attacks on Aristotle had been increasingly common and sometimes exceedingly bitter in the sixteenth century. In 1543—a year which we have already seen to be so important in connection with Copernicus and Vesalius as well as the revival of Archimedes—Pierre Ramus produced his famous *Animadversions on Aristotle*. This work, which was known to Francis Bacon, and which attacked Aristotle without ever really understanding him, proposed an alternative method which was rather that of a humanist and professor of Belles Lettres —namely, studying nature through the best writers, and then applying deductive and syllogistic procedures to the result. In 1581 another writer, François Sanchez, produced a further attack on Aristotle, and more particularly on the modern followers of Aristotle—a work which provides a remarkable anticipation of Descartes. He said:

> I questioned the learned men of bygone centuries; then I consulted those who were my contemporaries . . . but none of their replies was satisfactory. . . . So I turned in upon myself & put everything to doubt, as though I had never been told anything by anybody. I began to examine things myself in order to discover the true way of gaining knowledge—Hence the thesis which is the starting-point of my reflections: the more I think, the more I doubt.

He attacked the syllogistic reasoning of the prevalent Aristotelian school, because it turned men away from the study of reality and encouraged them to play a sophistical game of verbal subtlety. He promised to expound the true method of science, but in the fifty years of life that were left to him he never fulfilled the promise. One participant in the controversies over scientific method, Ev-

erard Digby, was teaching Logic in the University of Cambridge when Francis Bacon was there in his youth; and a German scholar has shown that at certain points Bacon appears to have followed the ideas of this man.

Bacon held that if Adam, owing to the Fall, had lost for the human race that domination over the created world which it had originally been designed to possess, still there was a subordinate command over nature, available if men worked sufficiently hard to secure it, though this had been thrown away by human folly. There had been only three short periods of genuine scientific progress throughout the whole course of human history, he said—one in Greek times, one in the Roman period, and the third which was being enjoyed in the seventeenth century. In each of the two ancient periods the era of scientific progress had been confined to two hundred years. The earlier Greek philosophers had set the course of enquiry on the right lines, but Plato and Aristotle had supervened, and they had come to prevail precisely because, being of light weight, they had managed to ride much farther down upon the stream of time. They had survived the storms of the Barbarian Invasions precisely because they had been shallow and buoyant, and Aristotle, in particular, had owed his remarkable sway in the world to the fact that, like the Ottoman sultans, he had pursued the policy of destroying all rivals. As for the scholastics of the middle ages, they had had "subtle and strong capacities, abundance of leisure, and but small variety of reading, their minds being shut up in a few authors"; and therefore they had "with infinite agitation of wit, spun out of a small quantity of matter those laborious webs of learning which are extant in their books." Bacon was impressed by the fact that scientific knowledge had made such extraordinarily little progress since the days of antiquity. He begins by saying that men ought to "throw aside all thought of philosophy, or at least to expect but little and poor fruit from it, until an approved and careful natural and Experimental History be prepared and constructed."

> For to what purpose are these brain-creations and idle display of power.... All these invented systems of the universe, each according to his own fancy [are] like so many arguments of plays ... every one philosophises out of the cells of his own imagination, as out of Plato's cave.

He uses the term "history" in the sense that we have in mind when we speak of natural history, and he regards it as comprising a collection of data, the fruits of enquiry.

He believed that many men had been led away by allowing their scientific work to become entangled in a search for final causes, which really belonged rather to philosophy, and which he said corrupted the sciences, except those relating to the intercourse of man with man. In education he thought that scholars were introduced too early to logic and rhetoric, which were the cream of the sciences since they arranged and methodised the subject-matter of all the others. To apply the juvenile mind to these before it had been confronted with the subject-matter of the other sciences was like painting and measuring the wind, he said—on the one hand it degraded logic into childish sophistry, on the other hand it had the effect of making the more concrete sciences superficial. In his reaction against the older ways of discussing science, Bacon carried

the attack beyond the bounds of prudence on occasion—denying the value of syllogistic modes of reasoning in a way that the modern philosopher would disapprove of; though the general line of attack was understandable, and very useful in view of the situation of things at that time. Bacon wanted men to close in on nature and get to grips with her, bringing their minds to mix in its actual operations. "The secrets of nature," he said, "betray themselves more readily when tormented by art than when left to their own course." "It is best to consider matter, its conformation, and the changes of that conformation, its own action, and the law of this action in motion." He did not support a dead kind of empiricism; the empirics, he said, were like ants merely heaping up a collection of data. The natural philosophers still generally current in the world, however, were rather like spiders spinning their webs out of their own interior. He thought that the scientists ought to take up an intermediate position, like that of the bees, which extracted matter from the flowers and then re-fashioned it by their own efforts. Existing interpretations of nature, he said, were generally "founded on too narrow a basis of experiment." "In any case," he insisted, "the present method of experiment is blind and stupid"—men did it as though they were schoolboys engaged "as it were in sport." He talked of "desultory, ill-combined experiment." The alchemists, he said, had theoretical preconceptions which hindered them from either carrying out their experiments along useful lines or extracting anything important from their results. Men in general glanced too hastily at the result of an experiment, and then imagined that the rest could be done by sheer contemplation; or they would fly off into the skies with a hasty first impression and attempt to make this square with the vulgar notions already existing in their minds. Even Gilbert working on the magnet had no unity or order in his experiments—the only unity in his treatise lay in the fact that he had been ready to try out anything that there was to try out with a magnet.

Now it was Bacon's firm principle that if men wanted to achieve anything new in the world, it was of no use attempting to reach it on any ancient method —they must realise that new practices and policies would be necessary. He stressed above all the need for the direction of experiments—an end to the mere haphazard experimenting—and he insisted that something far more subtle and far-reaching could be achieved by the proper organisation of experiments. It is quite clear that he realised how science could be brought to a higher power altogether by being transported away from that ordinary world of common-sense phenomena in which so much of the discussion had hitherto been carried on. He insisted on the importance of the actual recording of experiments, a point which, as we have already seen, was now coming to be of some significance. He urged that experimenters in different fields should get together, because they would knock sparks off one another; and things done in one field would give hints to people working in another field. In this sense he anticipated the point of Professor Whitehead who shows how, precisely in this period, the knowledge of several different branches of science at once might have an enriching effect on each. Also, suggestions which are scattered in various parts of Bacon's work seem to have served as an inspiration to some of the men who founded the Royal Society....

Place of Scientific Revolution in History

... The changes which took place in the history of thought in this period, how-
ever, are not more remarkable than the changes in life and society. It has long
been our tendency to push back the origins of both the industrial revolution
and the so-called agrarian revolution of the eighteenth century, and though...
we can trace back the origin of anything as far as we like, it is towards the end of
the seventeenth century that the changes are becoming palpable. The passion
to extend the scientific method to every branch of thought was at least equalled
by the passion to make science serve the cause of industry and agriculture, and
it was accompanied by a sort of technological fervour. Francis Bacon had always
laid stress on the immense utilitarian possibilities of science, the advantages be-
yond all dreams that would come from the control of nature; and it is difficult,
even in the early history of the Royal Society, to separate the interest shown in
the cause of pure scientific truth from the curiosity in respect of useful inven-
tions on the one part, or the inclination to dabble in fables and freakishness on
the other. It has become a debatable question how far the direction of scien-
tific interest was itself affected by technical needs or preoccupations in regard
to shipbuilding and other industries; but the Royal Society followed Galileo
in concerning itself, for example, with the important question of the mode of
discovering longitude at sea. Those who wish to trace the development of the
steam-engine will find that it is a story which really begins to be vivid and lively
in this period. Apart from such developments, the possibilities of scientific ex-
periment were likely themselves to be limited until certain forms of production
and technique had been elaborated in society generally. Indeed, the scientific,
the industrial and the agrarian revolutions form such a system of complex and
interrelated changes, that in the lack of a microscopic examination we have to
heap them all together as aspects of a general movement, which by the last
quarter of the seventeenth century was palpably altering the face of the earth.
The hazard consists not in putting all these things together and rolling them
into one great bundle of complex change, but in thinking that we know how
to disentangle them—what we see is the total intricate network of changes, and
it is difficult to say that any one of these was the simple result of the scientific
revolution itself....

It is always easy for a later generation to think that its predecessor was
foolish, and it may seem shocking to state that even after the first World War
good historians could write the history of the nineteenth century with hardly
a hint of the importance of Socialism, hardly a mention of Karl Marx—a fact
which we should misinterpret unless we took it as a reminder of the kind of
faults to which all of us are prone. Because we have a fuller knowledge of after-
events, we today can see the nineteenth century differently; and it is not we
who are under an optical illusion—reading the twentieth century back unfairly
into the nineteenth—when we say that the student of the last hundred years is
missing a decisive factor if he overlooks the rise of Socialism. A man of insight
could have recognised the importance of the phenomenon long before the end
of the nineteenth century. But we, who have seen the implications worked out

in the events of our time, need no insight to recognise the importance of this whole aspect of the story.

Something similar to this is true when we of the year 1957 take our perspective of the scientific revolution—we are in a position to see its implications at the present day much more clearly than the men who flourished fifty or even twenty years before us. And, once again, it is not we who are under an optical illusion-reading the present back into the past—for the things that have been revealed in the 1950s merely bring out more vividly the vast importance of the turn which the world took three hundred years ago, in the days of the scientific revolution. We can see why our predecessors were less conscious of the significance of the seventeenth century—why they talked so much more of the Renaissance or the eighteenth-century Enlightenment, for example—because in this as in so many other cases we can now discern those surprising overlaps and time-lags which so often disguise the direction things are taking. Our Graeco-Roman roots and our Christian heritage were so profound—so central to all our thinking—that it has required centuries of pulls and pressures, and almost a conflict of civilisations in our very midst, to make it clear that the centre had long ago shifted. At one time the effects of the scientific revolution, and the changes contemporary with it, would be masked by the persistence of our classical traditions and education, which still decided so much of the character of the eighteenth century in England and in France, for example. At another time these effects would be concealed through that popular attachment to religion which so helped to form the character of even the nineteenth century in this country. The very strength of our conviction that ours was a Graeco-Roman civilisation—the very way in which we allowed the art-historians and the philologists to make us think that this thing which we call "the modern world" was the product of the Renaissance—the inelasticity of our historical concepts, in fact—helped to conceal the radical nature of the changes that had taken place and the colossal possibilities that lay in the seeds sown by the seventeenth century. The seventeenth century, indeed, did not merely bring a new factor into history, in the way we often assume—one that must just be added, so to speak, to the other permanent factors. The new factor immediately began to elbow the other ones away, pushing them from their central position. Indeed, it began immediately to seek control of the rest, as the apostles of the new movement had declared their intention of doing from the very start. The result was the emergence of a kind of Western civilisation which when transmitted to Japan operates on tradition there as it operates on tradition here—dissolving it and having eyes for nothing save a future of brave new worlds. It was a civilisation that could cut itself away from the Graeco-Roman heritage in general, away from Christianity itself—only too confident in its power to exist independent of anything of the kind. We know now that what was emerging towards the end of the seventeenth century was a civilisation exhilaratingly new perhaps, but strange as Nineveh and Babylon. That is why, since the rise of Christianity, there is no landmark in history that is worthy to be compared with this.

The Scientific Revolution

The Scientific Revolution: The History of a Term

There was no such thing as the Scientific Revolution, and this [selection is from] a book about it. Some time ago, when the academic world offered more certainty and more comforts, historians announced the real existence of a coherent, cataclysmic, and climactic event that fundamentally and irrevocably changed what people knew about the natural world and how they secured proper knowledge of that world. It was the moment at which the world was made modern, it was a Good Thing, and it happened sometime during the period from the late sixteenth to the early eighteenth century. In 1943 the French historian Alexandre Koyré celebrated the conceptual changes at the heart of the Scientific Revolution as "the most profound revolution achieved or suffered by the human mind" since Greek antiquity. It was a revolution so profound that human culture "for centuries did not grasp its bearing or meaning; which, even now, is often misvalued and misunderstood." A few years later the English historian Herbert Butterfield famously judged that the Scientific Revolution "outshines everything since the rise of Christianity and reduces the Renaissance and Reformation to the rank of mere episodes.... [It is] the real origin both of the modern world and of the modern mentality." It was, moreover, construed as a conceptual revolution, a fundamental reordering of our ways of *thinking* about the natural. In this respect, a story about the Scientific Revolution might be adequately told through an account of radical changes in the fundamental categories of thought. To Butterfield, the mental changes making up the Scientific Revolution were equivalent to "putting on a new pair of spectacles." And to A. Rupert Hall it was nothing less than "an *a priori* redefinition of the objects of philosophical and scientific inquiry."

This conception of the Scientific Revolution is now encrusted with tradition. Few historical episodes present themselves as more substantial or more self-evidently worthy of study. There is an established place for accounts of the Scientific Revolution in the Western liberal curriculum, and this [selection] is an attempt to fill that space economically and to invite further curiosity about the making of early modern science. Nevertheless, like

many twentieth-century "traditions," that contained in the notion of the Scientific Revolution is not nearly as old as we might think. The phrase "the Scientific Revolution" was probably coined by Alexandre Koyré in 1939, and it first became a book title in A. Rupert Hall's *The Scientific Revolution* of 1954. Before that time there was no event to be studied in the liberal curriculum, nor any discrete object of historical inquiry, called the Scientific Revolution. Although many seventeenth-century practitioners expressed their intention of bringing about radical intellectual change, the people who are said to have made the revolution used no such term to refer to what they were doing.

From antiquity through the early modern period, a "revolution" invoked the idea of a periodically recurring cycle. In Copernicus's new astronomy of the mid-sixteenth century, for example, the planets completed their revolutions round the sun, while references to political revolutions gestured at the notion of ebbs and flows or cycles—fortune's wheel—in human affairs. The idea of revolution as a radical and irreversible reordering developed together with linear, unidirectional conceptions of time. In this newer conception revolution was not recurrence but its reverse, the bringing about of a new state of affairs that the world had never witnessed before and might never witness again. Not only this notion of revolution but also the beginnings of an idea of revolution in science date from the eighteenth century writings of French Enlightenment philosophes who liked to portray themselves, and their disciplines, as radical subverters of ancien régime culture. (Some... seventeenth-century writers... saw themselves not as bringing about totally new states of affairs but as restoring or purifying old ones.) The notion of a revolution as epochal and irreversible change, it is possible, was first applied in a systematic way to events in science and only later to political events. In just this sense, the first revolutions may have been scientific, and the "American," "French," and "Russian Revolutions" are its progeny.

As our understanding of science in the seventeenth century has changed in recent years, so historians have become increasingly uneasy with the very idea of "the Scientific Revolution." Even the legitimacy of each word making up that phrase has been individually contested. Many historians are now no longer satisfied that there was any singular and discrete event, localized in time and space, that can be pointed to as "the" Scientific Revolution. Such historians now reject even the notion that there was any single coherent cultural entity called "science" in the seventeenth century to undergo revolutionary change. There was, rather, a diverse array of cultural practices aimed at understanding, explaining, and controlling the natural world, each with different characteristics and each experiencing different modes of change. We are now much more dubious of claims that there is anything like "a scientific method"—a coherent, universal, and efficacious set of procedures for making scientific knowledge—and still more skeptical of stories that locate its origin in the seventeenth century, from which time it has been unproblematically passed on to us. And many historians do not now accept that the changes wrought on scientific beliefs and practices during the seventeenth century were as "revolutionary" as has been widely portrayed. The continuity of seventeenth-century natural philosophy with its

medieval past is now routinely asserted, while talk of "delayed" eighteenth- and nineteenth-century revolutions in chemistry and biology followed hard upon historians' identification of "the" original Scientific Revolution.

Why Write About the Scientific Revolution?

There are still other reasons for historians' present uneasiness with the category of the Scientific Revolution as it has been customarily construed. First, historians have in recent years become dissatisfied with the traditional manner of treating ideas as if they floated freely in conceptual space. Although previous accounts framed the Scientific Revolution in terms of autonomous ideas or disembodied mentalities, more recent versions have insisted on the importance of situating ideas in their wider cultural and social context. We now hear more than we used to about the relations between the scientific changes of the seventeenth century and changes in religious, political, and economic patterns. More fundamentally, some historians now wish to understand the concrete human *practices* by which ideas or concepts are made. What did people *do* when they made or confirmed an observation, proved a theorem, performed an experiment? An account of the Scientific Revolution as a history of free-floating concepts is a very different animal from a history of concept-making practices. Finally, historians have become much more interested in the "who" of the Scientific Revolution. What kinds of people wrought such changes? Did everyone believe as they did, or only a very few? And if only a very few took part in these changes, in what sense, if at all, can we speak of the Scientific Revolution as effecting massive changes in how "we" view the world, as the moment when modernity was made, for "us"? The cogency of such questions makes for problems in writing as unreflectively as we used to about the Scientific Revolution. Responding to them means that we need an account of changes in early modern science appropriate for our less confident, but perhaps more intellectually curious, times.

Yet despite these legitimate doubts and uncertainties there remains a sense in which it is possible to write about the Scientific Revolution unapologetically and in good faith. There are two major considerations to bear in mind here. The first is that many key figures in the late sixteenth and seventeenth centuries vigorously expressed *their* view that they were proposing some very new and very important changes in knowledge of natural reality and in the practices by which legitimate knowledge was to be secured, assessed, and communicated. They identified *themselves* as "moderns" set against "ancient" modes of thought and practice. Our sense of radical change afoot comes substantially from them (and those who were the object of their attacks), and is not simply the creation of mid-twentieth-century historians. So we can say that the seventeenth century witnessed some self-conscious and large-scale attempts to change belief, and ways of securing belief, about the natural world. And a book about the Scientific Revolution can legitimately tell a story about those attempts, whether or not they succeeded, whether or not they were contested in the local culture, whether or not they were wholly coherent.

But why do we tell *these* stories instead of others? If different sorts of seventeenth-century people believed different things about the world, how do we assemble our cast of characters and associated beliefs? Some "natural philosophers," for example, advocated rational theorizing, while others pushed a program of relatively atheoretical fact collecting and experimentation. Mathematical physics was, for example, a very different sort of practice from botany. There were importantly different versions of what it was to do astronomy and believe as an astronomer believed; the relations between the "proper sciences" of astronomy and chemistry and the "pseudosciences" of astrology and alchemy were intensely problematic; and even the category of "nature" as the object of inquiry was understood in radically different ways by different sorts of practitioners. This point cannot be stressed too strongly. The cultural practices subsumed in the category of the Scientific Revolution—however it has been construed—are not coextensive with early modern, or seventeenth-century, science. Historians differ about which practices were "central" to the Scientific Revolution, and participants themselves argued about which practices produced genuine knowledge and which had been fundamentally reformed.

More fundamentally for criteria of selection, it ought to be understood that "most people"—even most educated people—in the seventeenth century did not believe what expert scientific practitioners believed, and the sense in which "people's" thought about the world was revolutionized at that time is very limited. There should be no doubt whatever that one could write a convincing history of seventeenth-century thought about nature without even *mentioning* the Scientific Revolution as traditionally construed.

The very idea of the Scientific Revolution, therefore, is at least partly an expression of "our" interest in our ancestors, where "we" are late twentieth-century scientists and those for whom what they believe counts as truth about the natural world. And this interest provides the second legitimate justification for writing about the Scientific Revolution. Historians of science have now grown used to condemning "present-oriented" history, rightly saying that it often distorts our understanding of what the past was like in its own terms. Yet there is absolutely no reason we should not want to know how we got from there to here, who the ancestors were, and what the lineage is that connects us to the past. In this sense a story about the seventeenth-century Scientific Revolution can be an account of those changes that we think led on—never directly or simply, to be sure—to certain features of the present in which, for certain purposes, we happen to be interested. To do this would be an expression of just the same sort of legitimate historical interest displayed by Darwinian evolutionists telling stories about those branches of the tree of life that led to human beings—without assuming in any way that such stories are adequate accounts of what life was like hundreds of thousands of years ago. There is nothing at all wrong about telling such stories, though one must always be careful not to claim too much scope for them. Stories about the ancestors as ancestors are not likely to be sensitive accounts of how it was in the past: the lives and thoughts of Galileo, Descartes, or Boyle were hardly typical of seventeenth-century Italians, Frenchmen, or Englishmen, and telling stories about them geared solely to their ancestral role in formulating the currently accepted law of free fall, the

optics of the rainbow, or the ideal gas law is not likely to capture very much about the meaning and significance of their own careers and projects in the seventeenth century.

The past is not transformed into the "modern world" at any single moment: we should never be surprised to find that seventeenth-century scientific practitioners often had about them as much of the ancient as the modern; their notions had to be successively transformed and redefined by generations of thinkers to become "ours." And finally, the people, the thoughts, and the practices we tell stories about as "ancestors," or as the beginnings of our lineage, always reflect some present-day interest. That we tell stories about Galileo, Boyle, Descartes, and Newton reflects something about our late twentieth-century scientific beliefs and what we value about those beliefs. For different purposes we could trace aspects of the modern world back to philosophers "vanquished" by Galileo, Boyle, Descartes, and Newton, and to views of nature and knowledge very different from those elaborated by our officially sanctioned scientific ancestors. For still other purposes we could make much of the fact that most seventeenth-century people had never heard of our scientific ancestors and probably entertained beliefs about the natural world very different from those of our chosen forebears. Indeed, the overwhelming majority of seventeenth-century people did not live in Europe, did not know that they lived in "the seventeenth century," and were not aware that a Scientific Revolution was happening. The half of the European population that was female was in a position to participate in scientific culture scarcely at all, as was that overwhelming majority—of men and women—who were illiterate or otherwise disqualified from entering the venues of formal learning.

Some Historiographical Issues

I mean this [selection] to be historiographically up to date—drawing on some of the most recent historical, sociological, and philosophical engagements with the Scientific Revolution. On the other hand, I do not mean to trouble readers with repeated references to methodological and conceptual debates among academics. This [selection] is not written for professional specialized scholars.... There is no reason to deny that this story about the Scientific Revolution represents a particular point of view, and that, although I help myself freely to the work of many distinguished scholars, its point of view is my own. Other specialists will doubtless disagree with my approach—some vehemently—and a large number of existing accounts do offer a quite different perspective on what is worth telling about the Scientific Revolution. The positions represented here on some recent historiographic issues can be briefly summarized:

1. I *take for granted* that science is a historically situated and social activity and that it is to be understood in relation to the *contexts* in which it occurs. Historians have long argued whether science relates to its historical and social contexts or whether it should be treated in isolation. I shall simply write about seventeenth-century science as if it were a collectively practiced, historically embedded phenomenon, inviting readers to see whether the account is plausible, coherent, and interesting.

2. For a long time, historians' debates over the propriety of a sociological and a historically "contextual" approach to science seemed to divide practitioners between those who drew attention to what were called "intellectual factors" —ideas, concepts, methods, evidence—and those who stressed "social factors"— forms of organization, political and economic influences on science, and social uses or consequences of science. That now seems to many historians, as it does to me, a rather silly demarcation, and I shall not waste readers' time here in reviewing why those disputes figured so largely in past approaches to the history of early modern science. If science is to be understood as historically situated and in its collective aspect (i.e., sociologically), then that understanding should encompass all aspects of science, its ideas and practices no less than its institutional forms and social uses. Anyone who wants to represent science sociologically cannot simply set aside the body of what the relevant practitioners *knew* and how they went about obtaining that knowledge. Rather, the task for the sociologically minded historian is to display the structure of knowledge making and knowledge holding *as social processes*.

3. A traditional construal of "social factors" (or what is sociological about science) has focused on considerations taken to be "external" to science proper —for example, the use of metaphors from the economy in the development of scientific knowledge or the ideological uses of science in justifying certain sorts of political arrangements. Much fine historical work has been done based on such a construal. However, the identification of what is sociological about science with what is external to science appears to me a curious and a limited way of going on. There is as much "society" inside the scientist's laboratory, and internal to the development of scientific knowledge, as there is "outside." And in fact the very distinction between the social and the political, on the one hand, and "scientific truth," on the other, is partly a cultural product of the period [I discuss]. What is commonsensically thought of as science in the late twentieth century is in some measure a product of the historical episodes we want to understand here. Far from matter-of-factly treating the distinction between the social and the scientific as a resource in telling a historical story, I mean to make it into a topic of inquiry. How and why did we come to think that such a distinction is a matter *of course?*

4. I do not consider that there is anything like an "essence" of seventeenth-century science or indeed of seventeenth-century reforms in science. Consequently there is no single coherent story that could possibly capture all the aspects of science or its changes in which we late twentieth-century moderns might happen to be interested. I can think of no feature of early modern science that has been traditionally identified as its revolutionary essence that did not have significantly variant contemporary forms or that was not subjected to contemporary criticism by practitioners who have also been accounted revolutionary "moderns." . . .

⋘⟐⟩⋙

The confrontation over Newton's optical work can stand as an emblem of the fragmented knowledge-making legacies of the seventeenth century. A theoreti-

cally cautious and experience-based conception of science was here juxtaposed to one that deployed mathematical as well as experimental tools to claim theoretical certainty. Diffidence was opposed to ambition, respect for the concrete particularities of nature to the quest for universally applicable idealizations, the modesty of the fact gatherer to the pride of the abstracted philosopher. Do you want to capture the essence of nature and command assent to representations of its regularities? Do you want to subject yourself to the discipline of describing, and perhaps generalizing about, the behavior of medium-sized objects actually existing in the world?

Both conceptions of science persist in the late twentieth century, and both can trace elements of their formation back to the seventeenth century. The one is not necessarily to be regarded as a failed version of the other, however much partisans may defend the virtues of their preferred practice and condemn the vices of another. These are, so to speak, different games that natural philosophers might wish to play, and decisions about which game is best are different in kind from decisions about what is a sensible move within a given game: an accurate pass from midfield to the winger in soccer is not a bad jump shot in basketball. In the seventeenth century natural philosophers were confronted with differing repertoires of practical and conceptual skills for achieving various philosophical goals and with choices about which ends they might work to achieve. The goal was always some conception of proper philosophical knowledge about the natural world, though descriptions of what that knowledge looked like and how it was to be secured varied greatly.

POSTSCRIPT

Was the Scientific Revolution Revolutionary?

The question of whether or not the Scientific Revolution was revolutionary is a philosophical as well as a historical one. At issue is how we understand key terms such as *science* and *revolution* as well as how we interpret what philosophers call "epistemology," or knowledge theory. Both historians agree that key people in the past understood that what they were doing represented a break with the past. Where they disagree is over how to evaluate the past in the context of what we know in the present. Butterfield assumes that we can all agree on the meaning of science, but Shapin questions his definition. In the 40 years between Butterfield's and Shapin's books, knowledge theory has changed. Taking apart texts to reveal their hidden meanings has led many to question whether or not it is possible to have a single, universal meaning for a term like *science*. What the word may have meant to people practicing it in the seventeenth century may be worlds away from what it means to people practicing it today. And those of us outside the scientific community in either period generally have even less idea what may be at stake.

Thomas Kuhn, whose widely read book *The Structure of Scientific Revolutions* (University of Chicago Press, 1962, 1970) has shed some light on this controversy, combines continuity with discontinuity. Revolutions, Kuhn contends, are occasional, dramatic breaks from periods of what he calls "normal science," when everyone in the scientific community operates from within an accepted paradigm. Revolutions occur when experiments repeatedly do not yield the expected results or when data do not conform to predicted outcomes. Scientists struggle to make the new material fit the old paradigm; those who challenge the paradigm are marginalized or forced to conform. When it becomes clear that the paradigm has broken down, a new paradigm is accepted. Then everything is explained in terms of the new paradigm. Students are educated in the new paradigm, textbooks are written to reflect it, and research takes it as its starting point. Has the world changed or only our way of explaining it to ourselves?

A selection from Kuhn's book is the concluding essay in Vern L. Bullough, ed., *The Scientific Revolution* (Holt, Rinehart & Winston, 1970). The opening essay is an excerpt from Andrew Dickson White's classic *A History of the Warfare of Science With Theology*, which was first published in 1896. A more modern collection of essays appears in *Reappraisals of the Scientific Revolution*, edited by David C. Lindberg and Robert S. Westman (Cambridge University Press, 1990). In it, essays by philosophers of science and historians consider conceptions of science and the relationship between philosophy and science.

ISSUE 18

Did the West Define the Modern World?

YES: William H. McNeill, from *The Rise of the West: A History of the Human Community* (University of Chicago Press, 1991)

NO: Steven Feierman, from "African Histories and the Dissolution of World History," in Robert H. Bates, V. Y. Mudimbe, and Jean O'Barr, eds., *Africa and the Disciplines: The Contributions of Research in Africa to the Social Sciences and Humanities* (University of Chicago Press, 1993)

ISSUE SUMMARY

YES: Professor of history William H. McNeill states that in 1500, western Europe began to extend its influence to other parts of the world, resulting in a revolution in world relationships in which the West was the principal benefactor.

NO: History professor Steven Feierman argues that because historians have viewed modern history in a unidirectional (European) manner, the contributions of non-European civilizations to world history have gone either undiscovered or unreported.

It seems to be widely accepted that beginning in 1500, western Europe embarked on a course of world domination, the effects of which are still with us today. Due to factors such as superior military technology, immunity to diseases that ravaged others, and a strong will to succeed, Europeans were able to extend their influence over peoples in other parts of the world. An immediate result of this was the trans-Atlantic slave trade where Europeans traded products, including firearms, for human cargo. Since they were able to find African leaders willing to participate in this horrific practice, the Europeans did not have to penetrate into the heart of Africa to make their profits. The slaves-to-be were brought to coastal fortresses called "factories" to wait for the Western ships and the inhumane exchange to take place. It would not be until the nineteenth century that Europeans would begin to directly assert themselves into African affairs in what has been called the "Age of Imperialism."

In Asia the system was different, but with similar economic results. Trading posts were set up throughout Asia, particularly in India—and later—China,

where the Portuguese, Dutch, French, and British established commercial rivalries. These led to greater control over larger areas where the Europeans exploited the existence of local rivalries and corrupt, incompetent leaders to further their economic interests. These too would lead to a more direct control over some of the nations of Asia during the nineteenth century and a more indirect control over others.

Many have assumed that the capitalism and democracy that are so prominent among the world's nations today are part of a legacy that non-Western nations inherited from their contact with the West. In this view, the Western way was the wave of the future. Also, the West's technological and military superiority over the past 500 years have naturally led generations of Western historians to look at the last half-millennium through the eyes of their worldview. When the civilizations of the non-Western world were considered at all, they were simply included in a marginal and ancillary way.

All of this changed with the end of colonialism, an important result of World War II. The former colonies, mandated territories, and Western-controlled areas were now free and independent nations, ready to determine their own destinies—and interpret their own histories. In this process, they were joined by a generation of new Western historians, who did not see the world through Eurocentric-colored glasses. Together, they forced the historical profession to reevaluate the Eurocentric view of the world's last 500 years.

William H. McNeill's book *The Rise of the West*, first published in 1962, has achieved classic status among world history books. In the following selection from that book, McNeill operates from the thesis that from the earliest historical times, world civilizations have had contact with one another. He refers to this process as *ecumene* (from the Greek, meaning one world). From these contacts came exchanges of all types, which altered those civilizations in particular and the world in general. He states that this process has affected the scope of history, although it is the West—as the title of his book implies—that has benefited the most from the process. McNeill concludes that this superiority began during the Age of Exploration of the sixteenth century and continues to influence the current world.

Steven Feierman represents the new generation of historians, who are not wedded to a Western analysis of the world's history. He utilizes African social and intellectual history (his area of expertise) to argue for the need to explain the past through non-Western eyes. This will require not only a more inclusionary approach to the study of the world's past, Feierman asserts, but also new tools and attitudes to be used in analyzing and evaluating world civilizations, many of which might be considered nontraditional from a Western perspective. But it will mainly require open minds on the part of future historians to be willing to move away from the unidirectional view of the past that has dominated the historical profession for so long.

William H. McNeill

The Far West's Challenge to the World, 1500–1700 A.D.

T he year 1500 A.D. aptly symbolizes the advent of the modern era, in world as well as in European history. Shortly before that date, technical improvements in navigation pioneered by the Portuguese under Prince Henry the Navigator (d. 1460) reduced to tolerable proportions the perils of the stormy and tide-beset North Atlantic. Once they had mastered these dangerous waters, European sailors found no seas impenetrable, nor any ice-free coast too formidable for their daring. In rapid succession, bold captains sailed into distant and hitherto unknown seas: Columbus (1492), Vasco da Gama (1498), and Magellan (1519–22) were only the most famous.

The result was to link the Atlantic face of Europe with the shores of most of the earth. What had always before been the extreme fringe of Eurasia became, within little more than a generation, a focus of the world's sea lanes, influencing and being influenced by every human society within easy reach of the sea. Thereby the millennial land-centered balance among the Eurasian civilizations was abruptly challenged and, within three centuries, reversed. The sheltering ocean barrier between the Americas and the rest of the world was suddenly shattered, and the slave trade brought most of Africa into the penumbra of civilization. Only Australia and the smaller islands of the Pacific remained for a while immune; yet by the close of the eighteenth century, they too began to feel the force of European seamanship and civilization.

Western Europe, of course, was the principal gainer from this extraordinary revolution in world relationships, both materially and in a larger sense, for it now became the pre-eminent meeting place for novelties of every kind. This allowed Europeans to adopt whatever pleased them in the tool kits of other peoples and stimulated them to reconsider, recombine, and invent anew within their own enlarged cultural heritage. The Amerindian civilizations of Mexico and Peru were the most conspicuous victims of the new world balance, being suddenly reduced to a comparatively simple village level after the directing classes had been destroyed or demoralized by the Spaniards. Within the Old World, the Moslem peoples lost their central position in the ecumene as ocean routes supplanted overland portage. Only in the Far East were the effects of the new constellation of world relationships at first unimportant. From a Chinese

viewpoint it made little difference whether foreign trade, regulated within traditional forms, passed to Moslem or European merchants' hands. As soon as European expansive energy seemed to threaten their political integrity, first Japan and then China evicted the disturbers and closed their borders against further encroachment. Yet by the middle of the nineteenth century, even this deliberate isolation could no longer be maintained; and the civilizations of the Far East—simultaneously with the primitive cultures of central Africa—began to stagger under the impact of the newly industrialized European (and extra-European) West.

The key to world history from 1500 is the growing political dominance first of western Europe, then of an enlarged European-type society planted astride the north Atlantic and extending eastward into Siberia. Yet until about 1700, the ancient landward frontiers of the Asian civilizations retained much of their old significance. Both India (from 1526) and China (by 1644) suffered yet another conquest from across these frontiers; and the Ottoman empire did not exhaust its expansive power until near the close of the seventeenth century. Only in Central America and western South America did Europeans succeed in establishing extensive land empires overseas during this period. Hence the years 1500–1700 may be regarded as transitional between the old land-centered and the new ocean-centered pattern of ecumenical relationships—a time when European enterprise had modified, but not yet upset the fourfold balance of the Old World.

The next major period, 1700–1850, saw a decisive alteration of the balance in favor of Europe, except in the Far East. Two great outliers were added to the Western world by the Petrine conversion of Russia and by the colonization of North America. Less massive offshoots of European society were simultaneously established in southernmost Africa, in the South American pampas, and in Australia. India was subjected to European rule; the Moslem Middle East escaped a similar fate only because of intra-European rivalries; and the barbarian reservoir of the Eurasian steppes lost its last shreds of military and cultural significance with the progress of Russian and Chinese conquest and colonization.

After 1850, the rapid development of mechanically powered industry enormously enhanced the political and cultural primacy of the West. At the beginning of this period, the Far Eastern citadel fell before Western gunboats; and a few of the European nations extended and consolidated colonial empires in Asia and Africa. Although European empires have decayed since 1945, and the separate nation-states of Europe have been eclipsed as centers of political power by the melding of peoples and nations occurring under the aegis of both the American and Russian governments, it remains true that, since the end of World War II, the scramble to imitate and appropriate science, technology, and other aspects of Western culture has accelerated enormously all round the world. Thus the dethronement of western Europe from its brief mastery of the globe coincided with (and was caused by) an unprecedented, rapid Westernization of all the peoples of the earth. The rise of the West seems today still far from its apogee; nor is it obvious, even in the narrower political sense, that the era of Western dominance is past. The American and Russian outliers of

European civilization remain militarily far stronger than the other states of the world, while the power of a federally reorganized western Europe is potentially superior to both and remains inferior only because of difficulties in articulating common policies among nations still clinging to the trappings of their decaying sovereignties.

<center>⌘</center>

From the perspective of the mid-twentieth century, the career of Western civilization since 1500 appears as a vast explosion, far greater than any comparable phenomenon of the past both in geographic range and in social depth. Incessant and accelerating self-transformation, compounded from a welter of conflicting ideas, institutions, aspirations, and inventions, has characterized modern European history; and with the recent institutionalization of deliberate innovation in the form of industrial research laboratories, universities, military general staffs, and planning commissions of every sort, an accelerating pace of technical and social change bids fair to remain a persistent feature of Western civilization.

This changeability gives the European and Western history of recent centuries both a fascinating and a confusing character. The fact that we are heirs but also prisoners of the Western past, caught in the very midst of an unpredictable and incredibly fast-moving flux, does not make it easier to discern critical landmarks, as we can, with equanimity if not without error, for ages long past and civilizations alien to our own.

... Fortunately, a noble array of historians has traversed the ground already, so that it is not difficult to divide Western history into periods, nor to characterize such periods with some degree of plausibility. A greater embarrassment arises from the fact that suitable periods of Western history do not coincide with the benchmarks of modern world history. This is not surprising, for Europe had first to reorganize itself at a new level before the effects of its increased power could show themselves significantly abroad. One should therefore expect to find a lag between the successive self-transformations of European society and their manifestations in the larger theater of world history....

The Great European Explorations and Their World-Wide Consequences

Europeans of the Atlantic seaboard possessed three talismans of power by 1500 which conferred upon them the command of all the oceans of the world within half a century and permitted the subjugation of the most highly developed regions of the Americas within a single generation. These were: (1) a deep-rooted pugnacity and recklessness operating by means of (2) a complex military technology, most notably in naval matters; and (3) a population inured to a variety of diseases which had long been endemic throughout the Old World ecumene.

The Bronze Age barbarian roots of European pugnacity and the medieval survival of military habits among the merchant classes of western Europe, as

well as among aristocrats and territorial lords of less exalted degree, [are worth emphasizing.] Yet only when one remembers the all but incredible courage, daring, and brutality of Cortez and Pizarro in the Americas, reflects upon the ruthless aggression of Almeida and Albuquerque in the Indian Ocean, and discovers the disdain of even so cultivated a European as Father Matteo Ricci for the civility of the Chinese, does the full force of European warlikeness, when compared with the attitudes and aptitudes of other major civilizations of the earth, become apparent. The Moslems and the Japanese could alone compare in the honor they paid to the military virtues. But Moslem merchants usually cringed before the violence held in high repute by their rulers and seldom dared or perhaps cared to emulate it. Hence Moslem commercial enterprise lacked the cutting edge of naked, well-organized, large-scale force which constituted the chief stock-in-trade of European overseas merchants in the sixteenth century. The Japanese could, indeed, match broadswords with any European; but the chivalric stylization of their warfare, together with their narrowly restricted supply of iron, meant that neither *samurai* nor a sea pirate could reply in kind to a European broadside.

Supremacy at sea gave a vastly enlarged scope to European warlikeness after 1500. But Europe's maritime superiority was itself the product of a deliberate combination of science and practice, beginning in the commercial cities of Italy and coming to fruition in Portugal through the efforts of Prince Henry the Navigator and his successors. With the introduction of the compass (thirteenth century), navigation beyond sight of land had become a regular practice in the Mediterranean; and the navigators' charts, or *portolans,* needed for such voyaging showed coasts, harbors, landmarks, and compass bearings between major ports. Although they were drawn freehand, without any definite mathematical projection, *portolans* nevertheless maintained fairly accurate scales of distances. But similar mapping could be applied to the larger distances of Atlantic navigation only if means could be found to locate key points along the coast accurately. To solve this problem, Prince Henry brought to Portugal some of the best mathematicians and astronomers of Europe, who constructed simple astronomical instruments and trigonometrical tables by which ship captains could measure the latitude of newly discovered places along the African coast. The calculation of longitude was more difficult; and, until a satisfactory marine chronometer was invented in the eighteenth century, longitude could be approximated only be dead reckoning. Nevertheless, the new methods worked out at Prince Henry's court allowed the Portuguese to make usable charts of the Atlantic coasts. Such charts gave Portuguese sea captains courage to sail beyond sight of land for weeks and presently for months, confident of being able to steer their ships to within a few miles of the desired landfall.

The Portuguese court also accumulated systematic information about oceanic winds and currents; but this data was kept secret as a matter of high policy, so that modern scholars are uncertain how much the early Portuguese navigators knew. At the same time, Portuguese naval experts attacked the problem of improving ship construction. They proceeded by rule of thumb; but deliberate experiment, systematically pursued, rapidly increased the seaworthiness, maneuverability, and speed of Portuguese and presently (since

improvements in naval architecture could not be kept secret) of other European ships. The most important changes were: a reduction of hull width in proportion to length; the introduction of multiple masts (usually three or four); and the substitution of several smaller, more manageable sails for the single sail per mast from which the evolution started. These innovations allowed a crew to trim the sails to suit varying conditions of wind and sea, thus greatly facilitating steering and protecting the vessel from disaster in sudden gales.

With these improvements, larger ships could be built; and increasing size and sturdiness of construction made it possible to transform seagoing vessels into gun platforms for heavy cannon. Thus by 1509, when the Portuguese fought the decisive battle for control of the Arabian Sea off the Indian port of Diu, their ships could deliver a heavy broadside at a range their Moslem enemies could not begin to match. Under such circumstances, the superior numbers of the opposing fleet simply provided the Portuguese with additional targets for their gunnery. The old tactics of sea fighting—ramming, grappling, and boarding—were almost useless against cannon fire effective at as much as 200 yards distance.

The third weapon in the European armory—disease—was quite as important as stark pugnacity and weight of metal. Endemic European diseases like smallpox and measles became lethal epidemics among Amerindian populations, who had no inherited or acquired immunities to such infections. Literally millions died of these and other European diseases; and the smallpox epidemic raging in Tenochtitlan when Cortez and his men were expelled from the citadel in 1520 had far more to do with the collapse of Aztec power than merely military operations. The Inca empire, too, may have been ravaged and weakened by a similar epidemic before Pizarro ever reached Peru.

On the other hand, diseases like yellow fever and malaria took a heavy toll of Europeans in Africa and India. But climatic conditions generally prevented new tropical diseases from penetrating Europe itself in any very serious fashion. Those which could flourish in temperate climates, like typhus, cholera, and bubonic plague, had long been known throughout the ecumene; and European populations had presumably acquired some degree of resistance to them. Certainly the new frequency of sea contact with distant regions had important medical consequences for Europeans, as the plagues for which Lisbon and London became famous prove. But gradually the infections which in earlier centuries had appeared sporadically as epidemics became merely endemic, as the exposed populations developed a satisfactory level of resistance. Before 1700, European populations had therefore successfully absorbed the shocks that came with the intensified circulation of diseases initiated by their own sea voyaging. Epidemics consequently ceased to be demographically significant. The result was that from about 1650 (or before), population growth in Europe assumed a new velocity. Moreover, so far as imperfect data allow one to judge, between 1550 and 1650 population also began to spurt upward in China, India, and the Middle East. Such an acceleration of population growth within each of the great civilizations of the Old World can scarcely be a mere coincidence. Presumably the same ecological processes worked themselves out in all parts of

the ecumene, as age-old epidemic checks upon population faded into merely endemic attrition.

The formidable combination of European warlikeness, naval technique, and comparatively high levels of resistance to disease transformed the cultural balance of the world within an amazingly brief period of time. Columbus linked the Americas with Europe in 1492; and the Spaniards proceeded to explore, conquer, and colonize the New World with extraordinary energy, utter ruthlessness, and an intense missionary idealism. Cortez destroyed the Aztec state in 1519–21; Pizarro became master of the Inca empire between 1531 and 1535. Within the following generation, less famous but no less hardy conquistadores founded Spanish settlements along the coasts of Chile and Argentina, penetrated the highlands of Ecuador, Colombia, Venezuela, and Central America, and explored the Amazon basin and the southern United States. As early as 1571, Spanish power leaped across the Pacific to the Philippines, where it collided with the sea empire which their Iberian neighbors, the Portuguese, had meanwhile flung around Africa and across the southern seas of the Eastern Hemisphere.

Portuguese expansion into the Indian Ocean proceeded with even greater rapidity. Exactly a decade elapsed between the completion of Vasco da Gama's first voyage to India (1497–99) and the decisive Portuguese naval victory off Diu (1509). The Portuguese quickly exploited this success by capturing Goa (1510) and Malacca (1511), which together with Ormuz on the Persian Gulf (occupied permanently from 1515) gave them the necessary bases from which to dominate the trade of the entire Indian Ocean. Nor did they rest content with these successes. Portuguese ships followed the precious spices to their farthest source in the Moluccas without delay (1511–12); and a Portuguese merchant-explorer traveling on a Malay vessel visited Canton as early as 1513–14. By 1557, a permanent Portuguese settlement was founded at Macao on the south China coast; and trade and missionary activity in Japan started in the 1540's. On the other side of the world, the Portuguese discovered Brazil in 1500 and began to settle the country after 1530. Coastal stations in both west and east Africa, established between 1471 and 1507, completed the chain of ports of call which held the Portuguese empire together.

No other European nations approached the early success of Spain and Portugal overseas. Nevertheless, the two Iberian nations did not long enjoy undisturbed the new wealth their enterprise had won. From the beginning, the Spaniards found it difficult to protect their shipping against French and Portuguese sea raiders. English pirates offered an additional and formidable threat after 1568, when the first open clash between English interlopers and the Spanish authorities in the Caribbean took place. Between 1516 and 1568 the other great maritime people of the age, the Dutch, were subjects of the same Hapsburg monarchs who ruled in Spain and, consequently, enjoyed a favored status as middlemen between Spanish and north European ports. Initially, therefore, Dutch shipping had no incentive to harass Iberian sea power.

This naval balance shifted sharply in the second half of the sixteenth century, when the Dutch revolt against Spain (1568), followed by the English victory over the Spanish armada (1588), signalized the waning of Iberian sea

power before that of the northern European nations. Harassment of Dutch ships in Spanish ports simply accelerated the shift; for the Dutch responded by despatching their vessels directly to the Orient (1594), and the English soon followed suit. Thereafter, Dutch naval and commercial power rapidly supplanted that of Portugal in the southern seas. The establishment of a base in Java (1618), the capture of Malacca from the Portuguese (1641), and the seizure of the most important trading posts of Ceylon (by 1644) secured Dutch hegemony in the Indian Ocean; and during the same decades, English traders gained a foothold in western India. Simultaneously, English (1607), French (1608), and Dutch (1613) colonization of mainland North America, and the seizure of most of the smaller Caribbean islands by the same three nations, infringed upon Spanish claims to monopoly in the New World, but failed to dislodge Spanish power from any important area where it was already established.

⠀⠀⠀⠀⠀⠀⠀⠀⠀⠀⠀⠀⠀⠀⠀⠀*◆*

The truly extraordinary *élan* of the first Iberian conquests and the no less remarkable missionary enterprise that followed closely in its wake surely mark a new era in the history of the human community. Yet older landmarks of that history did not crumble all at once. Movement from the Eurasian steppes continued to make political history—for example, the Uzbek conquest of Transoxiana (1507–12) with its sequel, the Mogul conquest of India (1526–1688); and the Manchu conquest of China (1621–83).

Chinese civilization was indeed only slightly affected by the new regime of the seas; and Moslem expansion, which had been a dominating feature of world history during the centuries before 1500, did not cease or even slacken very noticeably until the late seventeenth century. Through their conquest of the high seas, western Europeans did indeed outflank the Moslem world in India and southeast Asia, while Russian penetration of Siberian forests soon outflanked the Moslem lands on the north also. Yet these probing extensions of European (or para-European) power remained tenuous and comparatively weak in the seventeenth century. Far from being crushed in the jaws of a vast European pincer, the Moslems continued to win important victories and to penetrate new territories in southeast Europe, India, Africa, and southeast Asia. Only in the western and central steppe did Islam suffer significant territorial setbacks before 1700.

Thus only two large areas of the world were fundamentally transformed during the first two centuries of European overseas expansion: the regions of Amerindian high culture and western Europe itself. European naval enterprise certainly widened the range and increased the intimacy of contacts among the various peoples of the ecumene and brought new peoples into touch with the disruptive social influences of high civilization. Yet the Chinese, Moslem, and Hindu worlds were not yet really deflected from their earlier paths of development; and substantial portions of the land surface of the globe—Australia and Oceania, the rain forests of South America, and most of North America and northeastern Asia—remained almost unaffected by Europe's achievement.

Nevertheless, a new dimension had been added to world history. An ocean frontier, where European seamen and soldiers, merchants, missionaries, and settlers came into contact with the various peoples of the world, civilized and uncivilized, began to challenge the ancient pre-eminence of the Eurasian land frontier, where steppe nomads had for centuries probed, tested, and disturbed civilized agricultural populations. Very ancient social gradients began to shift when the coasts of Europe, Asia, and America became the scene of more and more important social interactions and innovation. Diseases, gold and silver, and certain valuable crops were the first items to flow freely through the new transoceanic channels of communication. Each of these had important and far-reaching consequences for Asians as well as for Europeans and Amerindians. But prior to 1700, only a few isolated borrowings of more recondite techniques or ideas passed through the sea lanes that now connected the four great civilization of the Old World. In such exchanges, Europe was more often the receiver than the giver, for its people were inspired by a lively curiosity, insatiable greed, and a reckless spirit of adventure that contrasted sharply with the smug conservatism of Chinese, Moslem, and Hindu cultural leaders.

Partly by reason of the stimuli that flowed into Europe from overseas, but primarily because of internal tensions arising from its own heterogeneous cultural inheritance, Europe entered upon a veritable social explosion in the period 1500–1650—an experience painful in itself but which nonetheless raised European power to a new level of effectiveness and for the first time gave Europeans a clear margin of superiority over the other great civilizations of the world. . . .

Conclusion

Between 1500 and 1700, the Eurasian ecumene expanded to include parts of the Americas, much of sub-Saharan Africa, and all of northern Asia. Moreover, within the Old World itself, western Europe began to forge ahead of all rivals as the most active center of geographical expansion and of cultural innovation. Indeed, Europe's self-revolution transformed the medieval frame of Western civilization into a new and vastly more powerful organization of society. Yet the Moslem, Hindu, and Chinese lands were not yet seriously affected by the new energies emanating from Europe. Until after 1700, the history of these regions continued to turn around old traditions and familiar problems.

Most of the rest of the world, lacking the massive self-sufficiency of Moslem, Hindu, and Chinese civilization, was more acutely affected by contact with Europeans. In the New World, these contacts first decapitated and then decimated the Amerindian societies; but in other regions, where local powers of resistance were greater, a strikingly consistent pattern of reaction manifested itself. In such diverse areas as Japan, Burma, Siam, Russia, and parts of Africa, an initial interest in and occasional eagerness to accept European techniques, ideas, religion, or fashions of dress was supplanted in the course of the seventeenth century by a policy of withdrawal and deliberate insulation from European pressures. The Hindu revival in India and the reform of Lamaism in Tibet and Mongolia manifested a similar spirit; for both served to protect local

cultural values against alien pressures, though in these cases the pressures were primarily Moslem and Chinese rather than European.

A few fringe areas of the earth still remained unaffected by the disturbing forces of civilization. But by 1700 the only large habitable regions remaining outside the ecumene were Australia, the Amazon rain forest, and northwestern North America; and even these latter two had largely felt tremors of social disturbance generated by the approaching onset of civilization.

At no previous time in world history had the pace of social transformation been so rapid. The new density and intimacy of contacts across the oceans of the earth assured a continuance of cross-stimulation among the major cultures of mankind. The efforts to restrict foreign contacts and to withdraw from disturbing relationships with outsiders—especially with the restless and ruthless Westerners—were doomed to ultimate failure by the fact that successive self-transformations of western European civilization, and especially of Western technology, rapidly increased the pressures Westerners were able to bring against the other peoples of the earth. Indeed, world history since 1500 may be thought of as a race between the West's growing power to molest the rest of the world and the increasingly desperate efforts of other peoples to stave Westerners off, either by clinging more strenuously than before to their peculiar cultural inheritance or, when that failed, by appropriating aspects of Western civilization—especially technology—in the hope of thereby finding means to preserve their local autonomy.

NO ↵

Steven Feierman

African Histories and the Dissolution of World History

Once upon a time historians used to know that certain civilizations (Western ones) were their natural subject matter, that some political leaders (Thomas Jefferson, Napoleon, Charlemagne) were worth knowing about, and that particular periods and developments (the Renaissance, the Age of Enlightenment, the rise of the nation-state) were worthy of our attention. Other places, other people, other cultural developments less central to the course of Western civilization did not count. Now all of that has come into question. Historians no longer agree on the subjects about which they ought to write. . . .

The loss of agreement on history's subject is only one part of the change that provokes scholars to write about fragmentation and chaos. The debate on history's subject emerged at the same time that increasing numbers of historians began to doubt their own methods. Many now find it impossible to sustain the claims they might once have made that their choices of subject and method are based on objective knowledge. These historians have become acutely aware that their own writings, their ways of constructing a narrative, conceal some kinds of historical knowledge even while they reveal others, and that their choice of subject and method is a product of their own time and circumstances, not an inevitable outcome of the impersonal progress of historical science. This change, which has roots within contemporary philosophy, also emerges from the evolution of the historian's craft itself.

It is a profound paradox of history-writing in the most recent era that our faith in objective historical knowledge has been shaken precisely because of the advance of "knowledge" in its objective sense. The authoritative version of historical knowledge has been undermined because historians, in recent decades, have built bodies of knowledge about which their predecessors could only have dreamed. By carrying assumptions about historical knowledge through to their conclusions, historians have discovered some of the limits of those assumptions. . . .

One obvious consequence of the expansion of historical research in the years since 1960 has been to show just how limited were our earlier understandings. Much of the new specialized research focuses on people previously

excluded from the general history of humanity. The history of Africa is not alone in this respect. Alongside it are new bodies of knowledge on the history of medieval peasants, of barbarians in ancient Europe, of slaves on American plantations, and of women as the previously silent majority (silent, at least, in historians' accounts) in every time and place.

The very substantial dimensions of the gains in our knowledge have led to a sense of doubt rather than triumph. Historians now understand the dubious criteria according to which women and Africans, peasants and slaves were excluded from the histories of earlier generations. They therefore cannot help but wonder which populations, and which domains of human experience, they themselves are excluding today.

The previously excluded histories do not only present new data to be integrated into the larger narrative; they raise questions about the validity of that narrative itself. University historians integrate African history into the history of the eighteenth century, or the nineteenth, and yet many histories written or recited in Africa do not measure historical time in centuries. Academic historians appropriate bits of the African past and place them within a larger framework of historical knowledge which has European roots—the history of commodity exchange, for example. They rarely think of using bits of European history to amplify African narratives, about the succession of Akan shrines or the origin and segmentation of Tiv lineages.

Even before these more difficult issues began to trouble historians, the growth of knowledge about non-European societies began to undermine earlier histories, to bring into question narratives of academic history which, in the 1960s, seemed to be beyond reproach. The new knowledge showed that what was once thought to be universal history was in fact very partial and very selective. The narrative of human history which Western historians held at that time could no longer stand. Its destruction contributed to the sense of fragmentation and lost coherence. . . .

In the early 1960s it was still possible to describe human history in terms of a story with a single narrative thread, from the earliest periods until modern times. Now that possibility is gone. It is difficult for us to remember how profoundly our historical vision has changed unless we return to examine important works of that time. For example, William McNeill's *The Rise of the West*, published in 1963 when African history was just beginning to emerge, presented a unicentric and unidirectional narrative, of a kind that would not be acceptable today.

The Rise of the West divided the ancient world between "civilizations" and the land of "barbarians." The book focused on the diffusion of the techniques of civilization, originally from Mesopotamia, and then within the area McNeill calls the *ecumene,* as opposed to the land of the barbarians. *Oikoumenê* (one of Arnold Toynbee's terms) had been used also by the great anthropologist A. L. Kroeber to mean "the range of man's most developed cultures" and therefore "the millennially interrelated civilizations in the connected main land masses of the Eastern Hemisphere." This was an intercommunicating zone within which the basic techniques of civilization were created, and within which they spread.

The zone's boundaries shifted with time, but its early core was in the ancient Near East.

The origin of civilization, in McNeill's narrative, grows out of the introduction of agriculture. On this subject he takes contradictory positions but tries to maintain a single narrative thread. Even though the introduction explains that agriculture was introduced more than once, the book's narrative focuses on the central role of Mesopotamia, making a partial exception only for the introduction of agriculture in China. About the Americas, McNeill wrote, "Seeds or cuttings must have been carried across the ocean by human agency at a very early time." Then a bit later he explained that "contacts were far too limited and sporadic to allow the Amerindians to borrow extensively from the more advanced cultures of the Old World. As a result, the Andean and Mexican civilizations developed belatedly and never attained a mastery of their environment that could rival the levels attained by their contemporaries in Eurasia." He saw no possibility that domestication had independent beginnings in Africa and wrote that agriculture came to eastern and southern Africa only within the past five centuries. Until then, "primitive hunters roamed as their forefathers had done for untold millennia."

This statement is itself incorrect by millennia. We now know, as scholars of that generation did not, that animal domestication came very early to Africa (possibly earlier than to Southwest Asia), and that there were autonomous centers of crop domestication in Africa south of the Sahara.

Historians of McNeill's generation knew that great empires had grown up in sub-Saharan Africa by the first half of the present millennium—Ghana, Mali, Songhay, and other kingdoms in West Africa, and a great many kingdoms in eastern, central, and southern Africa, of which Zimbabwe was famous because of its great stone ruins. McNeill saw all of these as borrowings. The more advanced of Africa's societies, he wrote, "were never independent of the main civilizations of Eurasia." Islam, in his view, played a central role in bringing Eurasia's civilization to Africa. Even the southward migration of Bantu-speaking agriculturalists "may have been reinforced by the migration of tribes fleeing from Moslem pressures in the northwest."

Recent archaeological research in West Africa has shown that urbanism based on commerce came to West Africa before the birth of Islam. By about A.D. 500, Jenne, on the Niger River, emerged as a town built on local trade in agricultural surpluses drawn from lands flooded by the river. In this case, West Africans built their own town, which then grew further when Islam became important.

In central and southern Africa, also, kingdoms grew out of local roots. Zimbabwe is only one among the region's many stone ruins built in similar styles. These were sited so as to make farming and transhumant cattle-keeping possible as well as long-distance trade. As in West Africa, the evidence points to the growth of locally rooted centers which came ultimately to participate in long-distance trade. History can no longer be written as a single clear narrative of the spread of civilization's arts from the *ecumene*, the historical heartland, to Africa and other parts of the world.

Accounting for the new patterns challenged historians to find new ways of defining the spatial boundaries of important processes in world history. In this, as in so much else, the development of the *Annales* school of history writing in France interacted in creative ways with the development of African history. The creators of *Annales* history had a fresh historical vision; they challenged the orthodoxies of a style of history (associated with the legacy of Leopold von Ranke) that focused on the critical study of archival documents, especially as they related to the minutiae of political events. The early *Annalistes* reacted against the narrowly political definition of the historian's subject matter. Marc Bloch, in his early work, wrote about collectively held understandings of the world, in what seems to us now like an anthropological approach. Bloch, Lucien Febvre, and others were concerned with the history of society more generally, and not only with that narrow stratum to which the main political documents referred.

Fernand Braudel, the great leader of second-generation *Annales* historians, opened up the boundaries of historical space in a way that made it easier for us to understand Africa in world history. Many earlier scholars had limited themselves to national histories, of France, or of Italy, or of Spain. Others moved beyond national boundaries to continental ones. Braudel in his masterpiece saw the Mediterranean, with its palms and olive trees, as a significant historical unit, even though it took in parts of Europe and parts of Africa and Asia. It was tied together by its sea routes, but then extended wherever human communication took it: "We should imagine a hundred frontiers, not one," he wrote, "some political, some economic, and some cultural."

A flexible approach to spatial boundaries gives us a tool with which to break out of narrow definitions of core and periphery in world history. We do not need to see West African Muslims in a narrow framework which casts them only as bearers of culture from the center of civilization to the periphery. We can see them as West Africans, in economy, in language, and in many elements of discursive practice, and yet at the same time Muslims. We do not read from a single historical map that inevitably separates Africans from Middle Easterners. We read many maps side by side, some for language, some for economy, some for religion. Similarly, when we define the boundaries of African healing practices we do not need to stop at the continent's edge; our history can extend to the Americas. If we adopt a flexible and situationally specific understanding of historical space, the plantation complex, which is often seen as narrowly American, as a phenomenon of the Caribbean, Brazil, and the southern United States, can now be understood as extending to the East Coast of Africa and to northern Nigeria.

Braudel, along with the other *Annales* historians, insisted on asking how representative our historical knowledge is in relation to the totality of the universe that might be described, if only we knew the full story. He saw the economy as studied by economists, for example, as only one small part of a much larger and more shadowy sphere of economic activity. He observed that "The market economy still controls the great mass of transactions *that show up in the statistics*," as a way of arguing that the historian ought to be concerned also with what does not show up in the statistics. A concern with the represen-

tativeness of historical knowledge was at the heart of African history's growth, which in this sense can be seen as Braudelian in its inspiration. African historians were saying that even if conventional sources were silent on Africa, this could not be taken as evidence that nothing had happened in Africa. If the contours of world history were determined by the silence of our sources, and not by the shape of history's subject matter, then we needed to find new sources.

Yet Braudel himself could not break out of a unidirectional history of the world with Europe at its center. *Civilisation matérielle, économie et capitalisme,* his three-volume history of the world between the fifteenth and eighteenth centuries, is driven by a tension between Braudel's disciplined attempt to find the correct spatial frame for each phenomenon (to explain the eighteenth-century rise of population on a worldwide basis, for example), and his definition of modern world history as the rise of a dominant Europe.

Civilisation matérielle, as a world history, touches on Africa's place in comparative context. The first volume is concerned with the history of everyday material life: food, clothing, crops, housing, furniture, and so on. Braudel's weakness in understanding sub-Saharan Africa does not undermine his more general analysis, except as it shapes his most general reflections on the full range of human experience. The same is true of the second volume, on the techniques by which people exchanged goods in various parts of the world. In the third volume, however, the question of Africa's place in history (and Latin America's) comes closer to the center of the analysis. This volume, which draws heavily on the thought of Immanuel Wallerstein, asks about the process by which a dominant capitalist world economy emerged, with its core in the West. In 1750, he says, the countries which were later to become industrialized produced 22.5 percent of the world's gross product. In 1976 the same countries produced 75 percent of that product. What were the origins of this movement from the relative economic parity of the world's parts to the dominance of the capitalist core? . . .

Braudel adopted this framework, with its concern for the systematic character of inequality between the people he called "les *have* et les *have not.*" He was interested in how the dominance of the capitalist center grew out of developments within Europe, and out of relations among local world-economies. These latter were the spatial units which achieved a certain organic integration because of the density of exchange relations within them. The Mediterranean of the sixteenth century was a world-economy in this sense.

Braudel tried to make a serious assessment of the degree to which wealth drawn from outside Europe contributed to the rise of capitalism, but he treated Africans, and to a lesser extent people of the Americas, as historical actors only to the extent that they met European needs:

> While we might have preferred to see this "Non-Europe" on its own terms, it cannot properly be understood, even before the eighteenth century, except in terms of the mighty shadow cast over it by western Europe. . . . It was from all over the world . . . that Europe was now drawing a substantial part of her strength and substance. And it was this extra share which enabled Europeans to reach superhuman heights in tackling the tasks encountered on the path to progress.

This is a rather strange statement, lumping together much of the world simply on the basis that it is not Europe and proposing to ignore non-Europe on its own terms.

Braudel describes African developments, in particular, in terms of racial essences. In his view all civilization originated from the north, radiating southwards. He writes, "I should like now to concentrate on the heartland of Black Africa, leaving aside the countries of the Maghreb—a 'White Africa' contained within the orbit of Islam." Braudel's understanding of historical space is usually a subtle one in which each spatial frame is carefully differentiated. Here, however, he merges several frames in an inflexible and inaccurate way. Firstly, he merges race ("White" or "Black") with religion (Islamic or non-Islamic), even though many of the Muslims were people he would otherwise have described as "Black."

Secondly, he characterizes "Black Africa" as passive and inert. He writes that European ships on the West Coast met "neither resistance nor surveillance" and that the same thing happened on the shores of the desert: "Islam's camel-trains were as free to choose their entry-points as Europe's ships." This is demonstrably incorrect. A very large body of historical literature explores the complex interactions between West African kings or traders and those who came across the desert from the north. The spread of Islam and of the trans-Saharan trade was shared by initiatives taken on both sides of the desert.

According to Braudel, all movement was in a single direction. "Curiously, no black explorers ever undertook any of the voyages across either the desert or the ocean which lay on their doorstep.... To the African, the Atlantic was, like the Sahara, an impenetrable obstacle." He writes this despite the knowledge (with which he was certainly acquainted) that many Muslims who traded across the desert, or who went on the pilgrimage to Mecca from the West African Sudan, were Africans he would describe as black, carrying the cultural heritage of West Africa with them. Black African rulers are reported as having made the pilgrimage to Mecca as early as the eleventh century. Mansa Musa of Mali traveled from West Africa to Cairo and then to Mecca in the fourteenth century with a retinue reported to number 60,000. Even though the correct number is likely to be smaller, there is no question that thousands of Africans crossed the desert to visit the world of the Mediterranean and the Red Sea, and others (from the East Coast) crossed the Indian Ocean to reach the Persian Gulf and India.

Finally, it appears to be the case that Braudel's characterization of the difference between "Black Africa" and "White Africa" is based on his understanding of race. In *Grammaire des civilisations* he acknowledges that Ethiopia (in this case Christian) was a civilization, explaining that it "undeniably possess white ethnic elements, and is founded on a *métisse* population, very different, however, from those of the true Melano-Africans." At times he denies the existence of facts in order to preserve the clear distinction between a Black Africa that is uncivilized and a White Africa that is civilized. In a 1963 book he acknowledges that the region near the Gulf of Guinea was urbanized very early. But then in a later book which argues that towns were one of the distinguishing marks of civilization, he writes that there were no towns on the fringes of the Gulf of Guinea....

Because historians have come to a fuller understanding of African urbanization, and of African initiatives in intercontinental exchange, it is now easy to see the weakness of this small part of Braudel's work. A central question remains, however: whether his unidirectional interpretation of Africa is merely an unfortunate idiosyncracy of an otherwise great historian, or whether it is a sign of deeper problems in the way many historians construct their narratives....

A reading of McNeill, Braudel, Bennassar and Chaunu, Wolf, Curtin, and others points to a larger and more general development: that the emergence of African history (and of Asian and Latin American history) has changed our understanding of general history, and of Europe's place in the world, in profound ways. It is no longer possible to defend the position that historical processes among non-European peoples can be seen as the consequence of all-encompassing influences emerging from a dominant European center. This shift in our understanding is uncomfortable for those who see history as the spread of civilization from a European center, and it is equally uncomfortable for those who sketch history in terms of an all-determining system of capitalist exploitation.

The shift away from historical narratives that originate in Europe has been both accompanied and enabled by innovations in methods for constructing knowledge about people who had previously been left out of academic histories. These renovated methods, some of which achieved their fullest early development among historians of Africa, include oral history, historical archaeology, and historical linguistics, as well as anthropologically informed historical analysis. The new methods and modes of interpretation made it possible for scholars to approach the history of non-literate people, and in many cases powerless ones, without departing from the accepted critical canons of historical research. Scholars were able to know histories they had never known before. The consequences were, once again, paradoxical. These significant advances in the range and quality of historical knowledge helped to shake historians' faith in the quality of their knowledge. To glimpse whole regions of history previously unknown, to see the dark side of the moon, inevitably shook scholars' faith in their own omniscience.

The methodological advances were not narrowly African ones. They had an impact in a number of historical fields, but many of them emerged with particular clarity and power amongst historians of Africa. The impact of oral history was bound to be great in studies of sub-Saharan Africa, where many societies were ideally suited for this form of research: their people transmitted substantial bodies of knowledge from one generation to the next and sustained complex political and economic hierarchies, all without practicing writing. Oral traditions were still alive (in many cases *are* still alive) when the historians of the 1960s and 1970s went about their work. Unlike Latin America, where the colonial period had begun several centuries earlier, it was only in the late nineteenth century that most of sub-Saharan Africa experienced conquest. Before this Europeans did not, in most cases, intervene directly in the transmission of knowledge....

The amplified range of methods employed by African historians has proven useful not only in societies that lack writing, but also for studying the

underclasses of societies with a considerable range of literacy. Historians have used these amplified methods to construct rich accounts of the African majority in colonial society and especially to bring us magnificent accounts of peasant resistance to colonial domination. . . .

The sense that we can no longer tell history as a single story, from a single consistent point of view or from a unified perspective, strikes deep resonances in recent social and cultural thought. Michel Foucault wrote, in *Language, Countermemory, Practice,* that the idea of the whole society "arose in the Western world, in this highly individualized historical development that culminates in capitalism. To speak of the 'whole of society' apart from the only form it has ever taken is to transform our past into a dream." The very categories by which we understand universal experience originate in the particular experience of the core of the capitalist world.

This is the same lesson taught by an examination of African history: the categories which are ostensibly universal are in fact particular, and they refer to the experience of modern Europe. That we have learned this lesson in two different ways—through philosophically based writings on Europe and through histories of non-Europeans—forces us to ask about the relationship between the two sets of developments. A central question which has not yet been fully addressed is the relationship between the crisis of historical representation that came about when historians began to hear the voices of those who had been voiceless, and the more general epistemological crisis affecting all the social sciences and humanities. . . .

We are left, then, with an enormously expanded subject matter, with historical narratives originating in Africa that must be given full weight alongside those originating in Europe. We have seen, however, that this is not a simple process of adding one more body of knowledge to our fund, of increasing the balance in the account. The need for historians to hear African voices originates with the same impulse as the need to hear the voices that had been silent within European history. Since that is so, it hardly feels satisfying to listen to a single authoritative African voice, leaving others silent, or to read African texts without seeking marks of power, or without asking about the authority of the historian (African or American, European or Asian) who presumes to represent history. Historians have no choice but to open up world history to African history, but having done so, they find that the problems have just begun.

POSTSCRIPT

Did the West Define the Modern World?

Changes in the historical profession in the last quarter-century can be seen clearly in the 25th anniversary edition of McNeill's *Rise of the West*. In a retrospective essay entitled "The Rise of the West After Twenty-Five Years," McNeill states that the first edition of his book was influenced by the post–World War II imperial mood of the United States, which was then at its apex of power and ability to influence world affairs. He now urges historians to "construct a clear and elegant discourse with which to present the different facets and interacting flows of human history as we now understand them." The rise in the number of world history courses in college curricula (replacing the traditional Western history ones) and the number of advanced degrees awarded each year in non-Western humanities-related subjects, are the fruits of the new historical labors of which McNeill speaks.

This issue provides interesting tie-in opportunities with Issues 13 and 14 in this volume. In the former, Christopher Columbus's role in world history is analyzed and evaluated. Columbus was certainly an important figure in the development of European and world history, and, as it turned out, the Western hemisphere in particular. In the latter, reasons why the Chinese gave up on their maritime campaigns and the effects of such action are scrutinized and assessed. Both of these are directly related to this issue, especially the McNeill selection, which describes why the West was able to gain the upper hand over the rest of the world during the "Age of Exploration" and after.

But the term *dominance* should not be taken to imply that the modern world's development has been fueled solely by the centuries of Western influence. The work of a new generation of historians, described briefly in this issue's introduction, attests that the countries of Africa, Asia, and Latin America today owe a great deal to their own homegrown cultures, institutions, and mores.

A source helpful to understanding this issue is Eric Wolf, *Europe and People Without History* (University of California Press, 1982), a ground-breaking work on the need to provide an all-inclusive view of the world's history. Also see Fernand Braudel, *The Perspective of the World* (University of California Press, 1992), the third volume of a multi-volume study of the fifteenth–eighteenth century capitalist world that gives "the people without history" a voice. Finally, for a multi-disciplinary application of these principles that concentrates on Africa, see *Africa and the Disciplines: The Contributions of Research in Africa to the Social Sciences* (University of Chicago Press, 1993). This is the book from which Feierman's selection used in this issue was taken.

Contributors to This Volume

EDITORS

JOSEPH R. MITCHELL is a history instructor at Howard Community College in Columbia, Maryland, and a popular regional speaker. He received an M.A. in history from Loyola College in Maryland and an M.A. in African American History from Morgan State University, also in Maryland. He is the principal coeditor of *The Holocaust: Readings and Interpretations* (McGraw-Hill/Dushkin, 2001).

HELEN BUSS MITCHELL is a professor of philosophy and director of the women's studies program at Howard Community College in Columbia, Maryland. She is the author of *Roots of Wisdom* and *Readings From the Roots of Wisdom*. Both books were published by Wadsworth Publishing Company and are now in their third editions. She has also created, written, and hosted a philosophy telecourse, *For the Love of Wisdom*, which is distributed throughout the country by PBS. She has earned numerous degrees, including a Ph.D. in women's history from the University of Maryland.

STAFF

Theodore Knight List Manager
David Brackley Senior Developmental Editor
Juliana Gribbins Developmental Editor
Rose Gleich Administrative Assistant
Brenda S. Filley Director of Production/Design
Juliana Arbo Typesetting Supervisor
Diane Barker Proofreader
Richard Tietjen Publishing Systems Manager
Larry Killian Copier Coordinator

AUTHORS

RICHARD E. W. ADAMS is professor of anthropology at the University of Texas at San Antonio. He is also director of the Rio Azul Archaeological Project

KAREN ARMSTRONG teaches at the Leo Baeck College for the Study of Judaism and the Training of Rabbis and Teachers in London, England. Her published works include *Beginning the World* (St. Martin's Press, 1983) and *Holy War* (Macmillan, 1988).

KATHRYN A. BARD is assistant professor of archaeology at Boston University. She received her Ph.D. in Egyptian archaeology from the University of Toronto.

ANNE LLEWELLYN BARSTOW is professor of history, retired, at the State University of New York at Old Westbury. She is the author of *Witchcraze: A New History of the European Witch Hunts* (HarperCollins, 1994) and *War's Dirty Secret: Rape, Prostitution, and Other Crimes Against Women* (The Pilgrim Press/United Church Press, 2000).

CATHARINA BLOMBERG is a professor at Stockholm University, Sweden. She edited a 14-volume work entitled *The West's Encounter With Japanese Civilization.*

JOHN BOSWELL (1947–1994) was A. Whitney Griswold Professor of History at Yale University. He is the author of *The Kindness of Strangers: The Abandonment of Children in Western Europe From Late Antiquity to the Renaissance* (Pantheon Books, 1988).

ROBIN BRIGGS is a senior research fellow at All Souls College and a university lecturer in modern history at Oxford University, England.

HERBERT BUTTERFIELD taught for many years at Cambridge University. He is the author of *Herbert Butterfield on History* (Garland, 1985).

RACHEL CASPARI is a teacher and researcher at the University of Michigan.

GEORGE L. COWGILL is professor of anthropology at the University of Arizona. He is coeditor, with Norman Yoffee, of *The Collapse of Ancient States and Civilizations* (University of Arizona Press, 1988).

CLINTON CRAWFORD is an associate professor in the Department of Literature, Communications, and Philosophy at Medgar Evers College, City University of New York.

STEVEN FEIERMAN is a professor in and chair of the Department of History and Sociology at the University of Pennsylvania. He is the author of many works, including *Peasant Intellectuals* (University of Wisconsin Press, 1990).

FELIPE FERNÁNDEZ-ARMESTO is a writer who specializes in works on the Age of Exploration, one of which is *Before Columbus* (University of Pennsylvania Press, 1987).

RONALD C. FINUCANE is professor of history at Oakland University in Rochester, Michigan.

N. G. L. HAMMOND is professor emeritus of Greek at Bristol University, England. He is the author of *Alexander the Great: King, Commander, Statesman* (Bristol, 1994).

CHARLES HOMER HASKINS (1870–1937) was a history professor and dean of the Graduate School of Arts and Sciences at Harvard University. He is the author of *Studies in the History of Mediaeval Science* (Harvard University Press, 1927).

JOAN KELLY-GADOL (1928–1982) was a Renaissance scholar and theorist in women's history. Her works include *Leon Battista Alberti: Universal Man of the Early Renaissance* (University of Chicago Press, 1969).

JONATHAN MARK KENOYER teaches at the University of Wisconsin and did archaeological work in India and Pakistan for 25 years, including excavations at Harappa and Mohenjo-Daro.

KAREN L. KING is professor of New Testament studies at the Harvard Divinity School. She is the editor of *Images of the Feminine in Gnosticism* (Trinity Press, 2000) and *Women and Goddess Traditions in Antiquity and Today* (Fortress Press, 1997).

MARGARET L. KING is a history professor at the Graduate Center of the City University of New York. She has written extensively on the subjects of women, humanism, and the Renaissance.

WINSTON L. KING is professor emeritus at Vanderbilt University. A long-time writer on religion, he is the author of a number of books on Buddhism in Asia.

ROBERT KOLB is assistant professor of religion and history at Concordia College. He has written extensively on religious subjects, including Lutheran Church history and popular Christianity.

SAMUEL NOAH KRAMER (1897–1990) was a curator at the Museum of the University of Pennsylvania. He wrote and published widely on Sumerian texts and mythology.

NICHOLAS D. KRISTOF is a journalist specializing in Asian affairs. He is coauthor, with his wife Sheryl Wudunn, of *China Wakes* (Vintage Books, 1995).

HANS KÜNG, a Swiss Roman Catholic theologian credited with moderating and modernizing the rigid anti-Protestantism that grew out of the Council of Trent following the Reformation, is professor emeritus at Tubingen University in Germany and the author of dozens of influential books.

HANS EBERHARD MAYER is professor of medieval and modern history at the University of Kiel, Germany.

ROBIN McKIE is science editor of the *London Observer* and the author of *Dawn of Man: The Story of Human Evolution* (DK Publishing, 2000).

WILLIAM H. McNEILL taught history at the University of Chicago from 1947 to 1987. He served as president of the American Historical Association in 1981 and received the Erasmus Prize from the Dutch government in 1996.

MEHDI NAKOSTEEN is a former professor of history and the philosophy of education at the University of Colorado. He is the author of *The History and Philosophy of Education* (Ronald Press, 1965).

PHILIP LYNDON REYNOLDS is director of the Aquinas Center of Theology at Emory University. He is the author of *Marriage in the Western Church* (Brill, 1994).

KIRKPATRICK SALE is the author of five books, including *Human Scale* (Putnam Publishing Group, 1980). He is also a founder of the Green Party.

STEVEN SHAPIN is professor of sociology at the University of California at San Diego. He is the author of *Leviathan and the Air-Pump: Hobbes, Boyle, and the Experimental Life* (Princeton University Press, 1985).

CHESTER G. STARR (1914–1999) was professor of history at the University of Michigan, Ann Arbor. He was the author of many books on the ancient world, including some focusing on Greek and Roman civilizations.

CHRISTOPHER STRINGER is a principal researcher at London's Natural History Museum. He has cowritten, with Clive Gambee, *In Search of the Neanderthals: Solving the Puzzle of Human Origins* (Thames and London, 1995).

BRUCE SWANSON was a well-known authority of Chinese maritime affairs. He has written articles on the subject and was a regular participant in conferences related to the maritime environment in China.

STANLEY WOLPERT, professor of history at the University of California in Los Angeles, is a recognized expert in the history of India. Among his many books are biographies of Gandhi and Nehru.

MILFORD WOLPOFF is professor of anthropology at the University of Michigan at Ann Arbor. He is the author of *Paleoanthropology* (McGraw-Hill, 1998).

IAN WORTHINGTON is professor of Greek history at the University of Missouri, Columbus. He has a forthcoming book on Alexander the Great to be published by Routledge.

Index